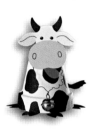

PAINTING AND DECORATING

# CLAY POTS

QUARRY

First published in the United States of America in 2004 by
Quarry Books, an imprint of
Rockport Publishers, Inc.
100 Cummings Center
Suite 406-L
Beverly, MA 01915-6101
Telephone: (978) 282-9590
Fax: (978) 283-2742
www.rockpub.com

This edition published in the United States of America in 2008

**Library of Congress Cataloging-in-Publication Data**

Kunkel, Natalie.
  Painting and decorating clay pots : 150 step-by-step projects for making people,
animals, and fantasy characters from terra-cotta pots / Natalie Kunkel and Annette Kunkel.
    p. cm.
  ISBN 1-59253-100-8 (pbk.)
   1. Painting. 2. Decoration and ornament. 3. Flower pots in art. I. Kunkel, Annette. II
Title
TT385.K85 2004
745.7'23—dc22

2004006565
CIP

ISBN-13: 978-1-59253-475-3
ISBN-10: 1-59253-475-9

10 9 8 7 6 5 4 3 2 1

Grateful acknowledgment is given to Natalie and Annette Kunkel for the work on pages 11–65; to Ute Iparraguirre De las Cassas and Gudrun Schmitt for the work on pages 66–91; to Sigrid Heinzmann for the work on pages 92–117; to Armin Täubner for the work on pages 118–144; and to Karen C. Ruth for the work on pages 145–176.

Photography: frechverlag GmbH, 70499 Stuttgart; Fotostudio Ullrich & Co., Renningen
With the exception of pages 145-176 by Creative Publishing international
Cover Design: Mattie Reposa

Printed in Singapore

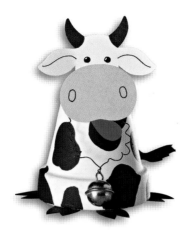

# PAINTING AND DECORATING
# CLAY POTS

## 150 Fun Step-by-Step Projects

for Making People, Animals, and Fantasy Characters from Terra-Cotta Pots

BEVERLY MASSACHUSETTS

QUARRY BOOKS

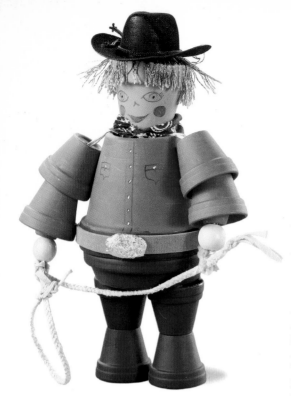

# CONTENTS

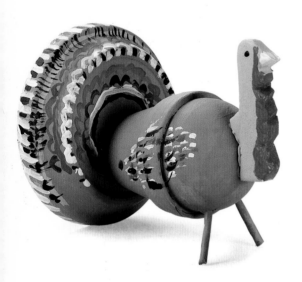

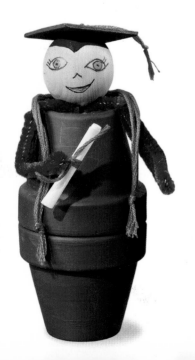

Introduction . . . . . . . . . . . . . . . . . . . . . . . . . . . . . . . . . . . . . . . . 6
Basics, Materials, and Tools . . . . . . . . . . . . . . . . . . . . . . . . . . . . . . 7
Boy with Dangling Legs . . . . . . . . . . . . . . . . . . . . . . . . . . . . . . . 11
Chimney Sweeper . . . . . . . . . . . . . . . . . . . . . . . . . . . . . . . . . . . 13
Lucky Pig . . . . . . . . . . . . . . . . . . . . . . . . . . . . . . . . . . . . . . . . . . 13
Centipede . . . . . . . . . . . . . . . . . . . . . . . . . . . . . . . . . . . . . . . . . 14
Miniature Boy and Girl . . . . . . . . . . . . . . . . . . . . . . . . . . . . . . . 14
Clay Pot Family . . . . . . . . . . . . . . . . . . . . . . . . . . . . . . . . . . . . . 16
Market Trader . . . . . . . . . . . . . . . . . . . . . . . . . . . . . . . . . . . . . . 18
Farming Family . . . . . . . . . . . . . . . . . . . . . . . . . . . . . . . . . . . . . 18
Easter Bunny . . . . . . . . . . . . . . . . . . . . . . . . . . . . . . . . . . . . . . . 22
Easter Chick . . . . . . . . . . . . . . . . . . . . . . . . . . . . . . . . . . . . . . . 22
Aztec Woman . . . . . . . . . . . . . . . . . . . . . . . . . . . . . . . . . . . . . . 24
Aztec Man . . . . . . . . . . . . . . . . . . . . . . . . . . . . . . . . . . . . . . . . . 25
Scarecrow . . . . . . . . . . . . . . . . . . . . . . . . . . . . . . . . . . . . . . . . . 26
Miniature Witch . . . . . . . . . . . . . . . . . . . . . . . . . . . . . . . . . . . . 28
Witchy the Witch . . . . . . . . . . . . . . . . . . . . . . . . . . . . . . . . . . . . 28
Standing Snowman . . . . . . . . . . . . . . . . . . . . . . . . . . . . . . . . . . 30
Snowman Bird Feeder . . . . . . . . . . . . . . . . . . . . . . . . . . . . . . . . 30
Standing Santa Claus . . . . . . . . . . . . . . . . . . . . . . . . . . . . . . . . 33
Santa Claus Wind Chime . . . . . . . . . . . . . . . . . . . . . . . . . . . . . . 34
Snowman Wind Chime . . . . . . . . . . . . . . . . . . . . . . . . . . . . . . . 34
Angel . . . . . . . . . . . . . . . . . . . . . . . . . . . . . . . . . . . . . . . . . . . . . 36
Raven . . . . . . . . . . . . . . . . . . . . . . . . . . . . . . . . . . . . . . . . . . . . . 37
Birdbath or Flower Stand . . . . . . . . . . . . . . . . . . . . . . . . . . . . . . 38
Fishing Cat and Mouse . . . . . . . . . . . . . . . . . . . . . . . . . . . . . . . 40
Rooster and Chick . . . . . . . . . . . . . . . . . . . . . . . . . . . . . . . . . . . 42
Water-Carrying Lady . . . . . . . . . . . . . . . . . . . . . . . . . . . . . . . . . 44
Turtle . . . . . . . . . . . . . . . . . . . . . . . . . . . . . . . . . . . . . . . . . . . . . 44
Raffia Figurer . . . . . . . . . . . . . . . . . . . . . . . . . . . . . . . . . . . . . . 46
Night Watchman . . . . . . . . . . . . . . . . . . . . . . . . . . . . . . . . . . . . 50
Gnome . . . . . . . . . . . . . . . . . . . . . . . . . . . . . . . . . . . . . . . . . . . 54
Goblin . . . . . . . . . . . . . . . . . . . . . . . . . . . . . . . . . . . . . . . . . . . . 55
Guard Dog . . . . . . . . . . . . . . . . . . . . . . . . . . . . . . . . . . . . . . . . . 56
Dragonfly . . . . . . . . . . . . . . . . . . . . . . . . . . . . . . . . . . . . . . . . . 60
Small Butterflies . . . . . . . . . . . . . . . . . . . . . . . . . . . . . . . . . . . . 61
Standing Butterfly . . . . . . . . . . . . . . . . . . . . . . . . . . . . . . . . . . . 62
Ladybug . . . . . . . . . . . . . . . . . . . . . . . . . . . . . . . . . . . . . . . . . . . 63
Miniature Troll . . . . . . . . . . . . . . . . . . . . . . . . . . . . . . . . . . . . . 65
Bee and Flower Mobile . . . . . . . . . . . . . . . . . . . . . . . . . . . . . . . 66
Caterpillar . . . . . . . . . . . . . . . . . . . . . . . . . . . . . . . . . . . . . . . . . 68
Frog . . . . . . . . . . . . . . . . . . . . . . . . . . . . . . . . . . . . . . . . . . . . . . 70
Bird Feeder . . . . . . . . . . . . . . . . . . . . . . . . . . . . . . . . . . . . . . . . 70
Clowns . . . . . . . . . . . . . . . . . . . . . . . . . . . . . . . . . . . . . . . . . . . . 72
Mouse . . . . . . . . . . . . . . . . . . . . . . . . . . . . . . . . . . . . . . . . . . . . 74
Colorful Fruit Bowl . . . . . . . . . . . . . . . . . . . . . . . . . . . . . . . . . . 75
Newspaper Lady . . . . . . . . . . . . . . . . . . . . . . . . . . . . . . . . . . . . 76
Funky Door Chime . . . . . . . . . . . . . . . . . . . . . . . . . . . . . . . . . . 78
Étagère with Butterflies . . . . . . . . . . . . . . . . . . . . . . . . . . . . . . . 78
Maritime Candleholders (Fish, Starfish, or Lighthouse) . . . . . . 80
Cheerful Ladybug Mobile . . . . . . . . . . . . . . . . . . . . . . . . . . . . . 82
Glowing Octopus . . . . . . . . . . . . . . . . . . . . . . . . . . . . . . . . . . . 84
Goblin Candleholder . . . . . . . . . . . . . . . . . . . . . . . . . . . . . . . . . 86
Funny Piglets Wind Chime . . . . . . . . . . . . . . . . . . . . . . . . . . . . 87
Christmas Tree . . . . . . . . . . . . . . . . . . . . . . . . . . . . . . . . . . . . . 88
Colorful Scarecrow . . . . . . . . . . . . . . . . . . . . . . . . . . . . . . . . . . 88

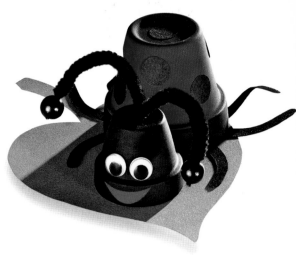

Sweet Angel . . . . . . . . . . . . . . . . . . . . . . . . . . . . . . . . . 90
Santa Claus with Gifts . . . . . . . . . . . . . . . . . . . . . . . . . . 90
Pair of Owls . . . . . . . . . . . . . . . . . . . . . . . . . . . . . . . . . 92
Gnome's Present . . . . . . . . . . . . . . . . . . . . . . . . . . . . . . 93
Mouse and Hedgehog . . . . . . . . . . . . . . . . . . . . . . . . . . 94
Sunflower People . . . . . . . . . . . . . . . . . . . . . . . . . . . . . 96
Summer Wind Chime . . . . . . . . . . . . . . . . . . . . . . . . . . . 96
Harry at Harvest . . . . . . . . . . . . . . . . . . . . . . . . . . . . . . 98
Miniature Raven . . . . . . . . . . . . . . . . . . . . . . . . . . . . . . 98
Children of the Forest . . . . . . . . . . . . . . . . . . . . . . . . . . 100
The Forester and Mushroom Pots . . . . . . . . . . . . . . . . . 103
Songbird Wreath . . . . . . . . . . . . . . . . . . . . . . . . . . . . . 104
Funny Scarecrow . . . . . . . . . . . . . . . . . . . . . . . . . . . . . 106
Lady Gardener and Pumpkin Face . . . . . . . . . . . . . . . . . 108
Raven and Sunflowers . . . . . . . . . . . . . . . . . . . . . . . . . 111
Drusilda the Witch . . . . . . . . . . . . . . . . . . . . . . . . . . . . 112
Ghost and Bats . . . . . . . . . . . . . . . . . . . . . . . . . . . . . . 114
Gnome, Mouse, and Mushroom . . . . . . . . . . . . . . . . . . 116
Cow . . . . . . . . . . . . . . . . . . . . . . . . . . . . . . . . . . . . . . 118
Duck Family . . . . . . . . . . . . . . . . . . . . . . . . . . . . . . . . 118
Cat and Mouse Pot . . . . . . . . . . . . . . . . . . . . . . . . . . . 121
Kiss Me Frog and Frog with a Fly . . . . . . . . . . . . . . . . . 122
Happy Birthday Mouse and Pen Mouse . . . . . . . . . . . . . 124
Easter Bunnies . . . . . . . . . . . . . . . . . . . . . . . . . . . . . . 126
Cool Rabbits . . . . . . . . . . . . . . . . . . . . . . . . . . . . . . . . 128
Hip Ladybugs . . . . . . . . . . . . . . . . . . . . . . . . . . . . . . . 128
Diving Hippos . . . . . . . . . . . . . . . . . . . . . . . . . . . . . . . 130
Turtles and Crabs . . . . . . . . . . . . . . . . . . . . . . . . . . . . 132
Frogs on Hearts . . . . . . . . . . . . . . . . . . . . . . . . . . . . . 134
Snail . . . . . . . . . . . . . . . . . . . . . . . . . . . . . . . . . . . . . 135
Raven Wind Chime . . . . . . . . . . . . . . . . . . . . . . . . . . . 138
Elephants . . . . . . . . . . . . . . . . . . . . . . . . . . . . . . . . . . 138
Halloween Bat . . . . . . . . . . . . . . . . . . . . . . . . . . . . . . 140
Spider . . . . . . . . . . . . . . . . . . . . . . . . . . . . . . . . . . . . 140
Penguins . . . . . . . . . . . . . . . . . . . . . . . . . . . . . . . . . . 142
Pigs . . . . . . . . . . . . . . . . . . . . . . . . . . . . . . . . . . . . . . 142
Angel . . . . . . . . . . . . . . . . . . . . . . . . . . . . . . . . . . . . 145
Devil . . . . . . . . . . . . . . . . . . . . . . . . . . . . . . . . . . . . . 145
Ballerina . . . . . . . . . . . . . . . . . . . . . . . . . . . . . . . . . . 146
Babies . . . . . . . . . . . . . . . . . . . . . . . . . . . . . . . . . . . . 147
Cupid and Bucket of Hearts . . . . . . . . . . . . . . . . . . . . . 148
Bride and Groom . . . . . . . . . . . . . . . . . . . . . . . . . . . . 150
Clown and Whimsical Fish . . . . . . . . . . . . . . . . . . . . . . 152
Mermaids . . . . . . . . . . . . . . . . . . . . . . . . . . . . . . . . . 154
Gingerbread Men . . . . . . . . . . . . . . . . . . . . . . . . . . . . 155
Hula Girl and Palm Trees . . . . . . . . . . . . . . . . . . . . . . . 156
Cowboy, Cowgirl, and Horse . . . . . . . . . . . . . . . . . . . . 158
Inuit and Igloo . . . . . . . . . . . . . . . . . . . . . . . . . . . . . . 162
Train Engine and Cars . . . . . . . . . . . . . . . . . . . . . . . . . 164
Robot . . . . . . . . . . . . . . . . . . . . . . . . . . . . . . . . . . . . 166
Jack-o-Lanterns . . . . . . . . . . . . . . . . . . . . . . . . . . . . . 167
Apple . . . . . . . . . . . . . . . . . . . . . . . . . . . . . . . . . . . . 168
Graduates . . . . . . . . . . . . . . . . . . . . . . . . . . . . . . . . . 169
Turkey, Pilgrims, and Native Americans . . . . . . . . . . . . . 170
Giraffe . . . . . . . . . . . . . . . . . . . . . . . . . . . . . . . . . . . . 174
Templates . . . . . . . . . . . . . . . . . . . . . . . . . . . . . . . . . 176

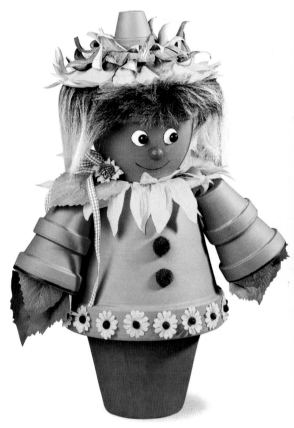

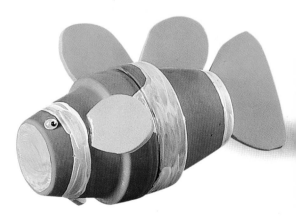

# Introduction

Clay pots have long been used around the house for garden plants. But, with a little creativity and imagination, you can easily turn what were once simple plant containers into a collection of original and charming decorative figures for both inside and outside the house.

Simple clay pots can be used for much more than just simple potted plants—with a little paint and a few easy-to-find craft materials you can make any plain terra-cotta clay pot into a fun and eye-catching decoration. You can create a whole range of decorative variations including holiday ornaments, friendship gifts, garden decorations, party favors, mementos, and mobiles. Let clay pot ladybugs loose in the garden or top your Christmas tree with a delightful angel. Halloween goblins and good-luck dragonflies are only a small taste of the 100 clay pot personalities that are included in this book. And, with a little creative vision, this book is really only a beginning.

Let these projects inspire you to build your own clay personalities or choose your favorites and make them your own. Mix and match decorative ideas or re-create the projects exactly. Whichever route you choose to explore, the possibilities for decorating clay pots is endless. We hope that, most of all, you have fun making them with your friends and your family.

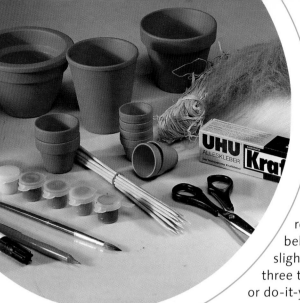

# Basics, Materials, and Tools

A variety of clay pots are used for the figures: regular-shaped pots, bell-shaped pots, and the slightly higher rose pots. All three types are available in crafting or do-it-yourself (DIY) stores.

Raffia can be used to tie the pots together and to attach arms and legs.

Wood glue is very strong and is ideal for gluing clay pots together. However, its runny consistency means that it has a rather long drying time. For parts that need to be glued horizontally and for attaching hair and other accessories, we recommend using superglue. A hot glue gun is not sufficient for gluing larger parts, but it can be used to attach elements made of poster board, such as animal heads, to the painted pot. Other elements, such as arms, wings, and feet can be fixed with an all-purpose glue.

The hair can be made from a variety of materials. Hemp looks like human hair, can be easily combed and styled, and fits well with natural materials. Hemp braids can be found in crafting and DIY stores. Abaca fiber is rougher and more difficult to work with, but it comes in different colors. Long-hair plush is available in all hair colors, and raffia is always suitable.

Crafting paints—water-based acrylic paints—are best for painting the clay pots. They cover well and dry quickly because the clay is absorbent. (For the same reason, you may need to apply a second coat of paint.) Use a small sponge or a hair paintbrush to apply the paint.

Cover the small hole in the clay pot (mostly behind the head) with a poster board circle of the same color. Use a circular stencil for best results.

To make wire spirals, wind wire around a wooden skewer. Pull off the resulting spiral and expand it to the desired length.

Many projects include templates, which are included at the back of this book. We've also provided some basic face templates, which you can use interchangeable on the faces. To use the template pages, tear along perforation and remove staples. Separate the pages and your templates are ready to use.

## Materials and Tools

### Basics
clay pots and saucers in various shapes and sizes
poster board (If no size is indicated, you will not need more than a leftover piece of 5 $7/8$" x 8 $1/4$" [14.5 cm x 21 cm] size.)
Raffia or jute cord
wooden skewers, toothpicks, or bamboo sticks
wooden beads in various sizes and colors
cardboard
air-drying modeling clay
pencil
clear tape
floral tape
carbon paper
tracing paper
ballpoint pen
water-resistant, resin-based clear varnish
waterproof felt pen, black

### Glues
Wood glue
Superglue
modeling glue
all-purpose glue
hot glue gun

### Decorative items
hemp
long-hair plush
abaca fiber
beige r
$1/2$"

## Materials and Tools
### continued

pom-poms
rubber mat
wobbly eyes
felt
tulle

### Paints and paintbrushes

fine natural-hair paintbrushes
bristle brushes
sponge
water glass
paint rag
crafting paints
terra cotta pens
lacquer pens
puff paint
granite paint
structural snow paint

### Wire

pipe cleaners
crafting wire
florist's wire
stainless-steel wire

### Tools

scissors
crafters pliers
round pliers
ruler
awl
punch
compass
mending, knitting,
  or crochet needle
cutter with cutting board
side cutter

The exact material requirements
will be detailed in each project.
Tools won't be specifically
mentioned.

## Tying the Clay Pots Together

The general approach is to stack the clay pots to help determine the length of raffia threads needed. Tie a wooden bead to one end of the raffia and pull the other end through the pot holes. For mobiles, tie the pots to the ends of the sticks, then push the knots along the sticks to balance the mobile.

**1.**

### Type 1: Sitting figure with legs

**1.** Cut a wooden stick to fit into the bottom of the clay pot and tie a raffia cord, about 20" (50 cm) long and consisting of four to five threads, to the middle of the stick. Before tying the knot, completely insert three or four small sticks and tie another knot so the sticks don't fall out. Push the sticks through the hole of the body pot and place them across the hole. Leave the leftover raffia thread for tying on arms.

**2.**

**2.** To fix the head, prepare an additional raffia cord as described above and thread it through the hole of the head pot. Continue to thread the raffia ends through the hole of the body pot. Tie the threads above the already placed wooden sticks. Leave the leftover raffia to tie on the legs.

**3.** For the arms, thread the raffia cord through the hole of the miniature pot and push it to where the shoulder starts. Make a loose knot and push it as far into the pot as possible. To make the raffia threads invisible, push the clay pots into one another before tying them together. You can also thread through a wooden bead beforehand to prevent the knot from slipping through the pot hole. Follow this to tie on both arms. Follow the illustration for the order of the arms.

**3.**

**4.** Make the legs in the same way. Make the first knot exactly below the rim of the pot.

*Note:* For small figures, you can use aluminium wire, figure wire, or pipe cleaners to position body parts.

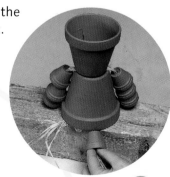

**4.**

**5.** To get a nice head shape as underlay for the wig, glue a Styrofoam ball of the appropriate size into the pot.

## Type 2: Standing figure

**6.** Make the upper part of the figure the same as for type 1. Simply omit tying on the legs (step 4). Cut the relevant raffia threads 1½" (4 cm) from the knot and wood-glue the upper part to the pot used for the bottom part. Wood glue must be left to dry overnight.

Cut strong cardboard to make a floor for the upper pot and glue into place. If desired, paint all the pots before gluing them together. Use modeling glue to fix the bottom part to the middle of the cardboard floor and an upside-down clay saucer. Let the glue dry for five minutes. Glue the head to the body. In most cases, the pot stays in place without extra support.

5.

## Type 3: Hands and hats

Bend aluminum wire twice around the middle of a wooden stick. Pull the stick from the loop thus formed and thread it from the outside through the pot hole. Use the stick as a lock to fix the wire inside of the pot. Cut strong cardboard to make a floor for the upper pot and glue it into place (see type 2). Thread three pots onto each of the arm wires, starting with the smallest, and pull them up to where the shoulder starts. Use crafters pliers to fix the pots into place with a loop each; make sure to bend the wire back as far as possible.

6.

For the hands, thread the small pots with the opening facing downward onto the wire and bend it once again into a loop. Cut the excess wire with the pliers. To finish the hands, glue on the last two pots with modeling glue. To make the head, gently tilt the rose pot forward and fix with modeling glue. Glue clay pots into each other to make the hat. Use the large rose pot as the bottom part and glue onto the cardboard floor of the main body.

## Sewing the Wig

You need a hemp plait and a ribbon ½" (1 cm) wide. For hairstyle A, stitch the hair to the middle of the ribbon in the length you want. For hairstyle B, stitch the hair along a ribbon of the same length as the pot circumference. For a fringe, just make hairstyle B with shorter hair.

### Tips

We show you a variety of face styles in this book. Use these for inspiration. Some of them you will find on the template. Sketch the faces with a pencil before painting so mistakes can be rubbed out and corrected. Lacquer pens make the exact painting of eyes and mouth lines easier. If a head is slightly wobbly, just fill the gap with hot glue.

Comb the hair with a rough comb. Make sure to pack the hair tightly while stitching so the underlay remains invisible.

Accessories shown are suggestions. You may modify them to suit your taste.

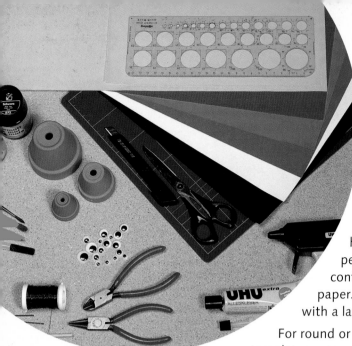

## Transfer of the Face Contours

Transfer the face contours from the template to tracing paper. Tape carbon paper to the pot, carbon side in. Be sure to get it tight against the pot. If the pot is rounded, snip the top and bottom rim of the carbon paper to get a smooth fit. Position the tracing paper over the carbon paper and tape it on. Pressing fairly hard, slowly trace the contours of the motif with a pencil or a ballpoint pen. This will transfer the face contours to the pot. Discard the tracing and carbon paper. Fill in the outlines and then accent the contours with a lacquer pen or waterproof felt pen.

For round or oval eyes, trace buttons, rings, or drawing templates onto paper, or use a compass and cut them out. Then lay them onto the pot and use a pencil to trace around them. If you don't like to paint, use wobbly eyes, wooden beads, cotton balls, or cardboard for eyes and noses.

If you want to paint the pot itself before adding the face, be sure to let each color dry thoroughly before beginning the transfer process.

### Painting with a Terra Cotta Pen

We have painted all objects with terra cotta pens. The paint in the terra cotta pen is highly concentrated, covers well, is water-soluble, and dries very quickly. Shake the pen well before the first use. Push the tip a few times onto a piece of paper until the paint comes through. Do not push the pens onto your craft project, as the color will run if the pressure is too great.

### Modeling with Modeling Clay

For some projects, modeling clay is used to make decorations. We suggest air-drying modeling clay, which does not need to be fired. Drying takes about 24 hours. Always use clean hands when working with clay and be sure to knead it well.

To make flower petals, form rolls about 1" (3 cm) long and 2/10" (0.5 cm) thick, then slightly flatten one side and form a peak for the other end. For flat elements, simply roll out the modeling clay and cut according to the template. After the clay has dried, it is still possible to correct problems, such as cracks, with additional modeling clay. When all the clay is completely dry, it can be painted. Store leftover modeling clay in a sealed plastic bag.

### Assembling the Figures

It is best to use wood glue to assemble the figures. Small accessories can be glued on with superglue.

Try using clay pots as gift wrap! You can tie them together with raffia just like any other gift wrap.

You can make projects shown in the book larger or smaller to suit any pot size. The size of the templates can be easily adapted with a photocopier.

---

**Tip**

To achieve a more intense color, apply several coats of paint.

---

**Tips**

Objects to be placed outdoors must be coated with a clear varnish to make them waterproof. You can find this varnish in any well-stocked craft supply store.

We often use half-pearls for eyes. You can easily make them yourself: Insert pointed scissors into the hole of the bead and forcefully press downward. Make sure to use a suitable work surface.

---

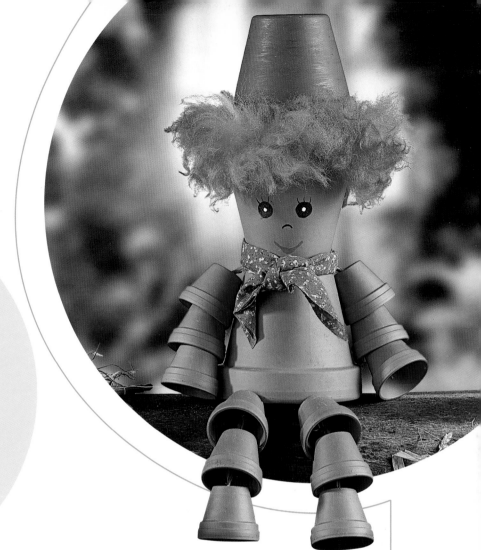

## Materials

- Finished height about 12" (30 cm)
- 2 clay pots, 2 ¾" (7 cm) in diameter
- 1 clay pot, 3" (8 cm) in diameter
- 12 miniature clay pots, 1 ¼" (3.5 cm) in diameter
- 1 Styrofoam ball, 2 ¾" (7 cm) in diameter
- 1 scrap of reddish-brown fake fur
- Green crafting paint
- 1 velour scarf, 11" x 11" (28 cm x 28 cm)

# Boy with Dangling Legs

Make the figures according to the instructions on page 8, using the largest pot as the body and the 2 ¾" (7 cm) pots as head and hat. Paint a nice face for the boy. Cut a strip, about 1" (3 cm) wide and as long as the circumference of the pot, from the piece of fake fur. Glue it to the Styrofoam ball just above the pot rim. Apply a base coat of green crafting paint to the hat pot and glue it to the head. As an accessory, tie on the colored velour scarf.

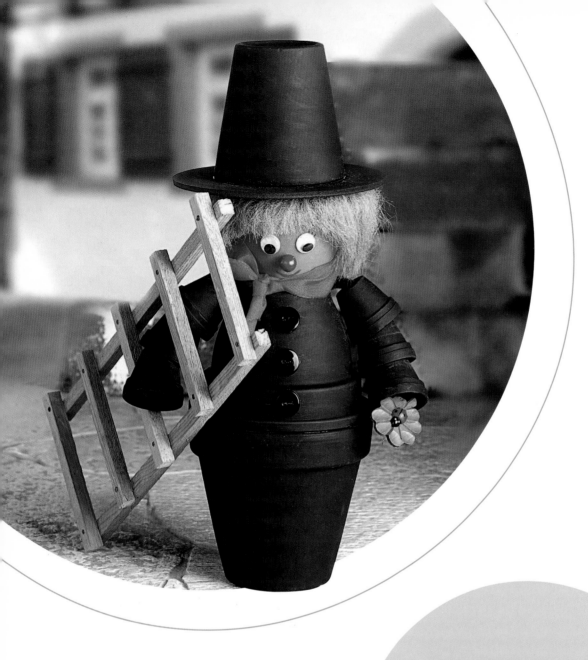

**Materials for Lucky Pig**

- Finished height about 5" (13 cm)
- 2 bell pots, 5" (13 cm) in diameter
- 1 clay pot, 2 ¼" (6 cm) in diameter
- 6 miniature pots, 1 ¼" (3.5 cm) in  diameter
- 2 wobbly eyes, ¾" (2 cm) in diameter
- 1 wooden shamrock

## Chimney Sweeper

Leave the small bell pot unpainted to serve as a head. Paint all other pots black. Make the body of the chimney sweep as described on page 9. Glue on the wobbly eyes and the nose and paint the mouth as shown in the illustration. Cut the long hair plush into a strip about ¾" (2 cm) and as long as the pot's circumference and glue it to the rim of the pot. For the brim of the hat, cut a circle 5" (13 cm) in diameter from the rubber sheet and glue it to the head. Fix the rose pot as a hat. Cut the hair to the right length. Fold the red scarf in half lengthwise and tie around the neck in a knot. Cut the ends at an angle. Fix the shamrock and hang the ladder over the right shoulder.

## Lucky Pig

Glue the two large clay pots together with wood glue and leave to dry in a vertical position. Fix the snout, ears, legs, and wobbly eyes with superglue. Paint on the mouth. Then attach the shamrock to the pig's snout.

**Materials for Chimney Sweeper**

- Finished height about 14" (35 cm)
- 1 bell pot, 3 ½" (9 cm) in diameter
- 1 bell pot, 4 ¼" (11 cm) in diameter
- 1 clay pot, 4" (10 cm) in diameter
- 6 miniature clay pots, 1 ¼" (3.5 cm) in diameter
- 1 rose pot, 2 ¾" (7 cm) in diameter
- 1 sheet of black rubber mat, 2 mm thick
- 2 wobbly eyes, about ½" (1 cm) in diameter
- 1 red wooden bead, about ½" (1 cm) in diameter
- 1 piece of blond long hair plush
- 1 red ribbon, 1 ½" x 20" (4 cm x 50 cm)
- 1 wooden shamrock
- 3 buttons, ½" (1 cm) in diameter
- Wooden ladder or thin slats

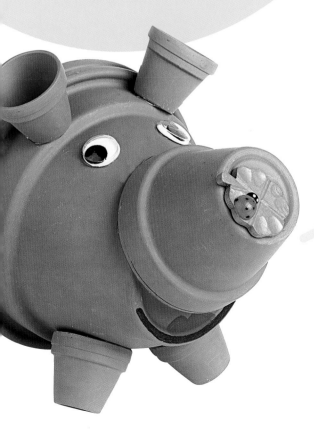

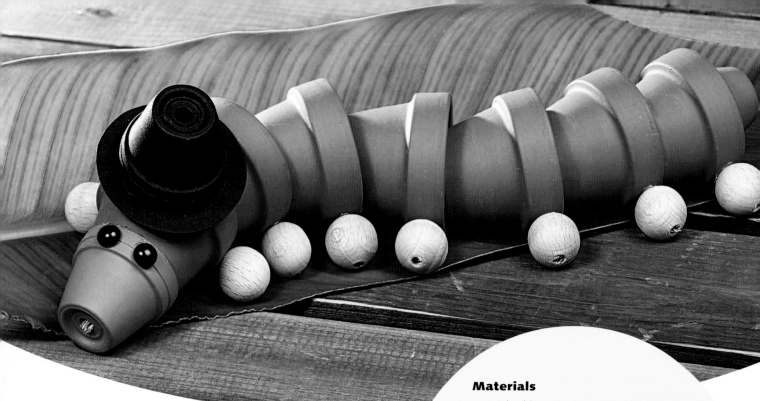

## Centipede

Onto the raffia rope, alternately thread
the clay pots and the 1" (3 cm) wooden
beads. Add a wooden bead after each
knot. Glue a small clay pot to the front of
the body to serve as a head. Fix the eyes
as shown in the illustration. Fix a small pot
pointing in the other direction to serve as an
end piece. Following the illustration, glue on the
remaining wooden beads as feet. To make the hat,
paint a clay pot black. Cut a rubber circle 2" (5 cm) in
diameter, add to the black pot, and glue into position.

### Materials

- Finished length about 16" (40 cm)
- 1 raffia rope, 24" (60 cm) long x 3 or 4 strands
- 3 clay pots, 1" (3 cm) in diameter
- 7 clay pots, 1 1/2" (4 cm) in diameter
- 14 natural-finish wooden beads, 3/4" (2 cm) in diameter
- 7 natural-finish wooden beads, 1" (3 cm) in diameter
- 1 piece of black rubber mat, 2 mm thick
- 2 black half-beads
- Black craft paint

## Miniature Boy and Girl

These figures are so small and light that they can almost fly through the air!

For the boy, apply a dark blue base coat to the small and large clay pot and also paint
the rim of the middle pot. Assemble the pots according to the instructions on page 9,
using the smallest pot as a head and gluing it into the middle pot. (Before you do this,
fix the spring into the inside.) Thread the pearls as arms, as shown in the illustration.
Tie the sisal rope with the raffia to make the legs. About 1/2" (1 cm) from the end,
apply glue and attach the feet.

Cut the leftover ends. Paint on buttons and the face and tie the ribbon in a bow around the neck.

For the girl, assemble the unpainted pots following the instructions for the boy, paint on the face, and glue in the Styrofoam ball as a foundation for the wig. Make the wig (see page 9) and decorate the figure with ribbons.

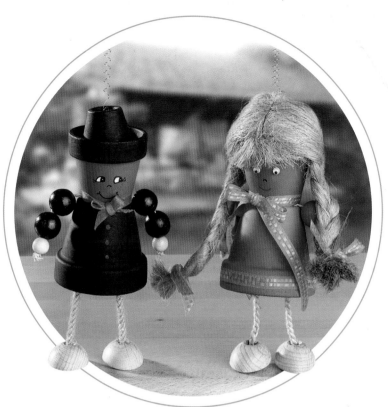

## Materials for the Boy

- Finished height about 6" (15 cm)
- 1 clay pot, 2" (5 cm) in diameter
- 1 miniature clay pot, 1 $\frac{1}{2}$" (4 cm) in diameter
- 1 miniature clay pot, 1 $\frac{1}{2}$" (3.5 cm) in diameter
- 4 dark blue wooden beads, $\frac{1}{2}$" (1 cm) in diameter
- 2 natural-finish wooden beads, $\frac{1}{4}$" (0.5 cm) in diameter
- 1 sisal rope, $\frac{1}{4}$" x 10" (0.5 cm x 25 cm)
- 1 red ribbon, $\frac{1}{4}$" x 12" (0.5 cm x 30 cm)
- 2 puppet feet, 1" x 1 $\frac{1}{4}$" (3 cm x 3.5 cm)
- Dark blue craft paint
- 1 suspension spring

## Materials for the Girl

- Finished height about 6" (15 cm)
- 1 clay pot, 2" (5 cm) in diameter
- 1 miniature clay pot, 1 $\frac{1}{2}$" (4 cm) in diameter
- 1 Styrofoam ball, 1 $\frac{1}{2}$" (4 cm) in diameter
- 1 sisal braid
- 1 yellow checkered ribbon, $\frac{1}{2}$" x 4' (1 cm x 1.2 m)
- 4 orange wooden beads, 4 $\frac{3}{4}$" (12 cm) in diameter
- 2 natural-finish wooden beads, $\frac{1}{4}$" (0.5 cm) in diameter
- 1 sisal rope, $\frac{1}{4}$" x 10" (0.5 cm x 25 cm)
- 2 puppet feet, 1" x 1 $\frac{1}{4}$" (24 cm x 3.5 cm)
- 1 suspension spring

# Clay Pot Family

The large figures are about 20" (50 cm) tall and can be placed in an entryway or used as garden ornaments. The head of the small figure is used for planting. Flat and bushy plants like Mind-your-own-business look best. Plant herbs for an especially pretty effect for a window sill. Make all three figures according to type 2 (see page 9). Follow the photograph at right for the pot arrangement and the face design. Decorate the large figures with moss collars and use dried beans as buttons. Decorate all the figures with raffia.

For the hair, sew pieces of raffia, cut to size, onto a ribbon (hairstyle B, page 9) and glue it to the inside of the hat pot. Make pigtails as well for the clay pot woman. Fix the hats at a slight angle and possibly shorten the hair and cut to shape.

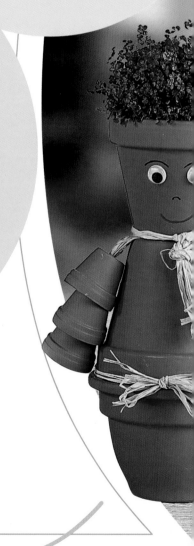

**Materials for the Clay Pot Man**

- Height about 21" (52 cm)
- 1 clay pot, 4 ³/₄" (12 cm) in diameter
- 3 clay pots, 5 ¹/₂" (14 cm) in diameter
- 6 miniature clay pots, 1 ¹/₂" (4 cm) in diameter
- 3 miniature clay pots, 1 ¹/₄" (3.5 cm) in diameter
- 2 wobbly eyes, ³/₄" (2 cm) in diameter
- Raffia
- 2 dried beans
- Moss

**Materials for the Clay Pot Woman**

- Height about 19" (48 cm)
- 1 clay pot, 4 ³/₄" (12 cm) in diameter
- 1 clay pot, 5 ¹/₂" (14 cm) in diameter
- 1 clay pot, 7" (18 cm) in diameter
- 1 bell pot, 12 ³/₄" (32 cm) in diameter
- 6 miniature clay pots, 1 ¹/₂" (4 cm) in diameter
- 2 miniature clay pots, 1 ¹/₄" (3.5 cm) in diameter
- 2 wobbly eyes, ³/₄" (2 cm) in diameter
- 1 wooden bead, ³/₄" (2 cm) in diameter
- Red craft paint
- Raffia
- 2 dried beans
- Moss

**Materials for the Clay Pot Boy**

- Height about 12" (30 cm)
- 1 clay pot, 3" (8 cm) in diameter
- 1 clay pot, 4" (10 cm) in diameter
- 1 bell pot, 4 ¹/₄" (11 cm) in diameter
- 6 miniature clay pots, 1 ¹/₄" (3.5 cm) in diameter
- 2 wobbly eyes, ¹/₂" (1 cm) in diameter
- Raffia

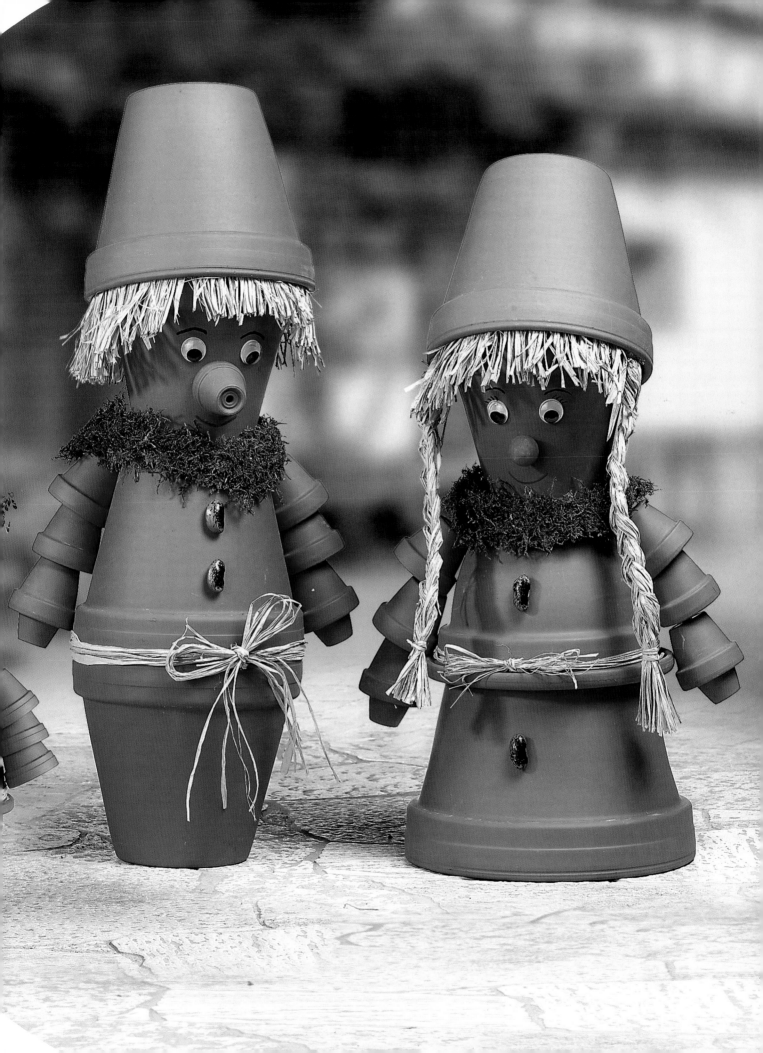

# Market Trader

(Photograph on pages 20–21)

Make the type 2 figure, as described on page 9. Turn the lowest pot upside down to serve as a skirt and glue it to the body pot. Do not cut the raffia after attaching the arms, as you will attach the straw basket to it later. Paint on the face and fix the Styrofoam ball as a wig foundation. Sew a hemp wig following the instruction for hairstyle B (page 9); make the ribbon the same length as the circumference of the pot. Apply glue to the ribbon and fix the wig to the pot's rim. Then fold the hair over the head, twist it into a bun, and fix with small hair clips. Tie the checkered ribbon in a bow around the neck. Tie on the straw basket with the leftover raffia.

# Farming Family

## Farmer

(Photograph on the next spread)

Make the basic figure following the instructions on page 9. Paint on the face. Glue the Styrofoam ball into the head. Make the wig type A (page 9), using hair about 4" (10 cm) long and the length of the pot's circumference. Attach the wig to the Styrofoam ball. Fold over both ends and distribute the hair to cover the forehead and the back of the head. Cut the hair as desired. Glue on the suspenders as shown in the photograph and cover the front ends with buttons. To finish the figure, tie on the neckerchief.

**Materials for the Market Trader**

- Height about 14" (35 cm)
- 1 clay pot, 3" (8 cm) in diameter
- 1 clay pot, 4" (10 cm) in diameter
- 1 bell pot, 5" (13 cm) in diameter
- 6 miniature clay pots, 1 ¼" (3.5 cm) in diameter
- 1 checkered ribbon, 1" x 23 ½" (3 cm x 60 cm)
- 1 Styrofoam ball, 3" (8 cm) in diameter
- 1 hemp braid
- 1 straw bag
- Small hair clips

## Farmer's Wife and Girl with Bucket

(Photographs on the next spread)

Make both figures according the instructions for type 2 (page 9), but do not cut the leftover raffia threads. Paint on the faces. Sew the hemp wigs in hairstyle A. To determine the length of the hair, measure from the pot's rim (the forehead) over the Styrofoam ball to about 2" (5 cm) below the back pot rim (the nape of the neck). Make a fringe according to hairstyle B,

## Materials for the Farmer

- Height about 12" (30 cm)
- 1 clay pot, 3" (8 cm) in diameter
- 1 clay pot, 3 ½" (9 cm) in diameter
- 1 clay pot, 4" (10 cm) in diameter
- 6 miniature clay pots, 1 ¼" (3.5 cm) in diameter
- 1 Styrofoam ball, 3" (8 cm) in diameter
- 1 hemp braid
- 2 checkered ribbons, 1" x 20" (3 x 50 cm)
- 2 buttons, ¾" (2 cm) in diameter
- 1 blue silk neckerchief, 11" x 11" inches (28 cm x 28 cm)
- 1 hat, 11 ½" (28.5 cm) in diameter

using a ribbon about 1 ½" x 2 ¼" (4 cm x 6 cm). Along the part, apply glue to the ribbon, then lay the wig just above the pot rim (forehead) and glue it over the Styrofoam ball to the nape. Fold over ½" (1 cm) of the hairline and the end piece in the nape. Apply glue to both sides of the fringe ribbon and push it underneath the hairline. Braid the hair into pigtails and tie them with a check bow. For the girl, braid the hair, twist it into two buns, and pin them with hair clips. Decorate the body with ribbons and bows. Tie on the small buckets with the leftover raffia.

## Materials for the Farmer's Wife

- Height about 12" (30 cm)
- 1 clay pot, 3" (8 cm) in diameter
- 1 clay pot, 4 ¾" (12 cm) in diameter
- 1 rose pot, 4" (10 cm) in diameter
- 6 miniature clay pots, 1 ¼" (3.5 cm) in diameter
- 1 Styrofoam ball
- 1 hemp braid
- 1 checkered ribbon, ½" x 2 yards (1 cm x 2 m)
- 1 straw hat, 4 ¾" (12 cm) in diameter
- 1 bucket, 1" (3 cm) tall

## Materials for the Girl with Bucket

- Height about 8 ½" (22 cm)
- 1 clay pot, 2" (5 cm) in diameter
- 1 clay pot, 2 ¼" (6 cm) in diameter
- 1 bell pot, 3 ½" (9 cm) in diameter
- 4 miniature clay pots, 1 ¼" (3.5 cm) in diameter
- 1 hemp braid
- 1 yellow checkered ribbon, ½" x 1 yard (1 cm x 1 m)
- 2 wobbly eyes, ¼" (0.5 cm) in diameter
- 1 bucket, 1" (3 cm) tall

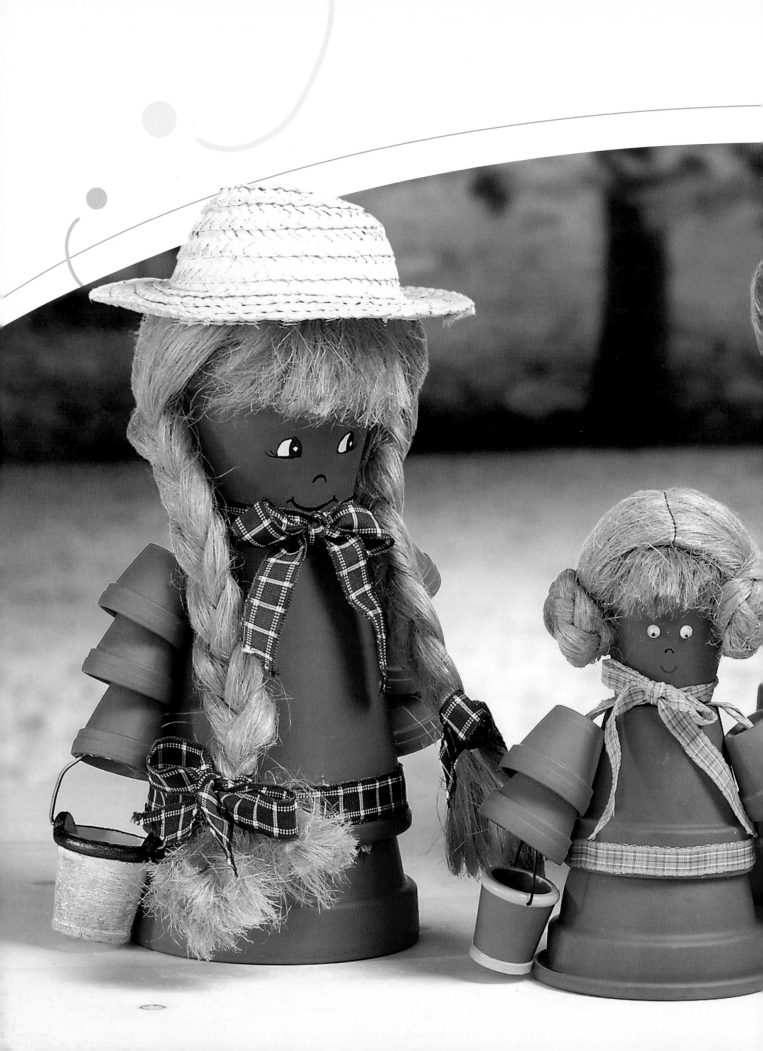

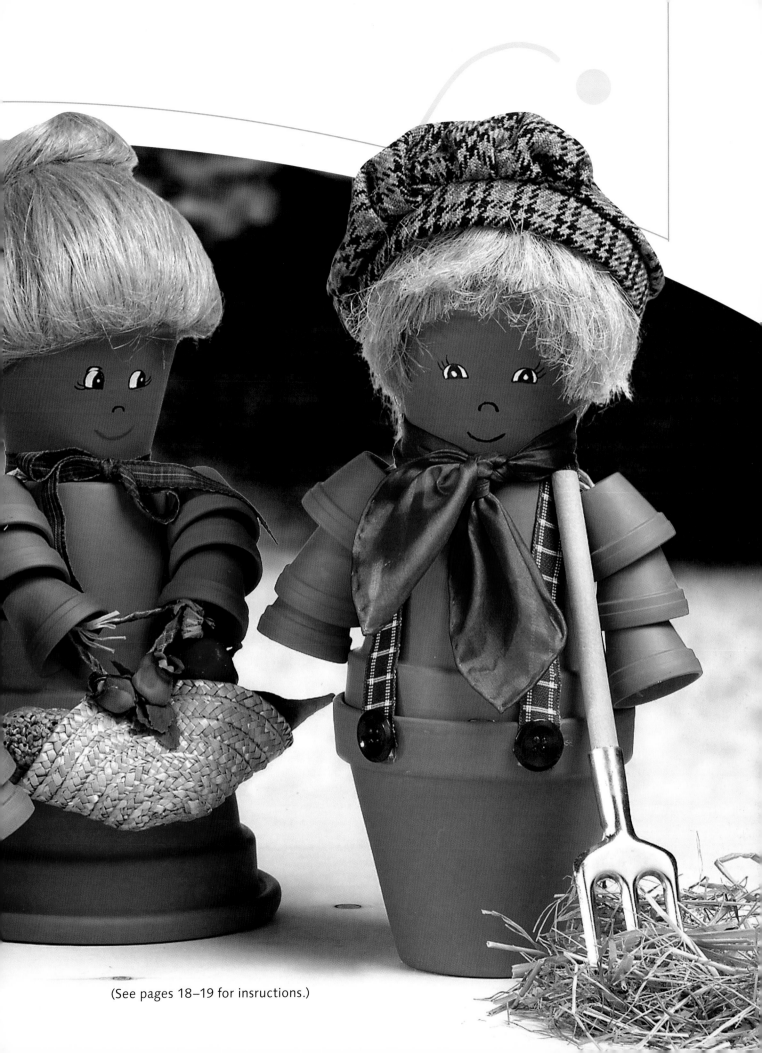

(See pages 18–19 for insructions.)

# Easter Bunny

Make the figure following the instructions for type 2 on page 9 and paint on the rabbit face. Make the ears from rubber mat. Cut small holes in each side of the hat and push the ends of the ears in. Glue the ears on the top of the opening to the hat. Fix the hat to the head.

Attach ribbons 12" (30 cm) long to each side of the basket and tie them to the shoulders. Finish the Easter bunny with a bow around the neck and a colored button on the belly.

**Materials for the Easter Bunny**

- Height about 15" (38 cm)
- 1 bell pot, 4 1/4" (11 cm) in diameter
- 2 bell pots, 5" (13 cm) in diameter
- 6 miniature clay pots, 1 1/4" (3.5 cm) in diameter
- 2 wooden beads, 3/4" (2 cm) in diameter
- 2 buttons, 3/4" (2 cm) in diameter
- 1 straw hat, 5 1/2" (14 cm) in diameter
- 1 piece of light brown rubber mat
- 1 wicker basket, 6" (15 cm) tall
- 1 colored ribbon, 1/2" x 4' (1 cm x 1.2 m)
- Template

# Easter Chick

Apply a yellow base coat to the clay pots and the Styrofoam ball. Glue the feathers as a ruff to the rim of the upper body. Use two larger feathers each to make wings on both sides of the body. Assemble the figure, tie the head and upper body with raffia, and glue on the lower part (see page 9).

Glue the Styrofoam ball into the pot as a foundation for the wig. Attach the feathers around the rim of the pot, mark the top of the spine with a dot, and then arrange the feathers in a radiating pattern to cover the area underneath. Fix the eyes and the beak and tie a bow around the chick's neck.

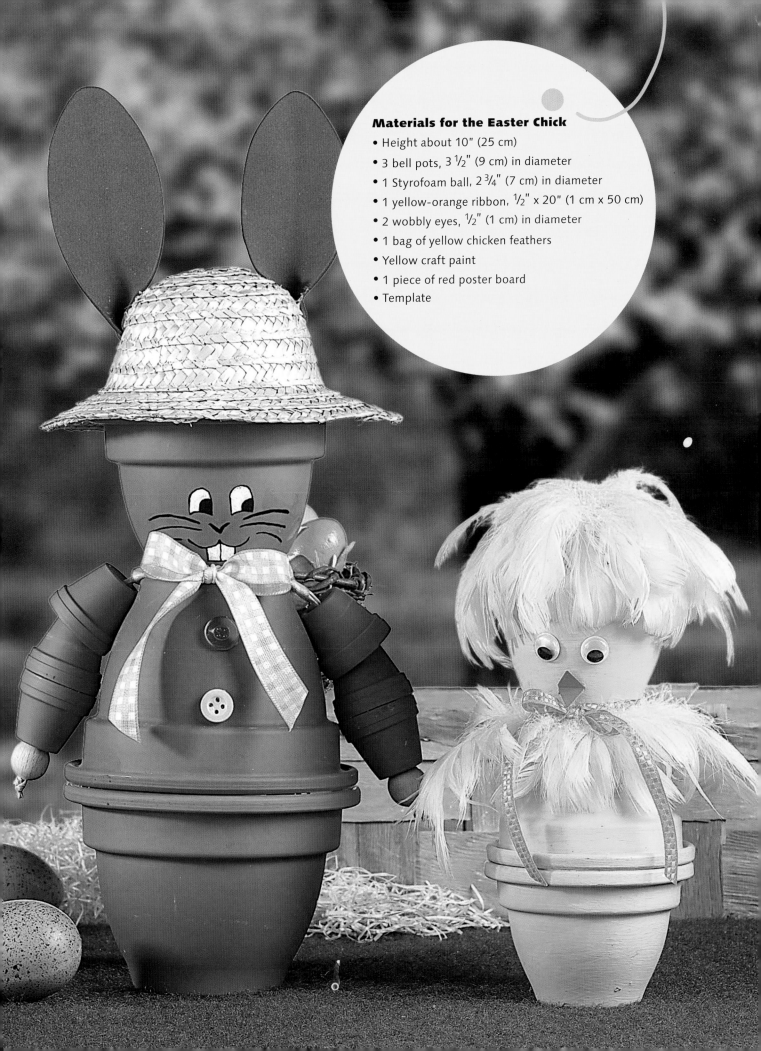

## Materials for the Easter Chick

- Height about 10" (25 cm)
- 3 bell pots, 3 ½" (9 cm) in diameter
- 1 Styrofoam ball, 2 ¾" (7 cm) in diameter
- 1 yellow-orange ribbon, ½" x 20" (1 cm x 50 cm)
- 2 wobbly eyes, ½" (1 cm) in diameter
- 1 bag of yellow chicken feathers
- Yellow craft paint
- 1 piece of red poster board
- Template

# Aztec Woman

Paint the 3" (8 cm) clay pot and the saucer black. Make the figure from the bell pots according to the instructions on page 9. Paint on the face (see template). Make two braids from abaca fiber and glue them to the pot's rim. Cover the hairline with the braid trimming. For the hat, glue the black pot onto the saucer and attach it to the head. Finish by tying the shawl around the shoulders.

## Materials for the Aztec Woman

- Height about 14" (35 cm)
- 1 bell pot, 3 ½" (9 cm) in diameter
- 1 bell pot, 5" (13 cm) in diameter
- 6 miniature clay pots, 1 ¼" (3.5 cm) in diameter
- 1 clay pot, 3" (8 cm) in diameter
- 1 clay saucer, 4 ¾" (12 cm) in diameter
- Black abaca fiber
- Black craft paint
- Braid trimming, ½" x 12" (1 cm x 30 cm)
- 1 black shawl, 16" x 16" (40 cm x 40 cm)
- Template

## Materials for the Aztec Man

- Height about 16" (40 cm)
- 1 bell pot, 3 ½" (9 cm) in diameter
- 1 bell pot, 4 ¼" (11 cm) in diameter
- 1 clay pot, 4" (10 cm) in diameter
- 7 miniature clay pots, 1 ¼" (3.5 cm) in diameter
- Clay saucers, 5 ½" (14 cm) in diameter
- Red, black, green, and white craft paint
- Red satin ribbon, ½" x 20" (1 cm x 50 cm)
- Long black hair plush
- Template

# Aztec Man

Paint the pot for the bottom part of the figure black and decorate the rim in a folk pattern. For the hat, paint the saucer with the same pattern. Paint a bell pot and one miniature clay pot black. Assemble the figures as for type 2 (page 9) and paint on the face (see template). For the hair, cut black long hair plush into a strip ½" (1 cm) wide and the length of the head's circumference. Glue the strip to the pot's rim and shorten it into a fringe in the face area. Assemble the hat and fix it to the head. As a decoration, tie a bow around the neck.

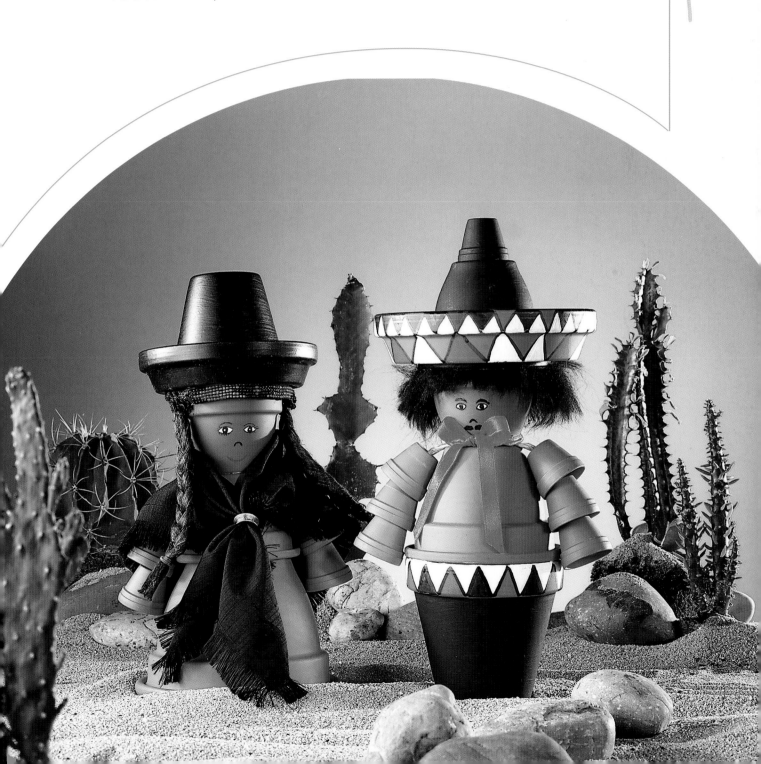

# Scarecrow

Make the figure according to the instructions for type 1 on page 8, but use a double layer of pipe cleaners, 20" (50 cm) long, instead of raffia to tie on arms and legs. Thread the miniature clay pots as arms, as shown in the photograph; it is not necessary to tie knots between the pots. Tie on the head with raffia as usual. Before you tighten the knots, tie in the two pieces of pipe cleaner for the legs, using the photograph as a guide to threading.

Cut the leftover arm and leg wires, leaving 1" (3 cm), and glue a wooden bead at the ends. Cut raffia threads, 4" (10 cm) long, as decorations for the arms and legs and fix them to the slightly bent wire ends. Make sure to twist the wire ends securely.

Thickly cover the wooden stick 2" (5 cm) from one end with ½" (1 cm) raffia and fix with glue. Carefully thread the stick through the two pot holes into the head piece until you reach the raffia. Fix with glue.

Place the Styrofoam ball, make the wig (type B; see page 9), and fix it above the pot's rim on the Styrofoam ball. Fold a hat from the felt piece (little boat; see template). Glue the ends of the wig onto the brim of the hat and glue it to the hat. Then tie the velour neckerchief and cut the hair to the desired length. Finish by gluing on the buttons and painting some patches.

## Materials

- Height about 16" (40 cm)
- 1 clay pot, 3" (8 cm) in diameter
- 1 clay pot, 4 ¾" (12 cm) in diameter
- 12 miniature clay pots, 1 ¼" (3.5 cm) in diameter
- 2 miniature clay pots, 1 ½" (4 cm) in diameter
- 2 wooden beads, ¾" (2 cm) in diameter
- 1 Styrofoam ball, 3" (8 cm) in diameter
- 2 wobbly eyes, ¾" (2 cm) in diameter
- 1 cotton ball, ¾" (2 cm) in diameter
- 2 buttons, ¾" (2 cm) in diameter
- Red, yellow, and red craft paint
- 1 rounded wooden stick, ¼" x 23 ½" (0.5 cm x 60 cm)
- 1 velour neckerchief, 11" x 11" (28 cm x 28 cm)
- 1 piece of brown felt
- Raffia
- 4 pipe cleaners, 20" (50 cm) long
- Template

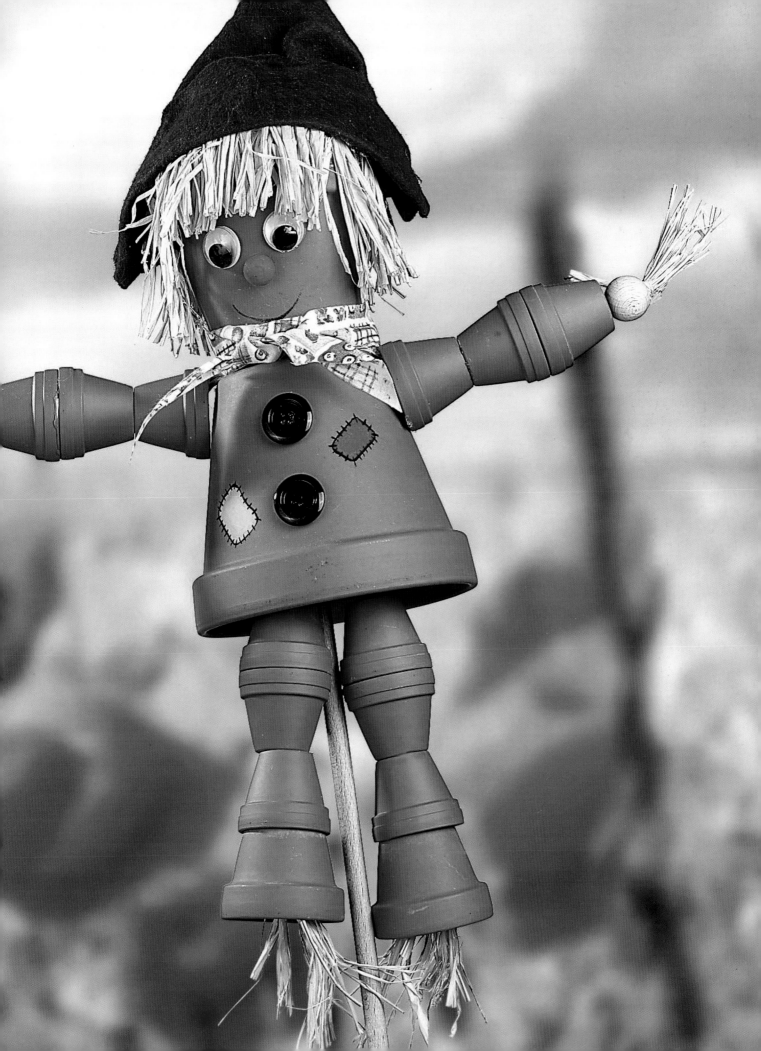

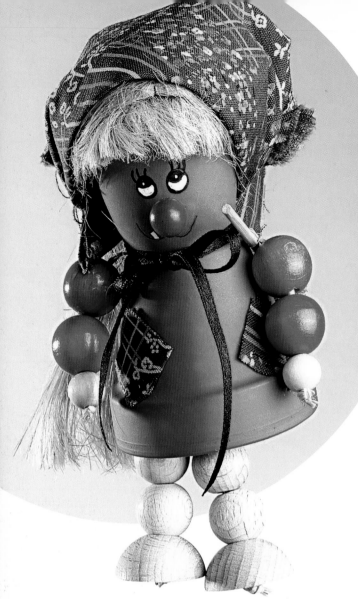

## Materials for Miniature Witch

- Height about 6" (15 cm)
- 1 clay pot, 2" (5 cm) in diameter
- 1 clay pot, 2 $\frac{1}{2}$" (6 cm) in diameter
- 1 Styrofoam ball, 2" (5 cm) in diameter
- 1 hemp braid
- 1 red wooden bead, $\frac{1}{2}$" (1 cm) in diameter
- 2 natural-finish wooden beads, $\frac{1}{4}$" (0.5 cm) in diameter
- 6 natural-finish wooden beads, $\frac{1}{2}$" (1 cm) in diameter
- 4 pink wooden beads, $\frac{1}{2}$" (1 cm) in diameter
- Fabric scraps
- 2 puppet feet, 1" x 1 $\frac{1}{4}$" (3 cm x 3.5 cm)
- Dark blue ribbon, $\frac{1}{4}$" x 23" (0.5 cm x 60 cm)
- Template

## Miniature Witch

If you do not have a lot of space on your windowsill, then this suspended witch is ideal. Assemble the pieces according to the instructions for type 1 (page 8). Instead of miniature clay pots use threaded beads as arms and legs. The round nose, the cheeky smile, and the colorful neckerchief all give the witch a droll look.

## Witchy the Witch

First paint the hat pieces and the cotton ball. Then make the figure according to the instructions for type 2 (page 9). Paint on the face and glue on the nose. Sew a wig from chestnut brown abaca fiber (type B; see page 9); make the hair the same length as the circumference of the pot.

## Materials for Witchy the Witch

- Height about 16" (40 cm)
- 1 bell pot, 5" (13 cm) in diameter
- 2 bell pots, 4 $\frac{1}{4}$" (11 cm) in diameter
- 1 clay pot, 5 $\frac{1}{2}$" (14 cm) in diameter
- 2 miniature clay pots, 1 $\frac{1}{4}$" (3.5 cm) in diameter
- 5 miniature clay pots, 1 $\frac{1}{2}$" (4 cm) in diameter
- 1 clay saucer, 4 $\frac{3}{4}$" (12 cm) in diameter
- Black and red craft paint
- Chestnut brown abaca fiber
- Textile scraps, 16" x 16" (40 cm x 40 cm)
- 1 cotton ball, $\frac{3}{4}$" (1.2 cm) in diameter
- 1 broom, 8" (20 cm) long
- Template

Glue the wig to the upper pot rim. Cut the hair to a fringe in the face area. Assemble the hat pieces and glue on above the hairline. Finish by tying on the neckerchief and adding the broom.

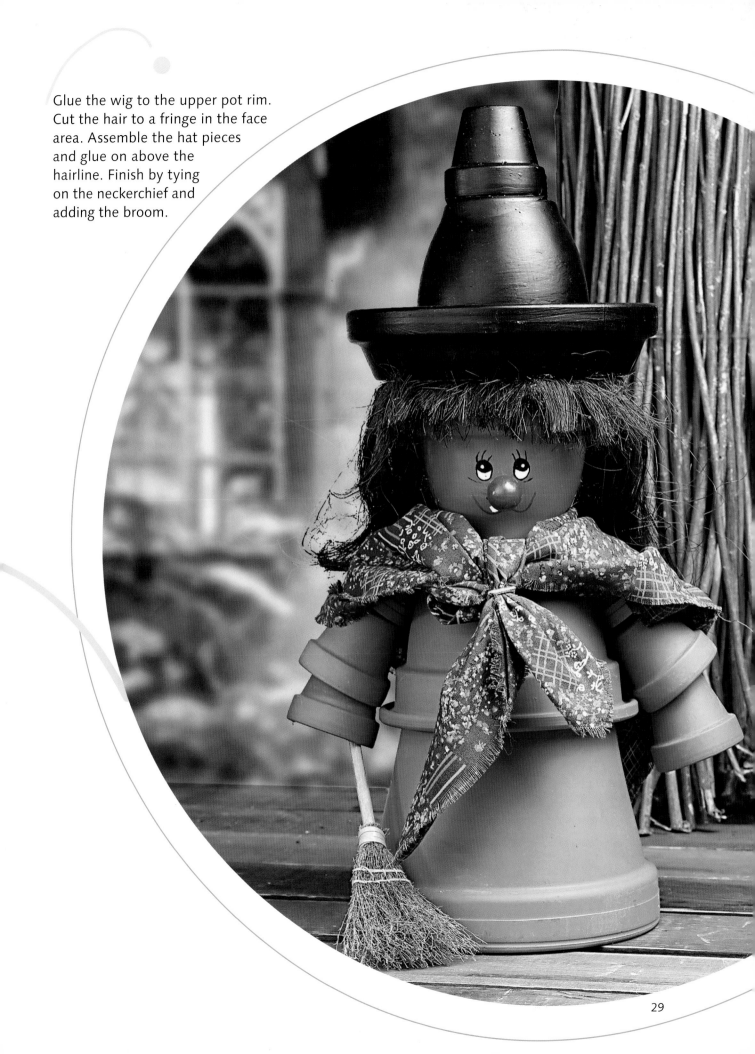

## Standing Snowman

Apply a black base coat to the hat pot and paint the rest of the pots white. Let dry, then make the figure according to the instructions for type 2 (page 9). For the brim, cut a 3" (16 cm) circle from rubber mat and glue it to the pot's rim. Then add the hat pot. Glue on the wobbly eyes, nose, and buttons. Paint the mouth and eyelashes. To prevent the snowman from catching a cold, tie on a scarf.

**Materials for the Standing Snowman**
- Height about 14" (35 cm)
- 2 bell pots, 4 1/4" (11 cm) in diameter
- 2 bell pots, 5" (13 cm) in diameter
- 6 miniature clay pots, 1 1/4" (3.5 cm) in diameter
- 1 sheet of black rubber mat, 2 mm thick
- Structural snow paint or white craft paint
- Black craft paint
- 2 wobbly eyes, 1/2" (1 cm) in diameter
- 1 plastic carrot, 2 1/4" (6 cm) long
- 1 scarf , 1 1/2" x 16" (4 cm x 40 cm)
- 3 buttons, 3/4" (2 cm) or 1/2" (1 cm)

## Snowman Bird Feeder

Paint the clay pots white. Let dry, and then tie the body and head pots together. Pass the threads originally intended for the arms up through the centrally cut hole of a rubber circle, 4 3/4" (12 cm) in diameter and also through the hat pot; tie in a knot. Tie the bird feeder to the leftover raffia threads. Finish the face and tie the scarf.

**Materials for the Snowman Bird Feeder**
- Height about 10" (25 cm)
- 2 bell pots, 3 1/2" (9 cm) in diameter
- 2 bell pots, 5 1/2" (14 cm) in diameter
- 1 sheet of black rubber mat, 2 mm thick
- 2 wobbly eyes, 1/4" (0.5 cm) in diameter
- 1 plastic carrot, 2" (5 cm) long

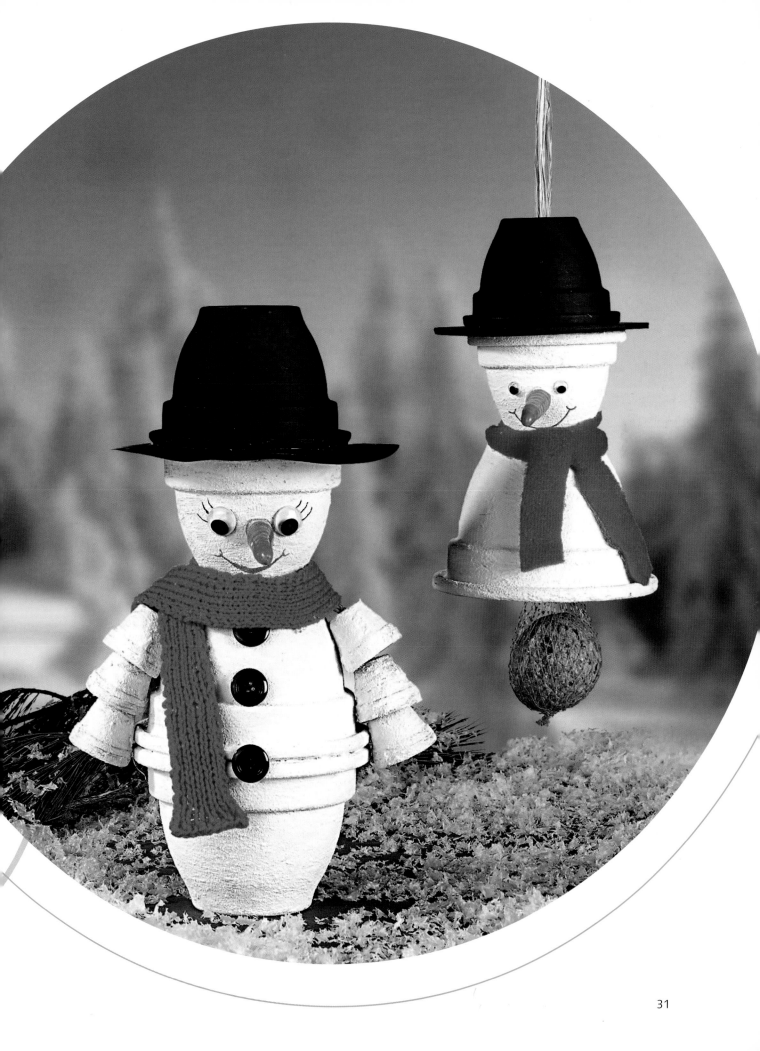

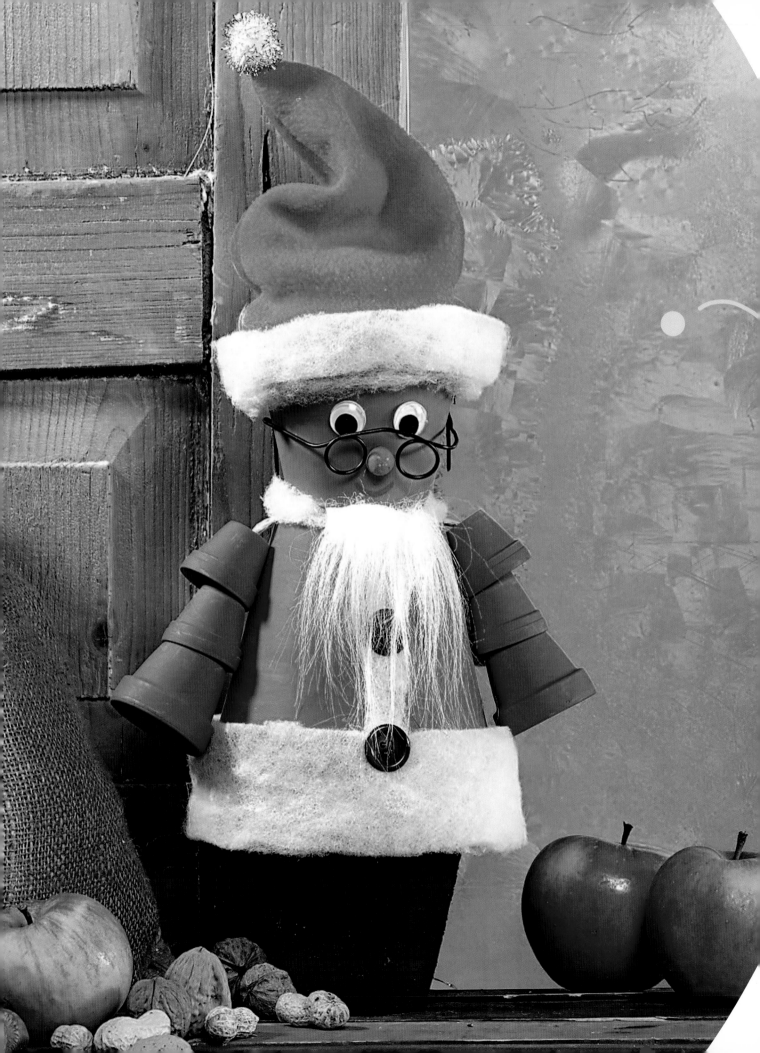

# Standing Santa Claus

Apply a red base coat to the pots, 4 ¾" (12 cm) in diameter, that make Santa's coat and to the miniature pots that make his arms. Apply a black base coat to the trouser pot, 4" (10 cm) in diameter. To achieve a balanced proportion for Santa's coat, fit two pots together. Make the upper part (see page 8).

Apply wood glue to the inside of the pot and put it over the second pot. Glue the trouser pot underneath the coat pot. Fix the red nose and the wobbly eyes and paint the mouth as shown in the photograph. Use the template to make the hat from red felt. Don't forget to leave ½" (1 cm) extra space for sewing when cutting the felt! Decorate the hat with a small pom-pom.

Glue the Styrofoam ball into the head and pull the hat over the pot's rim. Cover the brim of the hat and the double rim of the coat with white felt. Add a piece of white felt as a foundation for the buttons, and place some felt around the neck. Fix the buttons as in the photograph and glue on the beard. You can cut the beard to the desired length and finish by adding the glasses.

## Materials

- Height about 18" (45 cm)
- 1 clay pot, 3" (8 cm) in diameter
- 2 clay pots, 4¾" (12 cm) in diameter
- 1 clay pot, 4" (10 cm) in diameter
- 4 miniature clay pots, 1¼" (3.5 cm) in diameter
- 2 miniature clay pots, 1½" (4 cm) in diameter
- 1 Styrofoam ball, 3" (8 cm) in diameter
- 1 cotton ball, ½" (1 cm) in diameter
- 2 wobbly eyes, ¾" (2 cm) in diameter
- 1 pair of glasses, about 3" (8 cm) wide
- Red and black craft paint
- Long hair plush, ½" x 1" (1 cm x 3 cm)
- 1 sheet of red felt
- White felt, 16½" x 23⅜" (42 cm x 59½ cm)
- 1 silver-white wool pom-pom, 1" (3 cm) in diameter
- 3 buttons, ¾" (2 cm) in diameter
- Template

# Santa Claus Wind Chime

Paint the contours of the eyes black and then fill in with white paint. Glue on the half-pearls or wobbly eyes. Fix the red bead as a nose and paint on the mouth. Use the structural snow paint to paint on the beard and to cover the pot's rim. Fix the chimes to a wooden stick onto which the suspension is fixed (see page 8). Use extra glue to make sure the chimes won't slip out. Sew the hat and attach it to the head. Cut a small hole in the hat through which to pass the thread for hanging. Cover the brim of the hat with white felt and fix the pom-pom to the tip of the hat.

**Materials for Santa Claus Wind Chime**
- Height about 8 $\frac{1}{2}$" (22 cm)
- 1 clay pot, 3" (8 cm) in diameter
- Silver wind chime, 4 $\frac{3}{4}$" (12 cm) long
- Silver wind chime, 5 $\frac{1}{2}$" (14 cm) long
- Silver wind chime, 6" (16 cm) long
- Structural snow paint
- 2 half-pearls, $\frac{1}{4}$" (0.5 cm), or 2 wobbly eyes, $\frac{1}{2}$" (1 cm)
- 1 red wooden bead, $\frac{1}{2}$" (1 cm) in diameter
- 1 piece of white felt
- 1 sheet of red felt, 5 $\frac{7}{8}$" x 8 $\frac{1}{4}$" (14.5 cm x 21 cm)
- 1 white pom-pom, 1" (3 cm) in diameter
- Template

**Materials for Snowman Wind Chime**
- Height about 6" (16 cm)
- 1 clay pot, 2 $\frac{1}{4}$" (6 cm) in diameter
- Wind chime, 1 $\frac{1}{2}$" (4 cm) in diameter
- Wind chime, 2 $\frac{1}{4}$" (6 cm) in diameter
- Wind chime, 3" (8 cm) in diameter
- White craft paint
- Structural snow paint
- 2 wobbly eyes, $\frac{1}{4}$" (0.5 cm) in diameter
- 1 black half-pearl, $\frac{1}{4}$" (0.5 cm) in diameter
- 1 piece white felt
- 1 silver ribbon, $\frac{3}{4}$" x 8" (2 cm x 20 cm)
- 1 white pom-pom, 1" (3 cm) in diameter

# Snowman Wind Chime

Apply a white base coat to the clay pot. Glue on the wobbly eyes and the half-pearl for a nose. Paint the mouth. Assemble the chimes as described above. Make the hat from white felt and decorate it with a silver ribbon.

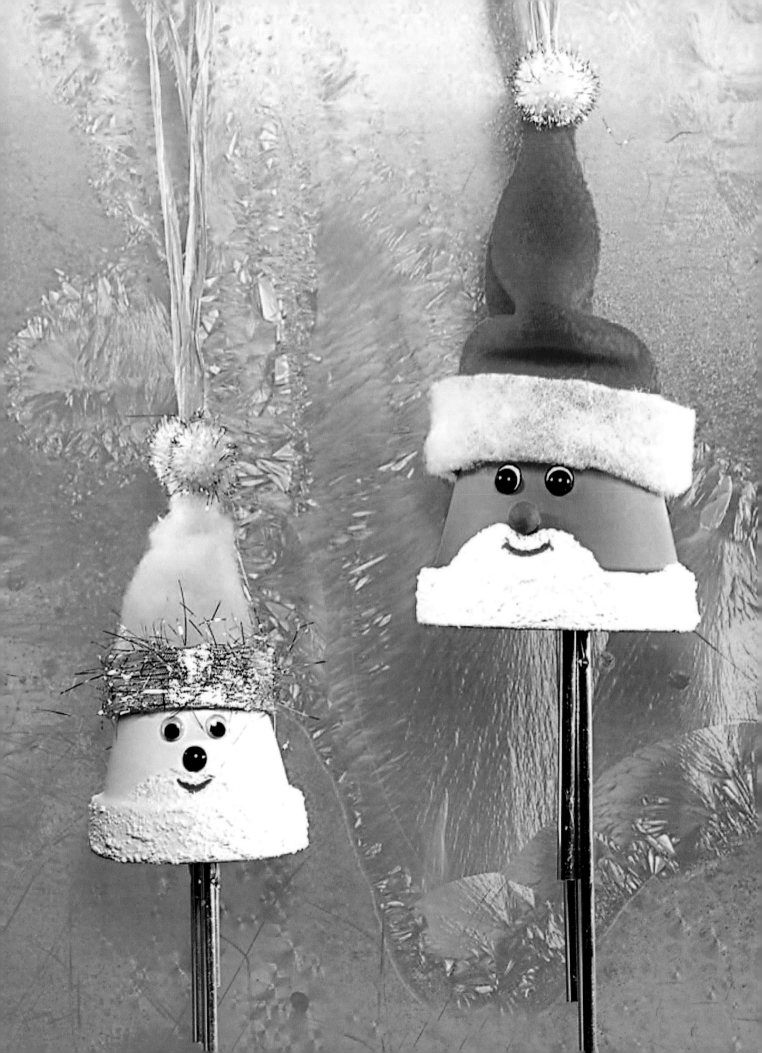

# Angel

## Materials

- Height about 14" (35 cm)
- 2 bell pots, 4¼" (11 cm) in diameter
- 1 bell pot, 6¾" (17 cm) in diameter
- 4 miniature clay pots, 1¼" (3.5 cm) in diameter
- 2 miniature clay pots, 1½" (4 cm) in diameter
- 2 wooden beads, ¾" (2 cm) in diameter
- 1 Styrofoam ball, 4" (10 cm) in diameter
- 1 hemp braid
- Gold and beige craft paint
- Glitter pen
- Gold wooden star, 2¼" (6 cm) in diameter
- Brass wire
- Gold ribbon, ¼" x 23" (0.5 cm x 60 cm)

Paint the 4¼" (11 cm) pot beige. Apply a gold base coat to the other pots. Assemble the figure according to the instructions for type 2 (page 9). Paint on the face and fix the Styrofoam ball as a foundation for the wig. Make the hemp wig and fringe (hairstyle B, page 9); make the ribbon as long as the circumference of the pot. Glue on the wig, starting at the forehead and moving to the nape of the neck. Fold in the leftover end and distribute the hair to cover the back of the head. Decorate the rim of the skirt and the upper part with a glitter pen. Fix the wooden star with brass wire to the wooden beads. Finish by tying a gold ribbon around the neck.

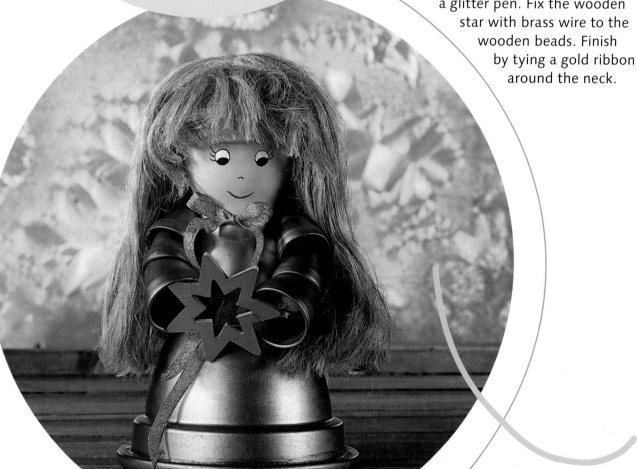

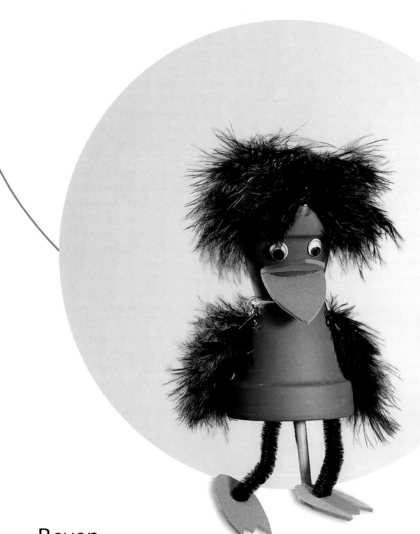

# Raven

Join the head and bead as described in step 2 on page 8. Use the overhanging threads to centrally fix the pipe cleaner for the legs. Make a hole in each of the rubber feet and push in the pipe cleaner. Fix the wooden bead into the top pot as a foundation for the wig. Cover the pot rim all around with feathers. Mark one point on the top pot with a dot as a nape and glue the feathers in a radiating pattern until the area is covered. Fix two feathers on each side as wings. Guide the stick from the bottom through the pot hole and glue into place. Finish by adding the beak and the eyes.

**Materials**

- Height about 4 ³/₄" (12 cm)
- 1 clay pot, 1 ¹/₄" (3.5 cm) in diameter
- 1 clay pot, 2" (5 cm) in diameter
- 1 wooden bead, 1 ¹/₄" (3.5 cm) in diameter
- 1 pack black marabou feathers
- 2 wobbly eyes, ¹/₄" (0.5 cm) in diameter
- orange rubber mat, 2 mm thick
- 1 black pipe cleaner, about 8" (20 cm) long
- 1 rounded wooden stick, ¹/₄" (0.5 cm) in diameter x 20" (50 cm) long
- Template

# Birdbath or Flower Stand

Glue raffia hair, 8" (20 cm) long, to the inner rim of the clay saucer. Glue the saucer to the bottom of the rose pot. Cut the hair to size and paint the face following the photograph. Finish by attaching the flower bowl, which is used for planting.

## Tip

If you substitute a waterproof saucer for the clay bowl, this figure can be used as a birdbath.

## Materials

- Height about 20" (50 cm)
- 1 rose pot, 8" (20 cm) in diameter x 14" (36 cm) tall
- 1 clay saucer, 5 ½" (14 cm) in diameter
- 1 flower bowl, 8 ½" (22 cm) in diameter
- 1 hank of raffia
- 2 wobbly eyes, ¾" (2 cm) in diameter
- 1 red wooden bead, ¾" (2 cm) in diameter
- Template

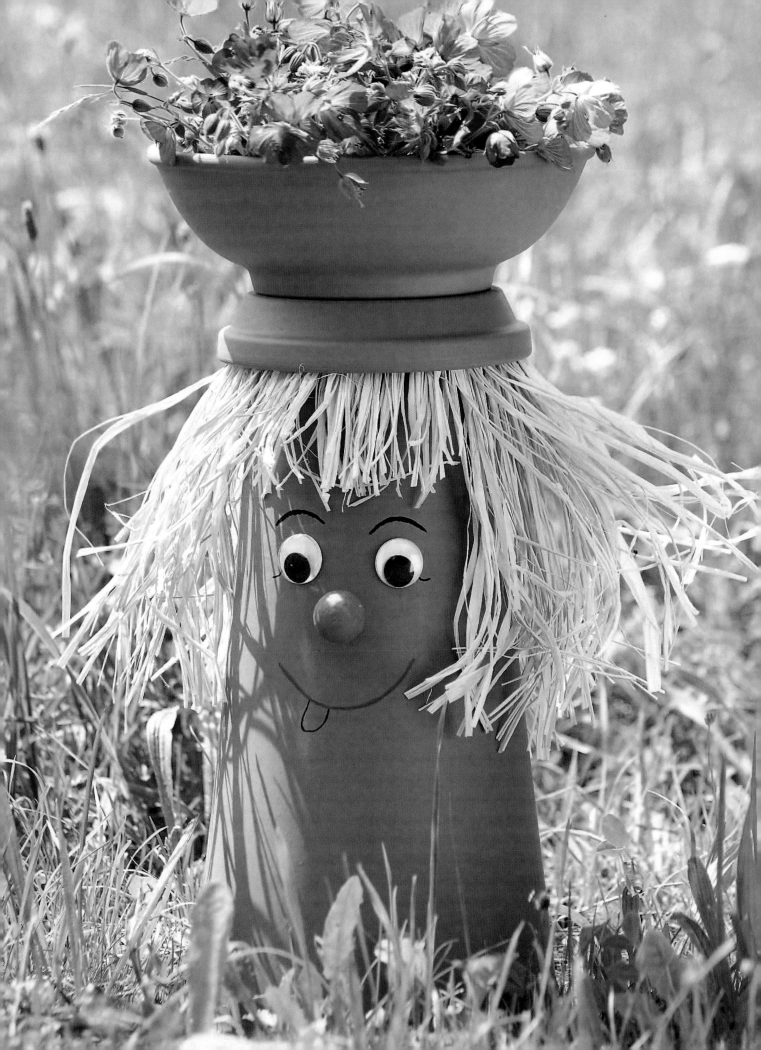

## Materials for the Cat

- Height about 14" (35 cm)
- 1 bell pot, 6 ¾" (17 cm) in diameter
- 1 clay pot, 6" (16 cm) in diameter
- 1 miniature clay pot, 1" (3 cm) in diameter
- 8 miniature clay pots, 1 ¼" (3.5 cm) in diameter
- 6 miniature clay pots, 2" (5 cm) in diameter
- 1 wooden bead, ¾" (2 cm) in diameter
- 1 wooden bead, 1" (3 cm) in diameter
- 1 straw hat, 11" (28 cm) in diameter
- 1 rounded wooden stick, 1 ½" (4 cm) in diameter x 16" (40 cm) long
- About 8" (20 cm) fishing line
- 1 wooden fish, 1 ½" (4 cm) long
- Light brown rubber mat, 2 mm thick
- Template

## Materials for the Mouse

- Height about 6 ¾" (17 cm)
- 1 clay pot, 2 ¼" (6 cm) in diameter
- 1 clay pot, 3" (8 cm) in diameter
- 2 miniature clay pots, 1" (3 cm) in diameter
- 10 miniature clay pots, 1 ¼" (3.5 cm) in diameter
- 1 straw hat, 4 ¼" (11 cm) in diameter
- Gray rubber mat, 2 mm thick
- 5 wooden beads, ¾" (2 cm) in diameter
- Wooden skewers
- About 8" (20 cm) fishing line
- 1 wooden fish, 1" (3 cm) long
- 1 black half-pearl, ¼" (0.5 cm) in diameter
- Template

# Fishing Cat and Mouse

Assemble the basic figures according to the instructions for type 1 (page 8), but do not cut the leftover raffia threads on the arms. Paint on the faces; use the half-pearl as the mouse's nose. Cut out the rubber ears. To insert the ears, use a craft knife to make two vertical cuts 2" (5 cm) into the hat of the cat; make horizontal cuts for the mouse's ears. Push the base into the cuts; fold the mouse ears before inserting them. Glue the ears to the inside of the hats and then fix the hats to the clay pot figures.

Make the fishing rods with a rounded wooden stick and attach the fishing line. Tie on the fish and secure the knots with glue. To keep the cat's fishing rod securely in place, glue a slightly upward-pointing miniature pot to the rim of the bottom pot; for the mouse, glue a wooden bead with wood glue, making sure the hole is pointing upward. Then put the last two beads over one another to imitate two fists with the holes pointing upward. Push the fishing rod through the bead holes and the miniature clay pot and fix with glue.

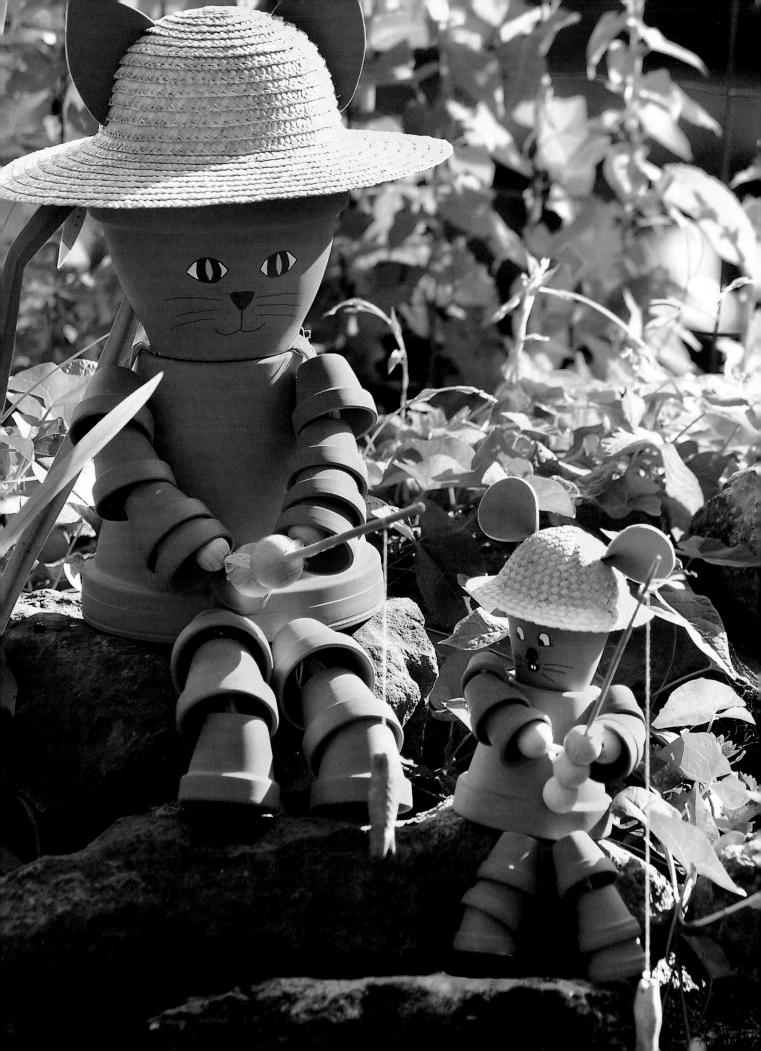

## Materials

- Height about 16" (40 cm)
- 1 rose pot, 3 $\frac{1}{2}$" (9 cm) in diameter x 4 $\frac{1}{4}$" (11 cm) tall
- 1 bell pot, 5" (13 cm) in diameter
- 2 bell pots, 6 $\frac{3}{4}$" (17 cm) in diameter
- 1 Styrofoam ball, 2 $\frac{1}{4}$" (6 cm) in diameter
- 4 packs brown chicken feathers
- Red and orange rubber mat, 2 mm thick
- 2 black half-pearls, $\frac{1}{4}$" (0.5 cm) in diameter
- Template

# Rooster

The rooster is a bit complicated to make, but he is a particularly attractive decoration.

Glue the two bell pots together with wood glue. Make the base for the head and neck from a rose pot with half a Styrofoam ball glued to the bottom. Before fixing the feathers, glue the comb to the head. To do this, make a vertical cut right down to the pot into the Styrofoam ball. Apply glue to the comb and gently push it into the incision.

Glue the head and neck pots to the body. Starting at the base of the neck, apply several layers of feathers until the area is covered. Make sure the first row of feathers overhangs the pot rim by about 2" (5 cm). For the tail, cover a small bell pot with feathers. To fix the tail to the main body, turn the rooster onto his belly. Use books on both sides as supports and to prevent him from rolling.

Attach small pieces of double-sided tape to the bottom of the tail piece and cover the gaps with wood glue. Position the tail piece, make sure it is supported, and let dry overnight. Attach feathers on each side as wings. Finish by gluing on the beak, eyes, and wattle.

# Chick

Apply a yellow base coat to the clay pot and the Styrofoam ball. Glue them together (see photograph). Mark a central point on the head and glue the feathers in a radiating pattern. Make wings using two feathers on each side. Finish by gluing on the beak and eyes.

## Materials

- Height about 4 $\frac{1}{4}$" (11 cm)
- Miniature clay pots, 2" (5 cm) in diameter
- 1 Styrofoam ball, 1 $\frac{1}{2}$" (4 cm) in diameter
- 1 pack yellow marabou feathers
- Yellow craft paint
- 2 wobbly eyes, $\frac{1}{4}$" (0.5 cm) in diameter
- Red rubber mat, 2 mm thick
- Template

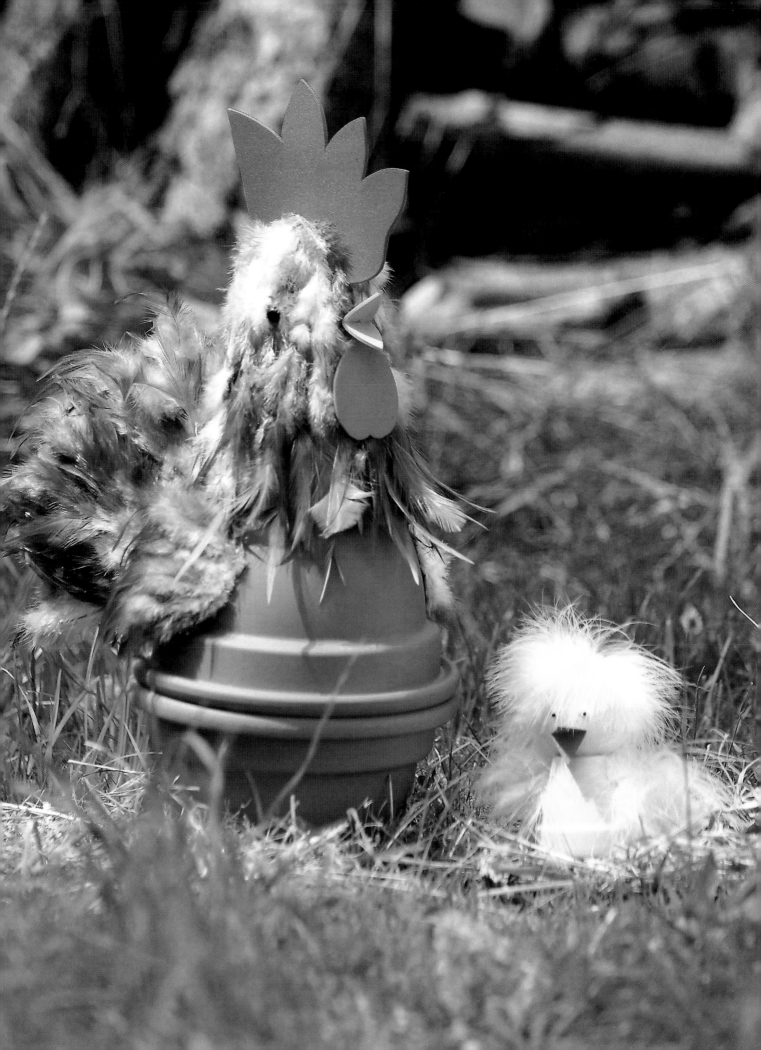

# Water-Carrying Lady

Assemble the figure following the instructions for type 2 (page 9). When making the arms, thread a small wooden bead before every knot between the miniature pots. For the hands, add the large wooden bead at the end. Do not cut off the overhanging raffia threads. Point the left arm upward and fix by gluing the leftover raffia to the upper pot rim. Paint on the face, and then glue the raffia hair to the inside rim of the saucer and fix it to the head. Glue the flower bowl on top. Finish by cutting the hair to shape and decorating the dress with a flowered ribbon.

**Materials**

- Height about 17" (44 cm)
- 1 clay pot, 4¾" (12 cm) in diameter
- 1 bell pot, 5" (13 cm) in diameter
- 1 bell pot, 6¾" (17 cm) in diameter
- 2 miniature clay pots, 1" (3 cm) in diameter
- 6 miniature clay pots, 1¼" (3.5 cm) in diameter
- 1 clay saucer, 5½" (14 cm) in diameter
- 1 flower bowl, 8½" (22 cm) in diameter
- 8 wooden beads, ¾" (2 cm) in diameter
- 2 wooden beads, 1" (3 cm) in diameter
- Brown raffia
- 1 yellow flower ribbon, ¾" x 60" (2 cm x 1.5 m)
- Template

**Tip**

If you substitute a waterproof saucer for the clay bowl, you can use this figure as a birdbath.

# Turtle

(Larger photograph on page 46)

Apply a pine green base coat to the flower bowl, the miniature clay pots, and the Styrofoam ball. Glue the saucer upside down to the lower inside rim of the bowl. For the legs, glue the miniature clay pots to the saucer using superglue. Paint the mouth and cheeks on the Styrofoam ball, glue on the wobbly eyes as well as the half bead for the nose, and glue the head to the body. Use apple green paint on the tortoiseshell pattern as shown in the photograph.

**Materials**

- Height about 4¾" (12 cm)
- 1 flower bowl, 6" (16 cm) in diameter
- 1 clay saucer, 6" (16 cm) in diameter
- 4 miniature clay pots, 1¼" (3.5 cm) in diameter
- 1 Styrofoam ball, 2" (5 cm) in diameter
- 2 wobbly eyes, ¼" (0.5 cm) in diameter
- 1 black half-pearl, ¼" (0.5 cm) in diameter
- Apple and pine green craft paint

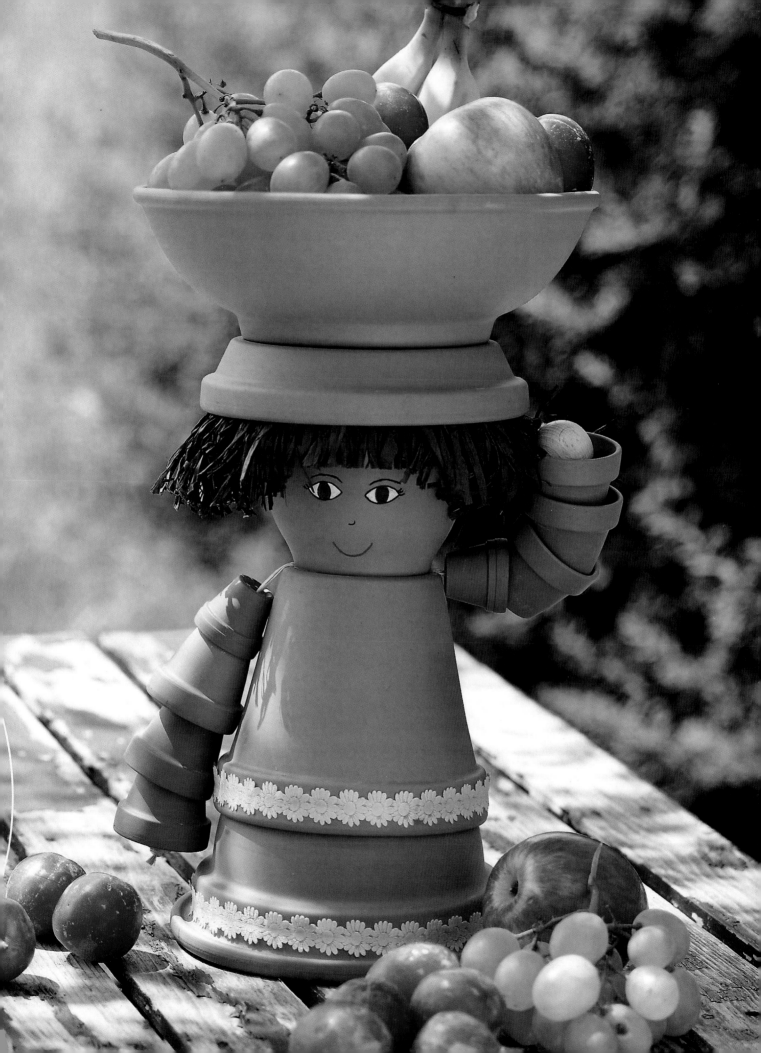

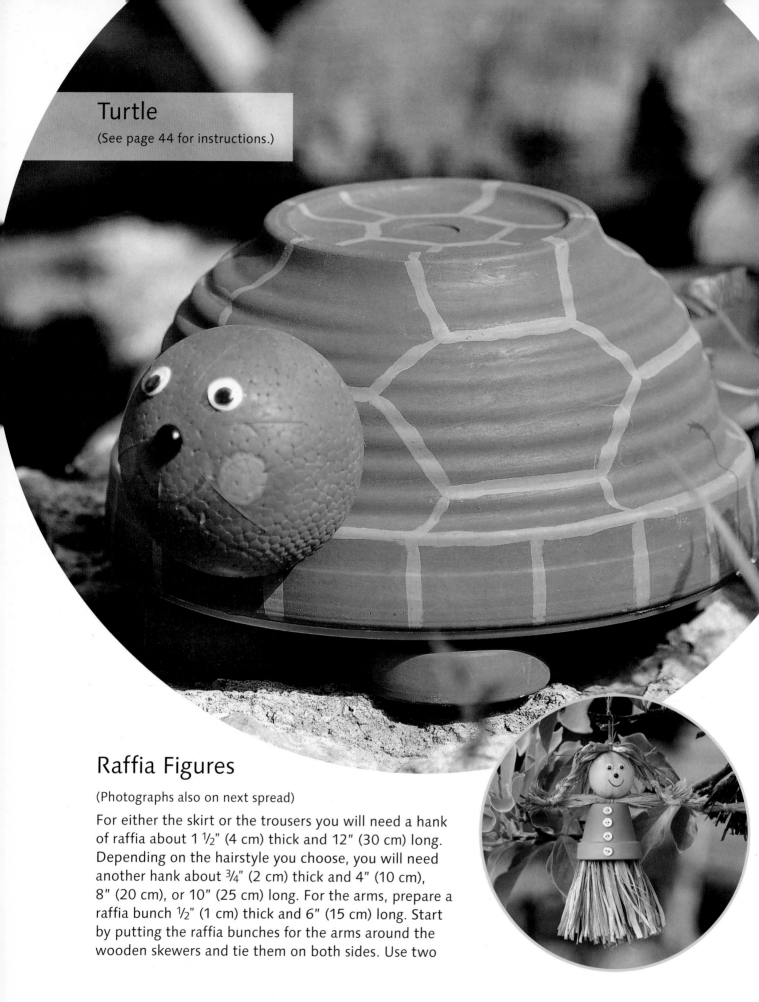

# Turtle

(See page 44 for instructions.)

# Raffia Figures

(Photographs also on next spread)

For either the skirt or the trousers you will need a hank of raffia about 1 ½" (4 cm) thick and 12" (30 cm) long. Depending on the hairstyle you choose, you will need another hank about ¾" (2 cm) thick and 4" (10 cm), 8" (20 cm), or 10" (25 cm) long. For the arms, prepare a raffia bunch ½" (1 cm) thick and 6" (15 cm) long. Start by putting the raffia bunches for the arms around the wooden skewers and tie them on both sides. Use two

doubled raffia threads 12" (30 cm) long, wrap in opposite directions, and make a central knot; use one thread for the suspension and one to fix the bottom part.

Pass the raffia cord that is hanging down through the pot hole and centrally tie the thick raffia bunch for the bottom part. For the raffia boy, divide the raffia and tie two trouser legs. Thread the raffia thread that is pointing upward through the wooden bead and tie it onto the hair. Use the leftover threads for the suspension. Cut the hair to size as shown in the photograph. You can braid the girl's hair into pigtails if you like. Glue on the buttons and make the face with the wobbly eyes and the half-pearl as the nose. Paint on the mouth.

## Materials for Each Figure

- Height about 8" (20 cm)
- 1 clay pot, 2 ¼" (6 cm) in diameter
- 1 wooden bead, 2" (5 cm) in diameter
- Green, brown, and orange raffia
- 3 light pink buttons, ½" (1 cm) in diameter
- 3 brown buttons, ½" (1 cm) in diameter
- 4 green buttons, ½" (1 cm) in diameter
- Wooden skewers, 3 mm in diameter x 10" (25 cm) long
- 2 wobbly eyes, ¼" (0.5 cm) in diameter
- 1 black half-pearl, 4 mm in diameter

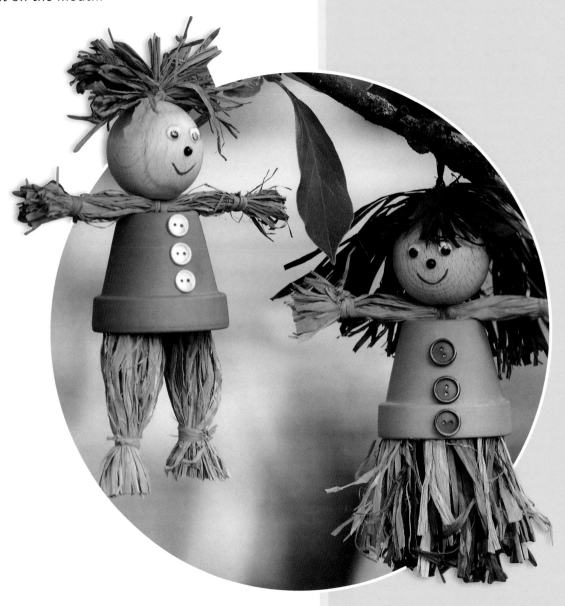

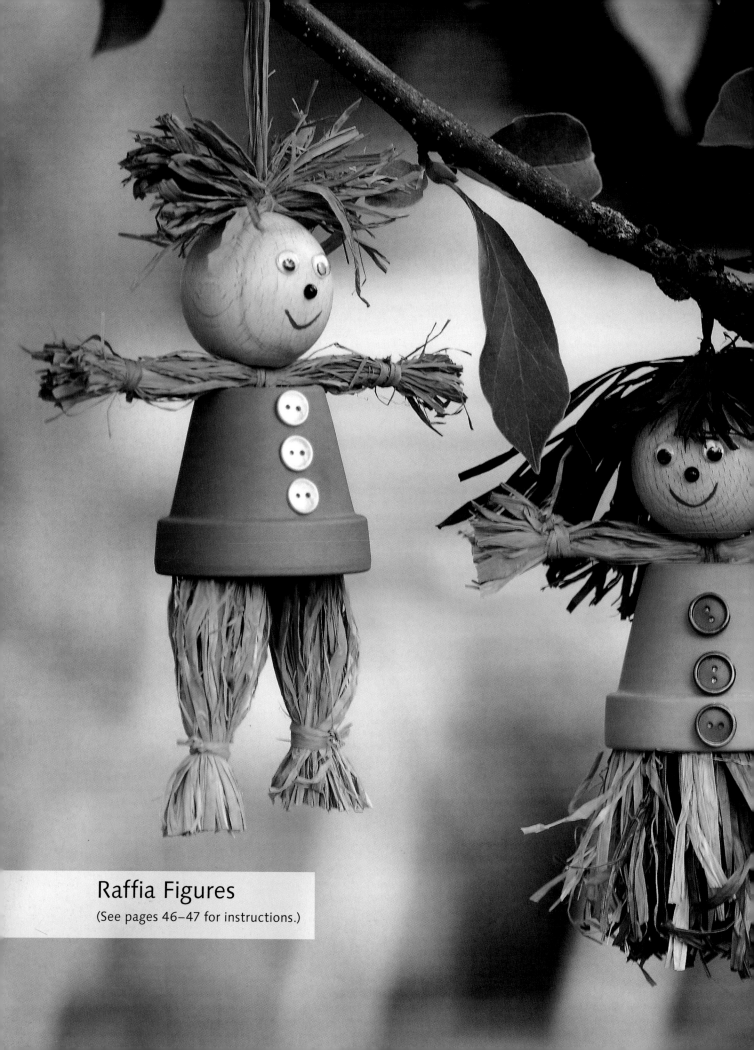

Raffia Figures

(See pages 46–47 for instructions.)

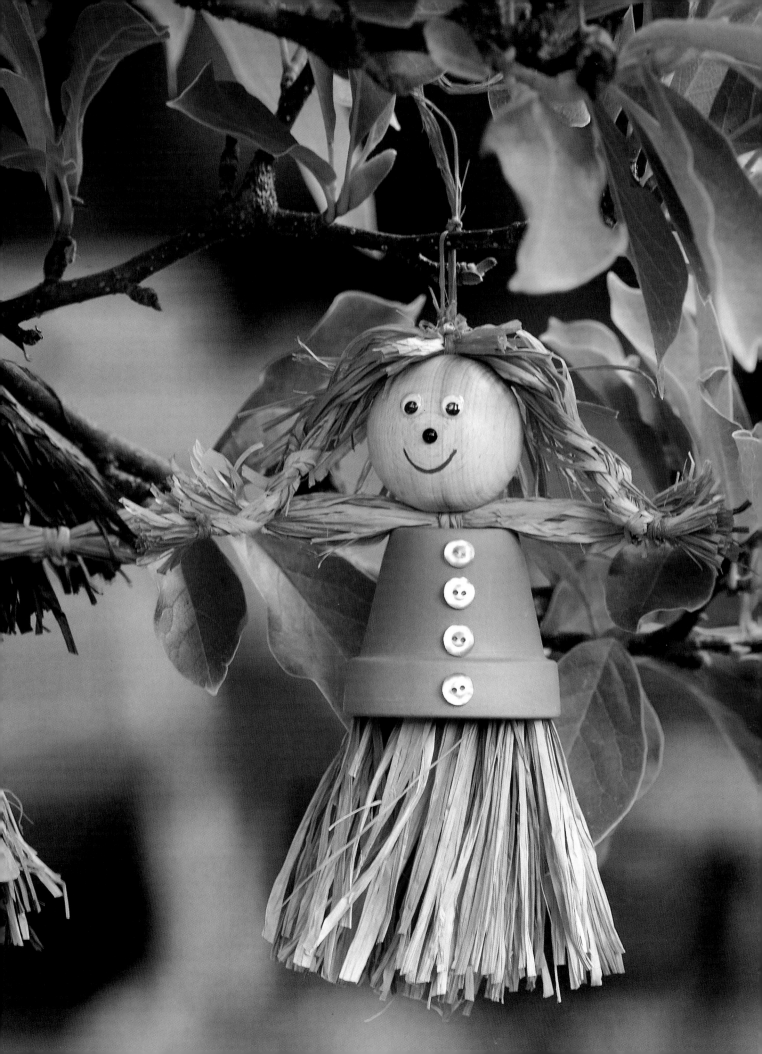

# Night Watchman

Apply a dark blue base coat to the smaller bell pots, the saucer, and the upper rim of the head pot; use one of the bell pots for the head and the other for the hat. Paint the large body bell pot, 6 miniature arm pots, and the rim of the bottom pot. Assemble the pieces according to the instructions for type 2 (page 9), but do not cut the overhanging raffia threads on the arms. Glue on the wobbly eyes and the nose. Paint the mouth as shown in the photograph. Cut gray-streaked long hair plush to size to make the moustache and wet it with hairspray. Part the beard in the middle. Twist the hair on the left and right around a pencil and keep the curls in place with a hair clip or a paper clip. Let dry.

After it has dried, glue on the moustache. For the hair, glue the black long hair plush to the pot rim and cut it into shape. Shorten a discarded belt to a suitable length and put it around the belly. To make the lance, cut two pieces of rubber mat and glue them to the rounded wooden stick. Attach both lance and lantern with the overhanging raffia threads. Fix the knots by adding wood glue before cutting the threads.

**Materials**
- Height about 26" (65 cm)
- 2 bell pots, 8" (20 cm) in diameter
- 1 bell pot, 9" (23 cm) in diameter
- 1 clay pot, 8 1/2" (22 cm) in diameter
- 2 miniature clay pots, 1 1/4" (3.5 cm) in diameter
- 6 miniature clay pots, 2" (5 cm) in diameter
- 1 clay saucer, 10" (26 cm) in diameter
- Dark blue craft paint
- 2 wobbly eyes
- 1 red wooden bead, 3/4" (2 cm) in diameter
- Black long hair plush, 3/4" x 28" (2 cm x 70 cm)
- Streaky gray long hair plush
- 1 belt, 1" (3 cm) wide x 1 yard (90 cm) long
- 6 buttons, 3/4" (2 cm) in diameter
- 1 rounded wooden stick, 1/4" x 20" (0.5 cm x 50 cm)
- 1 gray rubber sheet, 2 mm thick, 8 1/2" x 11" (21.5 cm x 28 cm)
- 1 miniature lantern, 6" (15 cm) tall
- 1 hair clip or paper clip
- Template

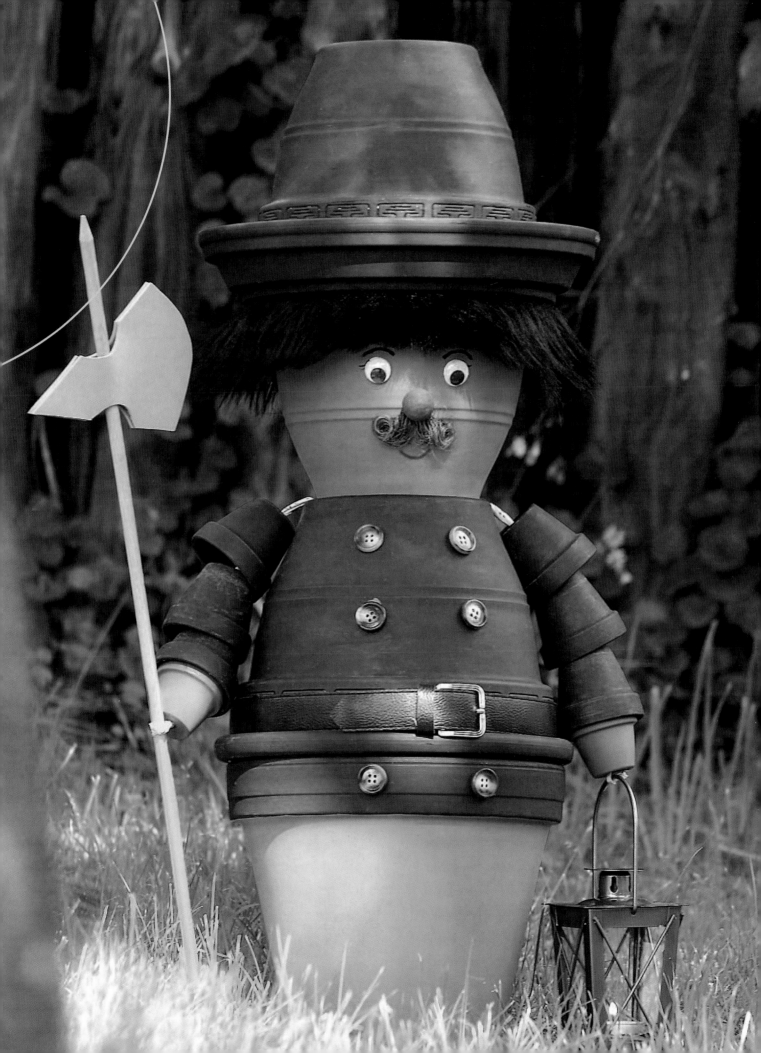

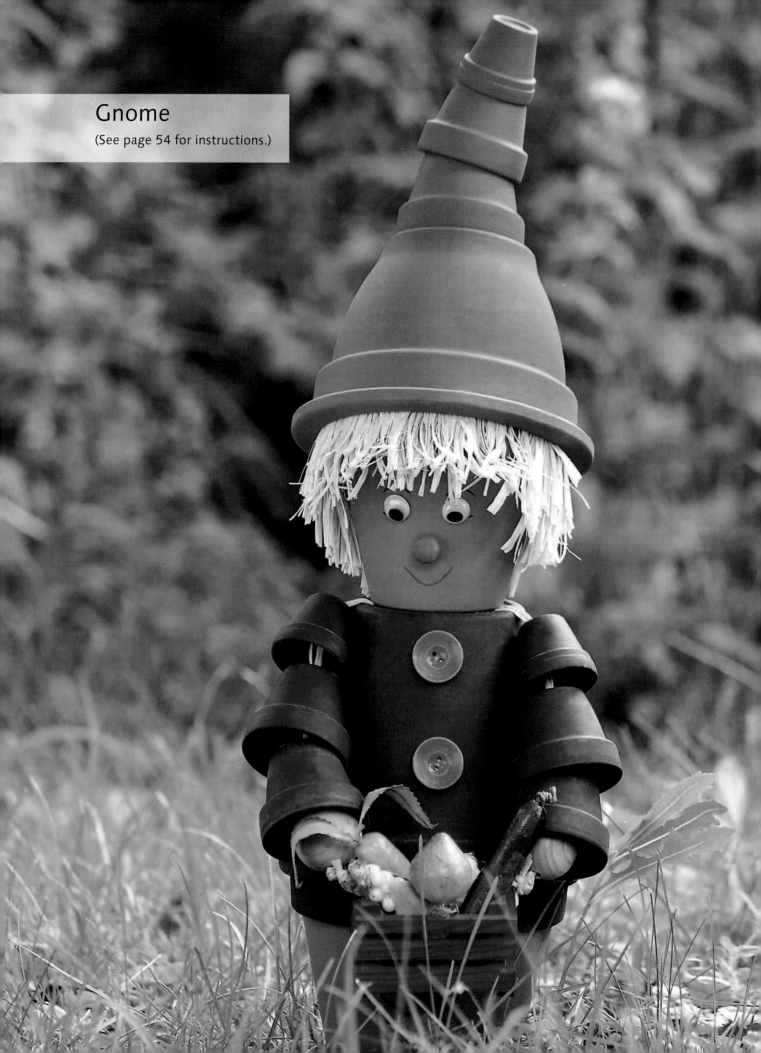

# Gnome

(See page 54 for instructions.)

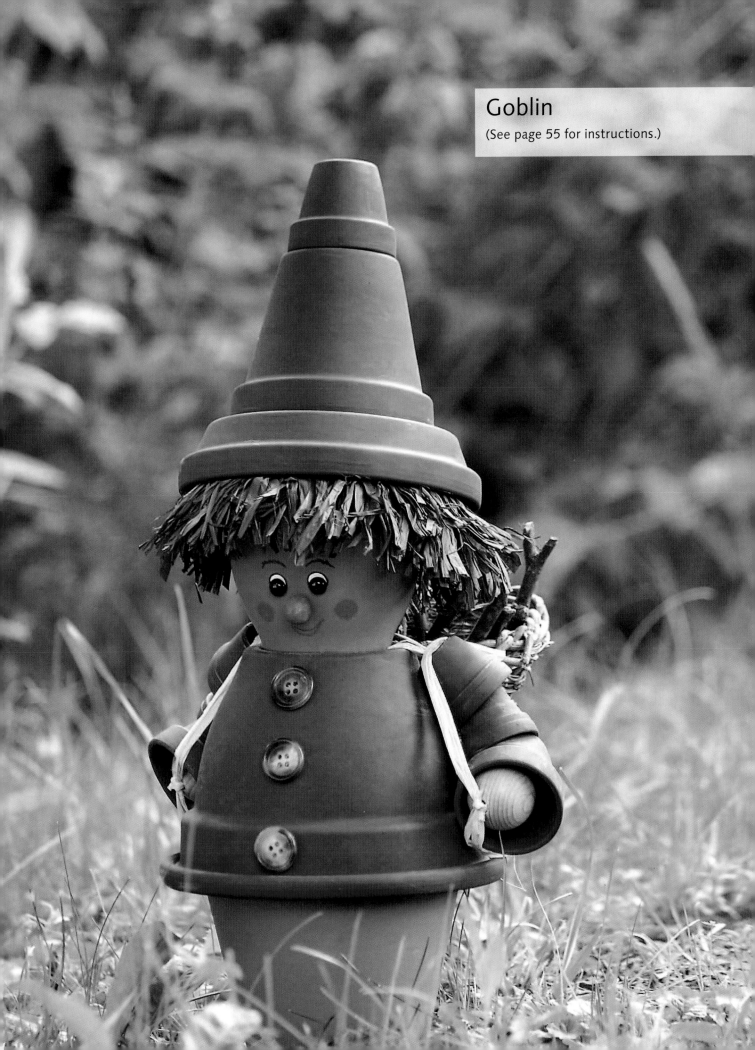

Goblin
(See page 55 for instructions.)

## Materials

- Height about 19" (48 cm)
- 3 miniature clay pots, 1" (3 cm) in diameter
- 5 miniature clay pots, 1¼" (3.5 cm) in diameter
- 1 miniature clay pot, 2" (5 cm) in diameter
- 1 clay pot, 3" (8 cm) in diameter
- 1 clay pot, 4¼" (11 cm) in diameter
- 1 clay pot, 4¾" (12 cm) in diameter
- 1 bell pot, 5" (13 cm) in diameter
- Raffia
- 1 red wooden bead, ¾" (2 cm) in diameter
- 2 wobbly eyes, ¾" (2 mm) in diameter
- 2 wooden beads, 1" (3 cm) in diameter
- Red and blue craft paint
- 2 red buttons, ¾" (2 cm) in diameter
- 1 blue vegetable box, 3" x 4" (8 cm x 10 cm)
- Assorted miniature vegetables

# Gnome

(Larger photograph on page 52)

For the hat, apply a red base coat to the bell pot and to three miniature clay pots, one in each size. Let dry, and then glue them together with wood glue and tilt them slightly (see photograph). Paint the large clay pot, the rest of the miniature pots, and the rim of the bottom pot blue. Assemble the figure according to the instructions for type 2 (page 9), but do not cut the overhanging raffia threads on the arms. Position the wobbly eyes and the nose and paint on the mouth. Cut raffia to 4" (10 cm) long for the hair and glue it to the inside rim of the hat pot. Put the hat on the head and fix it so it tilts slightly backward. Cut the hair into shape. Decorate the figure by adding two buttons and finish by fixing the vegetable box with the leftover raffia threads on the arms. Fill the box with vegetables.

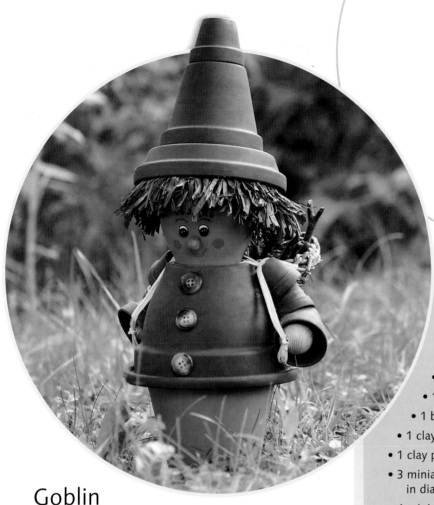

# Goblin

(Larger photograph on page 53)

Leave the smaller bell pot and the larger clay pot unpainted and apply a green base coat to all other pots. Assemble the basic figure according to the instructions for type 2 (page 9), but do not cut the leftover raffia threads. Glue the hat together as shown in the photograph. Let dry, and then fix the raffia hair to the inside of the pot rim. Fix the hat to the head so that it tilts slightly backward and cut the hair to shape. Paint on the eyes with white paint and outline them with a lacquer pen. Glue on half-pearls as irises. Glue on the red bead for the nose and paint on the mouth and cheeks as shown in the photograph. Decorate the jacket with the buttons. Tie raffia straps to each side of the basket. Place over the shoulders and tie the straps to the leftover raffia threads on the arms. Fix with wood glue and cut any leftover raffia.

## Materials

- Height about 16" (40 cm)
- 1 bell pot, 4 $\frac{1}{4}$" (11 cm) in diameter
- 1 bell pot, 5" (13 cm) in diameter
- 1 clay pot, 3" (8 cm) in diameter
- 1 clay pot, 4 $\frac{1}{4}$" (11 cm) in diameter
- 3 miniature clay pots, 1 $\frac{1}{4}$" (3.5 cm) in diameter
- 4 miniature clay pots, 1" (3 cm) in diameter
- 1 clay saucer, 4 $\frac{3}{4}$" (12 cm) in diameter
- 2 black half-pearls, $\frac{1}{4}$" (0.5 cm) in diameter
- 1 red wooden bead, $\frac{3}{4}$" (2 cm) in diameter
- 2 wooden beads, 1" (3 cm) in diameter
- Green craft paint
- Brown raffia
- 3 buttons, $\frac{3}{4}$" (2 cm) in diameter
- 1 basket, 4 $\frac{3}{4}$" (12 cm) in diameter x 5 $\frac{1}{2}$" (14 cm) tall
- Template

## Materials

- Height about 16" (40 cm)
- 1 clay pot, 4 3/4" (12 cm) in diameter
- 1 clay pot, 6" (16 cm) in diameter
- 1 clay saucer, 4 3/4" (12 cm) in diameter
- 1 clay saucer, 6" (16 cm) in diameter
- 4 miniature clay pots, 2" (5 cm) in diameter
- White craft paint
- 2 half-pearls, 1/4" (0.5 cm) in diameter
- Brown rubber mat, 2 mm thick, 8 1/2" x 11" (21.5 cm x 28 cm) size
- Template

# Guard Dog

Start by fixing the miniature clay pots to the larger clay saucer with wood glue. Join the head and body as shown on page 8 (step 1). Apply wood glue to the inside rim of the body and glue on the foot part. Cut out the ears and glue them to the edge of the head.

Close off the head pot with the matching saucer. Accent the legs, the belly, anad the face with white paint. Follow the photograph to draft some outlines with pencil. Use a wet sponge and dab on the white paint. Let dry, and then paint on the face as shown and glue on the half-pearls. Finish by painting a black line between the legs with a lacquer pen (see photograph).

### Tip

The paint will look especially even if applied with a cleaning sponge. Cut the sponge to the desired size. Absorb the paint with the sponge and dab it on evenly. For more intense color, apply a second coat after the first coat of paint is dry.

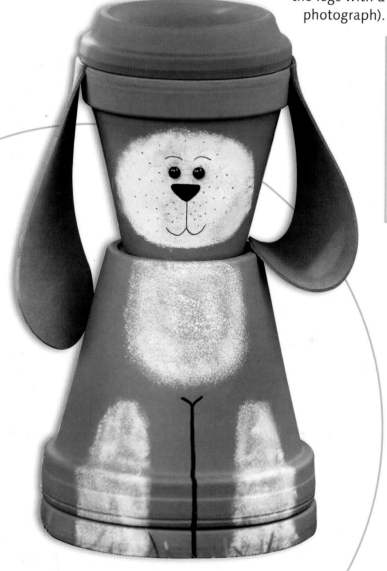

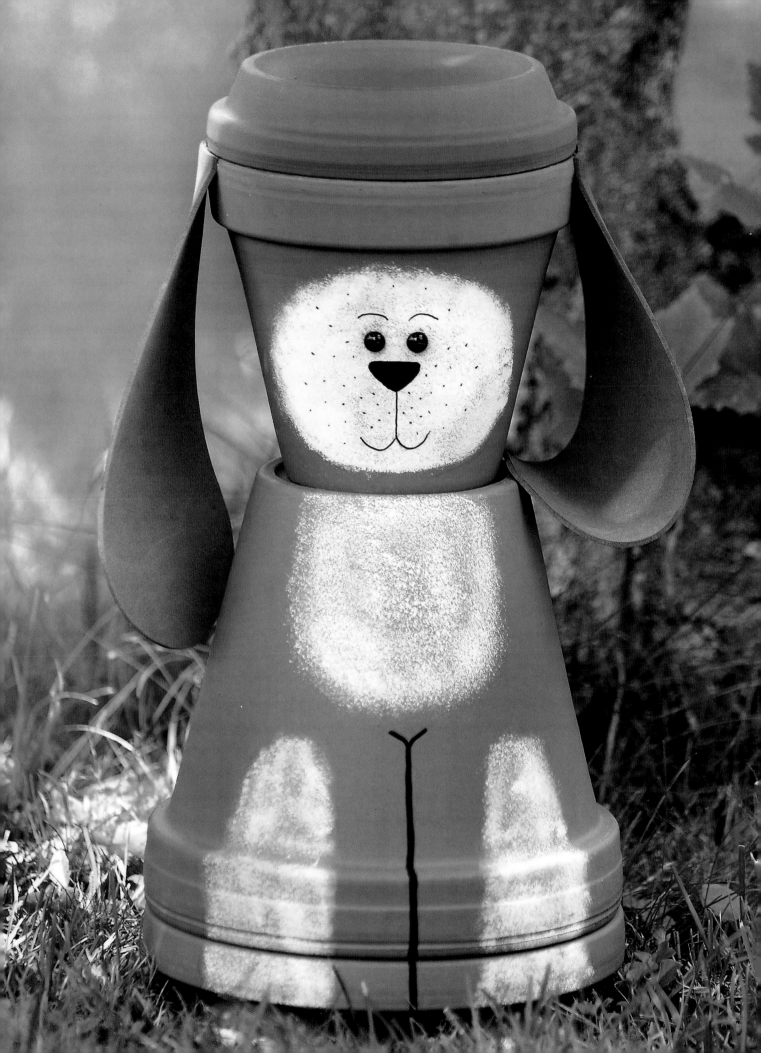

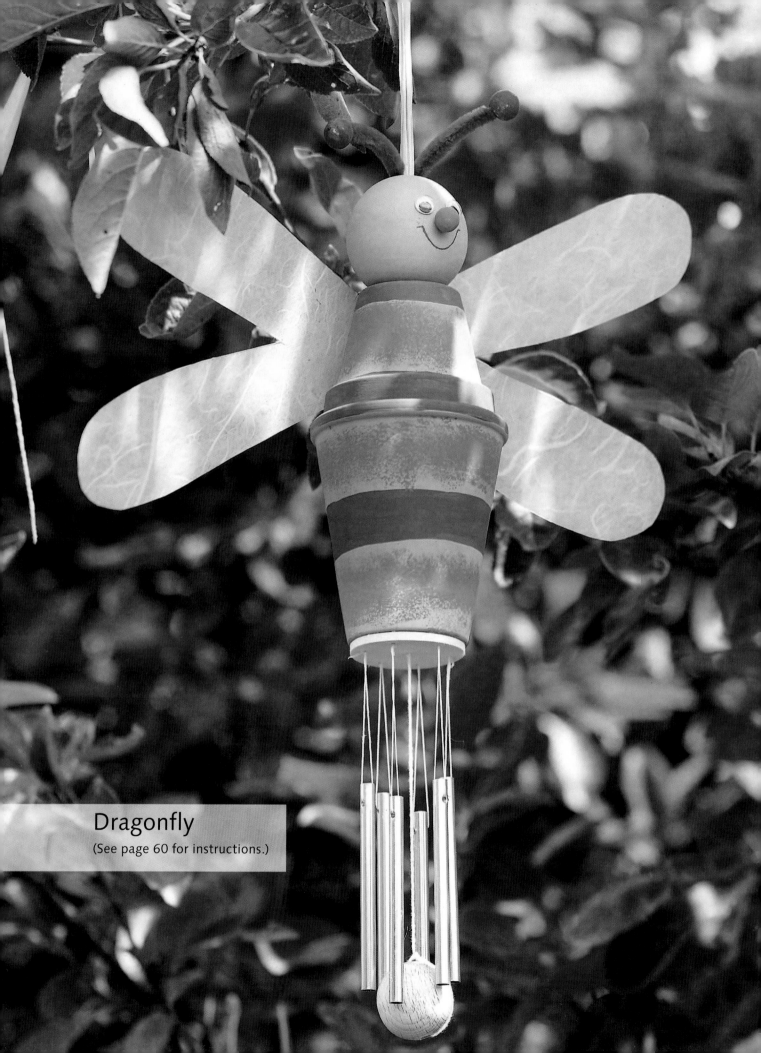

Dragonfly
(See page 60 for instructions.)

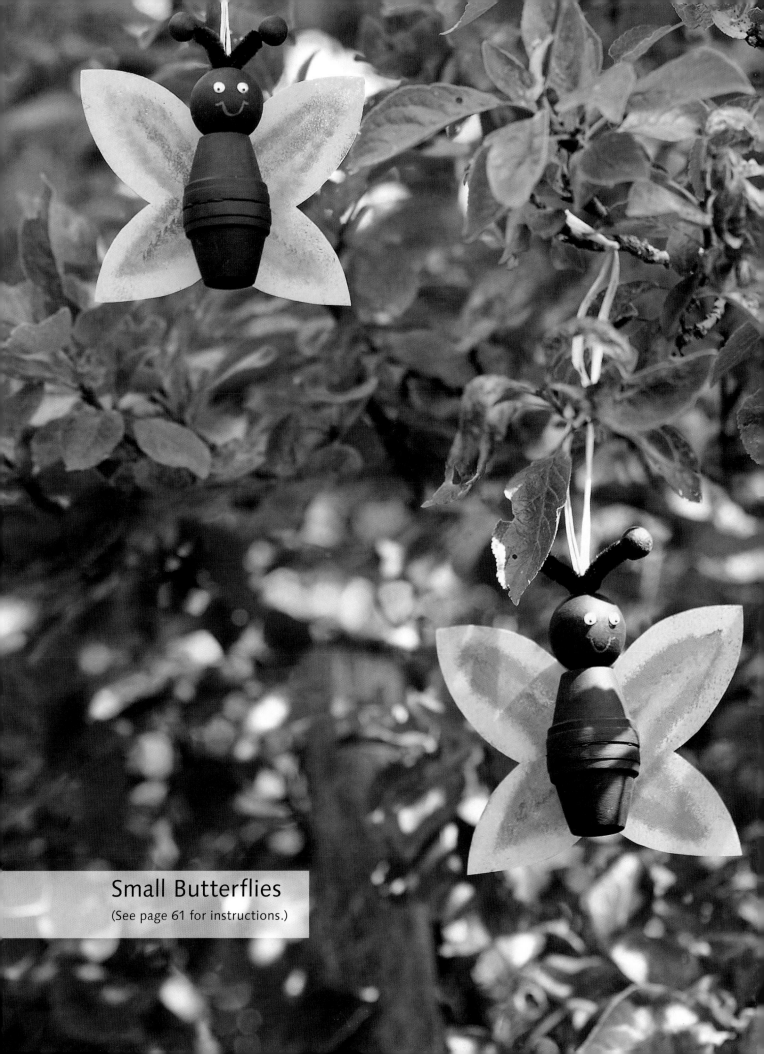

## Small Butterflies

(See page 61 for instructions.)

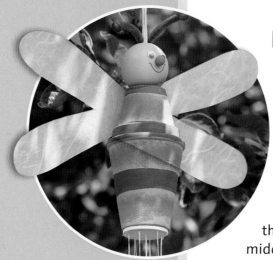

# Dragonfly

(Photograph also on page 58)

Apply a light green base coat to the clay pot, the rose pot, and the large wooden bead, and then paint a lilac stripe $1/2$" (1 cm) wide on the rim of the small pot. Paint $3/4$" (2 cm) lilac stripes above the base of the bottom pot and around the middle of the rose pot. Paint the rim of the bottom pot lilac too. Apply apple green paint to a wet sponge and dab it onto the light green base coat (see instructions on page 56 and photograph). Make the suspension by following step 1 on page 8. Pass the leftover raffia threads through the green wooden beads. Glue together head and the bottom part. For the antennae, cut two 4" (10 cm) pieces of pipe cleaner and glue them into the bead opening. Fix two green beads to the end of each pipe cleaner. Make the face using a wooden bead as a nose, gluing on the wobbly eyes, and painting on the mouth with a red lacquer pen. Use paper napkin glue to fix the fiber silk onto the mobile foil. Cut the wings and glue them on. Pass the suspension threads of the chimes and the bead through the holes of the spacer with drilled holes and tie in knots. Finish by gluing the assembled chime onto the base of the clay pot.

## Materials

- Height about 14" (35 cm)
- 1 rose pot, $2\,3/4$" (7 cm) in diameter x $3\,1/2$" (9 cm) tall
- 1 clay pot, $2\,1/4$" (6 cm) in diameter
- 1 wooden bead, $1\,1/4$" (3.5 cm) in diameter
- 1 wooden bead, 2" (5 cm) in diameter
- 2 green wooden beads, $1/2$" (1 cm) in diameter
- 1 green wooden bead, $1/2$" (1 cm) in diameter
- 2 wobbly eyes, $1/4$" (0.5 cm) in diameter
- 1 green pipe cleaner, 6" (15 cm) long
- 1 set of chimes with a spacer with drilled holes to keep the strands separate
- Light green, apple green, and lilac craft paint
- Mobile foil, $8\,1/2$" x 11" (21.5 cm x 28 cm) size
- Fiber silk
- Sponge
- Template

## Tip

If you want to keep the dragonfly outdoors, use a sponge to dab waterproof craft paint on the mobile wings.

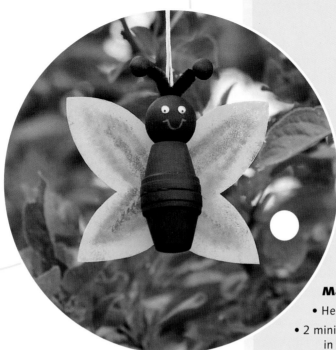

## Small Butterflies

(Photograph also on page 59)

Apply a black base coat to the miniature clay pots, the cotton balls, and the wooden bead. Make the suspension following the instructions on page 8 (step 1). Pass the suspension thread through the wooden bead. Glue the head and the bottom part together. Cut the pipe cleaner in half and push a cotton ball onto each end. Apply glue to the other ends and fix the antennae into the bead hole. Cut the wings from mobile foil. Dab on the colors with a wet sponge according to the photograph or your own design (see page 56). Fix the wings and wobbly eyes and paint on the mouth with a red lacquer pen.

**Materials for the Butterfly**

- Height about 4 3/4" (12 cm)
- 2 miniature clay pots, 1 1/4" (3.5 cm) in diameter
- 1 wooden bead, 1" (3 cm) in diameter
- 2 cotton balls, 1/2" (1 cm) in diameter
- 1 black pipe cleaner, 4" (10 cm) long
- 2 wobbly eyes, 4 mm in diameter
- Mobile foil, 8 1/2" x 11" (21.5 cm x 28 cm) size
- Red, yellow, and purple craft paint
- Template

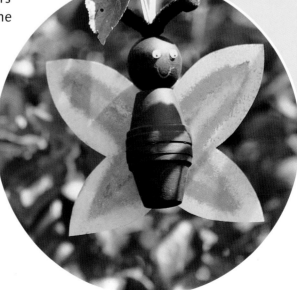

61

# Standing Butterfly

Paint all the clay pots black, but leave the face unpainted. Assemble the figure according to the instructions for type 2 (page 9). Glue the Styrofoam ball to the head. To fix the antennae, use a knitting needle to make two holes in the Styrofoam ball. Make the face as shown in the photograph. Cut the wings from mobile foil and use a wet sponge with craft paint to decorate them. Dab some paint onto the lower rim of the body. Finish by fixing the wings.

**Materials**

- Height about 8" (20 cm)
- 1 bell pot, 3 ½" (9 cm) in diameter
- 1 clay pot, 2 ¼" (6 cm) in diameter
- 4 miniature clay pots, 1" (3 cm) in diameter
- 1 miniature clay pot, 2" (5 cm) in diameter
- 2 wobbly eyes, ¼" (0.5 cm) in diameter
- 1 red wooden bead, ½" (1 cm) in diameter
- Mobile foil, 8 ½" x 11" (21.5 cm x 28 cm) size
- 1 Styrofoam ball, 2" (5 cm) in diameter
- 1 black pipe cleaner, 6" (15 cm) long
- Lilac, blue, and yellow craft paint
- Template

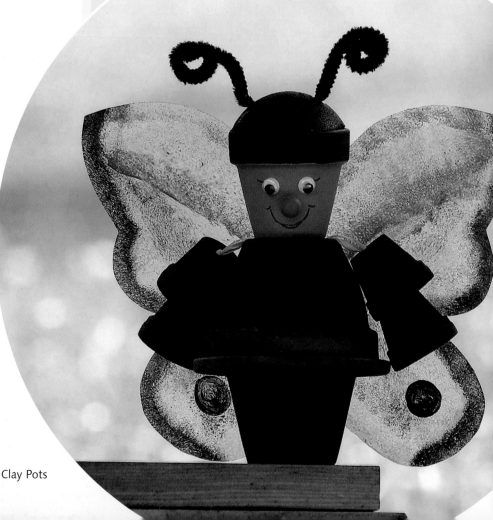

# Ladybug

Apply a black base coat to the halved Styrofoam ball, the large clay pot, the rim of the head pot, and the feet. Follow steps 1 and 2 on page 8 to assemble the figure, but instead of raffia threads use an 8" (20 cm) pipe cleaner and, for the legs, a 16" (40 cm) pipe cleaner. Tie in the pipe cleaners (see page 8, step 1).

Thread the black beads onto the chenille wire. Apply glue ½" (1 cm) from the wire ends and attach the hands. You will use the leftover wire to attach the arms to the swing. Fix the feet. Glue half the Styrofoam ball to the head and paint the face. Make two holes with a knitting needle for the antennae and paint the cotton balls red. Insert a 4" (10 cm) pipe cleaner into each cotton ball, apply glue to the wire ends, and fix the antennae into the holes in the Styrofoam ball.

Glue fiber silk onto the mobile foil; cut the wings and dot with a black lacquer pen. Fix the wings. For the seat of the swing, cut two pieces, 1 ½" (4 cm) long each, from a popsicle stick. Use two raffia threads, 20" (50 cm) long, for the ropes; spread them out on the seat and then glue them on centrally. Glue the other two pieces on top of the raffia. Glue the figure to the wooden seat and make sure it balances. Bend the pipe cleaner arms around the ropes of the swings.

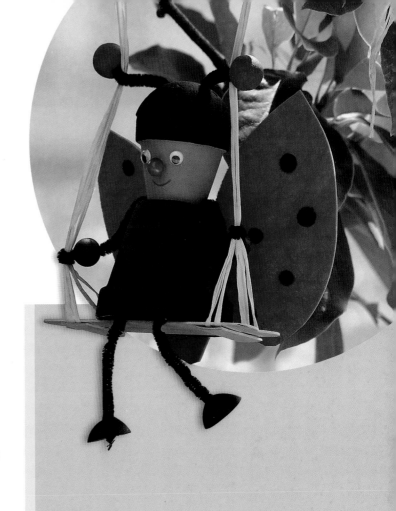

## Materials

- Height about 10" (25 cm)
- 1 clay pot, 2" (5 cm) in diameter
- 1 clay pot, 2 ¾" (7 cm) in diameter
- 1 Styrofoam ball, 2" (5 cm) in diameter
- 2 wobbly eyes, ¼" (0.5 cm) in diameter
- 1 red wooden bead, ½" (1 cm) in diameter
- 2 black wooden beads, ¾" (2 cm) in diameter
- 2 cotton balls, ¾" (2 cm) in diameter
- 1 black pipe cleaner, about 32" (80 cm) long
- 2 puppet feet, 1" x 1 ¼" (24 cm x 3.5 cm)
- Black and red craft paint
- Mobile foil, 8 ½" x 11" (21.5 cm x 28 cm) size
- Red fiber silk, 8 ½" x 11" (21.5 cm x 28 cm) size
- 3 popsicle sticks, ¾" x 6" (2 cm x 15 cm)
- Template

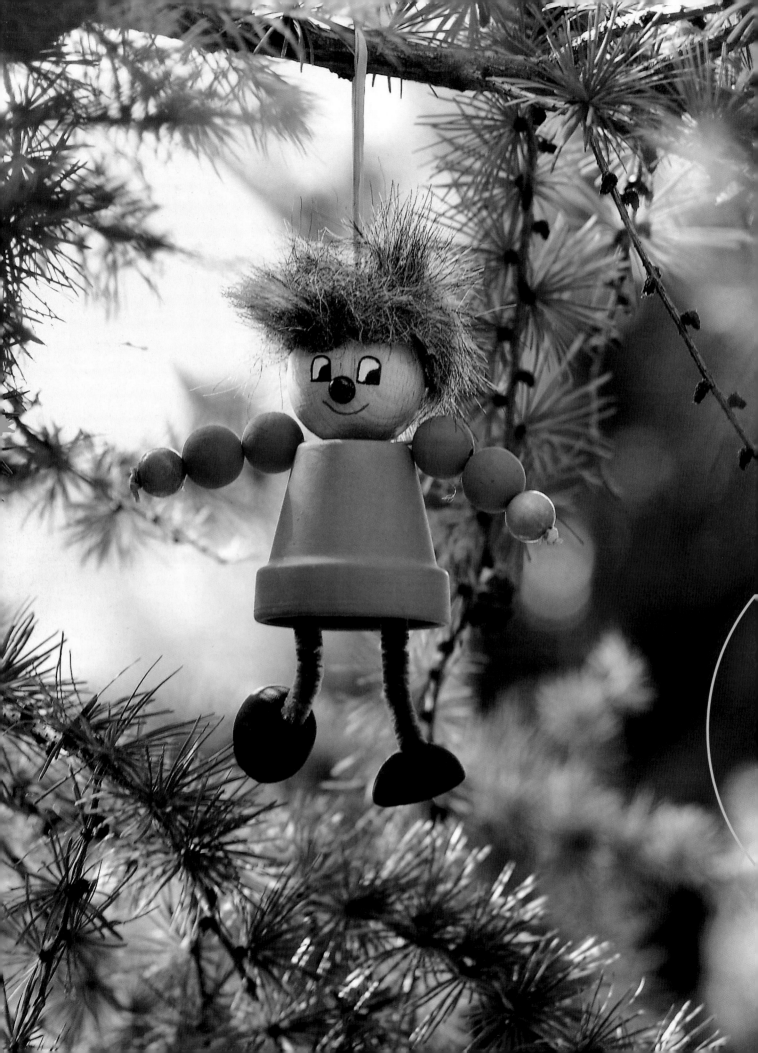

# Miniature Troll

Paint the miniature clay pot and the large beads orange, and paint the shoes brown. Assemble the figure according to the instructions for type 1 (page 8), but use wooden beads instead of clay pots for the arms. For the legs, tie pipe cleaners centrally into the raffia. Apply glue to the wire ends, and then fix the puppet feet to them. Apply glue to the middle of the fake fur piece and place the wig in position. You may need to make incisions in the wig to avoid folds. Finish gluing on the wig. Paint on the eyes and the mouth as shown, and glue on the half-pearl as a nose.

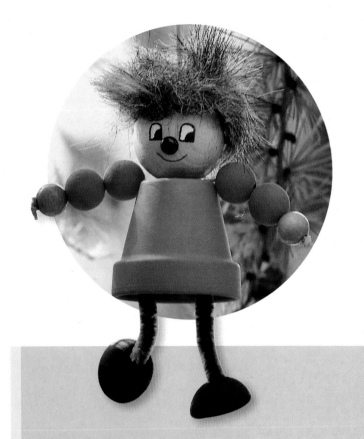

**Materials**

- Height about 6" (15 cm)
- 1 clay pot, 2" (5 cm) in diameter
- 6 wooden beads, ³⁄₄" (2 cm) in diameter
- 1 wooden bead, 1 ¹⁄₂" (4 cm) in diameter
- 1 green pipe cleaner, 8" (20 cm) long
- 2 puppet feet, 1" x 1 ¹⁄₄" (3 cm x 3.5 cm)
- 1 black half-pearl, ¹⁄₄" (0.5 cm) in diameter
- 1 piece of fake fur, about 3" x 3" (8 cm x 8 cm)
- Orange and brown craft paint
- Template

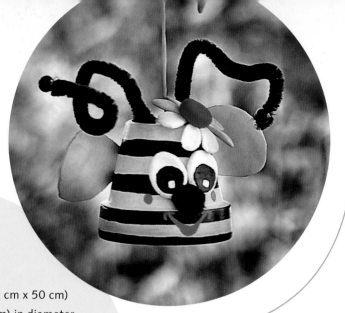

## Materials

- Dimensions about 10" x 20" (25 cm x 50 cm)
- 4 clay pots, 1 $\frac{1}{2}$" to 2" (4 to 5 cm) in diameter
- 1 clay pot, 6 $\frac{3}{4}$" (7 cm) in diameter
- Modeling clay
- Yellow, black, white, green, and red terra-cotta pens
- 2 black wooden beads, $\frac{1}{2}$" (1 cm) in diameter
- 2 black pipe cleaners, 6" (15 cm) long
- 1 black pom-pom, $\frac{1}{2}$" (1 cm) in diameter
- 2 mobile stocks or wooden skewers, 9" (23 cm) long
- Natural-finish raffia
- 5 wooden beads, $\frac{1}{2}$" (1 cm) in diameter
- Clear varnish
- Template

### Tip

Cover the figures in a clear varnish to weatherproof them. Now you can use the mobile as an eye-catching decoration on your balcony or terrace.

## Bee and Flower Mobile

Paint the clay pots as shown in the photograph and on the template sheet. The leaves, the bee's eyes, and the wings are also on the template sheet. Model the flower petals to about 1" (3 cm) long, as in the photograph (also see the instructions on page 10). The center of the flower on the head of the bee has a diameter of a bit more than $\frac{1}{2}$" (1 cm).

When the modeled objects are thoroughly dry, paint them, and once the paint is dry, glue them to the pot. Glue on the pom-pom as a nose and the pipe cleaners as antennae. Glue one black wooden bead to each wire. Now use raffia and wooden beads to tie the objects to the mobile sticks. Follow the photograph and the instructions on page 10.

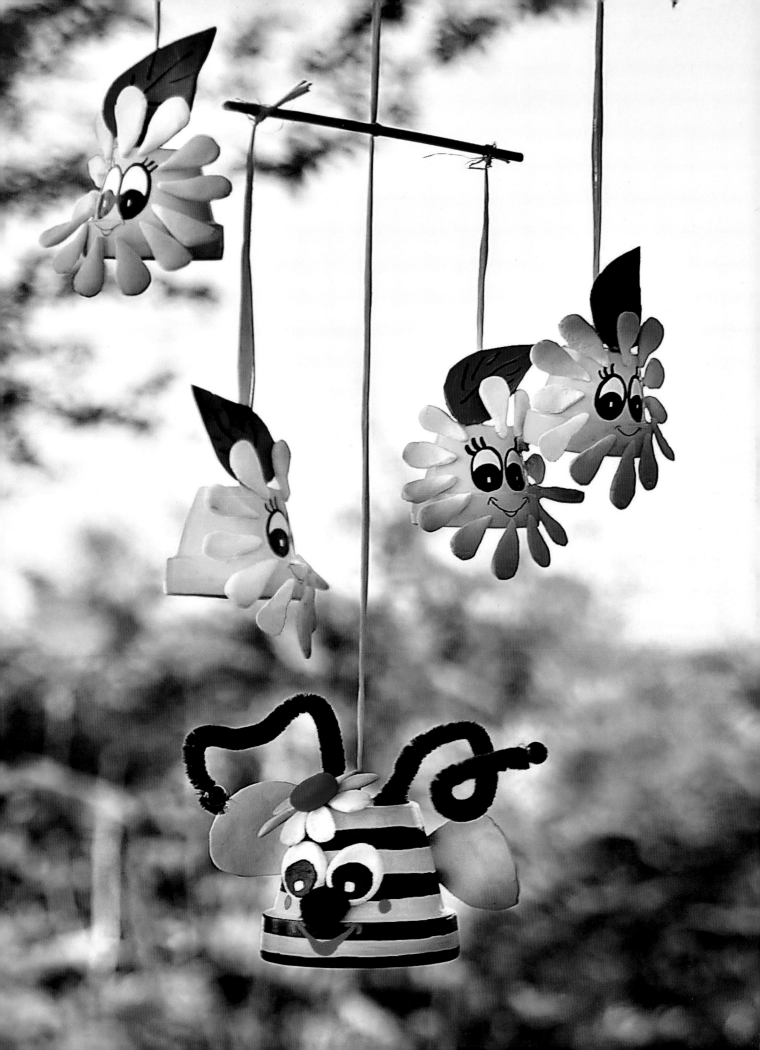

# Caterpillar

Buy a prefabricated wind chime and paint it green. After the paint is dry, apply the green puff paint as shown in the photograph and use a hair dryer to fluff it, following the manufacturer's instructions. Make the flowers and the teeth from modeling clay according to the template. After the modeling clay is dry, paint the flowers white, pink, and light blue. Finish by gluing on the teeth and the flowers.

**Materials**

- Height about 2 ¾" x 1 yard (7 cm x 90 cm)
- 1 clay pot wind chime, about 2 ½" (6.5 cm) in diameter x 1 yard (90 cm) long
- Modeling clay
- Green, white, black, light pink, and light blue terra cotta pens
- Green puff paint
- Template

**Tip**

You can make this wind chime yourself using ten clay pots, all the same size. You also need wooden beads a bit larger than the pot holes, plus raffia or a long, strong rope. Thread a bead onto the raffia or rope and tie a knot. Then thread the raffia or rope through the pot hole. Continue to alternate beads and pots until all the pots are hanging underneath one another. Decorate as described above.

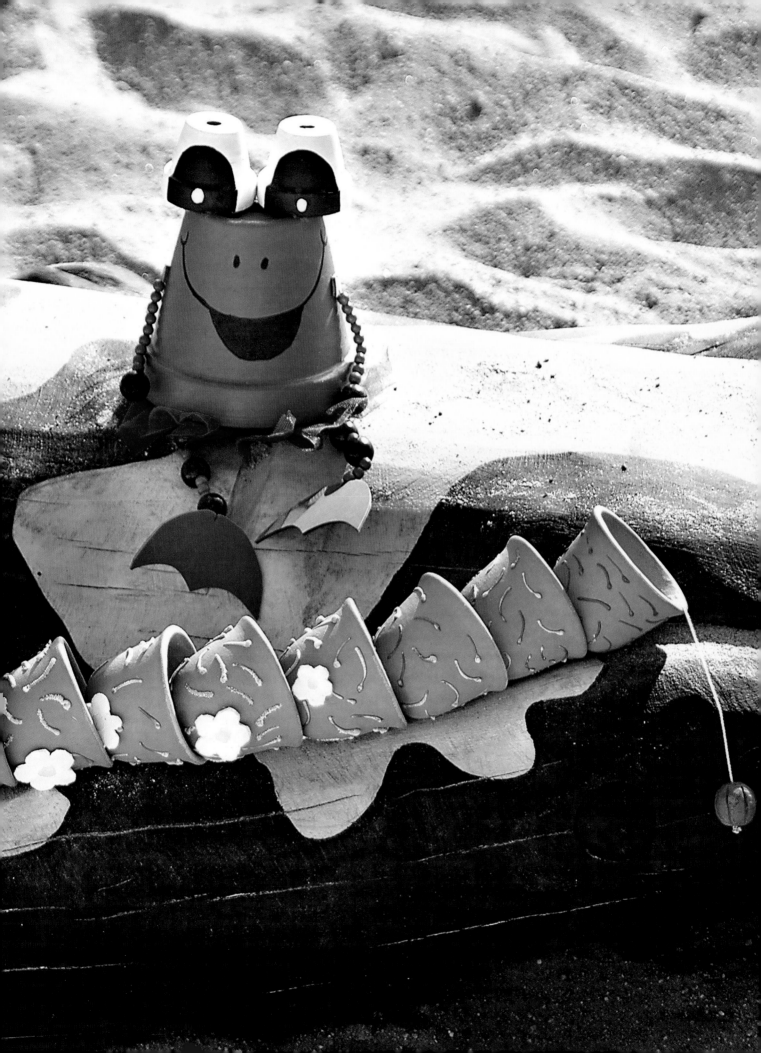

# Frog

(Photograph also on page 69)

Apply a green base coat to the frog. Paint the miniature clay pots for the eyes white. After they are dry, paint on the black irises and nostrils and the mouth according to the template. Use superglue to attach the tulle in the large clay pot. Divide the crafting wire into four equal pieces and thread on the pearls and rubber feet as in the photograph. Use a rubber square, about ½" x ½" (1 cm x 1 cm), to fix the arms and legs. Apply glue and attach the arms and legs as in the photograph. Finish by gluing on the two eyes.

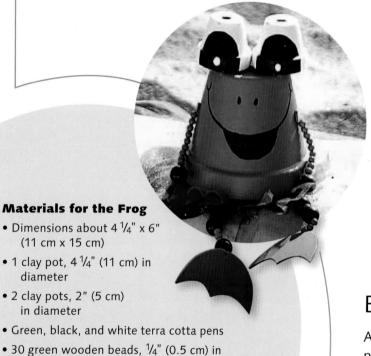

**Materials for the Bird Feeder**

- Dimensions about 9" x 10 ½" (23 cm x 27 cm)
- 1 clay pot, 4 ½" (11 cm) in diameter
- 1 clay pot, about 6" (15 cm) in diameter
- 1 clay saucer, 9" (23 cm) in diameter
- Blue, white, green, yellow, red, black, and pink terra cotta pens
- Template

**Tip**

To make the colors weatherproof, apply a clear varnish to the clay pots and saucer. Now the birdfeeder is ready for outdoor use.

**Materials for the Frog**

- Dimensions about 4 ¼" x 6" (11 cm x 15 cm)
- 1 clay pot, 4 ¼" (11 cm) in diameter
- 2 clay pots, 2" (5 cm) in diameter
- Green, black, and white terra cotta pens
- 30 green wooden beads, ¼" (0.5 cm) in diameter
- 6 dark green wooden beads, ½" (1 cm) in diameter
- Green rubber mat
- Blue tulle
- Green crafting wire, about 2' (60 cm) long
- Template

# Bird Feeder

Apply a blue base coat to the clay pots and saucer. After they are dry, apply the white paint with a stippling brush. Squeeze the white paint out of the pen onto the brush. Let dry again, and then transfer the motifs from the template to the clay pots and fill them in.

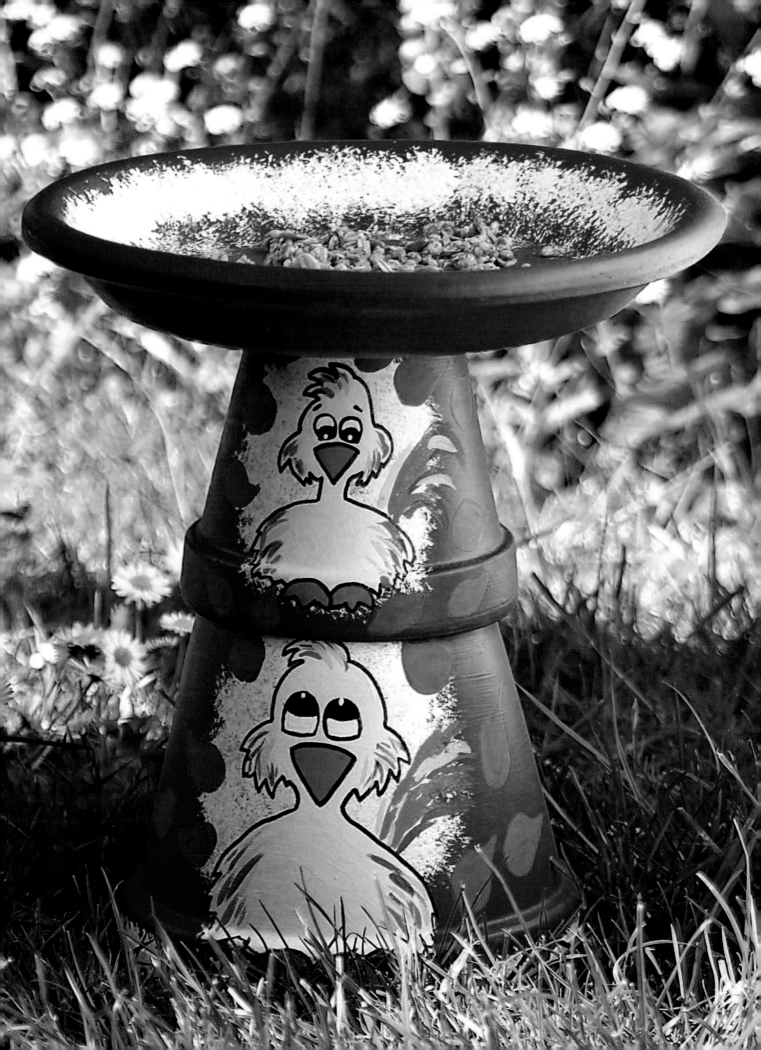

# Clowns

Paint the clay pots according to the photograph and the stencils on the template. To make the arms, alternate threading six rubber squares, ½" x ½" (1 cm x 1 cm), and five small beads on a nylon thread. Use one large natural-finish bead to finish each arm. Glue on the arms. Use superglue to attach the pom-pom noses as well as the raffia hair.

To make the boy clown's hair, glue several 2" (5 cm) raffia pieces onto his face. Make raffia pigtails, 5 ½" (14 cm) long, for the girl clown and braid them before gluing them on. Put the hats loosely on the heads so additional little surprises can be hidden there.

Fill the pot with the presents, and then use raffia to tie the package together like any other parcel. Now glue the head to the body. Finish attaching the hands to the body and head respectively, as in the photograph.

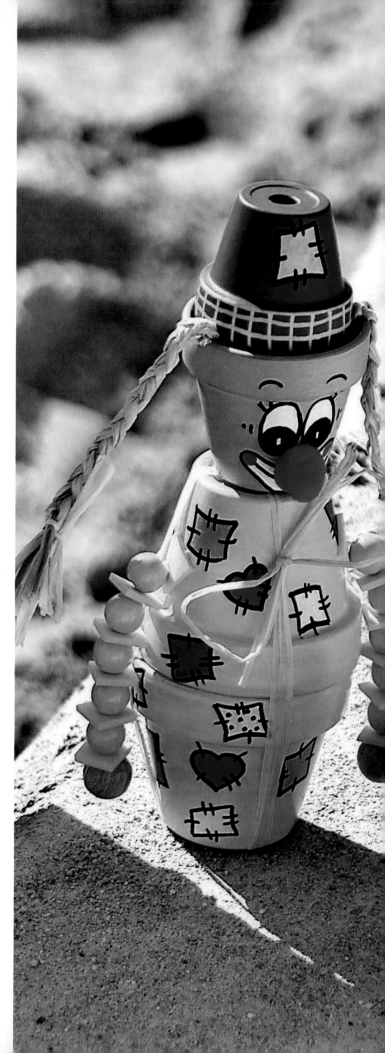

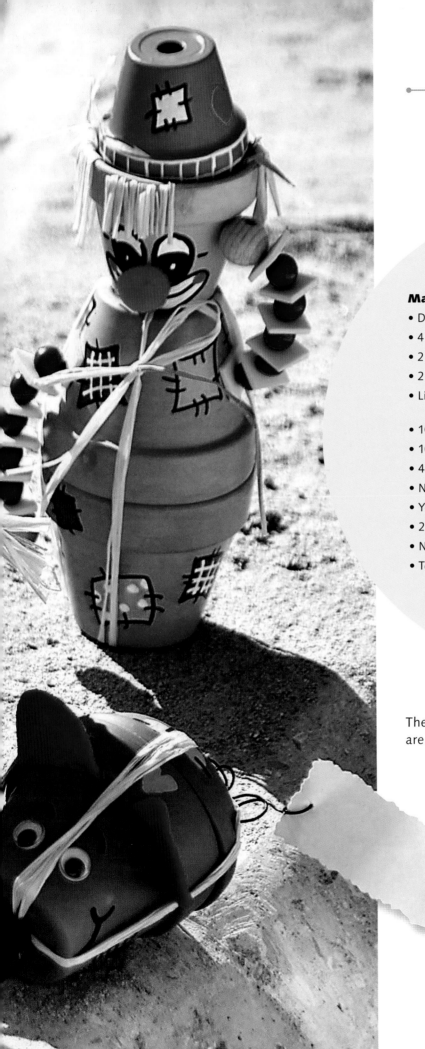

## Materials

- Dimensions about 4" x 8" (10 cm x 20 cm)
- 4 clay pots, 2 1/4" to 2 3/4" (6 cm to 7 cm) in diameter
- 2 clay pots, 2" to 2 1/4" (5 cm to 6 cm) in diameter
- 2 clay pots, 1 1/2" to 2" (4 cm to 5 cm) in diameter
- Light blue, dark blue, yellow, white, red, pink, green, light green, black, and lilac terra cotta pens
- 10 blue wooden beads, 1/2" (1 cm) in diameter
- 10 yellow wooden beads, 1/2" (1 cm) in diameter
- 4 natural-finish wooden beads, 1/2" (1 cm) in diameter
- Nylon threads
- Yellow rubber mat
- 2 red pom-poms, 1/2" (1 cm) in diameter
- Natural-finish raffia
- Template

The instructions for the mouse are on page 74.

**Materials for the Fruit Bowl**

- Dimensions about 4" x 9" (10 cm x 23 cm)
- 1 pink clay saucer, 9" (23 cm)
- 1 clay pot, 2 ½" (6.5 cm) in diameter x 9" (23 cm) tall
- Black, yellow, green, red, and blue terra cotta pens
- Clear varnish
- Template

# Mouse

(Photograph also on page 73)

Paint the mouse as shown in the photograph and on the template sheet. After the paint is dry, attach the wobbly eyes and the rubber ears with superglue. Fill with the presents and string the package together with raffia. Attach the pom-pom nose. Make a spiral tail by bending crafting wire around a pencil. Then attach a sign and tie the end with raffia. This funky gift idea is all done!

**Materials for the Mouse**

- Dimensions about 2 ¾" x 3 ¾" (7 cm x 9.5 cm)
- 1 clay pot, 2 ¼" to 2 ¾" (6 cm to 7 cm) in diameter
- 1 clay saucer, 2 ¾" (7 cm) in diameter
- Gray, light blue, black, pink, green, light green, and lilac terra cotta pens
- 2 wobbly eyes, ½" (1 cm) in diameter
- Pink felt
- Natural-finish raffia
- 1 black or pink pom-pom, ¾" (2 cm)
- Black crafting wire, about 6" (15 cm) long
- Slogan on paper
- Template

# Colorful Fruit Bowl

This beautiful fruit bowl is quickly made. Apply a yellow base coat to the clay pot and saucer. Transfer the motif from the template sheet and fill it in as shown in the photograph below.. Finish by gluing the saucer on top of the pot.

**Tip**

Apply a clear varnish to the fruit bowl so you can wipe it clean.

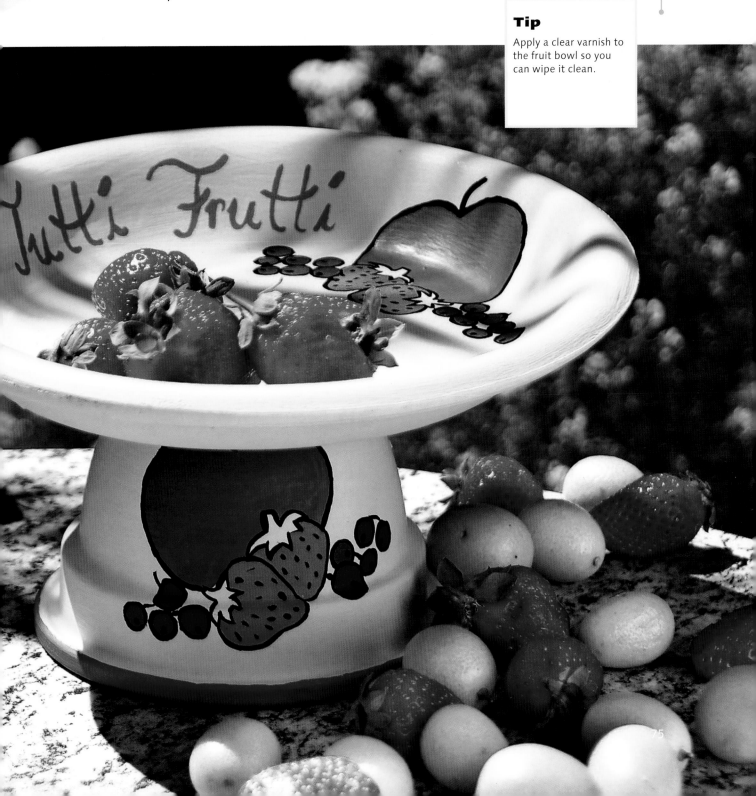

## Materials for the Newspaper Lady

- Dimensions about 12" x 31" (30 cm x 80 cm)
- 4 clay pots, 4" to 4 1/4" (10 cm to 11 cm) in diameter
- 2 clay pots, 2 1/4" to 2 3/4" (6 cm to 7 cm) in diameter
- 1 clay pot, 7" to 8" (18 cm to 20 cm) in diameter
- 1 clay pot, 5 1/2" to 6" (14 cm to 15 cm) in diameter
- 1 clay pot, 8" to 8 1/2" (20 cm to 22 cm) in diameter
- 1 clay pot, 12" to 13 1/2" (30 cm to 34 cm) in diameter
- 1 wall-mounted ceramic pot, 1 1/4" (3.5 cm)
- Blue, white, black, yellow, pink, green, red, and light green terra cotta pens
- Strong brown rope, 1/2" x 5' (1 cm x 160 cm)
- Several pieces of natural-finish raffia, each 2' (60 cm) long
- 1 aluminum pipe, 4 1/4" (11 cm) in diameter x 12" (30 cm) long
- Clear varnish
- Template

# Newspaper Lady

Apply the base coats in the colors shown in the photograph and transfer the individual motifs from the template sheet. Paint the apron and some decorative lines as shown. Use puff paint for the apron trimming as well as the grass on the bottom pot. Fluff the paint with a hair dryer according to the manufacturer's instructions. Glue the ceramic half-pot onto the apron.

When everything is thoroughly dry, assemble the newspaper lady. Use a strong rope to assemble the arms. Tie a knot after threading on each pot. Pull the ends of the rope through the hole of the middle pot (shirt with buttons) and tie securely in a knot. Fix the aluminum pipe underneath the left arm by pulling a piece of rope through it and tying it to the arm. Use raffia threads of the desired thickness to make braided pigtails 2' (60 cm) long and attach to the head. Finish by adding a nice plant to the head pot and some flowers to the apron pocket. Who wouldn't like to receive their newspaper each morning from such a charming lady!

## Tip

To stabilize the figure, assemble it with mortar or wood glue. If you want to use her outdoors, cover her with clear varnish.

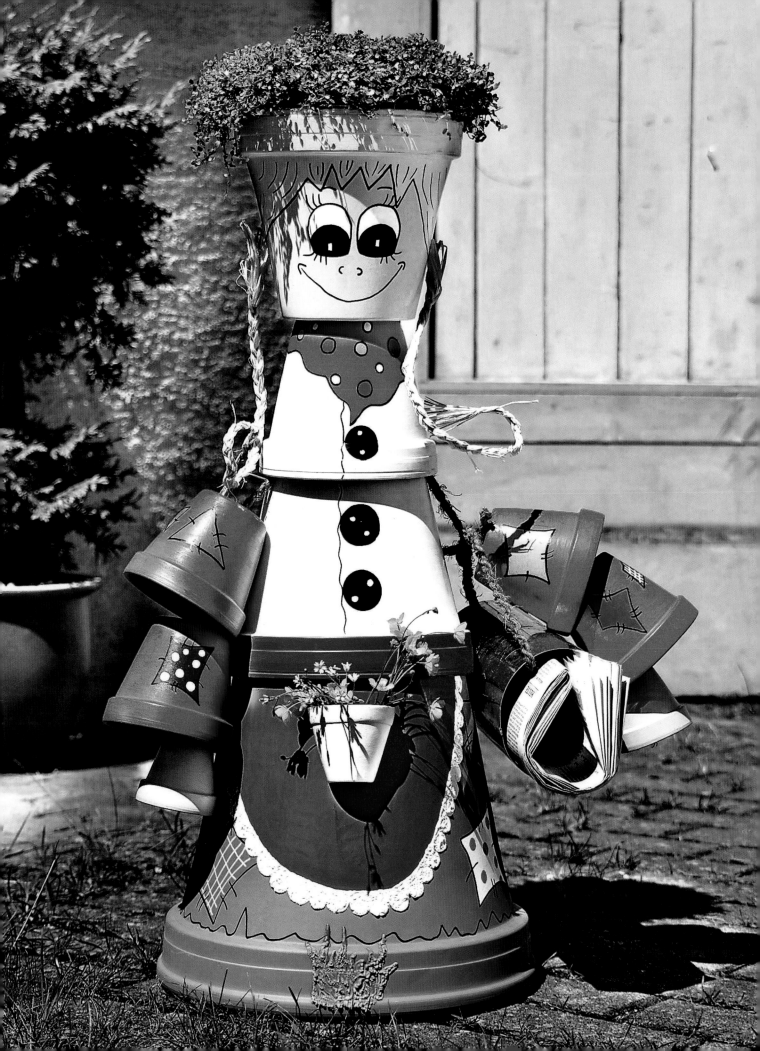

## Materials

- Dimensions about 12" x 18" (30 cm x 45 cm)
- 1 clay pot, 7" to 8" (18 cm to 20 cm) in diameter
- 1 clay pot, 6 $\frac{1}{4}$" to 7" (16 cm to 18 cm) in diameter
- 1 clay saucer, 10 $\frac{1}{2}$" (27 cm) in diameter
- 1 clay saucer, 9" (23 cm) in diameter
- Red, blue, yellow, green, white, and black terra cotta pens
- Clear varnish
- Template

**Tip**

You can use the étagère outdoors if you apply a coat of clear varnish.

## Étagère with Butterflies

Paint the clay pots and saucers according to the photograph. Transfer the butterflies from the template sheet onto the clay pots and fill in. After all the paint is dry, assemble the étagère by gluing them together as shown.

## Funky Door Chime

Paint the clay pots according to the photograph and the template. Paint the bricks and the wall on the largest pot with granite paint. Glue on the chimney. Assemble the pots with raffia and beads according to the instructions on page 10. Tie the figures to the bamboo stick, pull a raffia loop through it, and then thread the wind chime through the hole of the top clay pot. Fix the chimes with nylon or other strong thread. Pull the thread through the wooden bead to the lowest clay pot and tie securely in a knot. Finish by applying a clear varnish to the pots.

### Materials for Funky Door Chime
- Height about 3' (90 cm)
- 1 clay pot, 7" to 8" (18 cm to 20 cm) in diameter
- 1 clay pot, 2 $\frac{1}{4}$" to 2 $\frac{3}{4}$" (6 cm to 7 cm) in diameter
- 1 clay pot, $\frac{1}{2}$" to 2" (1 cm to 5 cm) in diameter
- 3 clay pots, 3" to 3 $\frac{1}{2}$" (8 cm to 9 cm) in diameter
- Black, pink, yellow, dark blue, green, light green, brown, white, and red terra cotta pens
- Gray granite paint
- 3 chimes, 4 $\frac{3}{4}$" (12 cm) long
- 4 natural-finish wooden beads, $\frac{1}{2}$" (1 cm) in diameter
- Natural-finish raffia, 6 $\frac{1}{2}$' (200 cm) long
- Bamboo stick, about $\frac{1}{2}$" (1 cm) in diameter x about 1 $\frac{1}{2}$" (4 cm) long
- Clear varnish
- Nylon or other strong thread
- Template

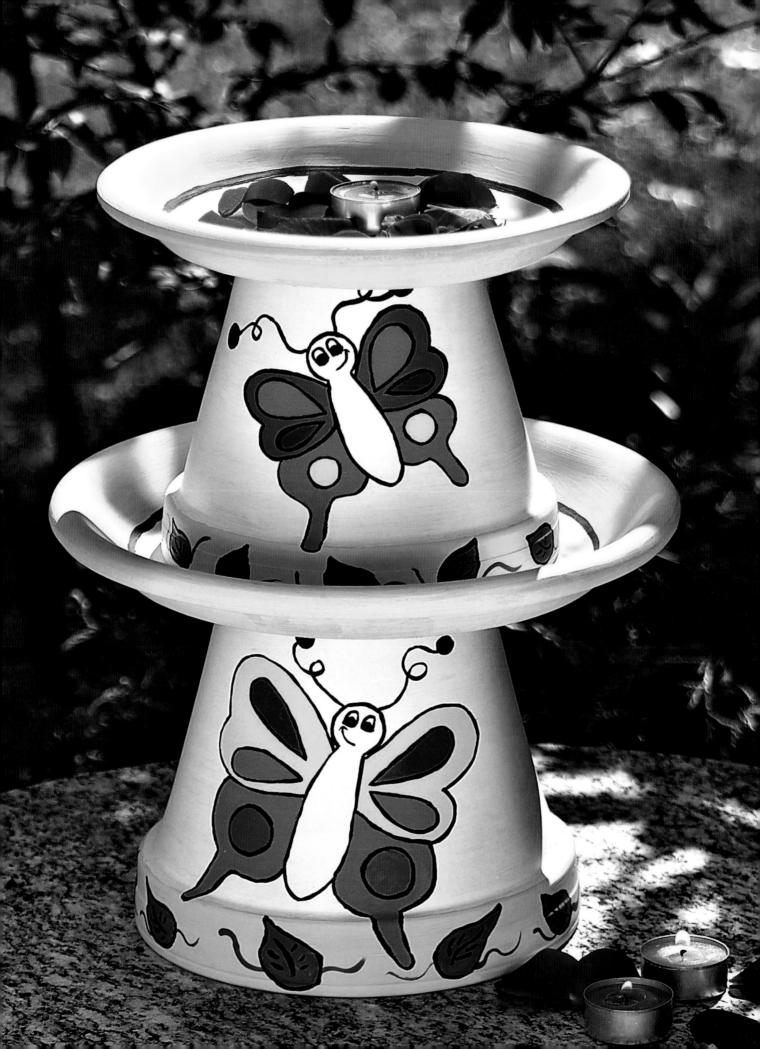

# Maritime Candleholders

Quickly create a maritime atmosphere for your table with these candleholders!

## Fish Motif

Apply the base coat to the clay pots and saucer. After the paint is dry, transfer the motifs from the template to the pots. Assemble the pieces. Fill the saucer with sand and sea glass and fix the tea light in the middle.

**Materials for Fish Motif**

- Dimensions about 4 ¼" x 6" (11 cm x 15 cm)
- 1 clay pot, 3" to 3 ½" (8 cm to 9 cm) in diameter
- 1 clay pot, 2" to 2 ¼" (5 cm to 6 cm) in diameter
- 1 clay saucer, 4 ¼" (11 cm) in diameter
- White and blue terra cotta pens
- Decorative sand
- Sea glass
- 1 tea light
- Template

## Starfish Motif

Paint the clay pots and the saucer according to the photograph and the drawings on the template sheet. After they are dry, assemble the candleholder. Fill the saucer with sand and sea glass and fix the tea light in the middle.

**Materials for Starfish Motif**

- Dimensions about 5" x 6 ¾" (13 cm x 17 cm)
- 1 clay pot, 4" to 4 ¼" (10 cm to 11 cm) in diameter
- 1 clay pot, 2 ¼" to 2 ¾" (6 cm to 7 cm) in diameter
- 1 clay saucer, 5" (13 cm) in diameter
- White and blue terra cotta pens
- Decorative sand
- Sea glass
- 1 tea light
- Template

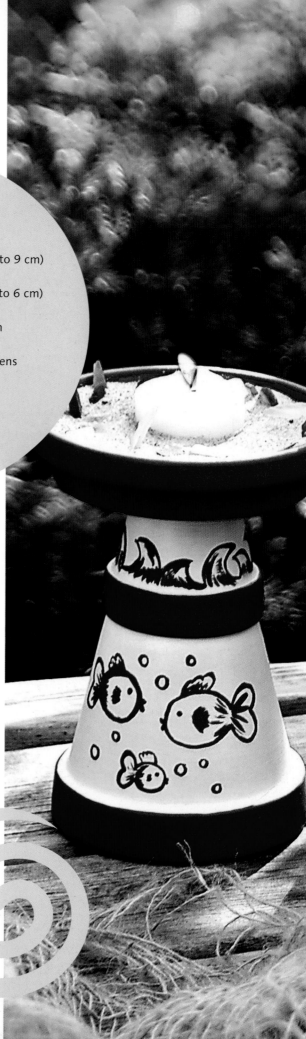

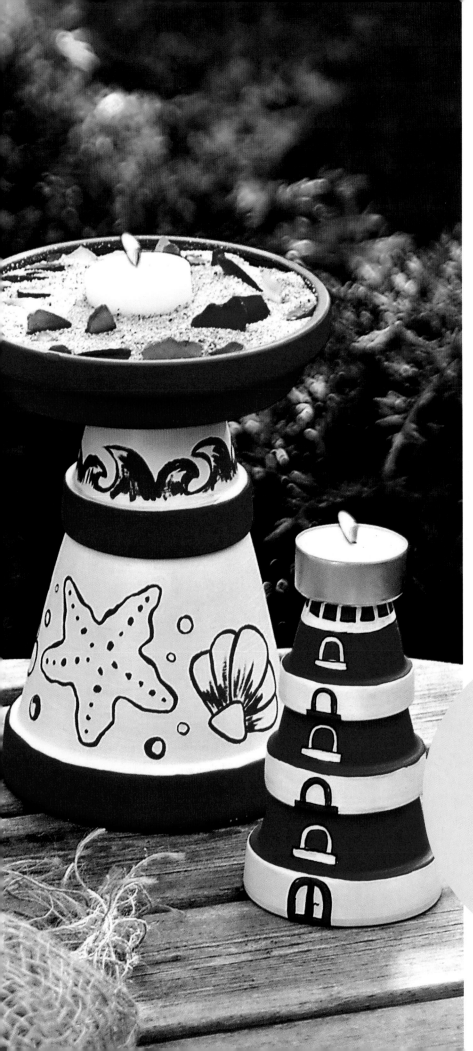

# Lighthouse

Paint the clay pots and the saucer according to the photograph and the drawings on the template sheet. After they are dry, assemble the lighthouse. Attach the tea light with superglue.

**Materials
for Lighthouse**

- Dimensions about 2 ¾" x 6"
  (7 cm x 15 cm)
- 1 clay pot, 2 ¼" to 2 ¾"
  (6 cm to 7 cm) in diameter
- 1 clay pot, 2" to 2 ¼"
  (5 cm to 6 cm) in diameter
- 1 clay pot, 1 ½" to 2"
  (4 cm to 5 cm) in diameter
- White and blue terra cotta pens
- 1 tea light
- Template

# Cheerful Ladybug Mobile

Paint the clay pots according to the photograph and the drawings on the template sheet. Use modeling clay to make wings for the ladybug mother. Let the paint and the modeling clay dry thoroughly. You can also decorate the wings with a terra cotta pen. Glue on the pom-pom as a nose and the pipe cleaners as antennae. Use raffia and beads to suspend the ladybugs from the mobile sticks according to the instructions on page 8.

## Materials
- Dimensions about 10" x 20" (25 cm x 50 cm)
- 5 clay pots, 2" to 2 $\frac{1}{4}$" (4 cm to 6 cm) in diameter
- 1 clay pot, 2 $\frac{1}{4}$" to 2 $\frac{3}{4}$" (6 cm to 7 cm) in diameter
- Modeling clay
- Red, black, and white terra cotta pens
- 8 white pipe cleaners, 4" (10 cm) long
- 4 red pipe cleaners, 2 $\frac{3}{4}$" (7 cm) long
- 1 red pom-pom, $\frac{1}{2}$" (1 cm) in diameter
- 2 mobile sticks or wooden skewers, each 9" (23 cm) long
- Natural-finish raffia
- 6 natural-finish wooden beads, $\frac{1}{2}$" (1 cm) in diameter
- Template

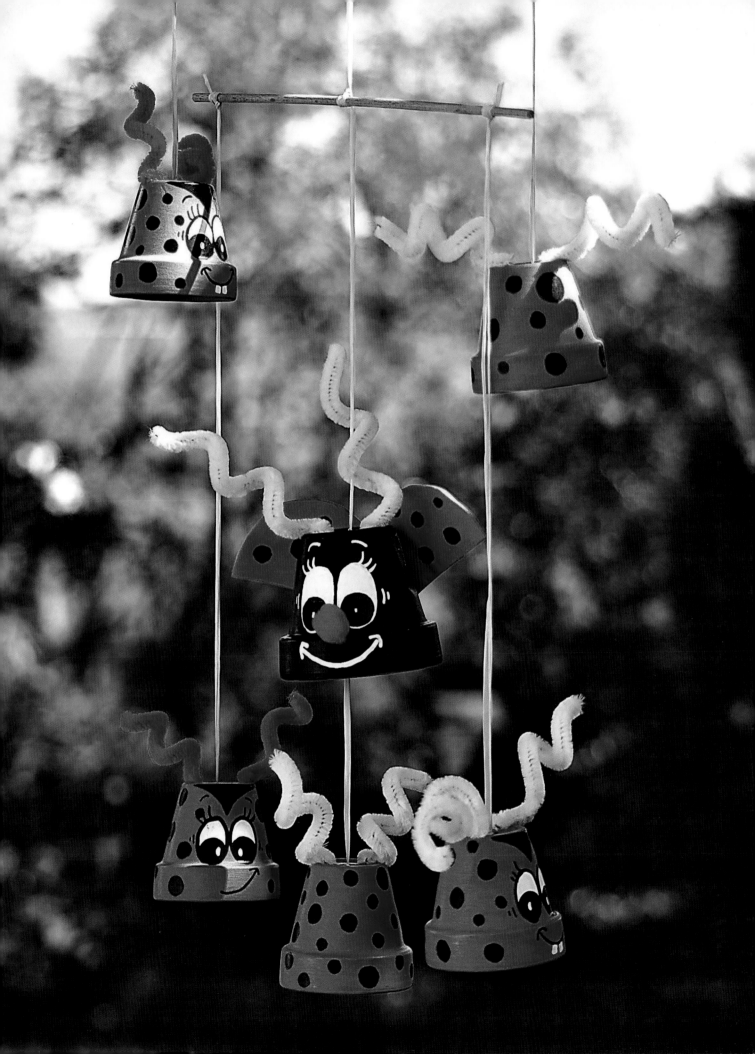

# Glowing Octopus

Paint the clay pots according to the photograph and the drawings on the template sheet. Let dry thoroughly. Paint on the algae using puff paint and use a hair dryer to fluff it according to the manufacturer's instructions. For the tentacles, alternate threading beads and rubber squares, $\frac{1}{2}$" x $\frac{1}{2}$" (1 cm x 1 cm), onto nylon string. For each tentacle use three white and three black beads as well as six rubber squares. Glue the tentacles to the small clay pot (octopus body), and then glue this to the large pot. You can now fix the candle on the octopus' head; use superglue to attach three thumbtacks to the clay pot and stick the candle onto them.

**Materials**
- Dimensions about 12" x 18" (30 cm x 45 cm)
- 1 clay pot, 4" to 4 $\frac{1}{4}$" (10 cm to 11 cm) in diameter
- 1 clay pot, 10" to 11" (24 cm to 28 cm) in diameter
- Lilac, white, black, dark blue, yellow, blue, red, and dark green terra cotta pens
- Green fluffing paint
- 18 white wooden beads, $\frac{1}{2}$" (1 cm) in diameter
- 18 black wooden beads, $\frac{1}{2}$" (1 cm) in diameter
- Lilac rubber mat
- Nylon thread
- 3 thumbtacks
- Candle
- Template

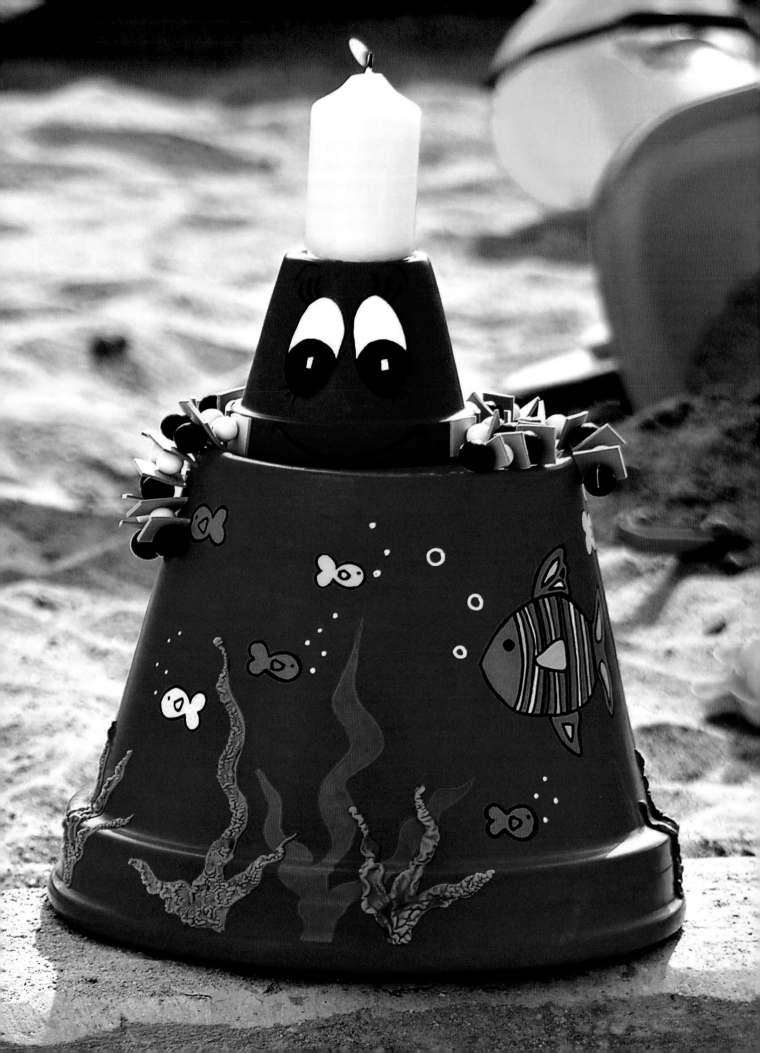

# Goblin Candleholder

Apply a base coat of granite paint to the clay pot. Model candleholders in three sizes. Depending on the candle diameter, make three rolls, ½" (1 cm) thick. Push the candles into the modeling clay. Let dry. Glue on the candleholders and paint them with granite paint. Paint the small clay pots green. After they are dry, paint on the eyes and mouth. Make the antennae by bending crafting wire and attaching them with superglue. Follow the template to make the ears from modeling clay. Let dry, paint, and attach them to the pot.

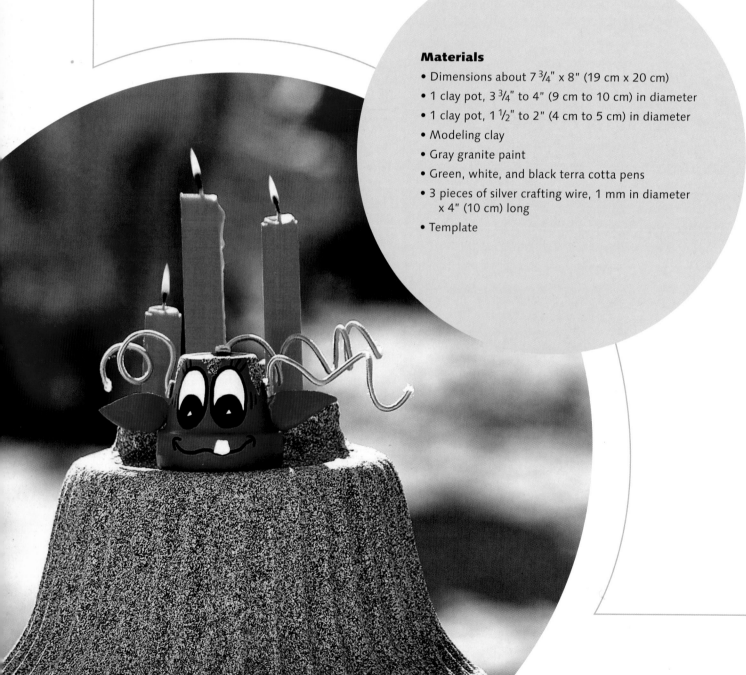

## Materials

- Dimensions about 7 ¾" x 8" (19 cm x 20 cm)
- 1 clay pot, 3 ¾" to 4" (9 cm to 10 cm) in diameter
- 1 clay pot, 1 ½" to 2" (4 cm to 5 cm) in diameter
- Modeling clay
- Gray granite paint
- Green, white, and black terra cotta pens
- 3 pieces of silver crafting wire, 1 mm in diameter x 4" (10 cm) long
- Template

# Funny Piglets Wind Chime

Apply a pink base coat to the clay pots. Model the clay snouts and ears directly on the painted pots. Let dry and then also paint pink. Use superglue to glue on the wobbly eyes. Paint on the rest of the face.

Make four clay balls, about 1" (3 cm) in diameter, and three slightly smaller balls to make the drop. Pierce them with a thick sewing needle. Let dry, and then paint them. Paint the bamboo pieces halfway and let dry. Pass the raffia through the pot holes and thread on the bamboo pieces. Assemble the piglets with raffia and wooden beads and decorate with the other clay balls. Also refer to the general instructions on page 8.

## Materials
- Length about 20" (50 cm)
- 1 clay pot, 1" to 1 1/2" (3 cm to 4 cm) in diameter
- 1 clay pot, 1 1/2" to 2" (4 cm to 5 cm) in diameter
- 1 clay pot, 2" to 2 1/2" (5 cm to 6 cm) in diameter
- Pink and black terra cotta pens
- Modeling clay
- 6 oval wobbly eyes, 1/2" (1 cm) in diameter
- 4 unpainted bamboo sticks, 1/2" (1 cm) in diameter x 3" (8 cm) long
- Natural-finish raffia
- 3 wooden beads, 1/2" (1 cm) in diameter
- Template

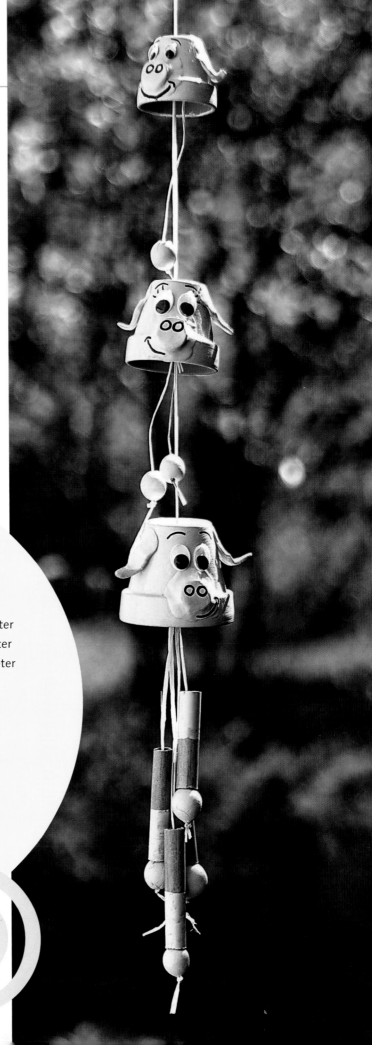

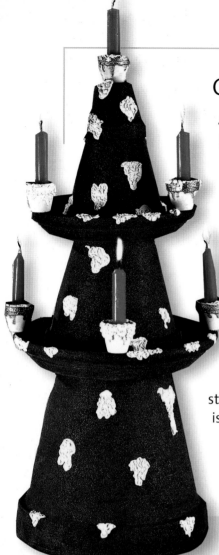

## Christmas Tree

Apply a base coat of green granite paint to the clay pots and saucers. Apply the white puff paint and fluff with a hair dryer following the manufacturer's instructions. Paint the rims of some of the smaller pots with glitter paint. We have placed the smaller pots on the rims of the clay saucers. Attach four small pots to the lower level, three to the higher level, and one to the peak. Now pile all the pots on top of each other as shown in the photograph. To make the tree more stable, glue the pots together. When everything is thoroughly dry, add the candles.

### Materials for Christmas Tree
- Dimensions about 8 ½" x 14" (22 x
- 1 clay pot, 8" to 8 ½" (20 cm to 22
- 1 clay pot, about 6" (15 cm) in diam
- 1 clay pot, 4" to 4 ¼" (10 cm to 11 c
- 1 clay pot, 2 ¼" to 2 ¾" (6 cm to 7 c
- 8 clay pots, 1" to 1 ½" (3 cm to 4 cm
- 1 clay saucer, 9" (23 cm) in diamete
- 1 clay saucer, 7 ½" (19 cm) in diame
- Green granite paint
- White puff paint
- Silver glitter paint

## Colorful Scarecrow

Paint the clay pots according to the photograph. Let dry and then paint on patches and flowers as well as the face of the scarecrow. Glue on about five pieces of raffia, 2 ¾" (7 cm) long, as hair and arms respectively. Tie two raffia bows and glue them to the shoes. Glue the hat onto the scarecrow's head. Assemble the scarecrow with raffia and wooden beads (follow the instructions on pages 8–10). Remember that the wooden beads must be bigger than the diameter of the pot holes.

### Materials for Colorful Scarecrow
- Dimensions about 8" x 16" (20 cm x 40 cm)
- 3 clay pots, 1 ½" to 2" (4 cm to 5 cm) in diameter
- 2 clay pots, 2" to 2 ¼" (5 cm to 6 cm) in diameter
- 3 clay pots, 2 ¼" to 2 ½" (6 cm to 7 cm) in diameter
- 1 clay pot, 4" to 4 ¼" (10 cm to 11 cm) in diameter
- Green, white, yellow, blue, black, red, light green, lilac, orange, red, pink, and light blue terra cotta pens
- 2 dark brown wooden beads, ½" (1 cm) in diameter
- 8 wooden beads, ½" (1 cm)
- Natural-finish raffia
- Template

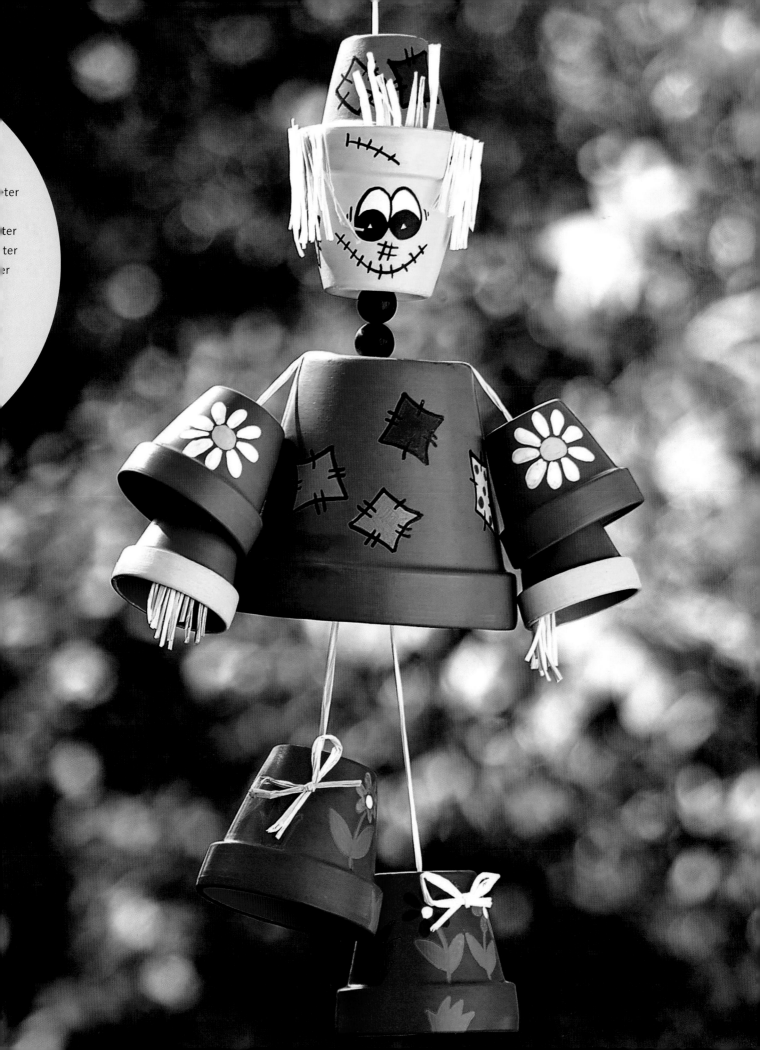

**Materials for Sweet Angel**

- Dimensions about 8" x 10" (20 cm x 25 cm)
- 1 rose pot, about 4 3/4" (12 cm) in diameter
- 1 clay pot, 4" to 4 1/4" (10 cm to 11 cm) in diameter
- Feather angel wings, about 4 3/4" (12 cm) in height
- Orange, gold, white, black, and red terra cotta pens
- Several pieces of gold raffia, each 3' (90 cm) long
- 1 pink rubber ball, 3/4" (2 cm) in diameter
- Template

# Sweet Angel

Paint the clay pots according to the photograph and the template. Use superglue to attach the rubber nose. Make the angel's pigtails in one piece by braiding up from one end, leaving about 10" to 12" (25 cm to 30 cm) in the middle, and then making the second pigtail. Use superglue to attach the hair to the front part of the clay pot. Use glue to attach the wings at the back. Now you can fill the head with festive sweets.

# Santa Claus with Gifts

Paint the clay pots according to the photograph and the template. Use superglue to attach the rubber nose. Apply the puff paint and fluff according to the manufacturer's instructions. Glue the head to the body. Glue on the cotton beard and collar. To make the arms, thread six rubber squares, 1/2" x 1/2" (1 cm x 1 cm), and five white beads alternately onto the nylon rope. Finish by threading on an unpainted wooden bead. Use superglue to attach the arms to the body. Fix the felt to the top pot's rim. Fill with sweets or small presents and close the hood with a satin ribbon.

**Materials for Santa Claus**

- Dimensions about 6" x 16" (15 cm x 40 cm)
- 1 clay pot, 4 3/4" to 5 1/2" (12 cm to 14 cm) in diameter
- 1 clay pot, 4" to 4 1/4" (10 cm to 11 cm) in diameter
- Orange, white, black, and red terra cotta pens
- White puff paint
- 10 white wooden beads, 1/2" (1 cm) in diameter
- 2 natural-finish wooden beads, about 1/2" (1 cm) in diameter
- 1 pink rubber ball, 3/4" (2 cm) in diameter
- Cotton
- Nylon thread
- Red rubber mat
- 1 piece of red felt, 10" x 24" (25 cm x 60 cm)
- 1 white satin ribbon, 1/2" x 8" (1 cm x 20 cm) long
- Template

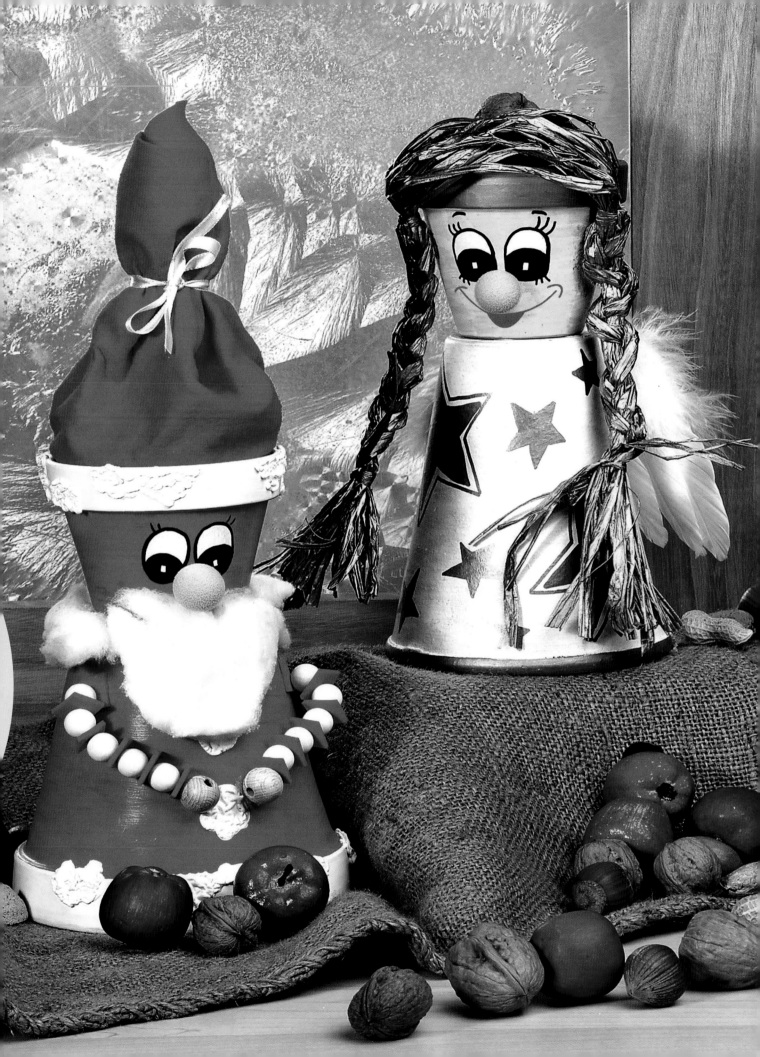

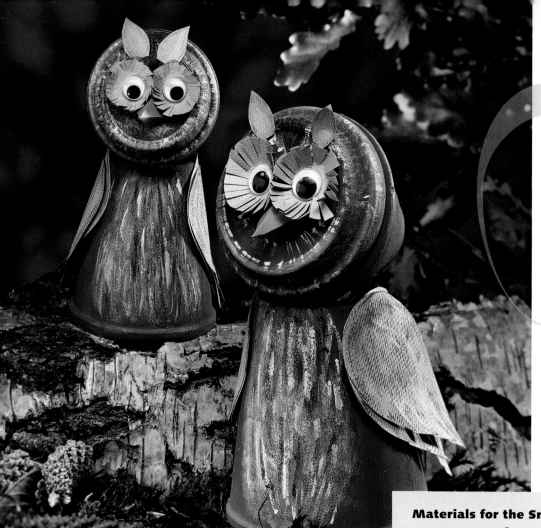

## Pair of Owls

Use modeling glue to attach the saucer over the opening of the clay pot to serve as the face. For the large owl, use the bell pot.

After the glue is dry, invert the rose pot and attach the head. Apply a base coat of antique red. While it is still wet, use a fine brush to paint thin lines (feathers) of white, black, and pumpkin-colored acrylic over it. Use the template to cut out beaks, ears, wings, and eye rosettes. Make small cuts in the undersides of the wings; also cut all around the eye rosettes and paint on the eyes. Fold the beaks as shown in the templates and glue the respective halves together. Glue the paper parts and the wobbly eyes to the body. Attach two slightly overlapping wings on each side.

**Materials for the Small Owl**
- Height about 6 ³/₄" (17 cm)
- 1 rose pot, 2 ³/₄" (7 cm) in diameter
- 1 clay pot, 2 ¹/₂" (6.5 cm) in diameter
- 1 clay saucer, 2 ³/₄" (7 cm) in diameter
- 2 wobbly eyes, about ¹/₂" (1 cm) in diameter
- White and black acrylic paint
- Autumn red and pumpkin orange antique paint
- Sandy and orange poster board
- Template

**Materials for the Large Owl**
- Height about 8" (20 cm)
- 1 rose pot, 3 ¹/₂" (9 cm) in diameter
- 1 bell pot, 3 ¹/₂" (9 cm) in diameter
- 1 clay saucer, 3 ¹/₂" (9 cm) in diameter
- 2 wobbly eyes, ³/₄" (2 cm) in diameter
- White and black acrylic paint
- Autumn red and pumpkin orange antique paint
- Sandy and orange poster board
- Template

# Gnome's Present

Paint the large clay pot orange or burgundy. After the paint is dry, fill the pot with dry floral foam. Wrap the wooden stick with the crepe masking tape, put it into the pot hole, and fix it with glue. Paint the Styrofoam hands beige and glue them to the pot's edge. Use modeling glue to attach the head pot, 1¾" (4.5 cm) in diameter, to the rim of the bottom part. Cover the still-visible dry floral foam with moss and leaves. To make the cap, cut the felt using the template and glue the pieces together. Glue craft hair around the pot to be the gnome's hair.

Bind some craft hair in the middle with raffia or thread to make the moustache. Paint the eyeballs with white paint and color the nose in burgundy. Place the irises, nose, and moustache on the face. Fix two silk leaves and loose raffia curls to the stick with wire or crepe masking tape. Glue on cones, twigs, flowers, and pearls as additional decorations. Use two glue pads to attach the money.

## Materials
- Height about 8" (20 cm) (without stick)
- 1 clay pot, 1¾" (4.5 cm) in diameter
- 1 clay pot, about 2" (5.5 cm) in diameter
- 1 cotton ball, ½" (1 cm) in diameter
- 2 black half-pearls, ⅛" (4 mm) in diameter
- 1 orange-red wooden bead, ¼" (0.5 cm) in diameter
- 1 pair of Styrofoam hands, about 1" (3 cm) long
- Orange, white, beige, and burgundy acrylic paint
- Red felt
- Green felt
- Light brown craft hair
- Green raffia curls
- Miniature silk leaves, small cones, small vine twigs, moss, flowers
- Green crepe masking tape
- Glue pads
- Dry floral foam
- Template

## Materials for the Mouse

- Height about 6" (16 cm)
- 1 half clay pot, 1 ½" x 2 ¼" (4 cm x 6 cm)
- 1 half clay pot, ¾" x 1 ¾" (2 cm x 3.5 cm)
- 1 clay pot, ¾" (2 cm) in diameter
- 2 black half-pearls, 6 mm in diameter
- Beige jute cord, 2.5 mm in diameter x 16" (40 cm) long
- Black bending wire
- 1 sheet of brown packing paper
- Beige and black acrylic paint
- Brown and beige kraft paper
- White modeling clay
- Template

## Materials for the Hedgehog

- Height about 5 ½" (14 cm)
- 1 half clay pot, 1 ½" x 2 ¼" (4 cm x 6 cm)
- 1 half clay pot, ¾" x 1 ¾" (2 cm x 3.5 cm)
- 2 black half-pearls, 4 mm in diameter
- 1 sheet of brown kraft paper
- Black acrylic paint
- Packing paper
- Toothpicks

Glue the two wall-mounted pots together as shown in the picture and let dry. Glue bunched-up packing paper into the pot opening at the bottom.

# Mouse

Form the modeling clay into a ball, about 1" (3 cm) in diameter, to make the muzzle. Cover the front of the pot with superglue and carefully push the ball onto the pot. Slightly wet the modeling clay and use your fingers to smooth it toward the middle of the pot. Cut whiskers, about 2" (5 cm) long, from the wire and push them into the modeling clay while it is still soft. Stab a small ball with a short piece of wire and attach it as the nose. Use the skewer to make a notch underneath the nose.

After the modeling clay is dry, paint the face beige and the nose black. Attach the eyes with superglue. Tear small pieces of packing paper and bunch them up. Placing them close together, attach each piece to the body with hot glue. Following the template, cut the ears from kraft paper and glue to the head. Fold the jute cord in half and attach one side to the bottom as a tail. Thread through the small pot and secure by tying the two ends together.

# Hedgehog

Make a small ball of clay with the bottom flattened and glue it on as a nose. Let dry. Paint the mouth of the hedgehog with a felt tip pen and glue on the eyes. Tear small pieces of kraft paper. Placing them closely together, attach each piece to the body with hot glue. Shorten the toothpicks to about 1" (3 cm) and attach between the paper pieces to make the spines.

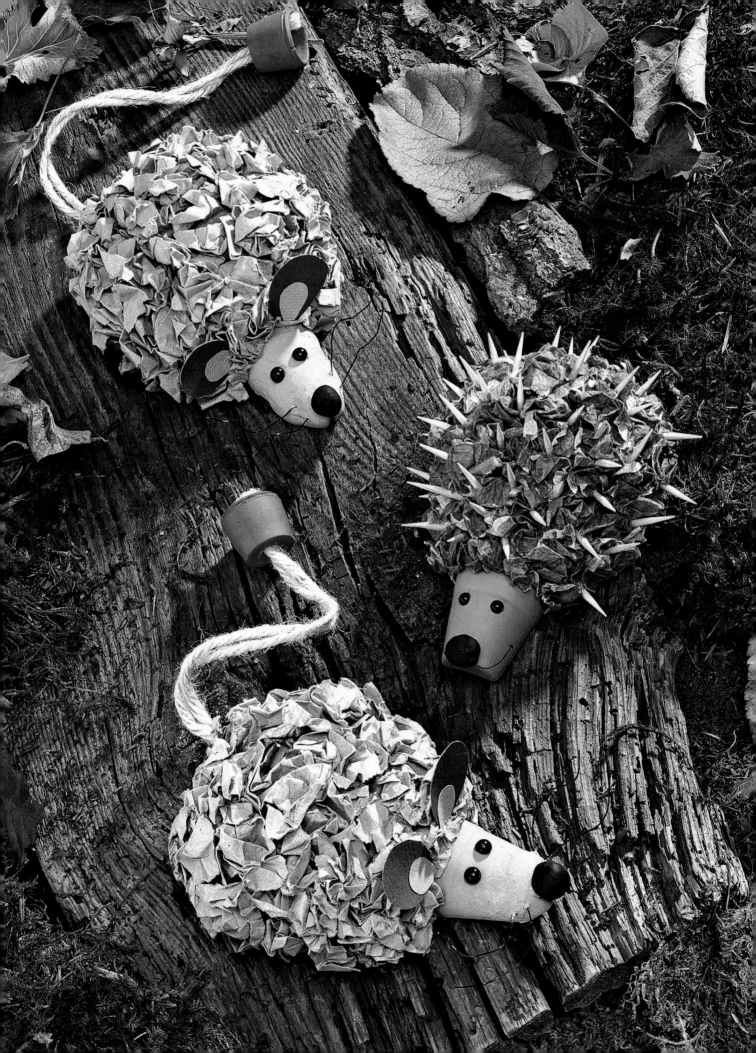

## Materials for the Sunflower Man

- Height about 14" (35 cm)
- 2 clay pots, 2 ¼" (6 cm) in diameter
- 2 clay pots, 1 ¾" (4.5 cm) in diameter
- 1 bell pot, 4 ¼" (11 cm) in diameter
- 1 clay pot, 6" (16 cm) in diameter
- 1 clay pot, 5 ½" (14 cm) in diameter
- 1 clay pot, 1 ¼" (3.5 cm) in diameter
- 2 silk sunflowers with leaves 6" (15 cm) in diameter
- 1 strip of gray fake fur 3" x 14" (8 cm x 35 cm)
- 2 black half-pearls, ¼" (0.5 cm) in diameter
- 1 cotton ball, ½" (1 cm) in diameter
- 1 bunch of yellow daisies
- 1 miniature sunflower
- White, dark red, and dark green acrylic paint
- Green lacquer pen
- Dry floral foam
- 1 green-and-white checkered ribbon, 2' (60 cm) long

## Materials for Wind Chime

- Height about 12" (30 cm)
- 1 clay pot, 2 ¼" (6 cm) in diameter
- 1 clay pot, ¾" (2 cm) in diameter
- 2 natural-finish wooden beads, about 1" (3 cm) in diameter
- 2 brown wooden beads, ¼" (0.5 cm) in diameter
- 1 yellow wooden bead, about 6 mm in diameter
- 2 yellow wooden beads, ¼" (0.5 cm) in diameter
- 3 green jute cords, 2.5 mm in diameter x 2' (60 cm) long
- 1 green jute cord, 2.5 mm in diameter x 3' (1 m) long
- 2 wobbly eyes, ¼" (0.5 cm) in diameter
- 1 orange wooden half-pearl, about ¼" (0.5 cm) in diameter
- Yellow puff paint
- Red pencil
- 2 small sunflower stems with leaves
- 2 miniature sunflowers
- 1 green-and-white checkered ribbon, 32" (80 cm) long
- Green lacquer pen
- Template

# Sunflower People

Apply a base coat of green acrylic paint to a pot, 5 ½"" (14 cm) in diameter, to use for the bottom part of the figure. Make the base figure (type 1) as described on page 8; trim the excess raffia from the arms. Outline the rims of the arm openings with a green lacquer pen and glue two silk leaves on each side as hands. Use hot glue to attach the strip of fake fur as well as the flower to the rim of the bell pot. Face the large sunflower downward and use it together with a small flower pot, 1 ¼" (3.5 cm) in diameter, to make the hat.

Carefully pull the second flower apart and set the pistils aside. Cut open the individual petal rings on one side and glue on as a frill around the neck of the figure. Use individual petals, the small flower, and the bow to decorate the collar. Decorate the rim of the large flower pot with small yellow flowers and attach two pistils as buttons.

Finally, paint the eyes and mouth and glue on the half-pearls. Paint a cotton ball red and, when it is dry, glue it on as a nose.

# Summer Wind Chime

Assemble the main rope, about 3' (1 m) long, and the dangling threads as shown. Pass the skein through the hole of the small pot and knot the ends. Using hot glue, attach the two sunflowers, the leaves, and two bows on top of the pot. Attach the wobbly eyes and the nose with strong glue. Paint on the rest of the face.

Disassemble the small flowers into individual petal rings. Hang the pot and thread through one petal ring, alternating with one pearl and one small pot. Fix the flowers and pots with knots and the pearls with glue. Decorate the rim with a green lacquer pen and add yellow dots with yellow puff paint.

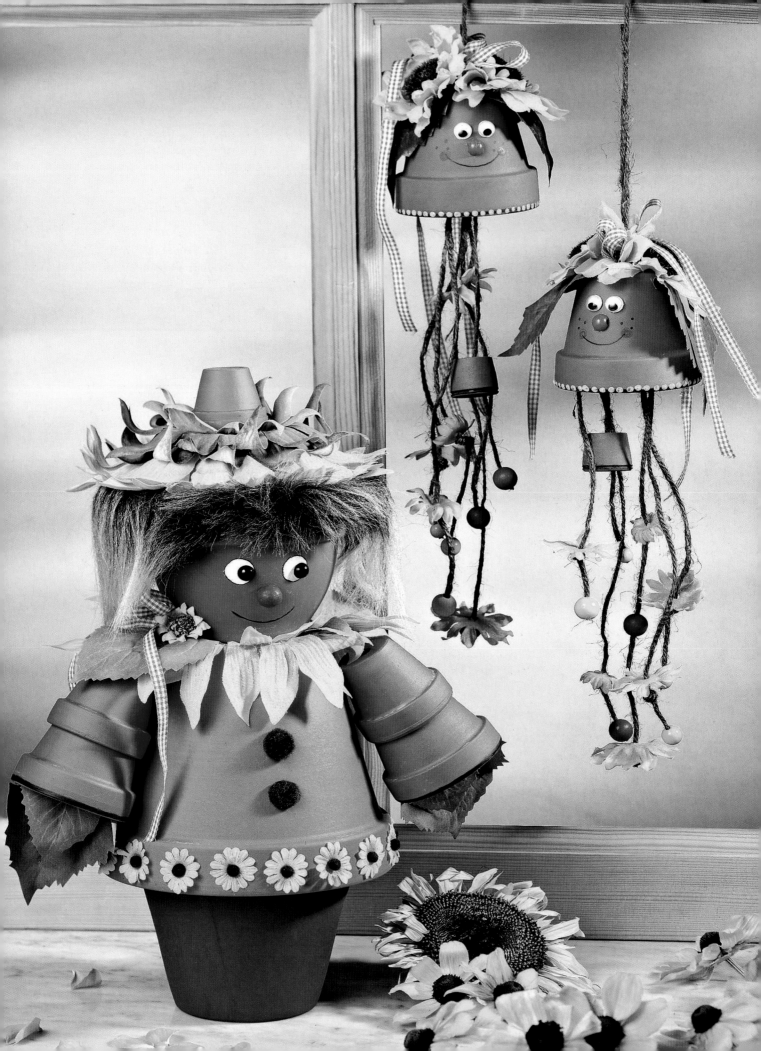

## Materials for Harry

- Height about 16" (40 cm)
- 1 rose pot, 5 $\frac{1}{2}$" (14 cm) in diameter
- 1 bell pot, 4 $\frac{1}{4}$" (11 cm) in diameter
- 1 bell pot, 6" (16 cm) in diameter
- 5 clay pots, 1 $\frac{3}{4}$" (4.5 cm) in diameter
- 1 clay pot, about 2 $\frac{1}{4}$" (5.5 cm) in diameter
- 1 clay pot, 1 $\frac{1}{4}$" (3.5 cm) in diameter
- 1 half-pot, 1 $\frac{1}{2}$" (4 cm) in diameter x 2 $\frac{1}{4}$" (6 cm) tall
- 4 small wooden disks, $\frac{1}{2}$" (1 cm) in diameter
- 2 black half-pearls, $\frac{1}{4}$" (0.5 cm) in diameter
- 1 wooden half-ball, $\frac{1}{2}$" (1 cm) across
- 1 bent flower wire, 4" (10 cm) long
- Raffia
- Fine myrte wire
- Dry floral foam
- Pink, dark blue, lime green, and deer brown acrylic paint
- Brown puff paint
- 2 orange felt strips, about 1" x 4 $\frac{3}{4}$" (3 cm x 12 cm)
- 1 blue-and-white checkered scarf, 8" x 8" (20 cm x 20 cm)
- Silk grasses, flowers, dried wheat, lavender
- Miniature pumpkins, corncobs, cotton wool mushrooms
- Miniature gardening tool
- Miniature green kindling basket
- Green lacquer pen

# Harry at Harvest

Paint the body of the rose pot blue and paint the rim deer brown. After the paint is dry, assemble the figure as described on page 8. Leave two raffia threads on the right arm for attaching the kindling basket later.

Cut the floral foam to size and glue into the head opening. Cut the raffia into pieces 3" (8 cm) and 8" (20 cm) long. Bunch the raffia together and tie with wire. Use the longer bunches as hair and glue into the pot opening. Glue the shorter bunches into the arm's gaps and into the last pot.

Outline each suspender with puff paint and glue on two small wooden disks as buttons. Tie the gingham cloth around the neck. Bend the thick wire to use as the mouth and glue it on together with the painted nose and the eyes. Attach the two half-pearls to the disks used for the eyes. Paint the cheeks.

Apply a base coat of acrylic to the small half-pot and decorate with a lacquer pen. Fix it with modeling glue to the bottom part of the figure (if necessary, add extra support with floral tape while the glue is drying). Attach small pumpkins, grass, leaves, flowers, and miniature gardening tools amid the hair and fill the pot and basket as well. Glue a miniature trowel into the left arm opening.

## Tip

The raven can also be used to decorate the scarecrow (see page 88) and the door wreath (see page 104).

# Miniature Raven

Apply a base coat to both the clay pot and the cotton ball. After the paint is dry, glue them together and add the feathers as wings and tail. Use the template to cut out the beak and glue the two halves together, adding a blade of grass. Fix the wobbly eyes and the beak to the head. Glue the finished raven to Harry's shoulder.

## Materials for the Raven

- Height about 2 $\frac{1}{4}$" (6 cm)
- 1 clay pot, 1 $\frac{1}{4}$" (3.5 cm) in diameter
- 1 cotton ball, $\frac{3}{4}$" (2 cm) in diameter
- 2 wobbly eyes, 3 mm in diameter
- Yellow poster board
- 3 small black marabou feathers
- Black acrylic paint
- Template

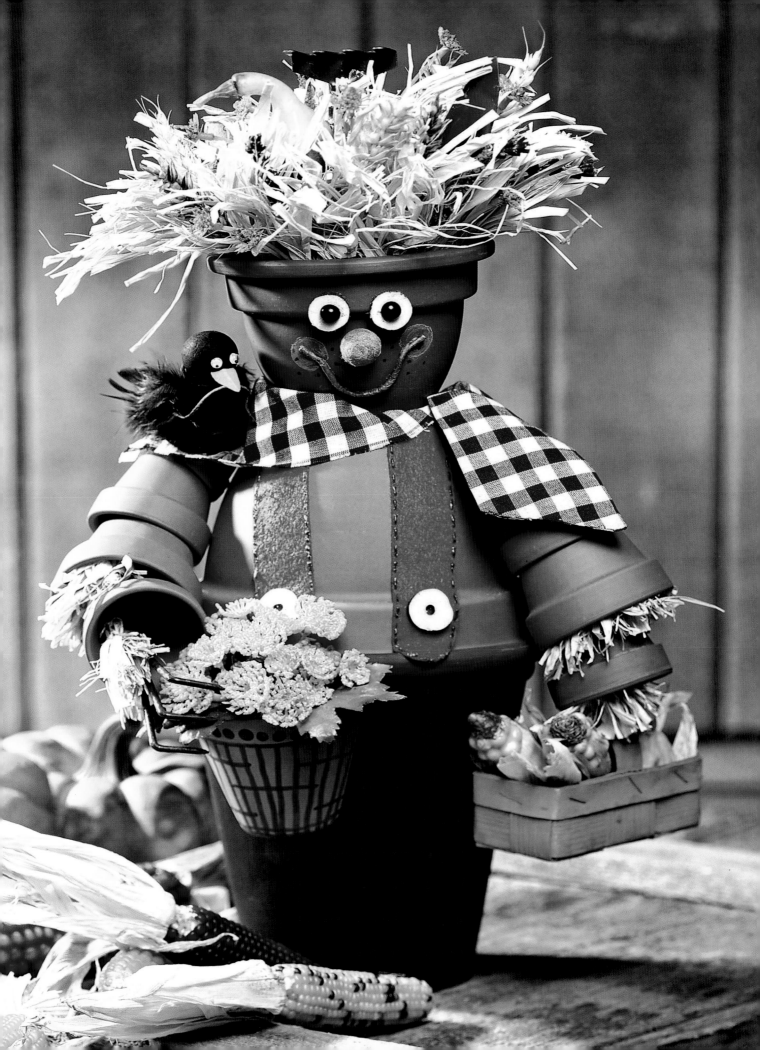

## Materials
### for the Twig Child

- Height about 6" to 8" (15 cm to 19 cm)
- 1 clay pot, 2 1/2" (6.5 cm) in diameter
- 1 clay pot, 1 1/4" (3.5 cm) in diameter
- 2 clay pots, about 1" (3 cm) in diameter
- 1 cotton ball with face, 1 1/2" (4 cm) in diameter
- 2 natural-finish wooden beads, about 1" (3 cm) in diameter
- 1 natural-finish jute cord, 2.5 mm in diameter x 14" (35 cm) long
- 1 natural-finish jute cord, 2.5 mm in diameter x 10" (25 cm) long
- Lupis fiber, 3" (8 cm) long
- Small vine twigs
- Spanish moss
- White, deer brown, orange, and red acrylic paint
- Template

## Materials
### for the Moss Child

- Height about 6" to 8" (15 cm to 19 cm)
- 1 clay pot, 2" (5 cm) in diameter
- 1 natural-finish jute cord, 2.5 mm in diameter
- 1 clay pot, about 1" (3 cm) in diameter
- 2 clay pots, 3/4" (2 cm) in diameter
- 1 cotton ball with face, 1 1/2" (4 cm) in diameter
- 2 natural-finish wooden beads, about 1" (3 cm) in diameter
- 1 natural-finish jute cord, about 2.5 mm in diameter x 10" (25 cm) long
- 1 natural-finish jute cord, about 2.5 mm in diameter x 8" (20 cm) long
- Calyx mushrooms
- Natural moss
- Vine twigs
- Wooden disks
- Deer brown, red, and white acrylic paint
- Template

# Children of the Forest

Decorate the cotton heads with white and red paint; use a cotton swab to touch up the cheeks. Apply a base coat to the small clay pots as shown in the photograph.

Mix the main color with white for a lighter shade to use for the rims. Paint on small dots with a skewer. Retain the natural finish of the clay pot used for the moss child and glue natural moss to the rim. To get a thinner cord, separate the cord into individual strings. Follow the template to assemble the figures. Use a knitting or mending needle to puncture the cotton ball; use a crocheting needle to thread the cord through.

Decorate the figures: For the hair use short lupis fiber, pulled-apart raffia curls, single leaves, vine twigs, and moss; also attach some around the neck. For the moss child, use a small cut-open mushroom as a neck frill; use a raffia bow for the hydrangea child. Use half a wooden bead (painted orange with sand paint) and a wooden disk respectively as buttons. For the twig child, glue a small bunch of vine twigs underneath the arm.

## Materials for
### the Hydrangea Child

Height about 6" to 8" (15 cm to 19 cm)

1 clay pot, 2" (5 cm) in diameter

2 clay pots, 3/4" (2 cm) in diameter

1 cotton ball with face, 1" (3 cm) in diameter

2 natural-finish wooden beads, about 1" (3 cm) in diameter

1 natural-finish jute cord, about 2.5 mm in diameter x 10" (25 cm) long

1 natural-finish jute cord, about 2.5 mm in diameter x 8" (20 cm) long

Green raffia

Green petals and miniature berries

White, deer brown, lime green, and red acrylic paint

Template

## Materials
### for the Leaves Child

1 clay pot, 2 1/2" (6.5 cm) in diameter

2 clay pots, 3/4" (2 cm) in diameter

1 cotton ball with face, 1 1/2" (4 cm) in diameter

2 natural-finish wooden beads, about 1" (3 cm) in diameter

1 natural-finish jute cord, 2.5 mm in diameter x 10" (25 cm) long

1 natural-finish jute cord, 2.5 mm in diameter x 8" (20 cm) long

Orange raffia curls

Miniature silk leaves

Natural-finish wooden beads, 1/2" (1 cm) in diameter

White, deer brown, red, and lime green acrylic paint

Orange sand paint

Template

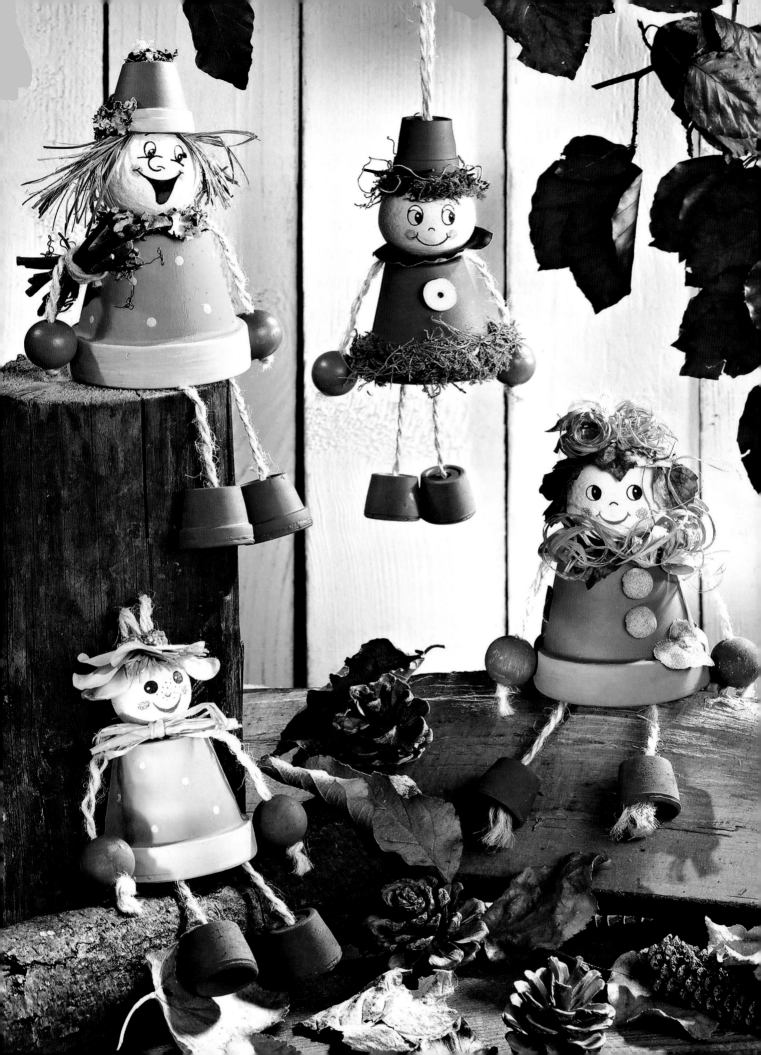

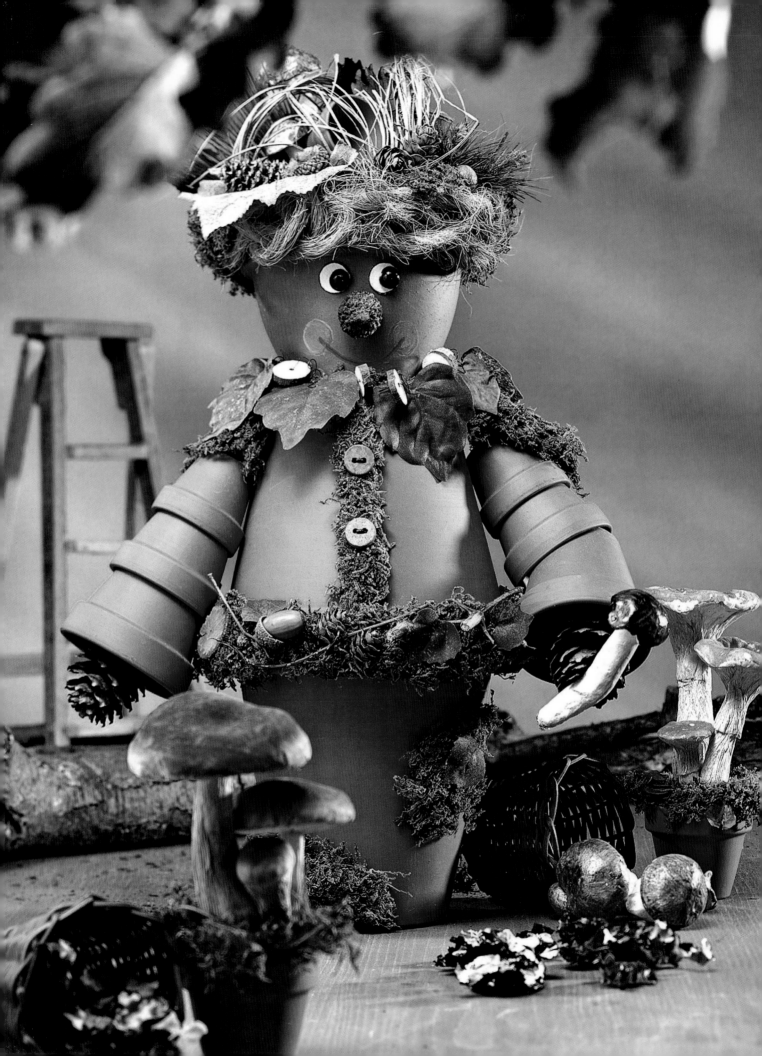

# The Forester

Make the figure according to type 1 (see page 8). Use scissors to cut the raffia threads inside the arm openings. With hot glue, attach two large pine-cones as hands. Break one of the cones open slightly and attach a cloth mushroom. Cut the dry floral foam to size and fill the head opening; fix with glue if necessary. Thread small silk leaves alternately with pierced wooden disks (or buttons or beads) on a fine wire. Tie around the neck and intertwine the wire ends.

Use hot glue to attach natural moss, small cones, and vine twigs to the top part; glue two small ceramic buttons to the jacket piece. Cover the gaps between shoulders, arms, and bottom part with larger moss pieces. Decorate the hair by gluing on short twigs, cones, mushrooms, and small pots; attach the hair to the head and fill any gaps with leaves and lupis fiber. To finish the hair, attach moss pieces and surround with looped rope.

Cut poster board to make the eyes, 1/2" (1 cm) in diameter. Glue on the end piece of an acorn as the nose and half-pearls as the irises. Use acrylic to paint on mouth and cheeks.

# Mushroom Pots

Put dry floral foam into two small pots, about 2" (5.5 cm) in diameter, and cover with mushrooms, cones, and natural moss.

## Materials for the Forester

- Height about 18" (45 cm)
- 1 bell pot, 4 1/4" (11 cm) in diameter
- 1 clay pot, 6" (16 cm) in diameter
- 2 clay pots, 2 1/2" (6.5 cm) in diameter
- 2 clay pots, about 2" (5.5 cm) in diameter
- 2 clay pots, 4 3/4" (5.5 cm) in diameter
- 1 clay pot, 1 1/4" (3.5 cm) in diameter
- 1 clay pot, 3/4" (1.2 cm) in diameter
- 1 rose pot, 6" (16 cm) in diameter
- 2 black wooden beads cut in half, 1/2" (1 cm) in diameter
- White and red acrylic paint
- White poster board
- 1 natural-finish sisal rope, about 1 yard (1 m) long
- 2 pinecones
- Natural moss, acorns, pinecones, silk leaves, lupis fiber, wooden disks, vine twigs
- 2 orange ceramic buttons
- Dry floral foam
- Fine brown myrte wire

## Materials for One Mushroom Pot

- Height about 6" (16 cm)
- 3 decorative mushrooms, 3" to 4" (8 cm to 10 cm) tall
- 1 clay pot, about 2" (4.5 cm) in diameter
- Dry floral foam
- Natural moss
- Leaves
- Dry twigs

# Songbird Wreath

Use modeling glue to glue two clay pots, 1 ¾" (4.5 cm) and 1 ¼" (3.5 cm) in diameter respectively, into each other. The nesting bird has only one pot (diameter 1 ¼" [3.5 cm]) for a body. Paint heads and bodies according to the photograph and attach with hot glue after the paint is dry. Cut the wings and beaks following the template, folding the latter as instructed and gluing the halves together. Paint the wings as shown in the photograph. After they are dry, use superglue to attach the paper parts as well as the half-pearls to the bodies.

Wind a skein of lupis fiber around the moss wreath, fixing the ends with either small strawflower needles or hot glue. Decorate with ivy, lepto grass, small berries, cones, and pot fragments. Attach the birds with hot glue. Use lupis fiber to make a small nest and glue it, together with the nesting bird, to the wreath. Attach the yellow hanging cord.

## Tip

Instead of a ready-made moss wreath, cover a Styrofoam wreath with moss, attaching it by winding thin wire around it.

## Materials

• Height about 12" (30 cm)
• 1 moss wreath, 10" to 12" (25 cm to 30 cm) in diameter
• 2 clay pots, 1 ¾" (4.5 cm) in diameter
• 5 clay pots, 1 ¼" (3.5 cm) in diameter
• 2 cotton balls, about 1" (3 cm) in diameter
• 1 cotton ball, ¾" (1.2 cm) in diameter
• 2 black half-pearls, 3 mm in diameter
• 4 black half-pearls, 4 mm in diameter
• White, yellow, and black acrylic paint
• Yellow poster board
• 1 yellow jute cord, 2.5 mm in diameter x 4' (1.2 m) long
• Natural-finish lupis fiber
• Dried leaves, acorns, one stem silk ivy, two bunches of red berries, small pinecones, dried clematis pistils
• 1 bunch of green lepto grass
• Small strawflower needles (optional)
• Template

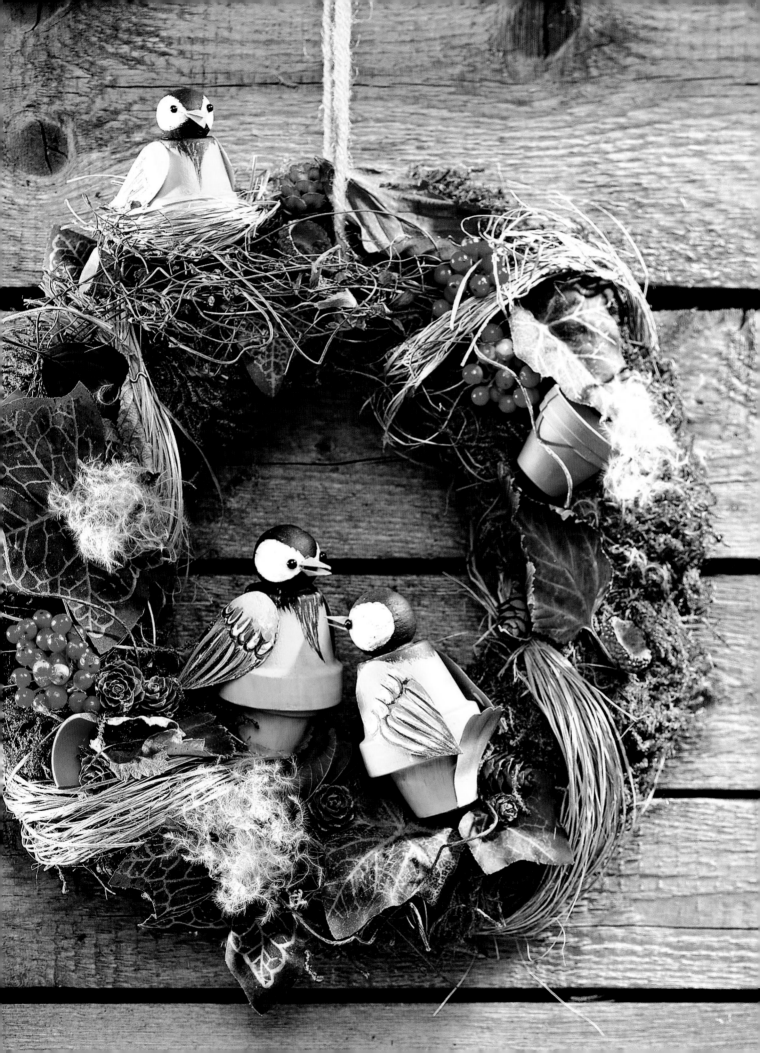

# Funny Scarecrow

Cut the dry floral foam to size and fill the clay pot; paint the rim deer brown. Paint the rounded stick green, let it dry, and then fix it in the pot hole. To make the arms, bunch the loose vine twigs together and push evenly onto the stick. Bend a wire several times around it to hold in place. Put a long piece of wire to the left and right of the head around the bunch of twigs and push the ends through the pot hole of the downward-pointing bell pot. Thread a small wooden bead and turn the wire with it to secure in the pot.

Glue the second bell pot on top of the opening. Cut corn straw to size to make the hair, bunch it together with wire, and glue it all around the rim. Glue the straw hat on top of the hair. Use the template to cut out the felt dress. Glue on single green leaves and decorate the seam with puff paint. Use raffia to hold the dress in place. Tie the petal collar around the neck (see the Sunflower Man, page 96).

Paint on the face and cut a carrot to use as a nose. Glue on the wooden bead halves as irises. Puncture the small cans with an awl and tie to the arms with jute cord. Decorate with a small wooden raven, ivy leaves, a miniature pumpkin, and petals.

## Materials

- Height about 14" (35 cm) (without stick)
- 1 clay pot, about 3" (7.5 cm) in diameter
- 2 bell pots, 4 3/4" (12 cm) in diameter
- 1 bunch of vine twigs, about 14" (35 cm) long
- 1 wooden bead, 1" (3 cm) in diameter
- 1 black wooden bead, about 1/2" (1 cm) in diameter
- 1 cotton carrot, about 1" (3 cm) long
- 1 rounded wooden stick, 1/2" (1 cm) in diameter x 3' (1 m) long
- Dry floral foam
- White, black, green, orange, and deer brown acrylic paint
- Yellow puff paint
- Winding wire
- Fine myrte wire
- 1 straw hat, 4 3/4" (12 cm) in diameter
- 1 piece of orange felt
- Green raffia
- 1 large sunflower
- 1 bunch of yellow corn straw, about 3" (8 cm) long
- 1 decorative wooden raven, 1 1/2" (4 cm) tall
- 1 decorative wooden raven, 2 1/4" (6 cm) tall
- Decorative pumpkin, 2 3/4" (7 cm) tall
- 4 empty cans, 2 3/4" (7 cm) tall
- 1 natural-finish jute cord, 2.5 mm in diameter x 3' (1 m) long
- Template

### Tip

Decorate the scarecrow with the small clay pot raven (page 98) instead of a purchased wooden raven.

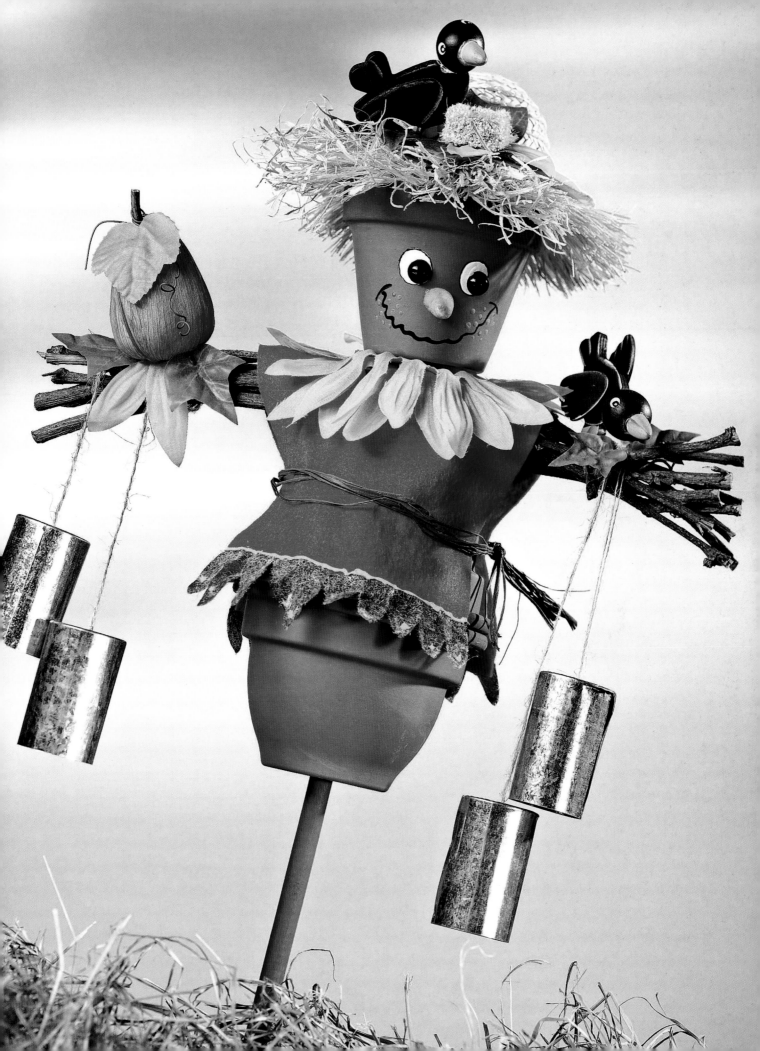

**Materials for the Lady Gardener**

- Height about 16" (40 cm)
- 1 ceramic or cotton pumpkin, 4 1/4" (11 cm) in diameter
- 1 bell pot, 5 1/2" (14 cm) in diameter
- 1 bell pot, 6" (16 cm) in diameter
- 1 clay pot, 5 1/2" (14 cm) in diameter
- 4 clay pots, 1 3/4" (4.5 cm) in diameter
- 2 clay pots, 1 1/4" (3.5 cm) in diameter
- 1 sheet of green velour paper, 9" x 13" (23 cm x 33 cm)
- 2 green wooden disks, 1/2" (1 cm) in diameter
- 2 black half-pearls, 1/4" (0.5 cm) in diameter
- 1 decorative watering can, 2" (5 cm) tall
- Orange puff paint
- Yellow raffia curls
- Green raffia
- 3 sunflowers
- 2 ivy leaves
- 1 orange-and-white checkered ribbon, 20" (50 cm) long
- 1 green miniature clothespin
- Template

**Materials for the Pumpkin Face**

- Height about 6" (16 cm)
- 1 ceramic or cotton pumpkin, 3" (8 cm) in diameter
- 1 clay pot, about 3" (7.5 cm) in diameter
- 1 clay pot, 3/4" (2 cm) in diameter
- 2 green moss latex disks, 1/2" (1 cm) in diameter
- 2 black half-pearls, about 1/4" (0.5 cm) in diameter
- Black and red puff paint
- Orange sand paint
- Green lacquer pen
- Yellow and green raffia curls
- Yellow-green ivy leaves
- Small berries
- 1 piece of green burlap

# Lady Gardener

Use green raffia to assemble the figure according to the instructions for type 1 (page 8). Turn the pumpkin on its side and use modeling glue to attach it to the body (for additional support, use floral tape as needed). Attach the watering can to the overhanging raffia of one of the arm openings. Cut a quarter of a raffia bunch into threads 2 3/4" (7 cm) long and bunch them together using wire. Use hot glue to fix the raffia inside the arm openings and cut all of the threads to the same size. Fix the yellow raffia curls to the pumpkin head and attach the bell pot with modeling glue as a hat.

Use the template to cut out the apron and pocket from a sheet of velour paper. Glue on the pocket and paint decorative stitches with puff paint. Put the apron around the body and glue the apron string as marked. Attach the straps to the clay pot. Tie on the bow and attach the floral decorations. Finish by painting the face using puff paint and a fine-point felt-tipped pen.

> **Tip**
>
> It is possible to use fresh pumpkins, but they don't last very long. Pumpkins that look natural but don't perish are easily and quickly made from quick-drying modeling clay. Follow the manufacturer's instructions and paint later with acrylic paint.

# Pumpkin Face

Paint the rim of the pot with orange sand paint and green lacquer pen. Slightly tilt the pumpkin and glue it into the pot. Attach the eyes with superglue and paint the face with puff paint. Decorate the pot all around with flowers, berries, leaves, and burlap pieces. Use raffia curls and a small clay pot to finish of the cheeky face. Decorate the hat with a berry.

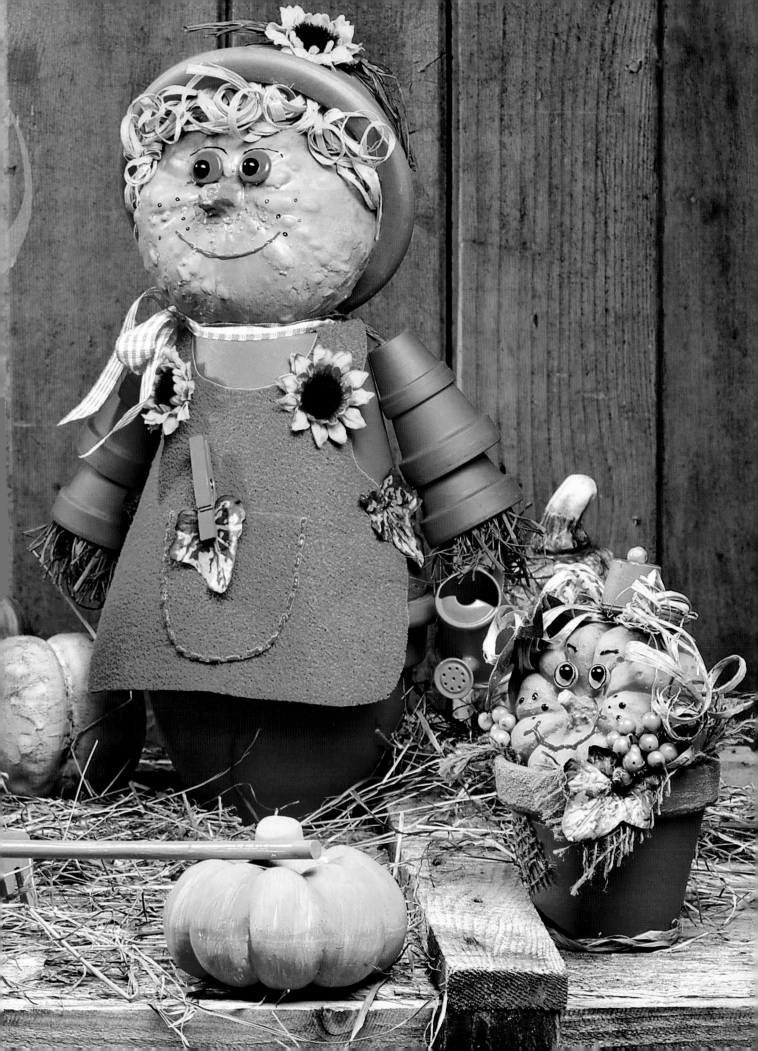

## Materials for the Small Raven

- Height about 6" (16 cm)
- 2 clay pots, 1 ¾" (4.5 cm) in diameter
- 1 clay pot, 2 ¾" (7 cm) in diameter
- 1 clay saucer, 2 ¾" (7 cm) in diameter
- 2 wobbly eyes, ½" (1 cm) in diameter
- 1 cotton ball, 1 ½" (4 cm) in diameter
- 1 cardboard disk, about 2" (5.5 cm) in diameter
- 1 straw hat, 3" (8 cm) in diameter
- Large black marabou feathers
- Black and yellow poster board pieces
- Black and dark green acrylic paint
- Orange lacquer pens
- 1 yellow wooden bead, about ½" (1 cm) in diameter
- Orange raffia
- Template

## Materials for the Large Raven

- Height about 10" (25 cm)
- 2 clay pots, 2 ¾" (7 cm) in diameter
- 1 clay pot, 4" (10 cm) in diameter
- 1 clay saucer, 3" (8 cm) in diameter
- 2 wobbly eyes, about ¾" (2 cm) in diameter
- 1 cotton ball, 2 ¼" (6 cm) in diameter
- 1 cardboard disk, 2 ½" (6.5 cm) in diameter
- 1 straw hat, 4 ¾" (12 cm) in diameter
- Large black marabou feathers
- Black and yellow poster board pieces
- Black and dark green acrylic paint
- Yellow lacquer pen
- 1 piece of black fake fur
- Green buttons, ¾" (2 cm) in diameter
- Green checkered ribbon, 20" (50 cm) long
- Green ear of corn
- Template

## Material for Small Sunflower

- Height about 7" (17 cm)
- 1 clay pot, 1 ¼" (3.5 cm) in diameter
- 1 clay pot, about 2" (5.5 cm) in diameter
- 1 wooden stick, 6 mm in diameter x 4" (10 cm) long
- 1 cotton ball, 1" (3 cm) in diameter
- 2 paper napkins with sunflower motif, 2 ¼" (6 cm) in diameter
- 1 piece of white poster board
- Florist foam
- Green Iceland moss
- Green raffia
- Green acrylic paint
- Paper napkin glue
- Green lacquer pen
- Wooden skewers

## Materials for Large Sunflower

- Height about 8 ½" (22 cm)
- 1 clay pot, 1 ¾" (4.5 cm) in diameter
- 1 clay pot, 2 ½" (6.5 cm) in diameter
- 1 wooden stick, 6 mm in diameter x 4 ¾" (12 cm)
- 1 cotton ball, 1 ½" (4 cm) in diameter
- 2 paper napkins with sunflower motif, 4 ¾" (12 cm) in diameter
- 1 piece of white poster board
- Florist foam
- Green Iceland moss
- Green raffia
- Green acrylic paint
- Paper napkin glue
- Green lacquer pen
- Wooden skewers

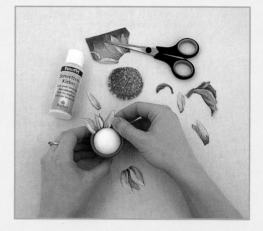

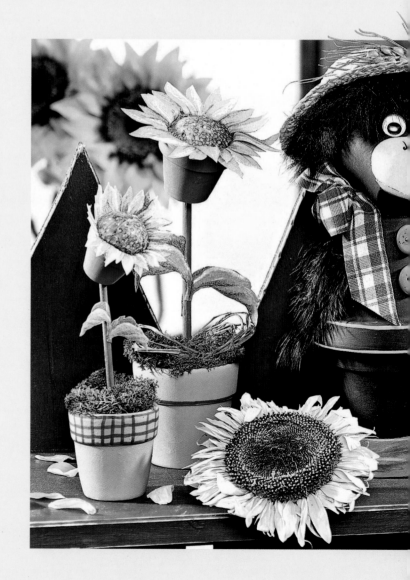

# Raven

Apply a base coat of black acrylic to all pots and saucers. Let dry, and then streak the saucers with green paint. Add body decorations with lacquer pens. Assemble the figures according to the instructions for type 2 (page 9).

Follow the template to cut out the beak and wings. Glue two or three marabou feathers to each wing. Glue the two beak halves individually to the head. Glue the cotton ball into the head pot and attach a small piece of fake fur around the pot rim as hair. Attach the straw hat on top of it. For the big raven, add an ear of corn. Use superglue to attach the eyes, buttons, wings, and bows to the birds. Use a long feather as a tail and attach with a bit of modeling glue, which can be painted with acrylic after it is dry.

# Sunflower

Glue a cotton ball into the smallest pot. Remove the white layers of the paper napkin, as only the printed layer will be used. Two large napkins are needed for each sunflower. Glue 1 motif (with leaf) to a piece of cardboard using special napkin glue. Let dry, and then carefully cut out each petal and glue it to the pot's inner rim with superglue. Cut out the leaf.

Roughly cut out the second motif's middle and glue it to the cotton with napkin glue. Use a wooden skewer to carefully push the excess napkin between the ball and the pot. Cut out the green leaf, glue it the wrong way around to the card, and cut it out. Decorate the larger clay pot with lacquer paint, fill it with dry foam, and cover with moss and raffia. Apply a green base coat to the stems and glue them in the middle of the moss pot using hot glue; slightly tilt the flowerpot and attach at an angle through the pot hole to the stem. Attach the two green leaves to the stem.

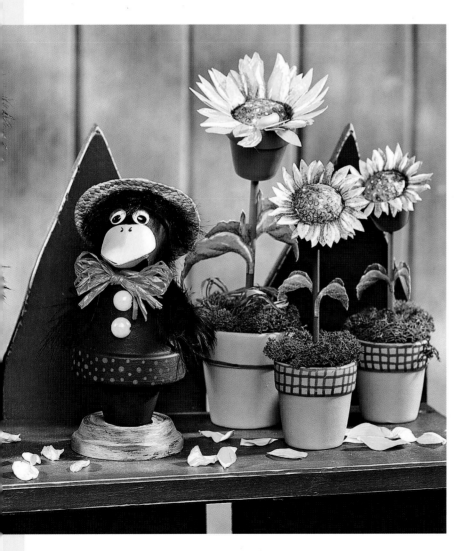

## Materials

- 1 bell pot, 6" (16 cm) in diameter
- 1 rose pot, 5 ½" (14 cm) diameter
- 1 clay pot, 4" (10 cm) diameter
- 1 piece of plywood, ½" (1 cm) thick (or air-drying modeling clay)
- 1 cotton or plastic carrot, 2" (5 cm) long
- 2 black button eyes, about ½" (1 cm) in diameter
- 1 piece of white poster board
- Felt scraps in various colors
- Black fabric, 3' x 3' (90 cm x 90 cm)
- Black, white, pink, dark green, and red acrylic paint
- Black, red, orange, green, and yellow puff paint
- Orange craft hair
- Heavy black crafting felt, 10" x 18" (25 cm x 45 cm)
- 1 red button, 1" (3 cm) in diameter
- Template

# Drusilda the Witch

Paint a green base coat on the upper part of the figure and white on the bottom part (see Ghost, page 114). Glue the pots together after the paint is dry. Use the template to cut out the hands from plywood; sand down the edges. Alternatively, make the hands from rolled-out modeling clay; follow the manufacturer's drying instructions. Paint the hands as shown in the photograph. Add small dots of hot glue to the cotton carrot as warts. Paint the carrot pink, and cut it evenly at the thicker end, and attach it to the face. Cut out the eyes from poster board and attach the half-pearls as irises. Paint the face.

Use modeling glue to attach the arms to the body pot. Fix the craft hair with superglue to the rim of the head pot and cut to shape. Cut out the felt hat and the small bat following the template, glue together, and attach the brim. Add stitches and dots using puff paint.

Bend the tip of the hat attractively and attach the bat with glue. Use pinking shears to cut out the felt patches and glue them to the pot. Use puff paint to decorate them with stitches. Drape the fabric around the witch's shoulders and hold it together by sewing on a large button.

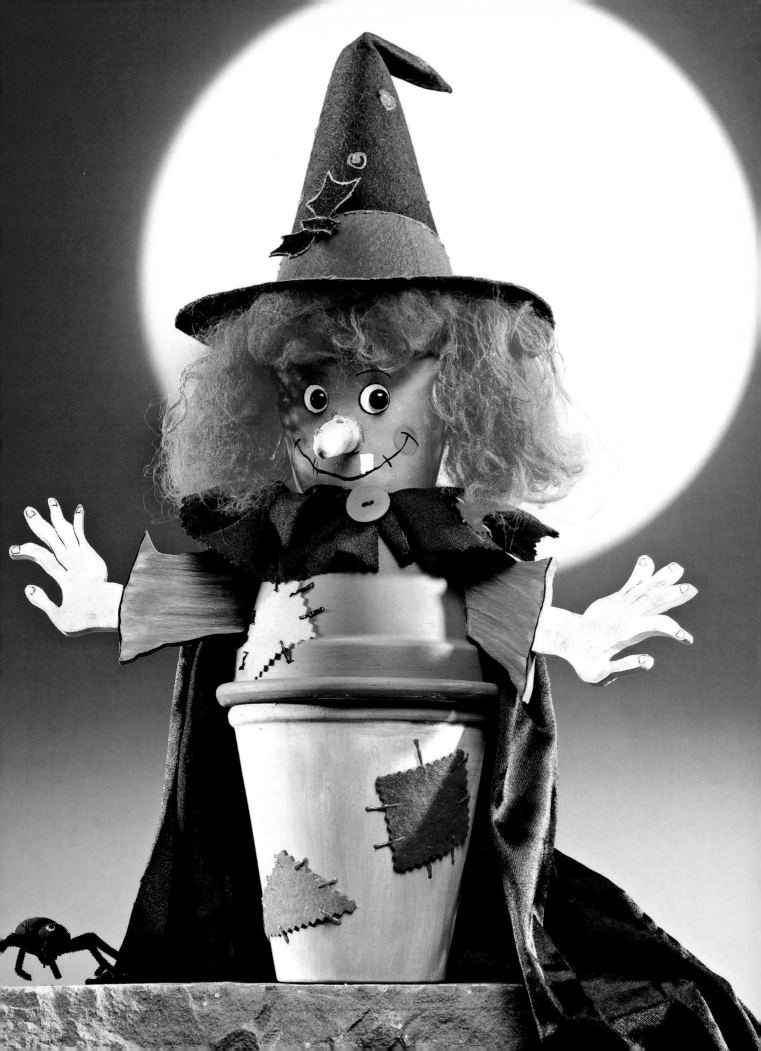

## Materials for Erwin the Ghost

- Height about 18" (45 cm)
- 1 rose pot, 3" (8 cm) in diameter
- 1 rose pot, 4" (10 cm) in diameter
- 1 clay pot, 6" (16 cm) in diameter
- 3 clay pots, about 2 ½" (5.5 cm) in diameter
- 2 clay pots, 2" (5 cm) in diameter
- 2 clay pots, about 1" (3 cm) in diameter
- 5 clay pots, 1 ¼" (3.5 cm) in diameter
- 1 cardboard disk, 5" (13 cm) in diameter
- Aluminum wire, 2 mm in diameter x 32" (80 cm) long
- 1 wooden stick, 6 mm in diameter x 2 ¾" (7 cm) long
- 1 cobweb, 4" (10 cm) in diameter
- 2 spiders
- ½ cotton ball, about ¾" (2 cm) in diameter
- White spinning fiber
- Thin black iron link chain, about ½" (1 cm) wide
- 1 piece of white poster board
- Black, white, yellow, red, and terra cotta acrylic paint
- Template

## Materials for One Bat

- Height about 5" (13 cm)
- 2 clay pots, 1 ¼" (3.5 cm) in diameter
- 1 wooden bead, 1 ¼" (3.5 cm) in diameter
- 1 red wooden half-bead, 6 mm in diameter
- 2 wobbly eyes, 6 mm in diameter
- Suspension spring with loop, 2 ¼" (6 cm) long
- Black rubber mat, 2 mm thick
- Black, white, red, and silver acrylic paint
- Template

# Ghost

Follow the instruction to make a type 3 figure (page 9) and glue on the half cotton ball as a nose. Use a damp sponge to cover the pots with white acrylic paint; use terra cotta paint on the cotton ball nose. Let dry, and then paint on the face. Use the template to cut out the paper letters and glue them onto the body with superglue. Pull apart the cobweb and cover the figure as in the photograph. Drape the ghost with the chain and distribute the spiders.

# Bat

Glue two small pots together. Attach the wooden bead for the head with modeling glue. Let dry, and then glue the spring into the bead opening. Apply a black acrylic base coat to the head and body and use a fine brush to add fine lines in white and silver to make the fur. Cut the wings and the ears from the rubber. Use superglue to attach the eyes, nose, and ears. Paint on the mouth. Last, glue the wings to the body and paint on silver contours.

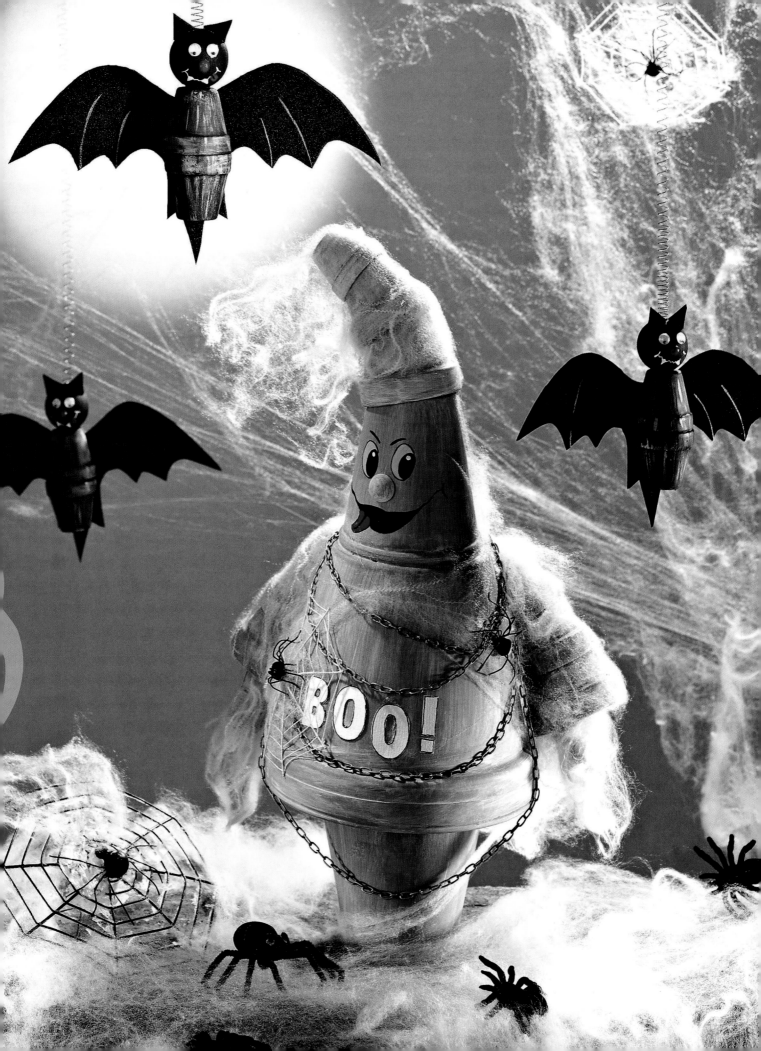

## Materials for One Gnome

- Height about 7" (18 cm)
- 1 clay pot, 2 1/2" (6.5 cm) in diameter
- 2 clay pots, 1 3/4" (4.5 cm) in diameter
- 2 clay pots, 3/4" (2 cm) in diameter
- 2 cotton ball halves, 3/4" (2 cm) in diameter
- 2 cotton balls, about 1" (3 cm) in diameter
- 1 cotton ball, about 1/2" (1 cm) in diameter
- 1 poster board disk, 2" (5 cm) in diameter
- 2 black half-beads, 1/8" (4 mm) in diameter
- 1 piece of brown rubber mat, 2 mm thick
- 1 piece of white poster board
- Green or blue felt scraps
- Green or blue, white, and deer brown acrylic paint
- Ruby antique paint
- Glossy varnish
- Light brown craft hair (green gnome only)
- Vine twigs, Spanish moss (blue gnome only)
- Yellow wooden bellflower
- Miniature cypress garland
- Small blue silk flower umbels
- Template

## Materials for One Mouse

- Height about 4 3/4" (12 cm)
- 1 clay pot, 1 1/4" (3.5 cm) in diameter
- 1 clay pot, 1 1/2" (4 cm) in diameter
- 1 cotton ball, about 1" (3 cm) in diameter
- 1 cotton ball, 1/2" (1 cm) in diameter
- 2 black half-pearls, 3 mm in diameter
- 2 pieces of black wire, 1" (3 cm) long
- 1 piece of brown poster board
- 1 piece of brown packing paper
- White acrylic paint
- Ruby and autumn red antique paint
- Glossy vanish
- Silk or natural leaves
- Template

# Gnomes

Glue the cotton ball halves to the small clay pots as shoulders and use the template to cut the shoes from rubber. Apply a base coat to all parts according to the photograph, including the cotton balls and the rubber parts. Let dry. Assemble the pots according to the instructions for the type 2 figure (page 9). Use superglue to attach the cotton hands and the shoes to the body. Use the template to cut out the felt hoods and the card moustache. Form a long craft-hair beard; add some craft hair to the moustache as well. Glue the hoods together. Carefully pull the hood brim apart and attach, along with the hair, to the figures. Paint the nose in ruby and white and glue on the eyes and the beard.

# Mouse

For the muzzle, glue one half of the cotton ball to the smaller clay pot. Apply a base coat of antique paint to all pots. Make a ball from brown packing paper and glue it between the two pots.

Paint the nose and cheeks in ruby and white. Use superglue to attach the eyes and nose to the head. Add two twisted pieces of wire each as whiskers. Follow the template to cut out paper ears and paint the insides with white paint. Make tails, 4" (10 cm) long, from brown packing paper. Use wire to attach the tail and the ears to the body. Use a black felt-tipped pen to paint on the face and glue the finished mouse to a leaf.

# Mushroom

Make the head of the mushroom from an upside-down saucer and attach half a Styrofoam ball with wood glue. Use the other small pots as the stem; glue them together and let dry. Glue the saucer to the stem.

> **Tip**
>
> You can make these mushrooms from larger clay pots and saucers and use them in the garden, either separately or in groups.

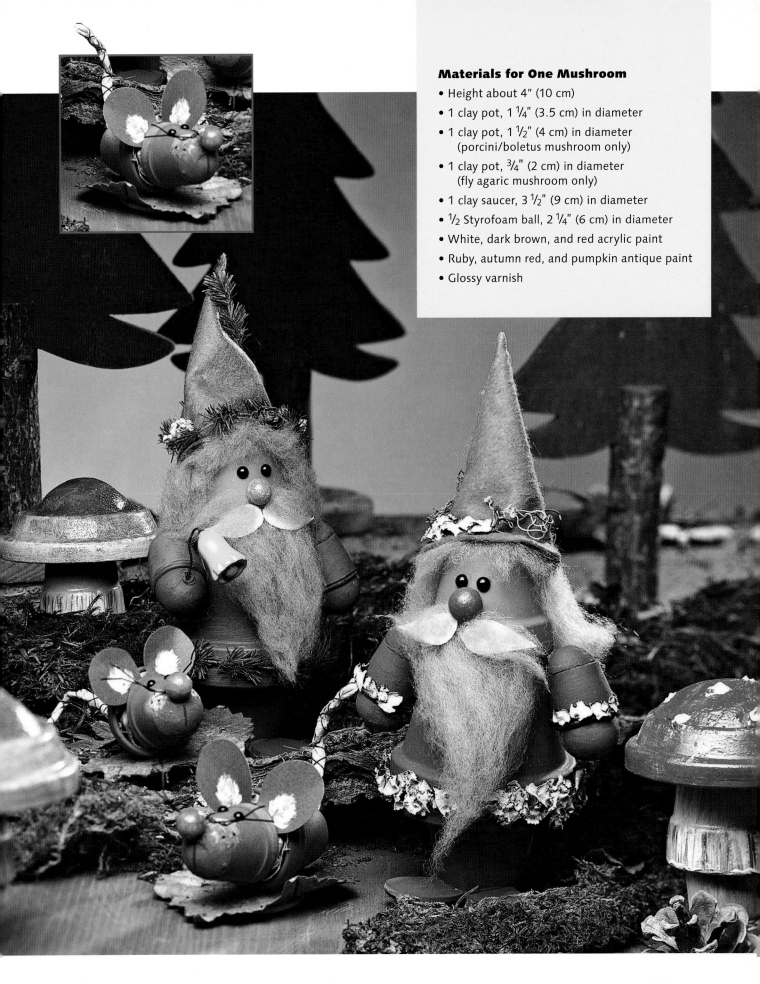

**Materials for One Mushroom**

- Height about 4" (10 cm)
- 1 clay pot, 1 ¼" (3.5 cm) in diameter
- 1 clay pot, 1 ½" (4 cm) in diameter
  (porcini/boletus mushroom only)
- 1 clay pot, ¾" (2 cm) in diameter
  (fly agaric mushroom only)
- 1 clay saucer, 3 ½" (9 cm) in diameter
- ½ Styrofoam ball, 2 ¼" (6 cm) in diameter
- White, dark brown, and red acrylic paint
- Ruby, autumn red, and pumpkin antique paint
- Glossy varnish

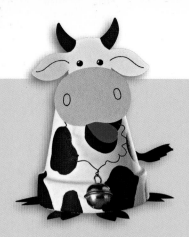

## Materials

- 1 clay pot, 2 ¾" (7 cm) in diameter
- Black and white craft paint
- Black, white, red, and light pink poster board
- 1 small metal bell, about ½" (1 cm) in diameter
- Burnished florist wire, 0.35 mm in diameter x 10" (25 cm) long
- Template

# Cow

First paint the clay pot white. Let dry, and then use a fine brush to paint on black dots as desired. Glue the light pink muzzle onto the white head, with the red tongue glued to the muzzle from behind. Paint on the nostrils and eyes, and paint the horns black. Glue on the head, tail, and feet. Thread the florist wire through the eye of the little bell and fix it into place by twisting it around in the middle. Twist the wire in a spiral. Tie the bell around the neck and twist the wire ends to secure.

# Duck Family

Use clay pots, about 2" (4.7 cm) in diameter, for the ducklings and the head of the large duck. Paint all the pots yellow; to get thorough coverage, apply several coats if necessary. Fold a red poster board square, 4" x 4" (10 cm x 10 cm), in half; score slightly with a cutting knife or a ruler. Place the beak stencil with the dotted line to the fold of the poster board square. Trace the contour with a pencil. Cut out the beak, unfold, and attach with the glue gun. Use all-purpose glue to attach the wobbly eyes just above the beak. Cover the hole of each small pot with a small yellow circle, ¾" (2 cm) in diameter. Finish by gluing on the wings and the feet.

## Materials for the Large Duck
- 1 clay pot, about 2" (4.7 cm) in diameter
- 1 clay pot, 2 ¾" (7 cm) in diameter
- 2 wobbly eyes, ½" (1 cm) in diameter
- Yellow craft paint
- Red and yellow poster board
- Template

## Materials for One Duckling
- 1 clay pot, about 2" (4.7 cm) in diameter
- 2 wobbly eyes, about ¼" (0.5 cm) in diameter
- Yellow craft paint
- Red and yellow poster board
- Template

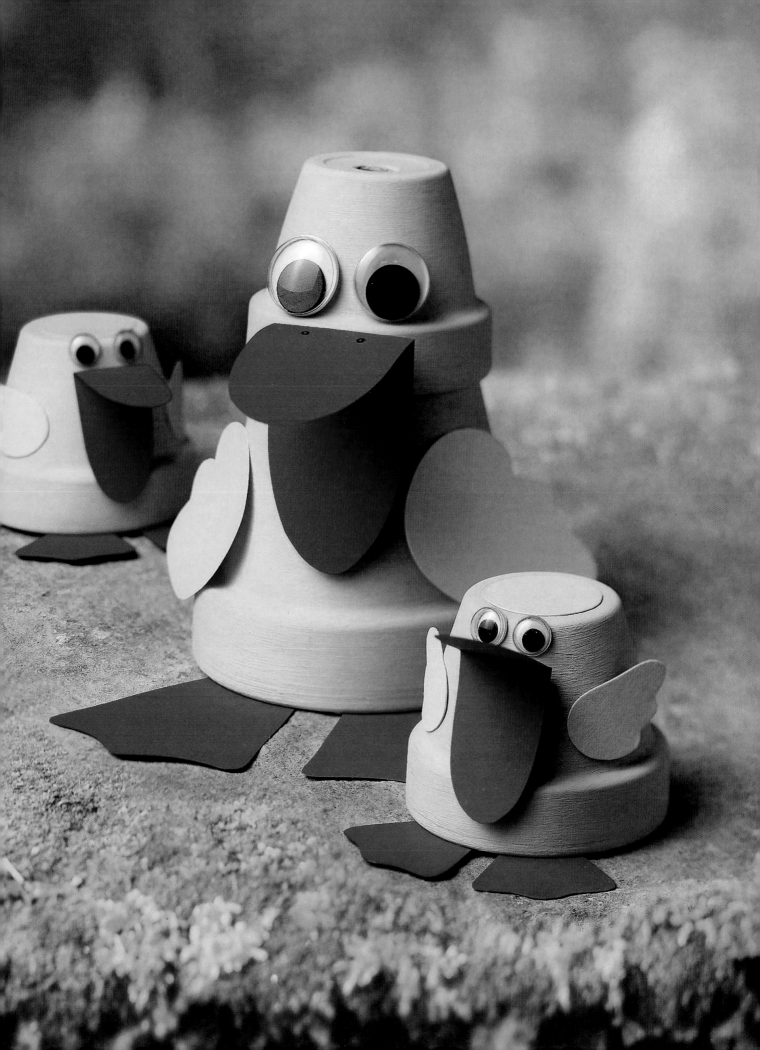

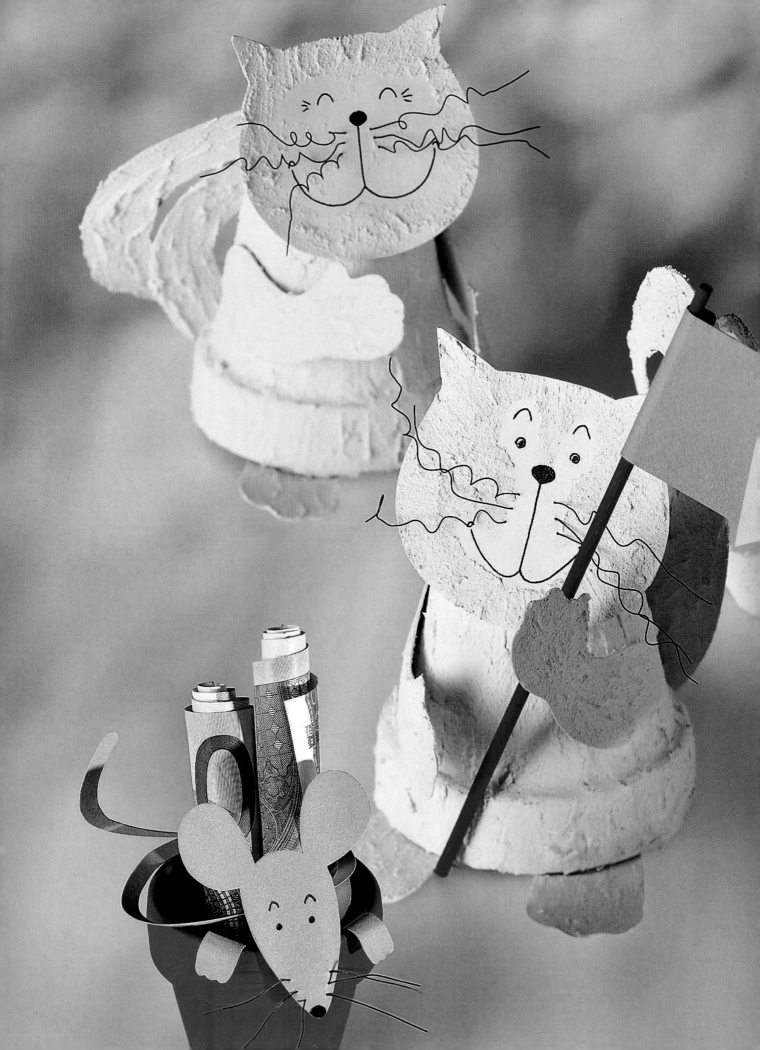

# Cat

Paint the clay pot white and cover the small pot hole with a white circle, about 1" (3 cm) in diameter. Use a bristle brush to apply a thin cover of structural snow paint. Cut out the poster board elements. For the spiral tail, mark the middle with a cross and cut out. Cover the tail, front legs, and feet with structural snow paint. For the head, first paint on the face and cover just the edges with snow paint. Let dry, and then make the holes for the whiskers. Push in three wire pieces and twist the ends into spirals. Use a glue gun to fix the head to the rim and the tail to the back. Paint the wooden stick blue and let dry. Glue the sign to the wooden stick and attach it to the cat's paw.

# Mouse Pot

Apply a blue base coat to the pot and cut out the poster board elements. First paint the face onto the mouse's head, then make the holes for the florist wire whiskers and pull them through the holes. Glue the middle of the tail spiral to the pot's bottom and attach the head and front paws to the rim. Finish by putting folded rolls of paper or other trinkets in the pot.

# Frog with Fly

Paint the clay pot light green and let dry. Make a cardboard template from the dot-lined circle on the template sheet and press it against the pot. Trace the mouth line with a pencil first and then repeat with a felt-tipped pen. Paint the nostrils and glue on the eyes and the tongue. Fold the hind legs outward alongside the dotted line and attach them, and the front legs, to the clay pot.

Attach the wings and wobbly eyes to the fly's body and make a hole in one wing. Use round pliers to bend the end of the sticking wire into an eye. Push the other end into the opening on the frog's head and attach with a glue gun between the front legs and on the inside of the pot. Make a spiral from the florist wire; attach one end to the fly's wing and the other to the wire eye.

## Materials

- 1 clay pot, 2 ¾" (7 cm) in diameter
- Light green craft paint
- Light green, red, black, and white poster board
- 2 wobbly eyes, about ¼" (0.5 cm) in diameter
- 2 wobbly eyes, ½" (1 cm) in diameter
- Burnished sticking wire, 1 mm in diameter x 10" (25 cm) long
- Burnished florist wire, 0.35 mm in diameter x 4 ¾" (12 cm) long
- Template

## Materials

- 1 clay pot, 3 ½" (9 cm) in diameter
- Medium blue craft paint
- Light green and red poster board
- 2 wobbly eyes, ½" (1 cm) in diameter
- Template

# Kiss Me Frog

Paint the inside of the pot and the upper rim blue. Cut out the poster board elements. Glue on the wobbly eyes and paint on the face. Fold the frog's neck along the dotted line and glue the head onto the body. Nestle the frog into the pot. Cut out the heart and put it in the frog's hand.

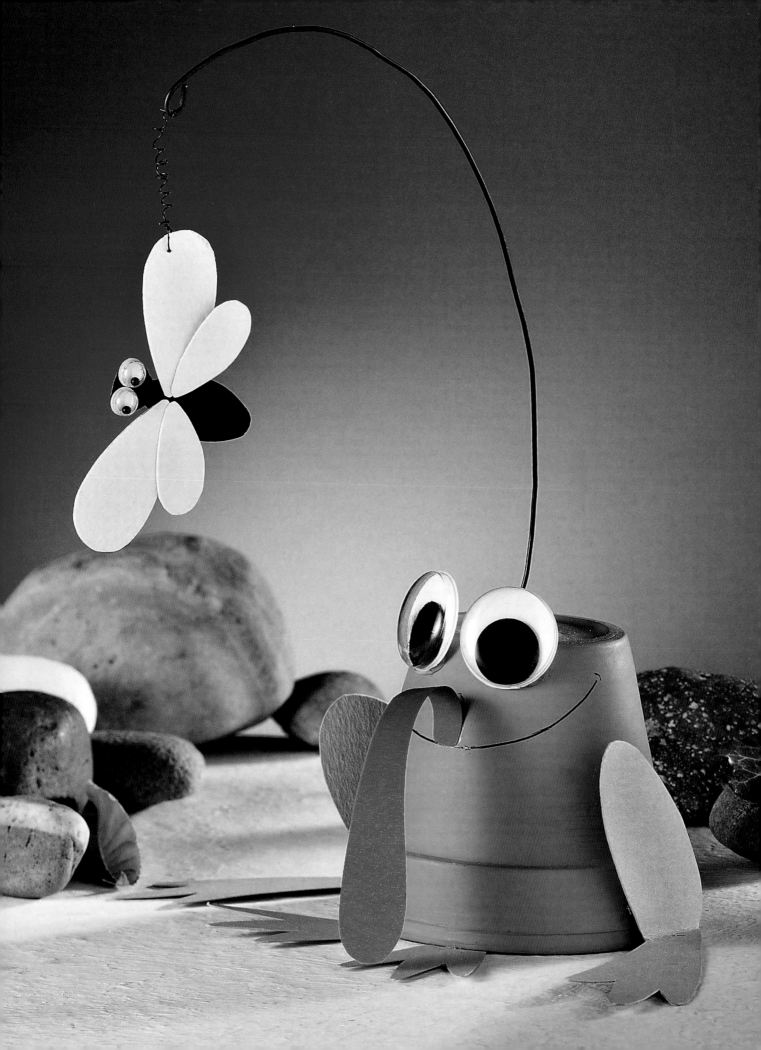

# Happy Birthday Mouse and Pen Mouse

Paint the pots gray and glue on the cut-out heart. Add the stitches on the heart with a felt-tipped pen. Use the side cutter to cut the pipe cleaner into three pieces: arms (A) 4 ¾" (12 cm); legs (B) 8" (20 cm); and tail (C) 7" (18 cm). Bend A and B according to the template exactly in the middle and put the two wire bows into each other. Where they cross, wind the end of C four times. Push the ends of A as arms from below through the small pot hole. Show the tail (C) at the back and the legs (B) at the front.

Make holes for the whiskers; pull the florist wire pieces through the holes and bend the ends into spirals. Glue on the wobbly eyes and use a glue gun to attach the head to the rim.

For the heart-shaped greeting, use rounded pliers to bend the zinc wire ends into eyes and to decoratively twist the wire further. Attach the heart to the florist wire spiral and attach that to the middle twist. Attach the pipe cleaner arms to the zinc wire. Make sure that the ends of the zinc wire are flat on the ground.

## Materials for the Happy Birthday Mouse
- 1 clay pot, about 2" (5 cm) in diameter
- Gray matte craft paint
- Gray and red poster board
- 1 gray pipe cleaner, 20" (50 cm) long
- 2 wobbly eyes, ½" (1 cm) in diameter
- 3 burnished florist wires, 0.35 mm in diameter x 3 ½" (9 cm) long
- 1 zinc wire, 1.6 mm in diameter x 16" (40 cm) long
- Template

## Materials for the Pen Mouse
- 1 clay pot, about 2" (5 cm) in diameter
- Gray matte craft paint
- Gray poster board
- 1 gray pipe cleaner, 20" (50 cm) long
- 2 wobbly eyes, ½" (1 cm) in diameter
- 3 burnished florist wires, 0.35 mm in diameter x 3 ½" (9 cm) long
- Template

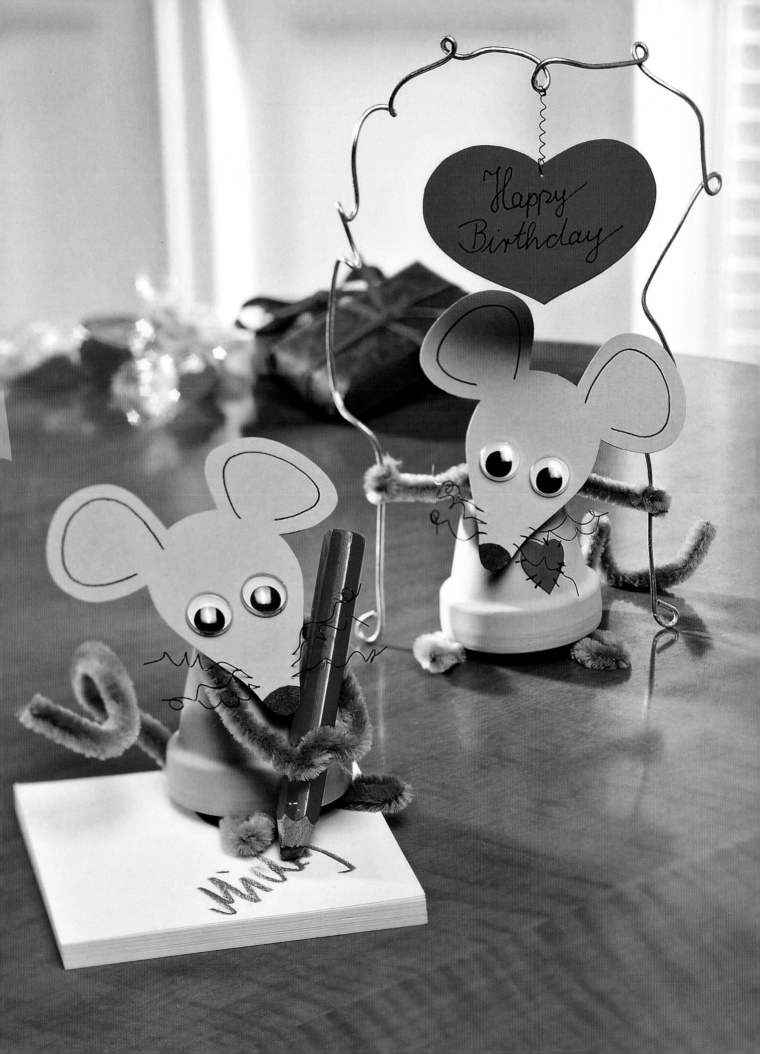

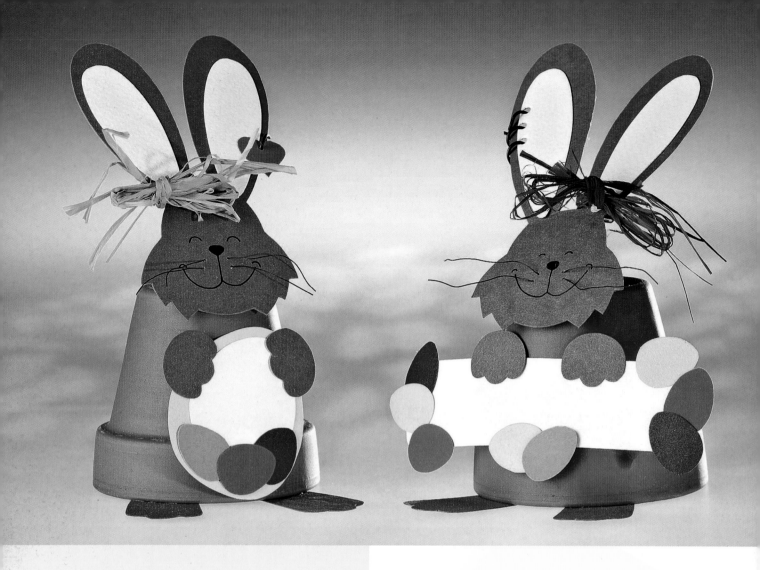

## Materials for One Bunny

- 1 clay pot, 2 3/4" (7 cm) in diameter
- Terra cotta, white, red, yellow, blue, and green poster board
- Red or light green raffia, 12" (30 cm) long
- 2 burnished florist wires, 0.35 mm in diameter x 3" (8 cm) long
- Black stainless-steel wire, 1 mm in diameter
- Template

# Easter Bunnies

Cut out the poster board elements. Glue the inside ear pieces to the ears and paint on the face. Make holes for the florist wire whiskers and punch holes for the earrings. Pass the wire pieces through the holes to make the whiskers. Use rounded pliers to bend pieces of stainless-steel wire, about 1/2" (1 cm) long, into open rings; if desired, thread a heart onto one ring. Attach the rings to the ear and close with the pliers. Glue the paws to the signs as shown in the photograph. Attach the sign, the head, and the feet, and decorate the ears with small raffia bows.

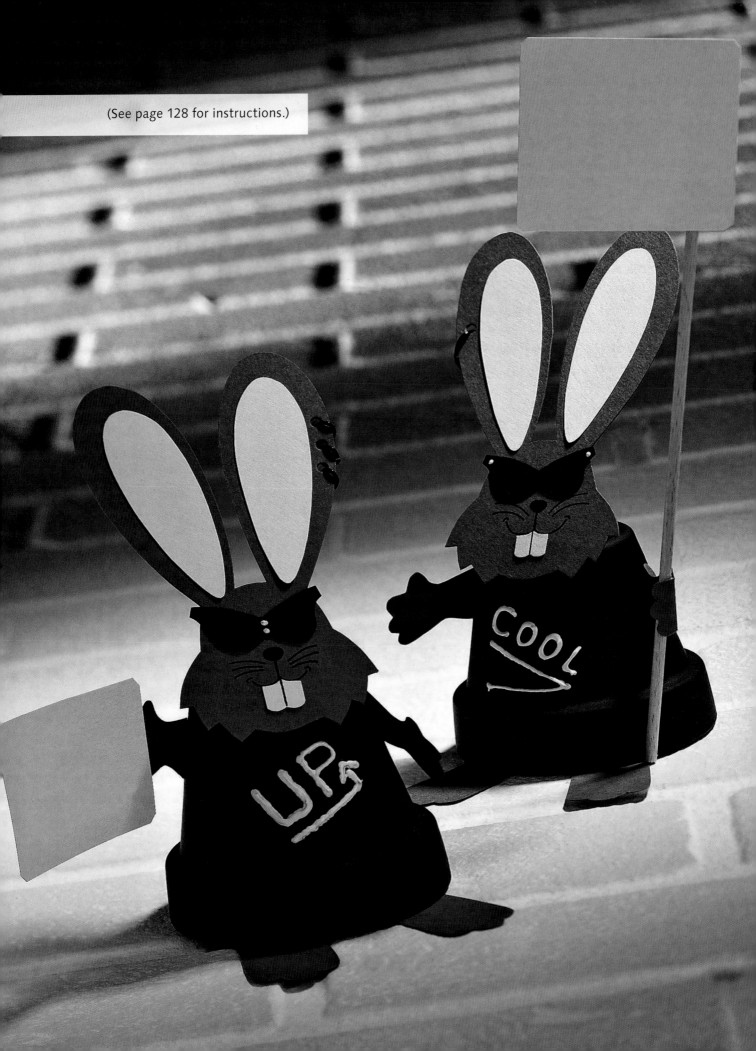

(See page 128 for instructions.)

**Materials for One Rabbit**

- 1 clay pot, 2 ¾" (7 cm) in diameter
- Black matte craft paint
- Terra cotta, black, and white poster board
- Black and white puff paint
- Black stainless-steel wire,
    1 mm in diameter
- Rounded wooden skewer,
    3 mm in diameter x 8" (20 cm) long
- Template

# Cool Rabbits

(Larger photograph on page 127)

Make the basic rabbit as described in the instructions for the Easter Bunny on page 126. Glue the teeth, glasses, and inner ears to the face. Decorate the sunglasses with a few dots of puff paint. Use puff paint to paint cool slogans onto the shirts and signs of these crazy rabbits. Attach to the paw and the wooden skewer respectively. Use the glue gun to attach the wooden skewer to the paw.

# Hip Ladybugs

Paint the small pot and the rim of the large pot black, and paint the rest of the large pot red. Attach the poster board mouth and the wobbly eyes to the black head pot. Bend the pipe cleaner in half and set it in the head opening. Attach a wooden bead to each end of the pipe cleaner to make the antennae. Distribute seven black card circles over the large clay pot, making sure to cover the pot hole.

**Materials for One Ladybug**

- 1 clay pot, about 2" (5 cm) in diameter
- 1 clay pot, 2 ¾" (7 cm) in diameter
- Black and carmine red matte craft paint
- Black, red, and green poster board
- 2 wobbly eyes, ½" (1 cm) in diameter
- 1 black pipe cleaner, 10 ½" (26 cm) long
- 2 black wooden beads, ½" (1 cm) in diameter
- Templates

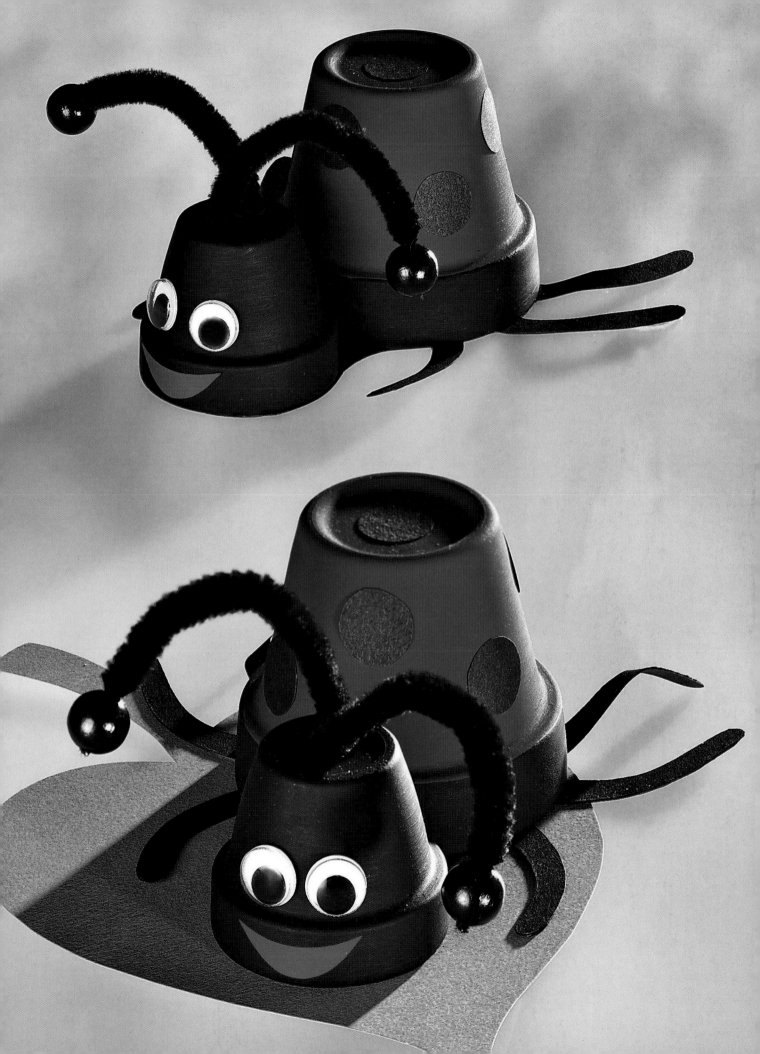

# Diving Hippos

Apply a light blue base coat to the clay pot and cut out the poster board elements. Glue the small white element to the colored diving mask piece, and then glue the diving mask to the head. Use a black felt-tipped pen to paint on the eyes, nostrils, and ear contours. Attach the snorkel to the back of the head. Use a glue gun to attach the head and arms to the pot. Glue the flippers to the bottom of the pot. Seal the pot hole with a light blue circle, about 1" (3 cm) in diameter. Thread the starfish, octopus, and fish onto wire and attach the "catch" to a hippo arm.

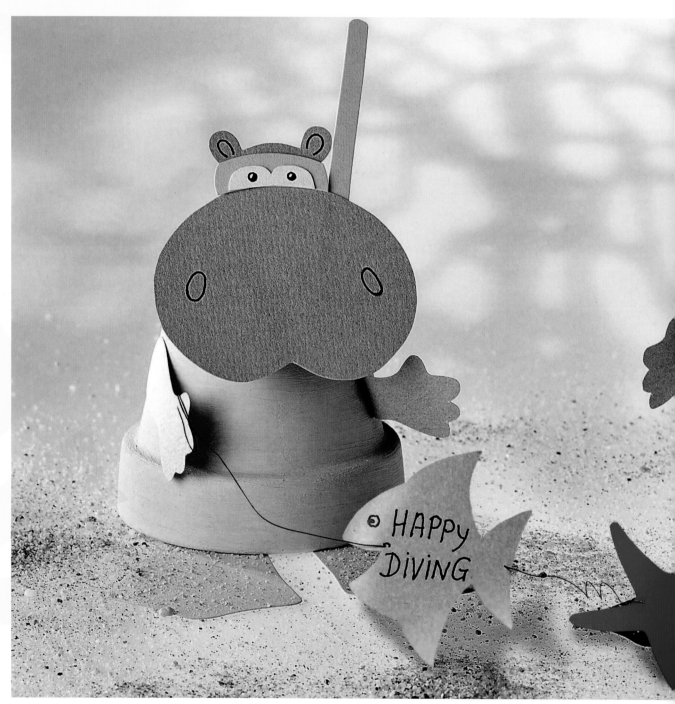

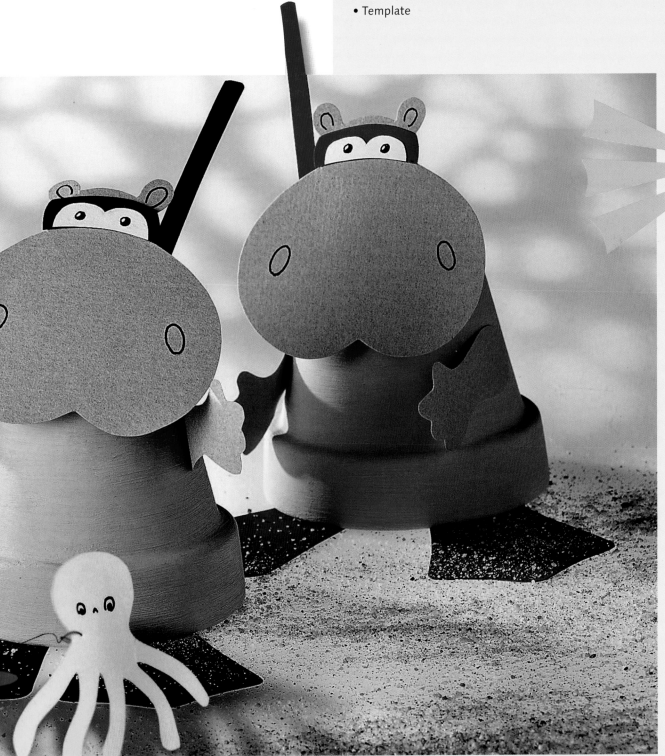

**Materials for One Hippo**

- 1 clay pot, 2 ¾" (7 cm) in diameter
- Light blue matte craft paint
- Red, yellow or black, light blue, and white poster board
- Burnished florist wire, 0.35 mm in diameter
- Template

# Turtles

Cut out the poster board elements. Glue the wobbly eyes to the head and paint on the face and toes. Fix the body underneath and attach five dots to each pot. Seal the pot hole with a circle ¾" (2 cm) in diameter.

**Materials for One Turtle**

- 1 clay pot, about 2" (4.7 cm) in diameter
- Beige poster board
- 2 wobbly eyes, ¼" (0.5 cm) in diameter
- Template

**Materials for One Crab**

- 1 clay pot, about 2" (4.5 cm) in diameter
- Black matte craft paint
- Terra cotta poster board
- 2 wobbly eyes, ½" (1 cm) in diameter
- 1 black pipe cleaner, 5 ½" (14 cm) long
- 2 black wooden beads, ½" (1 cm) in diameter
- Template

# Crabs

Paint the pots black. Glue on the mouth and eyes, followed by the claws and the leg piece. Fold the pipe cleaner in half and set it in the pot hole. Attach a wooden bead to each pipe cleaner end.

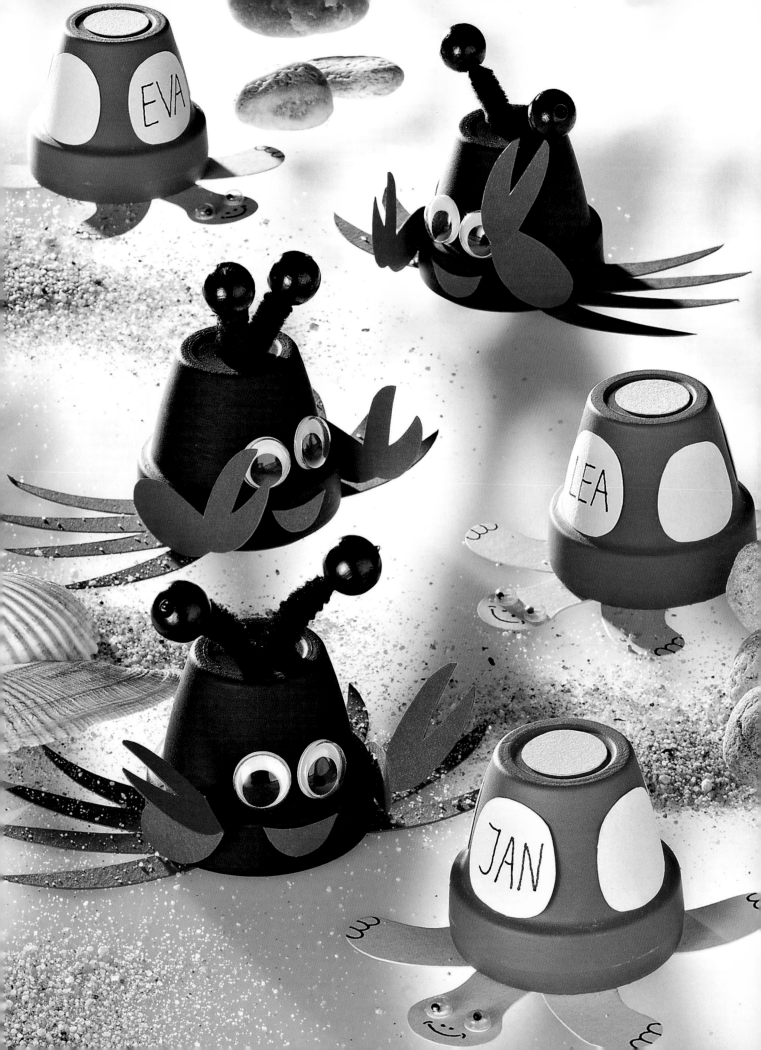

# Frogs on Hearts

Paint the clay pot and let dry. The dotted line on the template is the mouth line. Make a cardboard stencil and press it against the clay pot. Trace the mouth line with a pencil, remove the stencil, and trace the line with a felt-tipped pen. Use the wobbly eyes as a stencil to make the closed poster board eyes. Attach the eyes. Seal the pot hole behind the eyes with a light green circle, ¾" (2 cm) in diameter. Glue the clay pot onto the arm/leg piece. Finish by putting the happy couple on the cut-out red heart.

**Materials**
- 2 clay pots, about 2" (4.5 cm) in diameter
- Light green matte craft paint
- White, light green, and red poster board
- 2 wobbly eyes, about ¾" (2 cm) in diameter
- Template

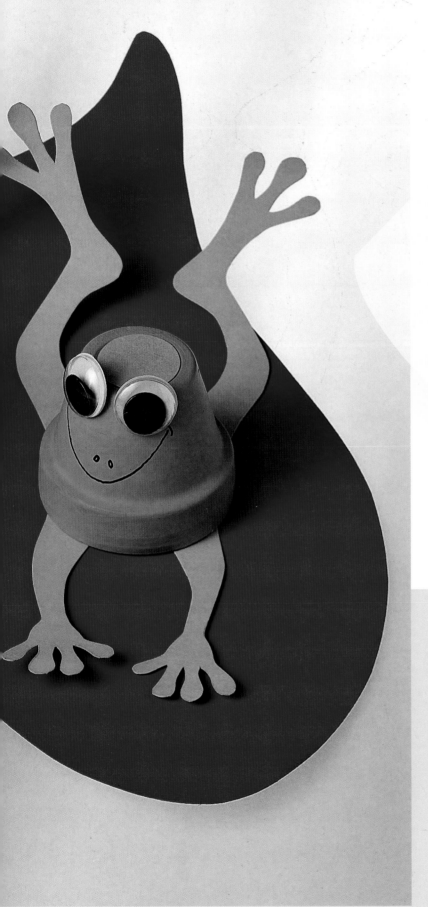

# Snail

(Photograph on page 136)

Paint the smaller pot beige and the large pot red. Glue on the wobbly eyes and paint on the nostrils and the mouth. Fold the pipe cleaner in half and set it in the hole of the smaller pot. Attach a wooden bead to each pipe cleaner end. Seal the hole of the large pot with a beige poster board circle, about ¾" (2 cm) in diameter.

## Materials

- 1 clay pot, 1 ¼" (3.5 cm) in diameter
- 1 clay pot, about 2 ¼" (5.5 cm) in diameter
- Beige and carmine red matte craft paint
- Beige and green poster board
- 1 black pipe cleaner, 6" (16 cm) long
- 2 red wooden beads, ½" (1 cm) in diameter
- 2 wobbly eyes, ½" (1 cm) in diameter
- Template

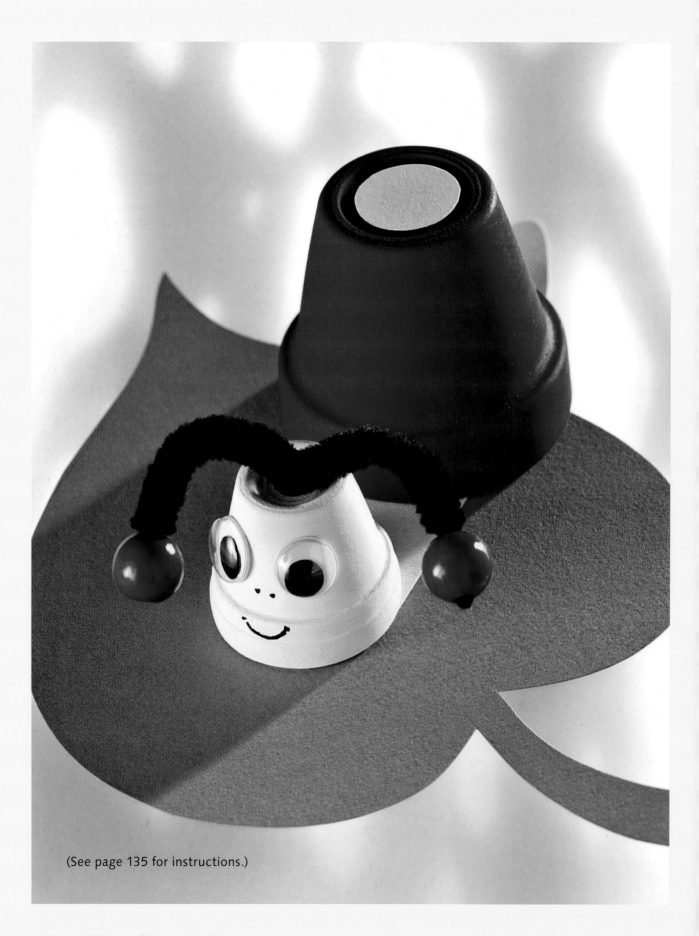

(See page 135 for instructions.)

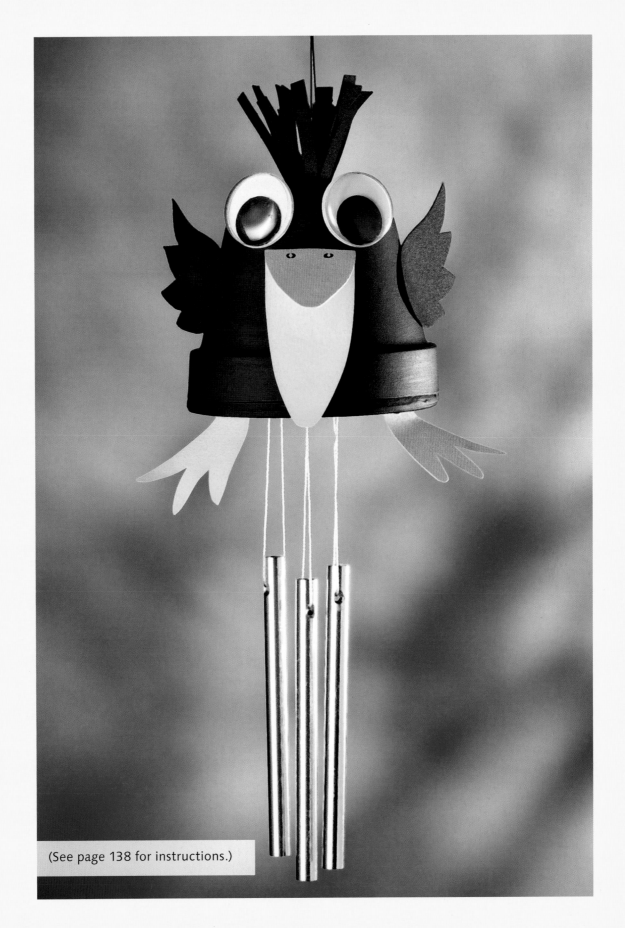

(See page 138 for instructions.)

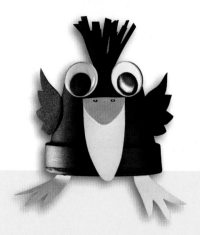

## Raven Wind Chime

(Photograph on page 137)

Pull the chimes onto the sticking wire. Use rounded pliers to bend the wire into a triangle (see template). With glue, fix the suspension threads at equal intervals so they do not slip out of place. From below, put the straight wire piece above the triangle into the small pot and through its hole. Bend the wire end into an eye for suspension. Glue about twenty card strips, about ¼" x 2" (0.5 cm x 5 cm) into the hole that already holds the wire. To make the beak, fold the yellow card strip, ¾" x 5⁻½" (2 cm x 14 cm), and hold the beak stencil with the dotted line facing the fold. Trace the contour with a pencil and cut out the beak. Finish by gluing on the eyes, beak, feet, wings, and tail.

### Materials

- 1 clay pot, 2 ¾" (7 cm) in diameter
- Black matte craft paint
- Black and yellow poster board
- 2 wobbly eyes, 1" (3 cm) in diameter
- 3 brass-colored chimes (with suspension threads), 3" (8 cm) long
- Burnished sticking wire, 5" (13 cm) long
- Template

## Elephants

Paint the pot and let dry. Glue on the trunk, and then attach the eyes, tusks, ears, and tail. Make several incisions in the end of the tail to make a tassel. Use a black felt-tipped pen to contour the toes before gluing on the feet. Cover the small pot hole with a gray circle, about 1" (3 cm) in diameter.

### Materials

- 1 clay pot, 2 ¾" (7 cm) in diameter
- Gray matte craft paint
- Gray and white poster board
- 2 oval wobbly eyes, ¼" (0.5 cm) in diameter
- Template

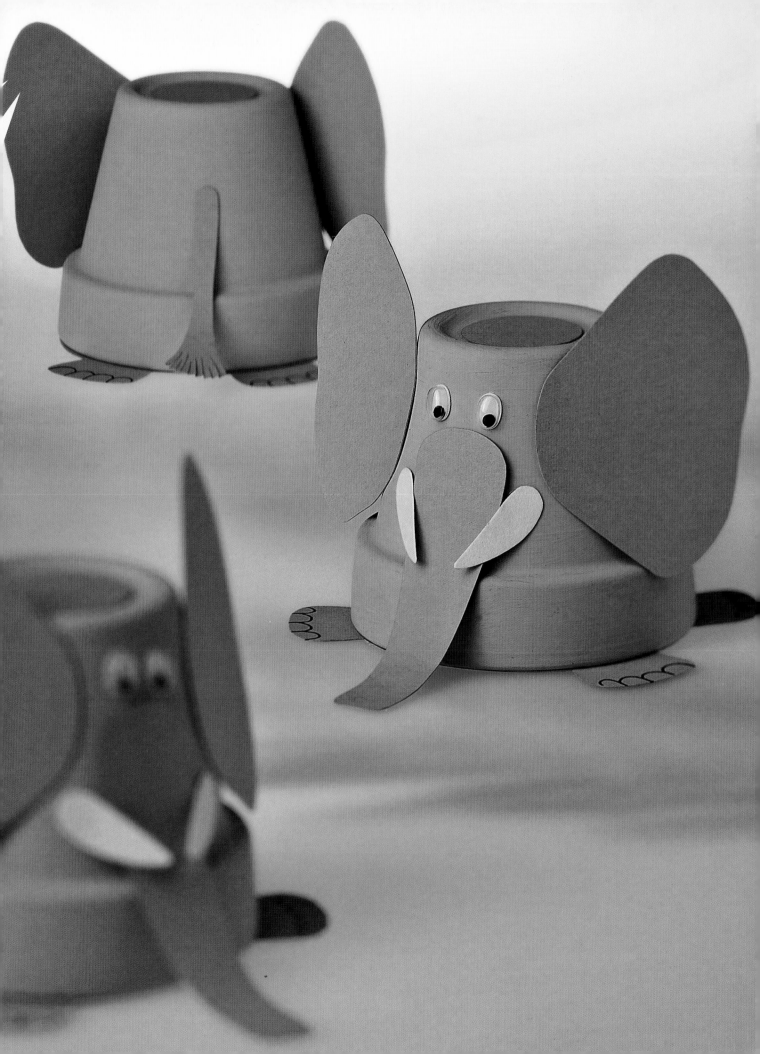

## Materials for the Bat

- 1 clay pot, 2 $\frac{3}{4}$" (7 cm) in diameter
- Terra cotta poster board, 5 $\frac{7}{8}$" x 8 $\frac{1}{4}$" (14.5 cm x 21 cm)
- Black broad-tipped felt pen
- 2 wobbly eyes, about $\frac{1}{2}$" (1 cm) in diameter
- 1 burnished sticking wire, 1 mm in diameter x 12" (30 cm) long
- 1 burnished sticking wire, 1 mm in diameter x 2 $\frac{3}{4}$" (7 cm) long
- Suspension spring, about $\frac{1}{4}$" (0.5 cm) in diameter x 8" (20 cm) long
- Template

# Halloween Bat

Draft the wingbone outlines and the ear contours with a pencil and trace with a broad felt-tipped pen. For the feet, fold a rectangular piece of poster board, 1" x 2 $\frac{1}{4}$" (3 cm x 6 cm), into a square, about 1" x 1" (3 cm x 3 cm). Draw the contours of the foot stencil twice along the fold; the dotted line should adjoin the fold. Cut out both feet. First glue the ears onto the clay pot and then the eyes. Paint on the face, and then attach the wings to the back of the pot.

Bend the long wire into shape for the sign. Put the wire into the fold of the feet, and then glue them together. Attach the sign with the two wire ends. From below, glue the feet together with the sign to the inside pot rim. Bend the short sticking wire into an eye (see template). From above, put the two ends through the pot hole, spread them apart, and attach the suspension spring to the eye.

# Spider

Glue the wobbly eyes onto the card head and paint on the face. Use a glue gun to attach the head to the clay pot. Cover the small pot hole with a black cross. Put the four pipe cleaners on top of each other in a star shape. Wind the long one a few times around the center to keep the shape together. Center the pot on the pipe cleaner star. Bend the spider legs upward against the pot rim and after about 1 $\frac{1}{2}$" (4 cm) bend them downward again. After another 1 $\frac{1}{2}$" (4 cm), bend them upward again.

## Materials for the Spider

- 1 clay pot, about 2" (5 cm) in diameter
- Terra cotta and black poster board
- 3 black pipe cleaners, 9 $\frac{1}{2}$" (24 cm) long
- 1 black pipe cleaner, 10 $\frac{1}{2}$" (26 cm) long
- 2 wobbly eyes, $\frac{1}{2}$" (1 cm) in diameter
- Template

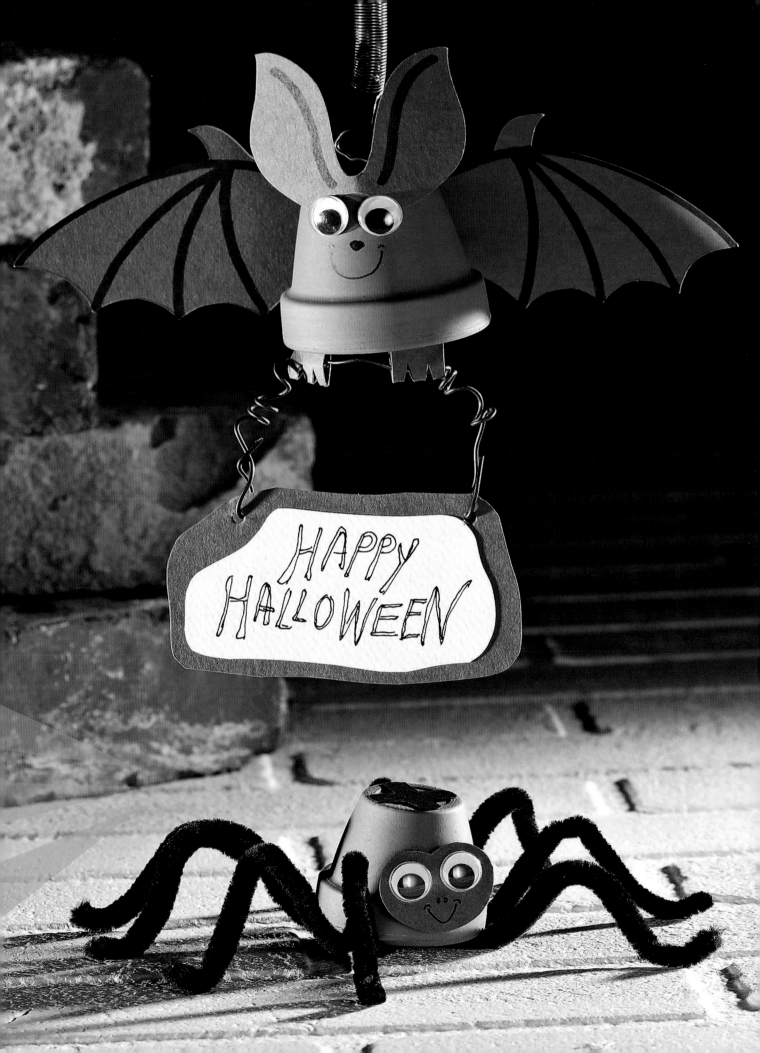

# Penguins

Make the belly cardboard stencil by following the dotted line on the template. Press the stencil against the clay pot and trace it with pencil. Paint the area inside the contour white, and paint the rest of the pot black. Paint the hat pot and the cotton ball either red or blue. Put the cotton ball onto the pipe cleaner and use a glue gun to fix the other end of the wire into the hole of the hat pot. Glue the hat to the body.

For the beak, fold an orange card strip, 1/2" x 3" (1 cm x 8 cm), in half. Place the triangular beak stencil on top of it with the dotted line next to the fold. Trace the stencil with pencil and cut out the folded beak. Cut out the other poster board elements. Wind the tips of the skis around a pen so they bend upward. Use a side cutter to shorten the wooden skewers to a suitable length, paint them, and glue them to the wings. Finish by gluing on the eyes, beak, wings, and feet with skis.

**Materials for One Penguin**
- 1 clay pot, about 2" (5 cm) in diameter
- 1 clay pot, 2 3/4" (7 cm) in diameter
- Black, white, and carmine red or medium blue matte craft paint
- Orange, black, and red or blue poster board
- 2 wobbly eyes, 1/2" (1 cm) in diameter
- Red or blue pipe cleaner, 4" (10 cm) long
- 1 cotton ball, 1" (3 cm) in diameter
- 2 rounded wooden skewers, 3 mm in diameter x 2 3/4" (7 cm) long
- Template

# Pigs

(Larger photograph on page 144)

Apply a pink base coat to the clay pot. Cut out the snout (dotted line on the template) and attach it to the head with tape. Paint on the face. Apply blusher with a colored pencil and, if desired, attach a shamrock with a small dot of glue. Use a glue gun to attach the head to the clay pot. Use all-purpose glue to attach the arms, feet, and tail (the gluing position is marked on the template with a small cross). Attach the heart between the front feet. To make the charm chain, pierce the hearts and shamrocks and thread them onto the wire. Twist the ends into spirals, tie the chain around the pig's neck, and twist the ends together.

**Materials for One Pig**
- 1 clay pot, 2 3/4" (7 cm) in diameter
- Pink matte craft paint
- Pink, red, and green poster board
- Red colored pencil
- Distancing tape
- Burnished florist wire, 0.35 mm in diameter x 8" (20 cm) long (optional)
- Template

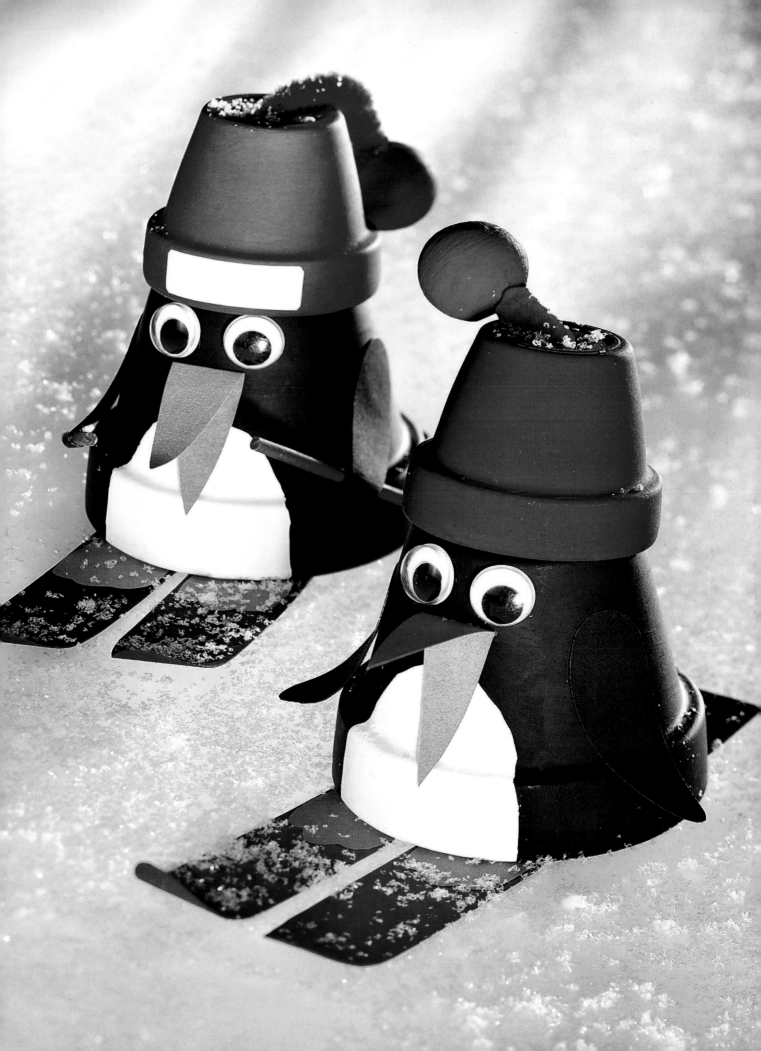

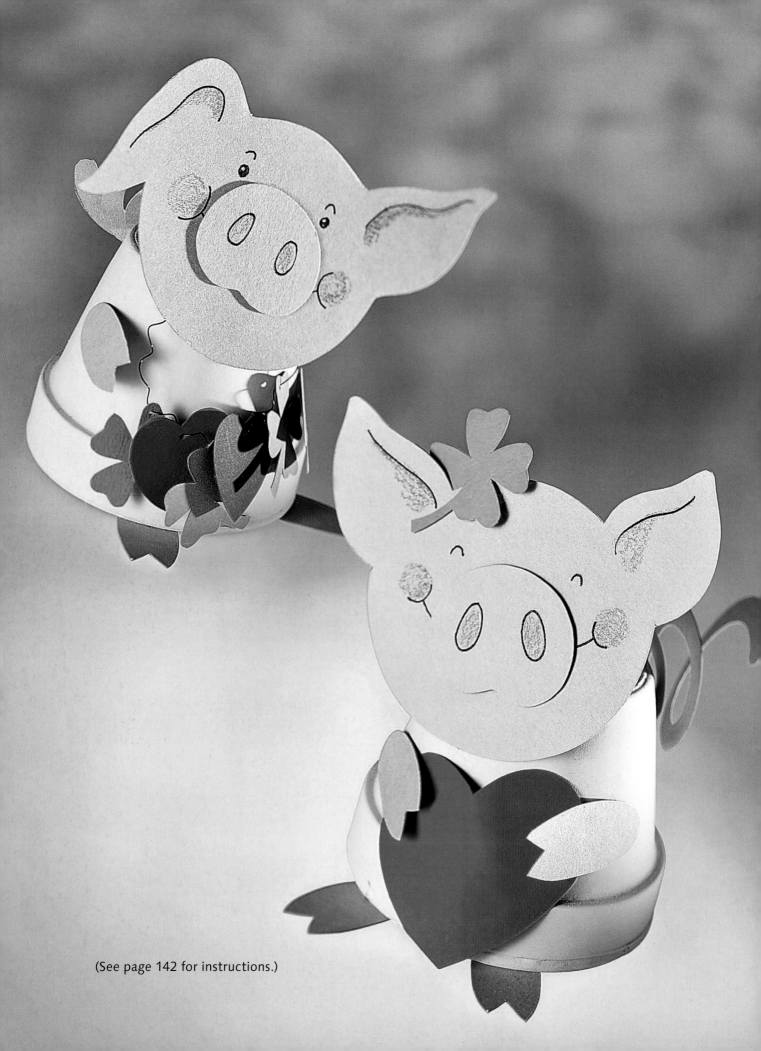

(See page 142 for instructions.)

## Materials for the Angel

- 2 clay pots, 2" (5.1 cm) in diameter
- Silver and gold metallic pipe cleaners
- 2 mm white foam mat
- 1 wood head bead, 1¼" (3.2 cm) in diameter
- 1 wood bead, ³⁄₈" (1 cm) in diameter
- Pearl white metallic paint
- Template

## Materials for the Devil

- 2 clay pots, 2" (5.1 cm) in diameter
- Red metallic pipe cleaner
- 1 wood head bead, 1¼" (3.2 cm) in diameter
- ³⁄₈" (1 cm) bead or craft wood stick
- Ruby red metallic paint
- Black or white poster board
- 2 mm white foam mat
- Template

# Angel

Thread the silver metallic pipe cleaner through the ³⁄₈" (1 cm) bead and bend in half. Push the ends through the bottom of one pot to make the arms. Glue the two pots together to form the body. Use the template to mark the angel wings on the foam mat; cut out. Attach the wings to the upper body using a low-heat glue gun. Paint the body, wings, and head with the pearl paint. After the paint dries, glue the head onto the body. Make a halo from the gold metallic pipe cleaner and glue to the back of the head with hot glue. Draw the face using a medium-point black permanent marker. Bend the arms in half and twist to secure.

# Devil

Thread the pipe cleaner through the ³⁄₈" (1 cm) bead and bend in half. Push the ends through the bottom of one pot to make the arms. Glue the two pots together to form the body. Use the template to mark the devil horns on the foam mat; cut out. Attach the horns to the upper head using a low-heat glue gun. Paint the body and head with the metallic paint. After the paint dries, glue the head onto the body. Make the pitch-fork from black poster board, or paint white poster board. Draw the face using a medium-point black permanent marker. Highlight the face with silver permanent marker. Bend the arms in half and twist to secure. Insert the pitchfork into the bend at the end of one arm.

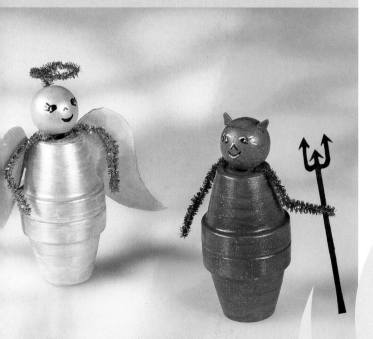

- 1 clay pot, 2" (5.1 cm) in diameter
- 1 clay pot, 1¾" (4.4 cm) in diameter
- 1 wooden bead head, 1¼" (3.2 cm) in diameter
- 2 wooden beads, ³/₈" (1 cm) in diameter
- 1 wooden bead, ¼" (0.6 cm) in diameter
- Pink tulle, 3"x 36" (7.6 x 91 cm)
- Pink, light brown, and silver pipe cleaners
- Pearlized pink, pearlized white, pink, red, blue, and brown craft paint

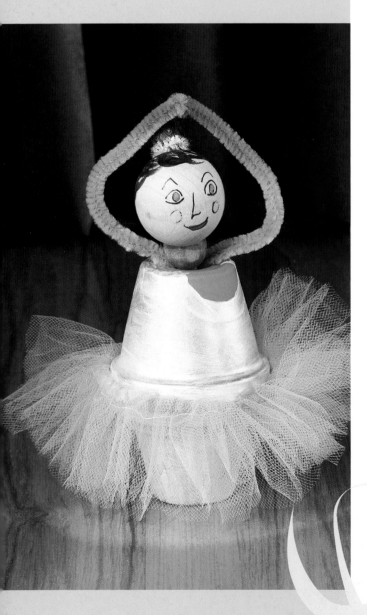

# Ballerina

Fold the brown pipe cleaner in half and insert the folded end into one ³/₈" (1 cm) bead. Glue the hole of the head bead over the folded pipe cleaner end and onto the smaller bead. Thread the loose ends of the pipe cleaner through the hole of the larger pot and through the second ³/₈" (1 cm) bead. Pull the head and neck tight to the pot, and then thread the pipe cleaner ends back through the pot hole to form the arms. Glue the smaller pot onto the larger pot. Paint the larger pot pearl white and the smaller pot pearl pink.

Fold the tulle in half. Baste along the folded edge, about ⅛" to ¼" (0.3 to 0.6 cm) from the folded edge. Slide the pink pipe cleaner into the pocket formed by the fold and the basting. Scrunch the tulle evenly along the pipe cleaner, and pull the basting thread tight to secure. Wrap the pipe cleaner around the ballerina's waist, and adjust the tulle to form the tutu. Cut the pipe cleaner to length. Use low-heat hot glue to glue the tutu in place. Glue the ¼" (0.6 cm) bead to the rear of the top of the head to form the bun Paint the bun and hair brown. Draw the face with a fine-point permanent marker. Wrap a short length of white or sparkle pipe cleaner around the base of the bun. Paint in the face details. Pose the arms as desired.

**TIP**

A variety of face templates is included on page 177.

# Babies

Paint the pot and head pink, if desired, or paint the head terra cotta to match the pot. Cut a 1½" x 6" (3.8 x15 cm) piece of white foam mat. Align the foam mat so it slightly overlaps the bottom of the rim, and overlaps the top of the pot by about ½" (1.3 cm). Using low-heat hot glue, glue the mat to one point on the rim. Fold the mat over the rim and glue, and then stretch it tightly until it conforms to the shape of the rim. Glue in place and cut off any overlap. Cut the arms and legs from pink or brown foam mat according to the template. Glue the legs to the base of the pot. Glue the arms to the sides of the pot. Glue on the head. Use the template to trace the face. Outline the face with a fine-point permanent marker, and then paint in color details. Glue a twist of floss to the top of the head for hair.

**Materials for One Baby**

- 1 clay pot, 2" (5.1 cm) in diameter
- 2 mm foam mat, white, pink, or brown
- Pink, terra-cotta, white, red, blue or brown craft paint
- 1 wood head bead, 1½" (3.8 cm) in diameter
- Embroidery floss, yellow or black
- Template

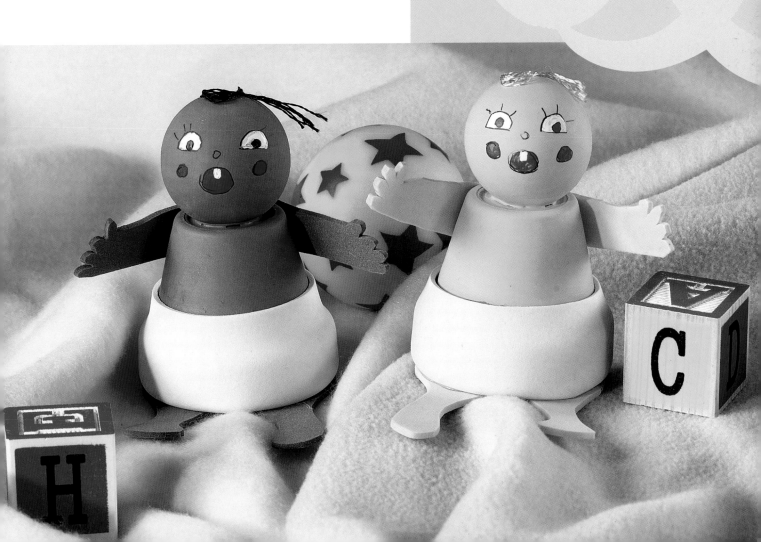

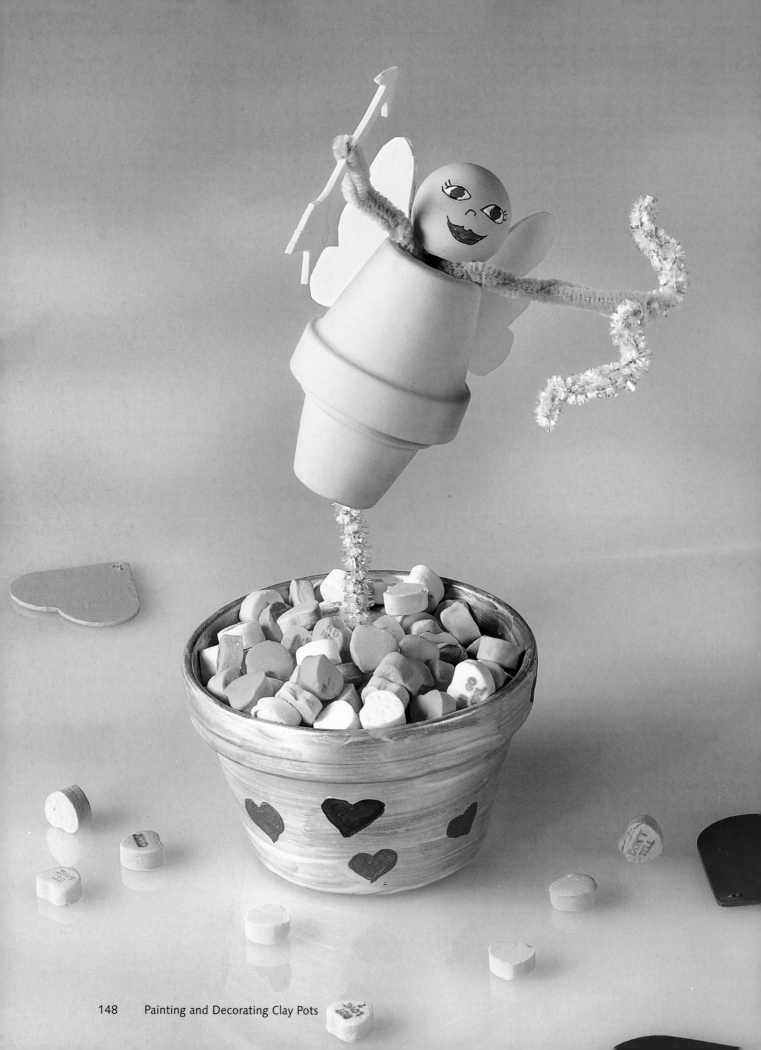

# Cupid

Thread the pink pipe cleaner through the ⅜" (1 cm) bead and bend in half. Push the ends through the bottom of one pot to make the arms. Glue the two pots together to form the body. Paint the body and head pink. Use the template to mark the wings on the foam mat; cut out. Attach the wings to the upper body using a low-heat glue gun. Glue the head onto the body. Draw the face with a fine-point permanent marker. Paint in the face details. Bend the arms in half and twist to secure. Make a bow from the silver metallic pipe cleaner and push through the end of one arm. Cut an arrow from the foam, and push through the end of the other arm. Slide the Cupid over the wire from the Bucket of Hearts.

# Bucket of Hearts

Cut the hanger wire to about 12" (30 cm). Drill a small hole in the bottom of the saucer. Bend a circle at one end of the wire to fit the saucer, with the straight end of the wire protruding through the bottom of the saucer. Glue the saucer upside down in the bottom of the pot. This makes the holder for the Cupid. Paint the pot inside and out with pearlized white paint. Paint the pot with hearts, or glue wood or foam hearts to the pot. Wrap the wire with pipe cleaners.

**Materials for Cupid**
- 2 clay pots, 2" (5.1 cm) in diameter
- 1 wood head bead, 1¼" (3.2 cm) in diameter
- 2 mm pink foam mat
- Pink and silver pipe cleaners
- 1 wood bead, ⅜" (1 cm) in diameter
- Pink, red, blue, and white craft paint
- Template

**Materials for Bucket of Hearts**
- 1 clay bulb pot, 4" (10 cm) in diameter
- 1 clay saucer, 2¾" (7 cm) in diameter
- Red, berry, pink and pearlized white craft paint
- Hanger wire
- Pink or white pipe cleaners
- Wood or foam heart cutouts

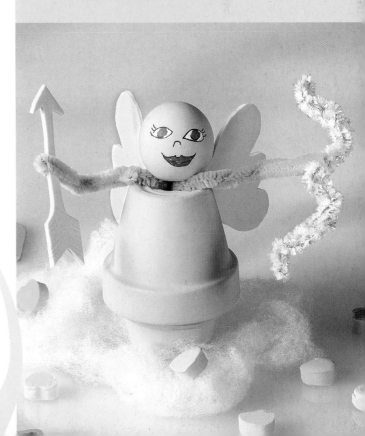

# Groom

Thread the bead onto the pipe cleaner to the halfway point. Thread the ends of the pipe cleaner through the bottom of one of the 2" (5.1 cm) pots. Glue the two 2" (5.1 cm) pots together, rim to rim. Glue a small pot right side up on top of the arms. Paint the black tails, gray pants, and white shirt. Paint on the bow tie and black buttons. Use a fine-point black permanent marker to draw the pin stripes onto the gray pants. Cut the hat brim from the black foam, using the template. Glue the brim onto the head, and glue the second small pot on top to form the top hat. Paint the hat black. Use the marker to draw the face, and then paint in the color details. Fold pipe cleaners in half to make arms.

# Bride

Thread a bead onto the pipe cleaner to the halfway point. Thread the ends of the pipe cleaner through the bottom of the 1¾" (4.4 cm) pot. Glue this pot over the bottom of the larger pot. Glue the smaller pot right side up on the bottom of the 1¾" (4.4 cm) pot. Paint the body pots pearl white. Fold one pipe cleaner arm in half, then slide the second through the fold, and fold it in half. Draw the face with a fine-point permanent marker, and then paint in the color details. Thread the tulle into the second bead. Arrange the veil as desired, and then glue the bead into the head pot. Create a bouquet of small faux flowers, and slide into the hands.

**TIP**

Paint the bride's dress and make the veil to match the bride of your choice.

**Materials for the Groom**
- 2 clay pots, 2" (5.1 cm) in diameter
- 2 clay pots, 1¼" (3.2 cm) in diameter
- Black pipe cleaner
- Red, blue, white, black, gray, and white craft paint
- 1 wood bead, ³/₈" (1 cm) in diameter
- 2 mm black foam mat
- Template

**Materials for the Bride**
- 1 clay pot, 2½" (6.4 cm) in diameter
- 1 clay pot, 1¾" (4.4 cm) in diameter
- 1 clay pot, 1¼" (3.2 cm) in diameter
- 2 wood beads, ³/₈" (1 cm) in diameter
- White tulle, 6" X 18" (15 X 46 cm)
- White pipe cleaner
- Pink, red, blue, and pearlized white craft paint
- Small faux flowers

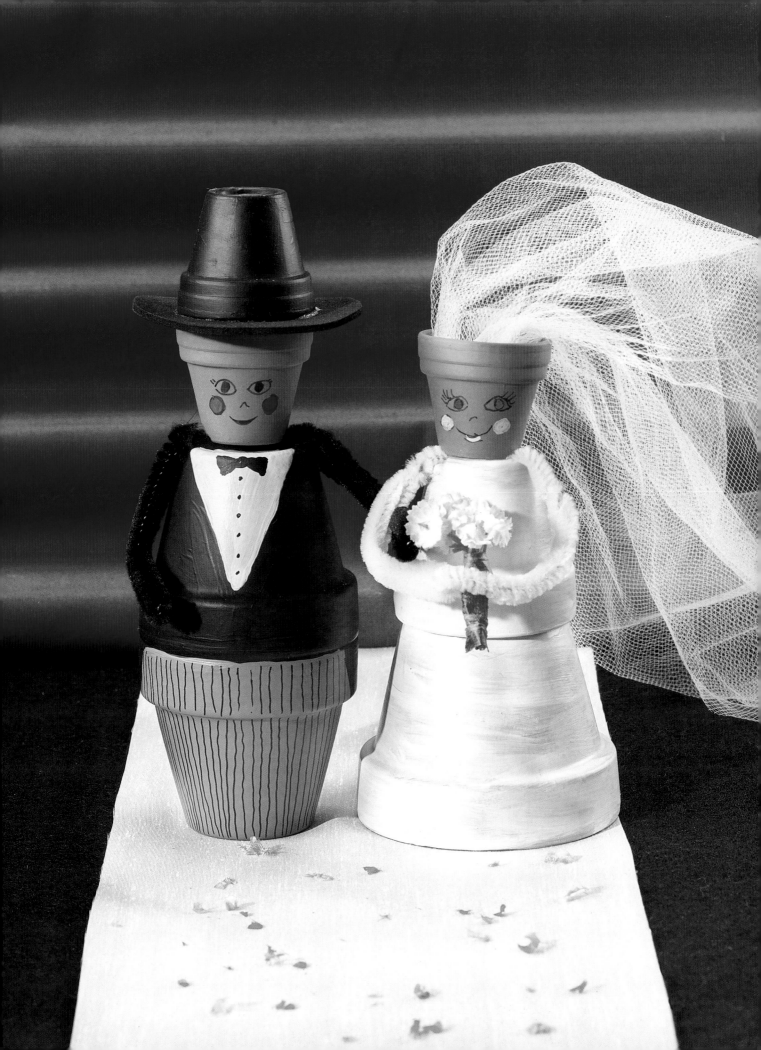

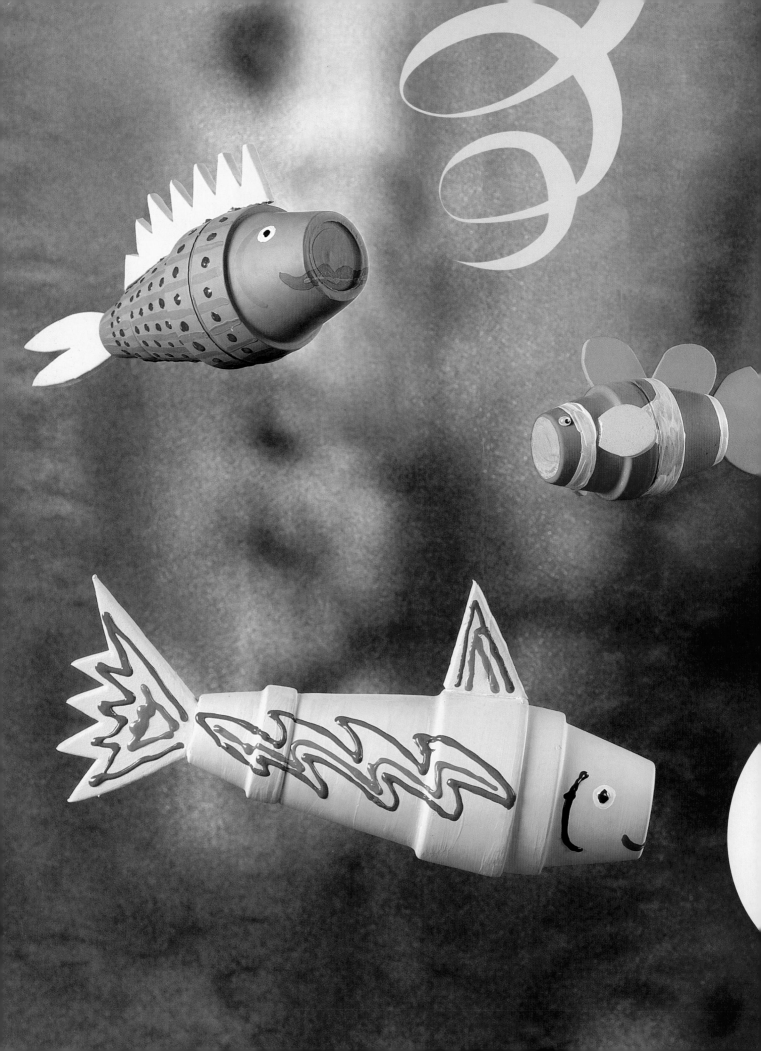

# Green Whimsical Fish

Glue the two larger pots together rim to rim. Glue the smaller pot to the bottom of one pot. Cut out the fin and tail, and glue in place using a low-heat glue gun. Paint the fin and tail yellow. Paint the body garden green, striped with blue. Apply dots of berry red dimensional paint. Paint in the eyes, mouth, and gills.

# Clown Fish

Glue the two pots together rim to rim. If you will be suspending the fish, tie the filament around the middle of the body. Cut the foam fins, using the template. Glue the fins to the body using a low-heat glue gun. Paint the body orange and white. Glue on the wobbly eyes.

# Yellow Whimsical Fish

Glue the two larger pots together rim to rim. Glue the smaller pot to the bottom of the rose pot. Cut out the fin and tail, and glue in place using a low-heat glue gun. Paint the body, fin, and tail yellow. Use red and orange dimensional paint to create the lightning bolt and the fin and tail highlights. Paint in the eyes and gills with lavender dimensional paint. Paint around the eyes with white. Draw the mouth with berry dimensional paint.

**Materials for Green Whimsical Fish**
- 2 clay pots, 2" (5.1 cm) in diameter
- 1 clay pot, 1¼" (3.2 cm) in diameter
- 6 mm white foam mat
- Yellow, azure blue, berry, and garden green craft paint
- Berry red dimensional paint
- Template

**Materials for the Clown Fish**
- 2 clay pots, 1¾" (4.4 cm) in diameter
- 2 mm orange foam mat
- Orange and cream craft paint
- Wobbly eyes
- Clear filament
- Template

**Materials for Yellow Whimsical Fish**
- 1 clay pot, 2½" (6.4 cm) in diameter
- 1 clay rose pot, 2½" (6.4 cm) in diameter
- 1 clay pot, 1¾" (4.4 cm) in diameter
- 6 mm white foam mat
- Yellow and white craft paint
- Red, orange, lavender, and berry red dimensional paint
- Template

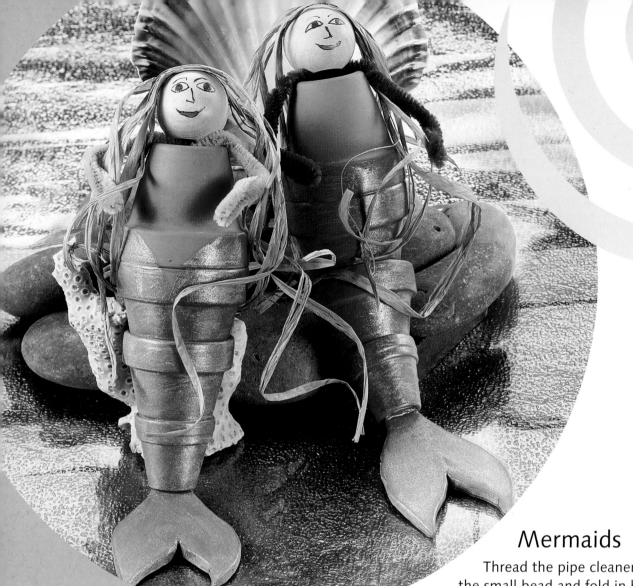

## Materials
### for One Mermaid

- 2 clay pots, 2½" (6.4 cm) in diameter
- 1 clay pot, 2" (5.1 cm) in diameter
- 1 clay pot, 1¼" (3.2 cm) in diameter
- 6 mm white foam mat
- Green raffia
- Red, blue, garden green, reef blue, and clear pearlizing craft paint
- Brown or light brown pipe cleaner
- 1 wood bead, ⅜" (1 cm) in diameter
- 1 wood head bead, 1¼" (3.2 cm) in diameter
- Template

# Mermaids

Thread the pipe cleaner through the small bead and fold in half. Thread the two ends through the hole in the bottom of one of the 2½" (6.4 cm) pots to form the arms. Glue the 2½" (6.4 cm) pots together rim to rim. Glue a 2" (5.1 cm) pot over one of the 2½" (6.4 cm) pots. Glue the 1¼" (3.2 cm) pot over the 2" (5.1 cm) pot. The tail can be made straight, or slightly curved by gluing the smaller pots at slight angles. Cut the tail from the foam mat, using the template. Glue on the tail using a low-heat glue gun. Glue the head to the body. Cut the raffia to 12" (30 cm) lengths and glue to the top of the head. Paint the tail garden green. Mix the blue paint with the pearlizing medium and paint over the tail. Draw the face with a fine-point permanent marker. Paint in the face details. Trim the raffia to the desired length.

## Standing Gingerbread Man

Glue the two 1¾" (4.4 cm) saucers together rim to rim to make the head. Glue the 2" (5.1 cm) saucer to the 2" (5.1 cm) pot. When dry, glue the head to the body. Glue the 1¼" (3.2 cm) pots to the body to make the arms and legs. When dry, "frost" with shiny white dimensional paint.

## Seated Gingerbread Man

Glue the two 1¾" (4.4 cm) saucers together rim to rim to make the head. Thread two strands of raffia through the hole in the 2" (5.1 cm) pot. Tie or glue into place. Glue the head to the body. Decorate the head, body, arms, and legs with shiny white and berry red dimensional paint. When dry, knot the legs and arms onto the raffia.

### Materials for Standing Gingerbread Man
- 1 clay pot, 2" (5.1 cm) in diameter
- 4 clay pots, 1¼" (3.2 cm) in diameter
- 1 clay saucer, 2" (5.1 cm) in diameter
- 2 clay saucers, 1¾" (4.4 cm) in diameter
- Shiny white dimensional paint

### Materials for Seated Gingerbread Man
- 1 clay pot, 2" (5.1 cm) in diameter
- 4 clay pots, 1¼" (3.2 cm) in diameter
- 2 clay saucers, 1¾" (4.4 cm) in diameter
- Shiny white and berry red dimensional paint
- Raffia

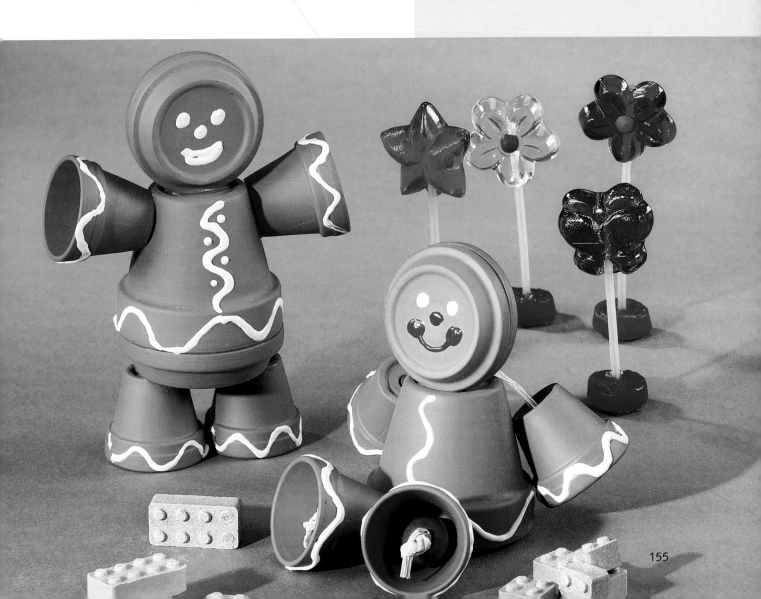

## Materials for Hula Girl

- 2 clay pots, 2" (5.1 cm) in diameter
- 1 wood bead, 3/8" (1 cm) in diameter
- 1 wood head bead, 1¼" (3.2 cm) in diameter
- Green raffia
- Black embroidery floss
- Small white shell beads and weathered glass beads
- Red, brown, red iron oxide, and terra-cotta craft paint
- Brown pipe cleaner

## Materials for One Palm Tree

- 4 clay pots, 2" (5.1 cm) in diameter
- 3 clay pots, 1¾" (4.4 cm) in diameter
- 1 clay saucer, 4" (10 cm) in diameter
- Wood beads, 3/8" (1 cm) and ¼" (0.6 cm) in diameter
- Hanger wire
- 2 mm green foam mat
- Template

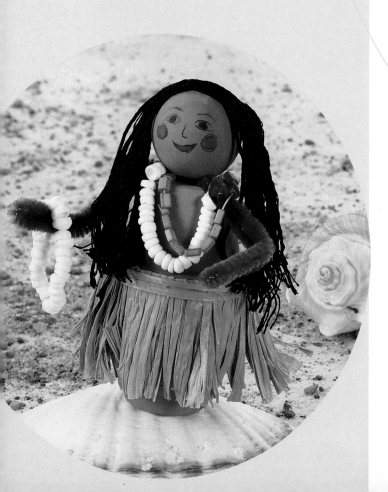

# Hula Girl

Paint the head bead terra cotta. Mix in red or red iron oxide, if necessary, to match the shade of the pots. Thread the pipe cleaner through the smaller wood bead and bend in half. Thread the ends of the pipe cleaner through the hole in one of the pots to form the arms. Glue the two pots together rim to rim. Glue on the head. Cut the floss into 6" (15 cm) lengths. Glue the floss to the top of the head to form hair. Cut a length of cardboard 8" long x 2" wide (20 x 5.1 cm). Wrap the raffia around the width of the cardboard, securing each end with tape. Glue a 10" (25 cm) length of raffia aligned along one 8" (20 cm) edge to form the waistband of the grass skirt. When the glue has dried, cut through the raffia opposite the waistband. Wrap the grass skirt around the waist of the hula girl and glue in place. Trim the skirt to the desired length. Bend the arms in half to double the pipe cleaner. Thread the shell beads and glass beds onto white thread to make the leis. Tie two leis around the neck and drape the third over the arm.

# Palm Trees

Cut the hanger wire to about 12" (30 cm). Wrap the wire around a 3/8" (1 cm) wood bead and glue into the bottom of a 2" (5.1 cm) pot, so the wire protrudes through the hole. When dry, glue the pot upside down onto the bottom of the saucer. Bend the wire to form an arching trunk, or leave straight for an upright tree. Stack the 2" (5.1 cm), then the 1¾" (4.4 cm) pots over the wire, using the beads for spacers. Glue the top pot to the top of the last spacer. Cut the wire at the end of last pot. Cut 8 to 10 leaves from the foam mat, using the template. Fold each leaf in half lengthwise and stretch to form a gentle curve. Make diagonal cuts along the sides of the leaves, almost to the fold. Attach the leaves to the top of the trunk.

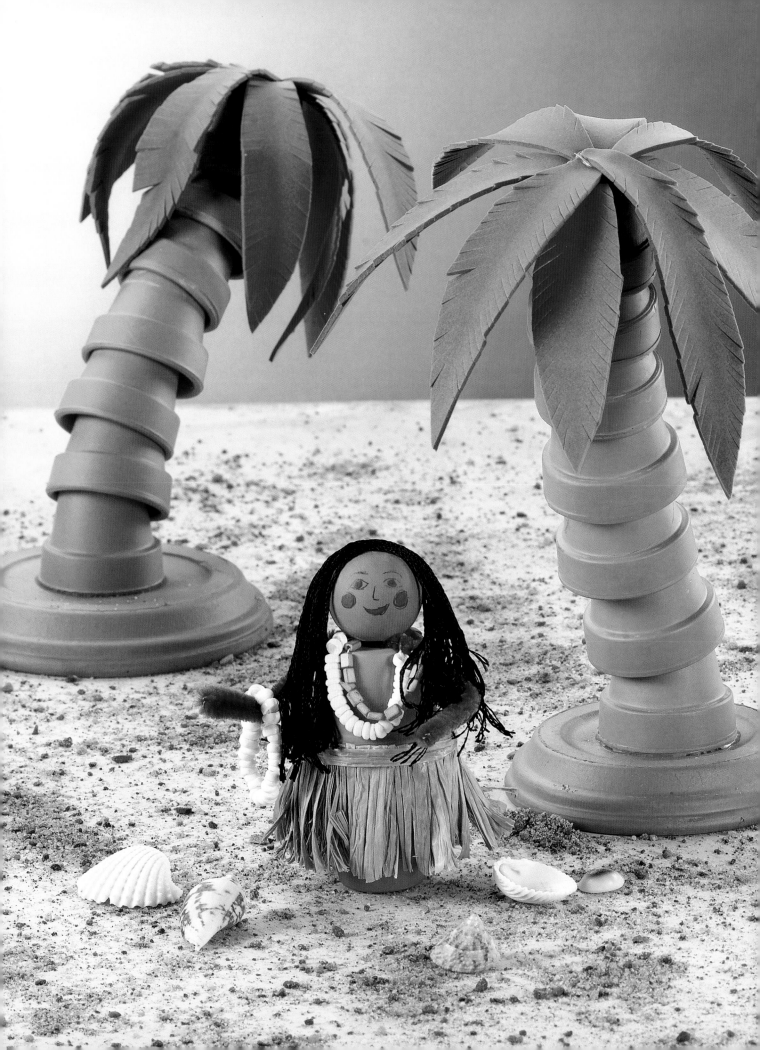

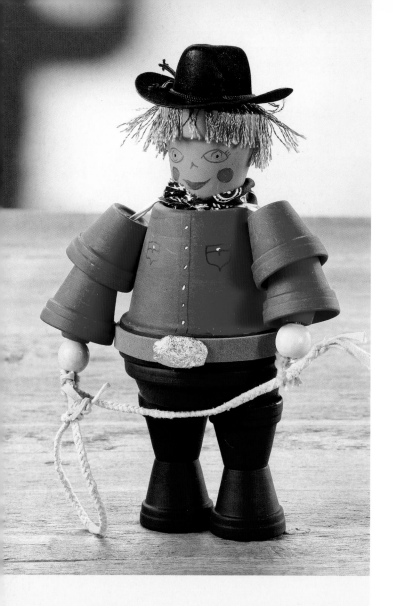

# Cowboy

Paint four of the 1¼" (3.2 cm) pots, the minipots, and the 3" (7.6 cm) pot red. Paint the saucer and four of the 1¼" (3.2 cm) pots blue. Draw in the western shirt details and use a silver marking pen to create pearl buttons. Assemble the body according to directions on page 9, but without legs and using only two pots for each arm. Thread a minipot onto the end of each arm, followed by a bead. You may need to drill a hole in the base of the minipot. Tie off the raffia and cut. Glue the saucer to the opening of the body pot. Glue the bases of the leg pots together, then glue to the saucer.

Draw the face onto the 1¾" (4.4 cm) pot, using a fine-point permanent marker. Paint in the color highlights. Glue the head pot to the body. Cut the floss into 6" (15.2 cm) lengths, and glue onto the large bead. When dry, untwist the floss strands, and cut to length. Glue the ball onto the head pot. Cut the bandana material to size using the template, fold in half, and tie around the neck. Glue the hat onto the ball or the rim of the head pot. Create the lariat and glue to the hands. Cut the belt from the foam mat. Cut a small oval of foam and cover with crumpled aluminum foil to form the rodeo buckle. Glue the belt and buckle to the cowboy's waist.

**Materials for Standing Cowboy**
- 1 clay pot, 3" (7.6 cm) in diameter
- 1 clay saucer, 3" (7.6 cm) in diameter
- 1 clay pot, 1¾" (4.4 cm) in diameter
- 8 clay pots, 1¼" (3.2 cm) in diameter
- 2 miniature clay pots
- Raffia
- 1 wood head bead, 1¼" (3.2 cm) in diameter
- 2 wood beads, ³/₈" (1 cm) in diameter
- Light brown embroidery floss
- Blue bandana fabric
- 3" (7.6 cm) cowboy hat
- Light blue, red, and navy blue paint
- Braided suede or twine
- 2 mm brown foam mat
- Aluminum foil
- Template

# Cowgirl

Paint the 1¼" (3.2 cm), miniature pots, and 3" (7.6 cm) pots light blue. Draw in the western shirt details and use a silver marking pen to create pearl buttons. Assemble the body according to directions on page 9, but without legs and using only two pots for each arm. Thread a minipot onto the end of each arm, followed by a bead. You may need to drill a hole in the base of the minipot. Tie off the raffia and cut. Draw the face onto the 1¾" (4.4 cm) pot, using a fine-point permanent marker. Paint in the color highlights. Glue the head pot to the body. Cut the floss into 6" (15.2 cm) lengths, and glue onto the large bead.

When dry, untwist the floss strands, cut bangs to length and pull the hair into pony tails and tie with floss. Glue the ball onto the head pot. Cut the bandana material to size using the template, fold in half, and tie around the neck. Glue the hat onto the ball or the rim of the head pot. Cut out the chaps using the template. Cut the chap fringe. Create the chaps by rolling the suede into a tube. To have the fringe facing backwards, roll one chap clockwise and the other counter clockwise. Bend the pipe cleaners in half and create a foot shape at the fold end. Place two cotton balls between the pipe cleaner ends and twist at the end. Push the assembly into the chaps to make a leg. Glue the top of the chaps together, then glue the tabs onto the inside sides of the cowgirl body. Glue the cowgirl to the top of the horse, if desired (see page 160), and glue or tie the reins onto one hand.

**Materials for Riding Cowgirl**
- 1 clay pot, 3" (7.6 cm) in diameter
- 1 clay pot, 1¾" (4.4 cm) in diameter
- 4 clay pots, 1¼" (3.2 cm) in diameter
- 2 miniature clay pots
- Raffia
- 1 wood head bead, 1¼" (3.2 cm) in diameter
- 2 wood beads, ⅜" (1 cm) in diameter
- Yellow and red embroidery floss
- Red bandana fabric
- Suede or Ultrasuede
- Brown pipe cleaners
- Cotton balls
- 3" (7.6 cm) cowboy hat
- Light blue, red, and navy blue paint
- Template

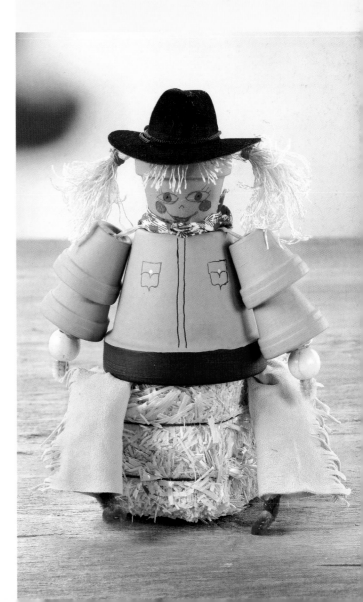

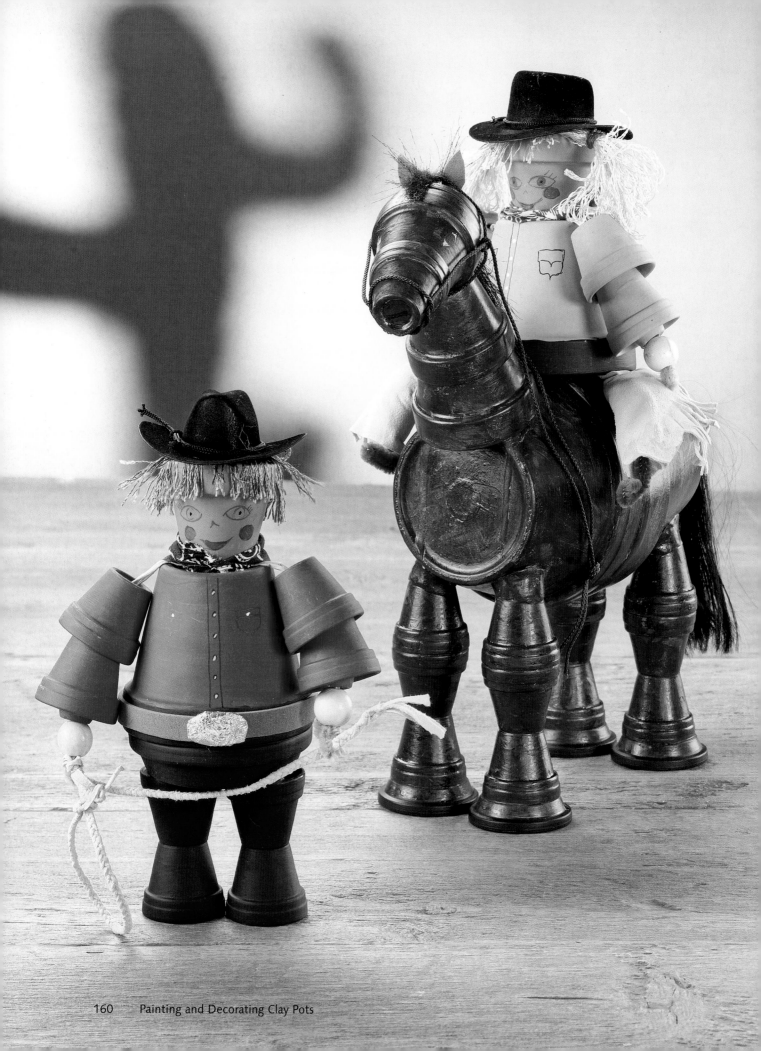

# Horse

Glue the two 4" (10 cm) pots together rim to rim to make the body. Glue the 2" (5.1 cm) pot inside the 1¾" (4.4 cm) pot to make the neck. Glue the 1¾" (4.4 cm) pot inside the 1¼" (3.2 cm) to make the head. Glue a saucer onto the open end of the head. Glue three 1¼" (3.2 cm) pots together to make each leg. Two pots are glued rim to rim, with the third glued end to end. Glue a saucer to the open-ended pot to create a hoof. Glue the head onto the neck at 90 degrees. When the legs have dried, glue them to the body. Use small wedges cut from the craft wood to fill the space between the curve of the body pot and the flat bottom of the leg pots. Glue the neck and head onto the body. If desired, use terra-cotta-colored modeling clay to fill in the gaps around the wood wedges and the pots.

Paint the horse. Cut out the ears and glue in place. Cut a strip of faux fur and glue it to the head and neck for the mane. Bundle the doll hair into a ¼" (0.6 cm) diameter hank. Apply glue to one end, and then wrap the end with additional hairs to secure. When dry, use hot glue to attach the tail to the body. Use a fine-point permanent marker to draw on the eyes and nose. Paint the whites of the eyes. Create a bridle with the twine.

**Materials for the Horse**
- 1 clay bulb pot, 4" (10 cm) in diameter
- 1 clay pot, 4" (10 cm) in diameter
- 1 clay pot, 2" (5.1 cm) in diameter
- 2 clay pots, 1¾" (4.4 cm) in diameter
- 13 clay pots, 1¼" (3.2 cm) in diameter
- 4 clay saucers, 1¾" (4.4 cm) in diameter
- Camel, dark brown, black, and white craft paint
- Braided twine
- Black faux fur
- Black straight doll hair

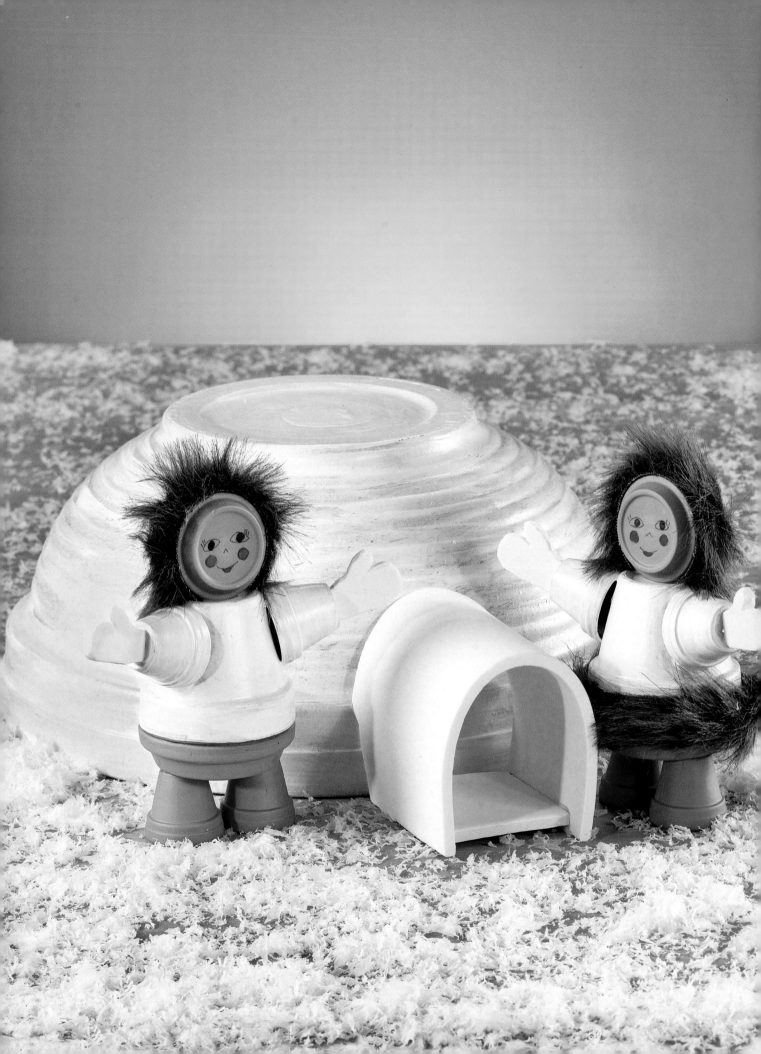

# Inuit

Glue the 3" (7.6 cm) pot and saucer together rim to rim to make the body. Glue the two small saucers together rim to rim to make the head. Glue the open ends of two small pots to the body to make the arms. Glue the bottoms of two small pots to the bottom of the body to make the legs. Glue the head to the body. Paint the body pot, arms, and back of the head shiny white. Cut strips of faux fur to fit around the face and waist, if desired, and glue in place. Cut the mittens from the foam and glue in place. Draw on the faces with a fine-point permanent marker. Paint in the face colors.

# Igloo

Glue a circle of paper over the hole in the pot. Paint the outside of the pot shiny white. Cut the foam pieces to size. Make the arch and glue to the edges of the arch floor. Glue the arch to the pot.

**Materials for One Inuit**
- 4 clay pots, 1¼" (3.2 cm) in diameter
- 2 clay saucers, 1¾" (4.4 cm) in diameter
- 1 clay pot, 3" (7.6 cm) in diameter
- 1 clay saucer, 3" (7.6 cm) in diameter
- 6 mm white foam mat
- Brown faux fur
- Shiny white, red, and brown paint
- Template

**Materials for Igloo**
- 1 clay bowl pot, 11" (28 cm) in diameter
- 6 mm white foam mat
- Shiny white craft paint
- Template

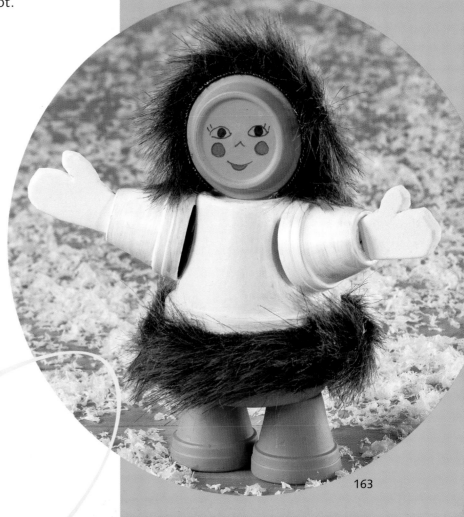

163

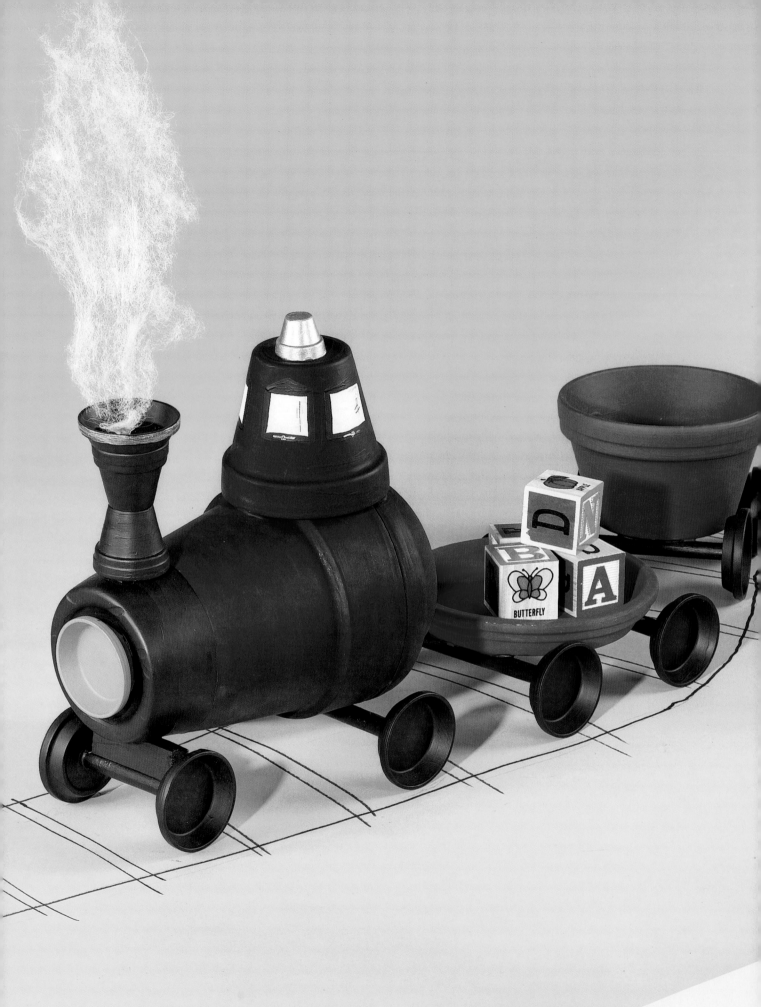

# Train Engine

Glue the large pot and saucer together rim to rim. Glue the two 1¼" (3.2 cm) pots together end to end and glue a saucer to one end to make the smoke stack. Cut two lengths of dowel, 4¼" (10.8 cm) long. Glue a saucer to each end of the dowels, with the bottom of the saucer facing in to make the axles and wheels. Glue a small saucer to the bottom of the rose pot to make the headlight. Glue the axles to the saucer and rose pot. Because the rose pot has a more angled shape, you may need to build up the front axle with a piece of craft wood. Glue the smoke stack onto the rose pot. Use a wedge cut from craft wood to make the smoke stack plumb. Glue the 3" (7.6 cm) pot upside down to form the cabin. Glue the minipot over the hole of the 3" (7.6 cm) pot to form the bell. Paint the wheels, axles, smoke stack, and front section of the engine black. Paint the rest of the engine blue. Paint the bell gold and paint a trim of gold around the top of the smoke stack. Paint windows with window frames on the cabin.

## Materials for Train Engine

- 1 clay saucer, 4" (10 cm) in diameter
- 1 clay rose pot, 4" (10 cm) in diameter
- 6 clay saucers, 1¾" (4.4 cm) in diameter
- 2 clay pots, 1¼" (3.2 cm) in diameter
- 1 clay pot, 3" (7.6 cm) in diameter
- 1 miniature clay pot, ½" (1.3 cm) in diameter
- Wood dowel, ¼" (0.6 cm) in diameter
- Craft wood, ¼" x ¾" (0.6 x 1.9 cm)
- Black, blue, gold, and white craft paint

# Flatbed Car

Cut two pieces of dowel long enough to extend past the bottom of the saucer ¼" (0.6 cm) on each side. Glue the small saucers to the ends of the dowels, with the bottoms of the saucers facing in. Paint the wheels and axles black. Paint the large saucer red. Glue the axles to the bottom of the saucer.

## Materials for the Flatbed Car

- 1 clay saucer, 4" (10 cm) in diameter
- 4 clay saucers, 1¼" (3.2 cm) in diameter
- Wood dowel, ¼" (0.6 cm) in diameter
- Red and black craft paint

# Coal Car

Put two pieces of dowel long enough to extend past the bottom of the pot ¼" (0.6 cm) on each side. Glue saucers to the ends of the dowels, with the bottoms of the saucers facing in. Paint the wheels and axles black. Paint the pot green. Glue the axles to the bottom of the pot.

## Materials for the Coal Car

- 1 clay bulb pot, 4" (10 cm) in diameter
- 4 clay saucers, 1¼" (3.2 cm) in diameter
- Wood dowel, ¼" (0.6 cm) in diameter
- Green and black craft paint

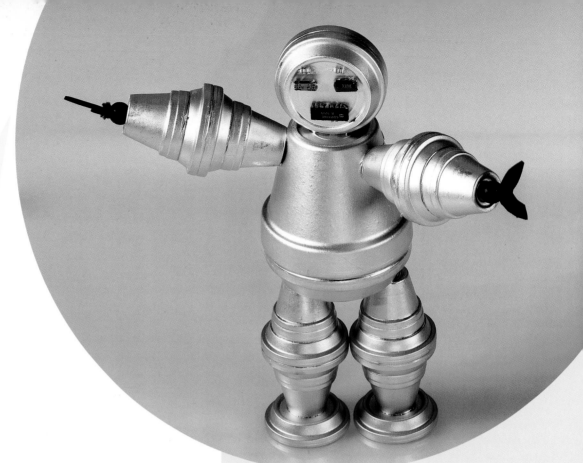

# Robot

Glue the 3" (7.6 cm) pot and saucer together rim to rim. Glue five sets of two 1¼" (3.2 cm) saucers together rim to rim to form the head and the arm and knee joints. Cut two pinchers from the foam mat, using the template. Poke a pipe cleaner through the middle of the pincher, twist together, thread through the bead and through the hole in a small pot and secure in place. Repeat for the other arm. Glue each hand pot to a saucer joint. Glue another pot to the other side of the joint to complete the arms. Glue pots to each side of the knee joint, then glue a saucer to the end of each leg to form a foot. Glue the feet and arms to the body. Use masking tape to hold the pieces in place while the glue dries. Glue on the head. Cover the pinchers and beads with masking tape. Spray paint the robot silver. When the paint has dried, remove the masking tape. Glue the electronic parts to the head to make the face. If you cannot find electronic parts, cut the face pieces from foam mat or create from modeling clay.

## Materials for the Robot

- 8 clay pots, 1¼" (3.2 cm) in diameter
- 12 clay saucers, 1¾" (4.4 cm) in diameter
- 1 clay pot, 3" (7.6 cm) in diameter
- 1 clay saucer, 3" (7.6 cm) in diameter
- Silver spray paint
- 2 mm black foam mat
- Silver pipe cleaner
- 2 black wood beads, ¼" (0.6 cm) in diameter
- Memory chips, capacitors, or transistors
- Template

### TIP

You can find electronic parts at surplus liquidators, or you can scavenge them from any broken appliance or electronic toy.

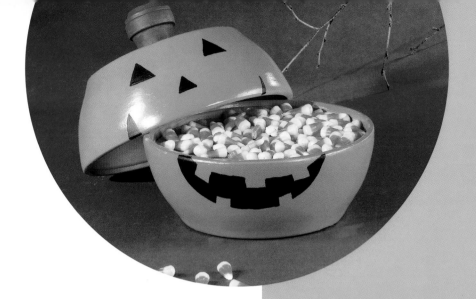

## Jack-o-Lanterns

If you are creating a candy bowl, do not glue the bowls together. Otherwise, glue the bowls together rim to rim. Glue the small pot upright on the base of one bowl. Glue the rims of the small pot and saucer together. Cover the stems with masking tape. Spray paint the bowls orange. Remove the masking tape, and paint the stems green. Sketch the face onto the pumpkin and paint black.

### Materials for Large Jack-o-Lantern

- 2 clay bowl pots, 11" (28 cm) in diameter
- 1 clay pot, 2½" (6.4 cm) in diameter
- 1 clay saucer, 2½" (6.4 cm) in diameter
- Glossy orange spray paint
- Black and green craft paint

### Materials for Small Jack-o-Lantern

- 2 clay bowl pots, 8" (20.3 cm) in diameter
- 1 clay pot, 1¾" (4.4 cm) in diameter
- 1 clay saucer, 1¾" (4.4 cm) in diameter
- Orange spray paint
- Black and green craft paint

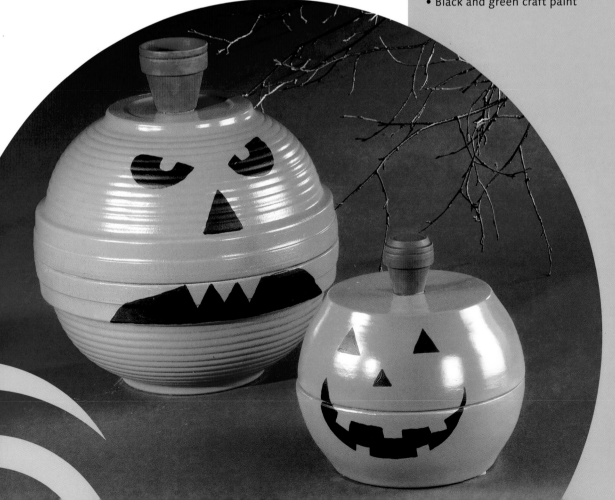

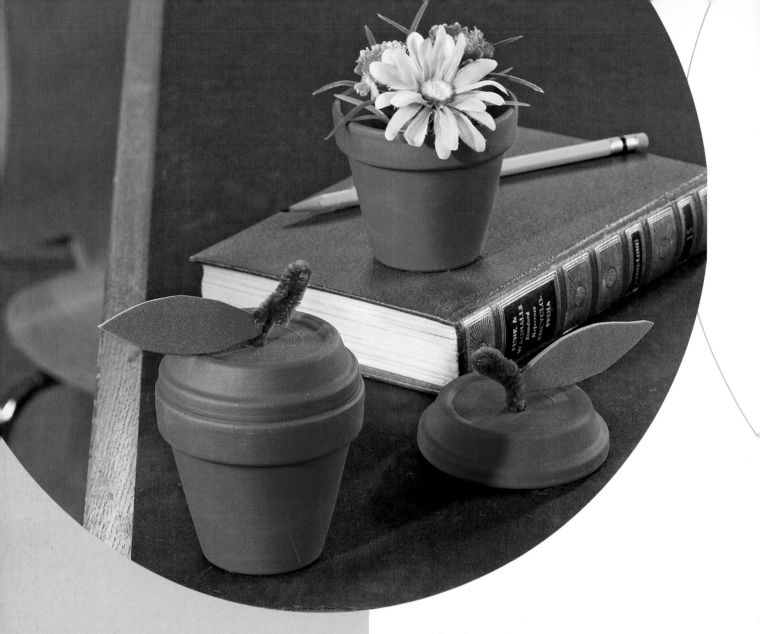

## Apple

If you want to use the apple as a candy dish, do not glue the saucer to the pot. Also, to make the stem sturdier, drill a small hole through the center of the saucer, push the bent, double pipe cleaner through the hole, and secure with a small craft stick or piece of poster board glued to the saucer. Paint the pot and saucer red. To make a shinier apple, use gloss paint, or finish with a gloss coating. Twist the pipe cleaner and cut to length. Cut the leaf using the template. Insert the leaf into the twists of the stem and secure with hot glue.

**Materials for One Apple**

- 1 clay pot, 3" (7.6 cm) in diameter
- 1 clay saucer, 3" (7.6 cm) in diameter
- Brown pipe cleaner
- 2 mm green foam mat
- Red craft paint
- Template

# Graduates

Thread the pipe cleaner through the smaller wood bead and bend in half. Thread the ends of the pipe cleaner through the hole in one of the pots to form the arms. Glue the two pots together rim to rim. Glue on the head, with the opening at the top. Paint the body pots black or blue. Paint the base of the cap on the head bead. Cut a 1" (2.5 cm) square from the foam mat and glue to the top of the head for the mortar board. To make the tassel, cut a 3" (7.6 cm) piece of embroidery floss, fold in half, and tie a knot at the fold. Tie another knot about 1" (2.5 cm) from the fold. Cut the floss about ¼" (0.6 cm) from the second knot and untwist the floss strands. Cut a pin in half and push through the first knot and into the center of the mortar board. Make the honor cords by knotting two strands of floss together. Draw the face using a fine-point permanent marker. Paint in the face colors. Bend the arms in half and pose as desired. Roll small pieces of paper and tie with red floss to make diplomas.

## Materials for One Graduate

- 2 clay pots, 2" (5.1 cm) in diameter
- 1 wood bead, ³⁄₈" (1 cm) in diameter
- 1 wood head bead, 1¼" (3.2 cm) in diameter
- Colored embroidery floss
- Black or blue craft paint
- Black or blue pipe cleaner
- Black or blue plastic head pin
- 2 mm black or blue foam mat

**TIP**

Paint the caps and gowns of the graduates to match your school colors.

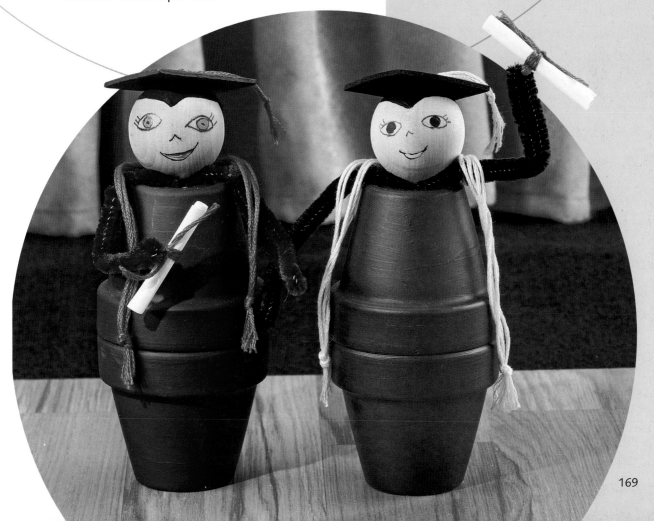

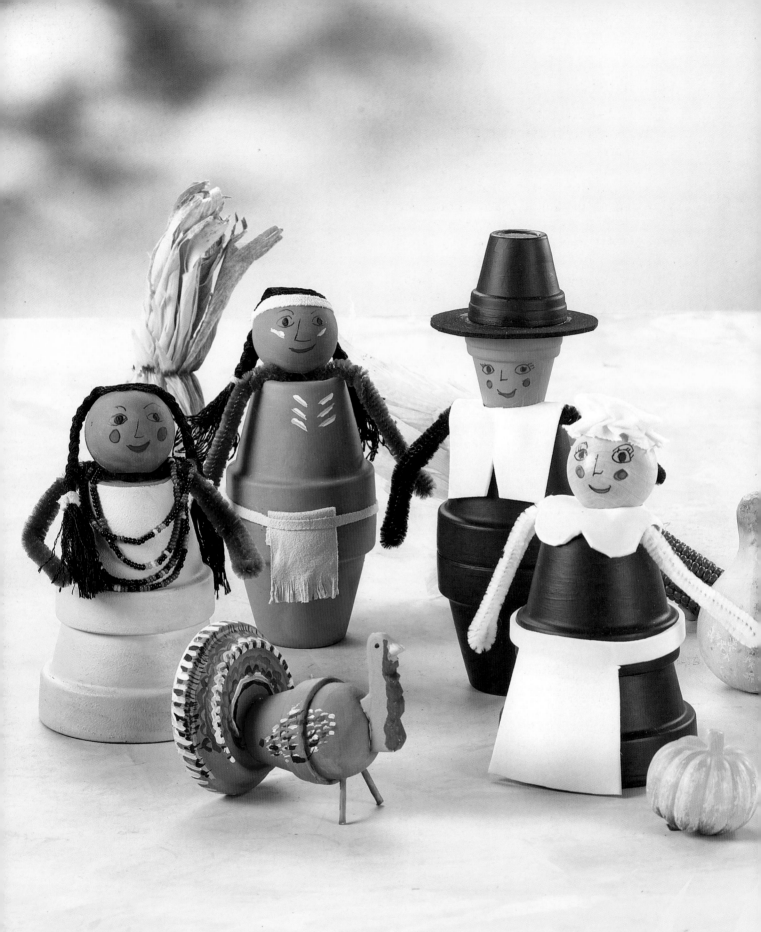

# Turkey

Glue the head bead into the pot. Glue the bottom of the saucer to the bottom of the pot, off center to form the tail. Drill small holes into the head bead and insert the toothpicks to form legs. Cut the toothpicks to length and glue in place. Cut the head and wattle from the 6-mm foam mat, using the template. Glue onto the bead. Paint the bead terra cotta to match the pots. Paint wings and feather details. Paint the neck and head lavender. Paint the wattle red and the beak yellow.

**Materials for Turkey**

- 1 clay pot, 1¼" (3.2 cm) in diameter
- 1 clay saucer, 1¾" (4.4 cm) in diameter
- 1 wood head bead, 1¼" (3.2 cm) in diameter
- Toothpicks
- 6 mm white foam mat
- Brown, dark brown, white, lavender, red ironoxide, and terra-cotta craft paint
- Template

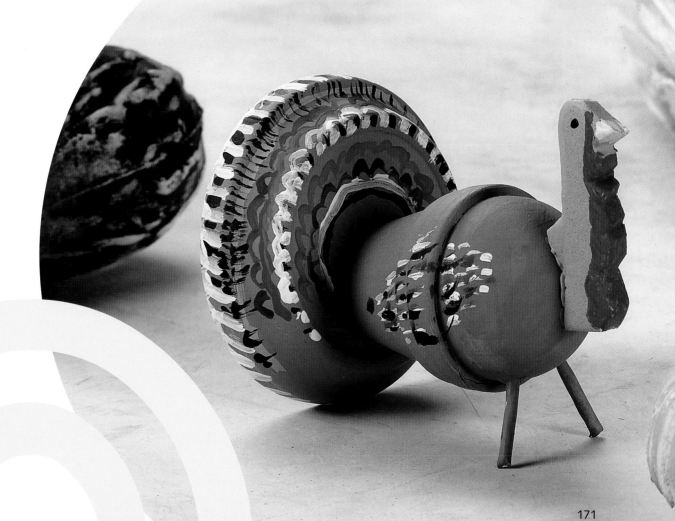

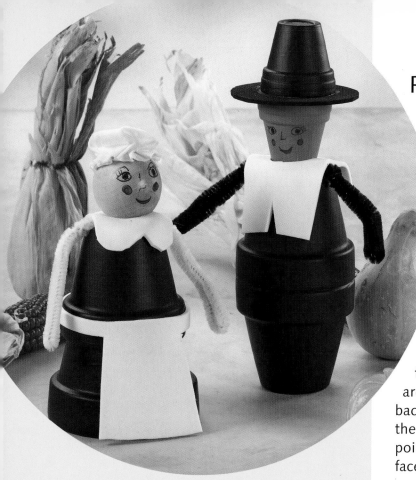

# Pilgrim Woman

Thread the pipe cleaner through the smaller wood bead and bend in half. Thread the ends of the pipe cleaner through the hole in the smaller of the pots to form the arms. Glue the smaller pot over the larger pot. Glue on the head. Cut the mop cap from the muslin. Baste around the edge of the cap circle and pull to pucker. Flatten the cap. Place a small amount of cotton in the cap and glue to the top of the head. Cut the collar and apron from the foam mat. Place the collar around the neck and glue in front and back using low-heat hot glue. Glue on the apron. Draw the face using a fine-point permanent marker. Paint in the face colors. Bend the arms in half and pose as desired.

# Pilgrim Man

Thread the pipe cleaner through the smaller wood bead and bend in half. Thread the ends of the pipe cleaner through the hole in one of the pots to form the arms. Glue the two 2" (5.1 cm) pots together rim to rim. Glue one of the smaller pots onto the body to form the head. Cut the hat brim from the black foam mat. Paint the second small pot black, and glue onto the hat brim. Glue the hat to the top of the head. Paint the body black. Cut the collar from the white foam mat. Place around the neck, and glue front and back, using low-heat hot glue. Draw the face using a fine point permanent marker. Paint in the face colors. Bend the arms in half and pose as desired.

**Materials for Pilgrim Woman**
- 1 clay pot, 2" (5.1 cm) in diameter
- 1 clay pot, 2½" (6.4 cm) in diameter
- red, blue, and black craft paint
- White pipe cleaner
- 1 wood bead, 3/8" (1 cm) in diameter
- 1 wood head bead, 1¼" (3.2 cm) in diameter
- 2 mm white foam mat
- White muslin or sheeting
- Cotton ball
- Template

**Materials for Pilgrim Man**
- 2 clay pots, 2" (5.1 cm) in diameter
- 2 clay pots, 1¼" (3.2 cm) in diameter
- Black, blue, and red craft paint
- Black pipe cleaner
- 2 mm white and black foam mat
- 1 wood bead, 3/8" (1 cm) in diameter
- 1 wood head bead, 1¼" (3.2 cm) in diameter
- Template

# Native American Woman

Paint the head bead terra cotta. Mix in red or red iron oxide, if necessary, to match the shade of the pots. Thread the pipe cleaner through the smaller wood bead and bend in half. Thread the ends of the pipe cleaner through the hole in one of the pots to form the arms. Glue the smaller pot over the larger pot. Glue on the head. Cut the floss into 6" (15 cm) lengths. Glue the floss to the top of the head to form hair. Braid the hair and tie with small strips of suede. Paint the body soft yellow. String colored beads and tie around the neck. Draw the face using a fine-point permanent marker. Paint in the face colors. Bend the arms in half and pose as desired.

# Native American Man

Paint the head bead terra cotta. Mix in red or red iron oxide, if necessary, to match the shade of the pots. Thread the pipe cleaner through the smaller wood bead and bend in half. Thread the ends of the pipe cleaner through the hole in one of the pots to form the arms. Glue the two pots together rim to rim. Glue on the head. Cut the floss into 6" (15 cm) lengths. Glue the floss to the top of the head to form hair. Braid the hair and tie with small strips of suede. Make a headband from a small strip of suede and tie around the head. Cut a small fringed loincloth from the suede and glue to the waist. Cut the belt from the suede and glue around the waist. Draw the face using a fine-point permanent marker. Paint in the face colors. Paint the ceremonial paint on the cheeks and chest. Bend the arms in half and pose as desired.

**Materials for Native American Woman**

- 1 clay pot, 2" (5.1 cm) in diameter
- 1 clay pot, 2½" (6.4 cm) in diameter
- Black embroidery floss
- Small colored beads
- Red, brown, red iron oxide, soft yellow, and terra-cotta craft paint
- Brown pipe cleaner
- 1 wood bead, 3/8" (1 cm) in diameter
- 1 wood head bead, 1¼" (3.2 cm) in diameter
- Suede, chamois or Ultrasuede

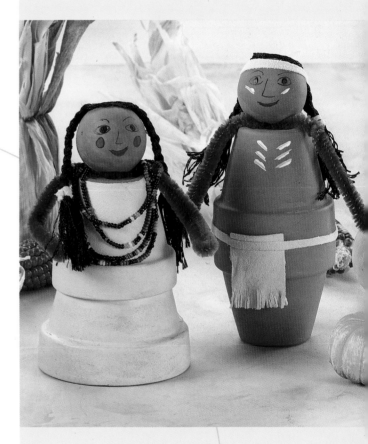

**Materials for Native American Man**

- 2 clay pots, 2" (5.1 cm) in diameter
- Black embroidery floss
- White, red, brown, red iron oxide, and terra-cotta craft paint
- Brown pipe cleaner
- 1 wood bead, 3/8" (1 cm) in diameter
- 1 wood head bead, 1¼" (3.2 cm) in diameter
- Suede, chamois or Ultrasuede

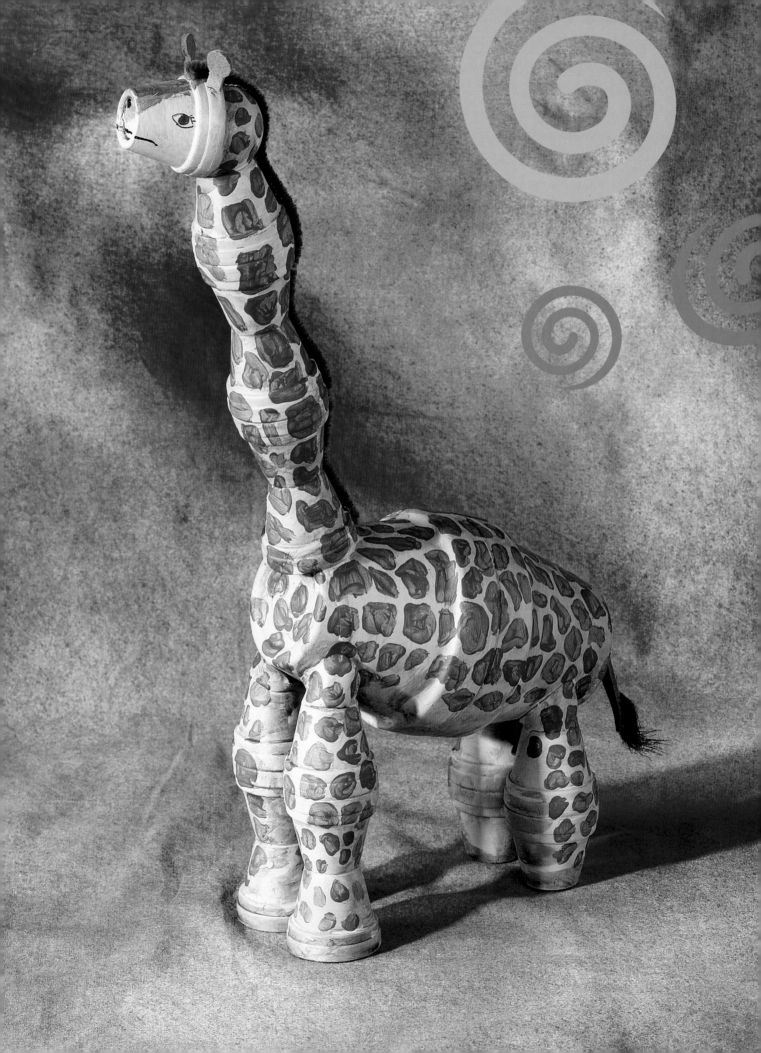

# Giraffe

Glue the 3" (7.6 cm) pots together rim to rim to make the body. Cover the end holes with circles of paper or cardboard. Make each hind leg by gluing two 1¼" (3.2 cm) pots together rim to rim. Make each front leg by gluing two 1¼" (3.2 cm) pots together rim to rim, then adding a third glued end to end. Make the neck by gluing five 1¼" (3.2 cm) pots together, alternating rim to rim and end to end. Glue the head bead into the remaining 1¼" (3.2 cm) pot. When the glue has dried, glue the head bead to the closed end of the neck at an angle to form the head and neck. Glue the closed ends of the legs to the body.

Cut small wedges from craft wood to create a gluing surface between the curve of the body and the tops of the legs. Glue the open end of the neck to the front of the body at a slight angle. Paint the entire giraffe with camel craft paint. When dry, paint on the spots, using red iron oxide. Create an antiquing wash by diluting burnt umber paint, 1 part paint to 3 or 4 parts water. Coat the giraffe with the wash and wipe off with a lint-free cloth. Glue the pipe cleaner down the back of the neck. Cut the tail and horns from foam mat using the template. Cut a small piece of faux fur and glue it to the end of the tail. Glue the tail and horns in place. Draw on the eyes and mouth with a fine-point permanent marker. Paint in the whites of the eyes.

**Materials for the Giraffe**

- 2 clay pots, 3" (7.6 cm) in diameter
- 16 clay pots, 1¼" (3.2 cm) in diameter
- 1 wood head bead, 1¼" (3.2 cm) in diameter
- 2 mm brown foam mat
- Black faux fur
- Medium brown pipe cleaner
- Camel, red iron oxide, white, and burnt umber craft paint
- Craft wood, ¼" x ¾" (0.6 x 1.9 cm)

# Templates

All templates should be photocopied at 100% unless otherwise noted.

For instructions on transferring the templates, see page 10.

## Hat

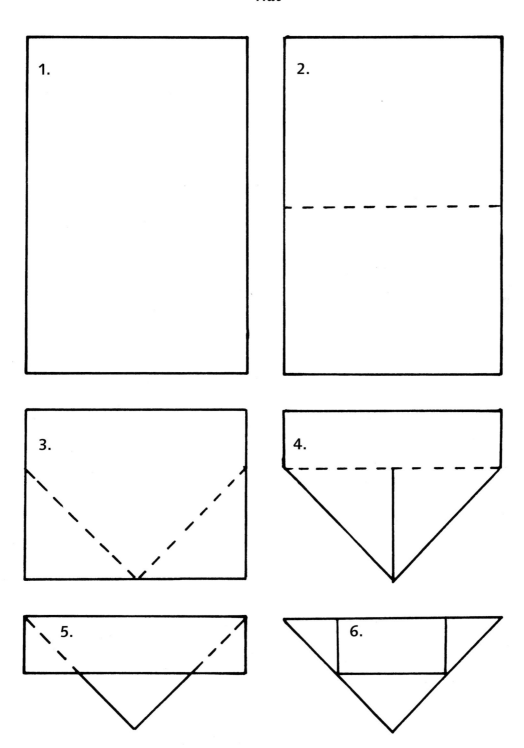

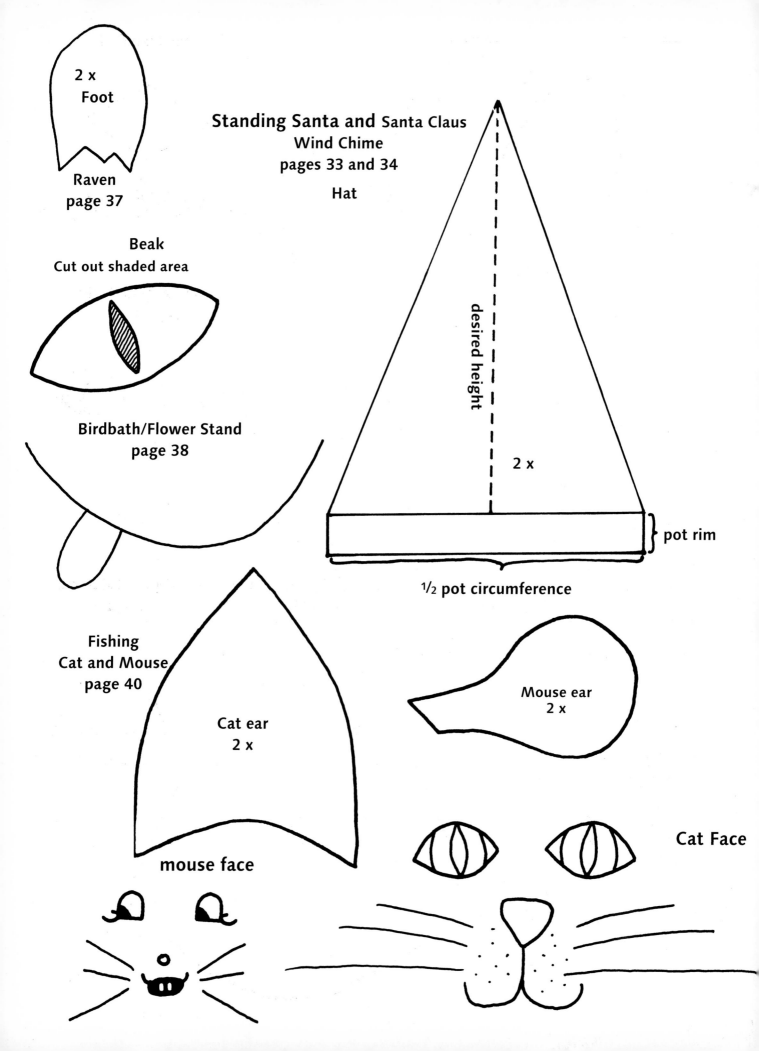

2 x
Foot

Raven
page 37

Standing Santa and Santa Claus
Wind Chime
pages 33 and 34

Hat

Beak
Cut out shaded area

Birdbath/Flower Stand
page 38

desired height

2 x

pot rim

½ pot circumference

Fishing
Cat and Mouse
page 40

Cat ear
2 x

Mouse ear
2 x

Cat Face

mouse face

Rooster
page 42

Chick page 42

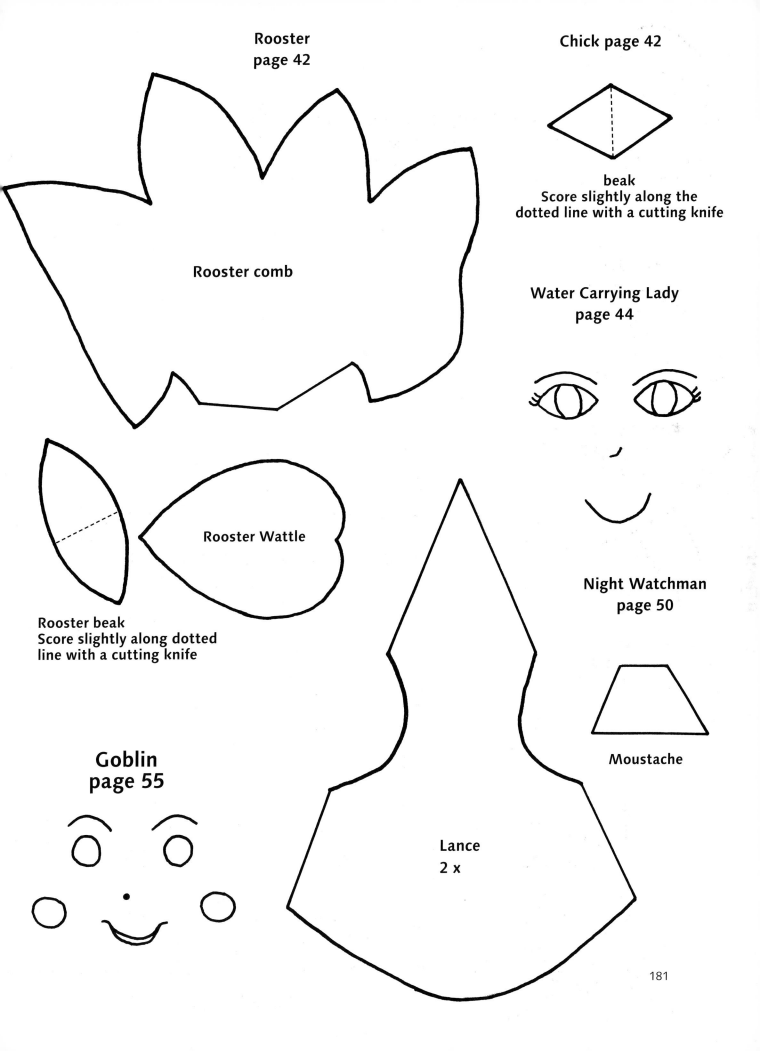

beak
Score slightly along the
dotted line with a cutting knife

Rooster comb

Water Carrying Lady
page 44

Rooster Wattle

Rooster beak
Score slightly along dotted
line with a cutting knife

Night Watchman
page 50

Moustache

Goblin
page 55

Lance
2 x

181

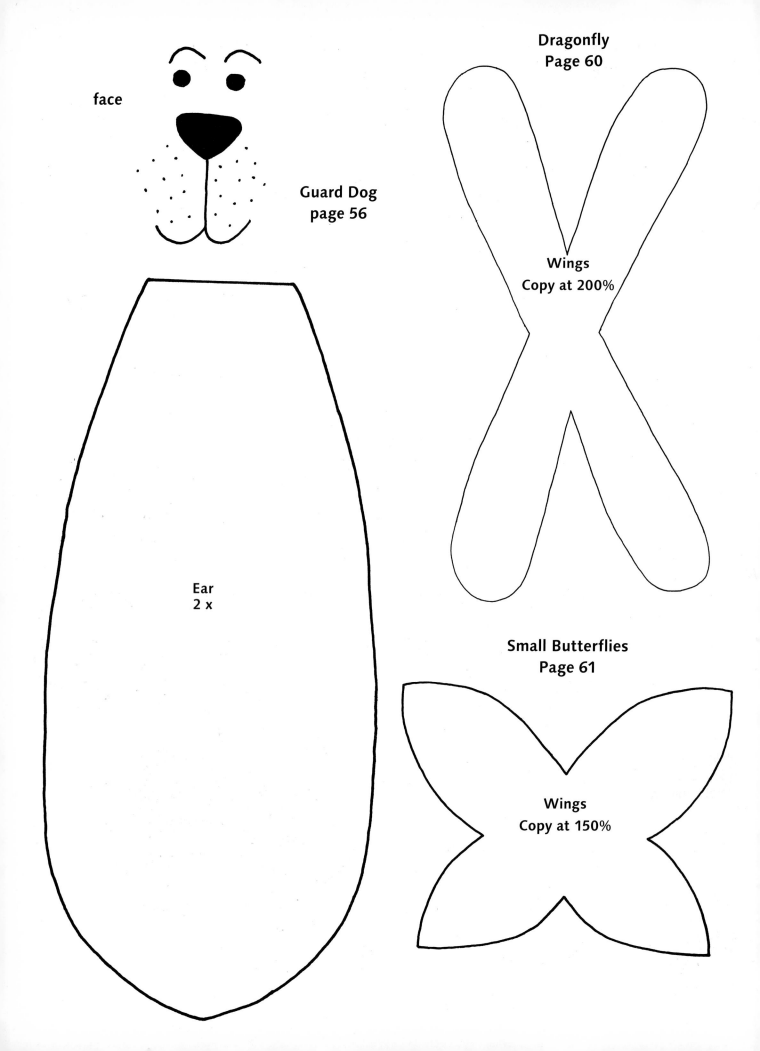

face

Guard Dog
page 56

Ear
2 x

Dragonfly
Page 60

Wings
Copy at 200%

Small Butterflies
Page 61

Wings
Copy at 150%

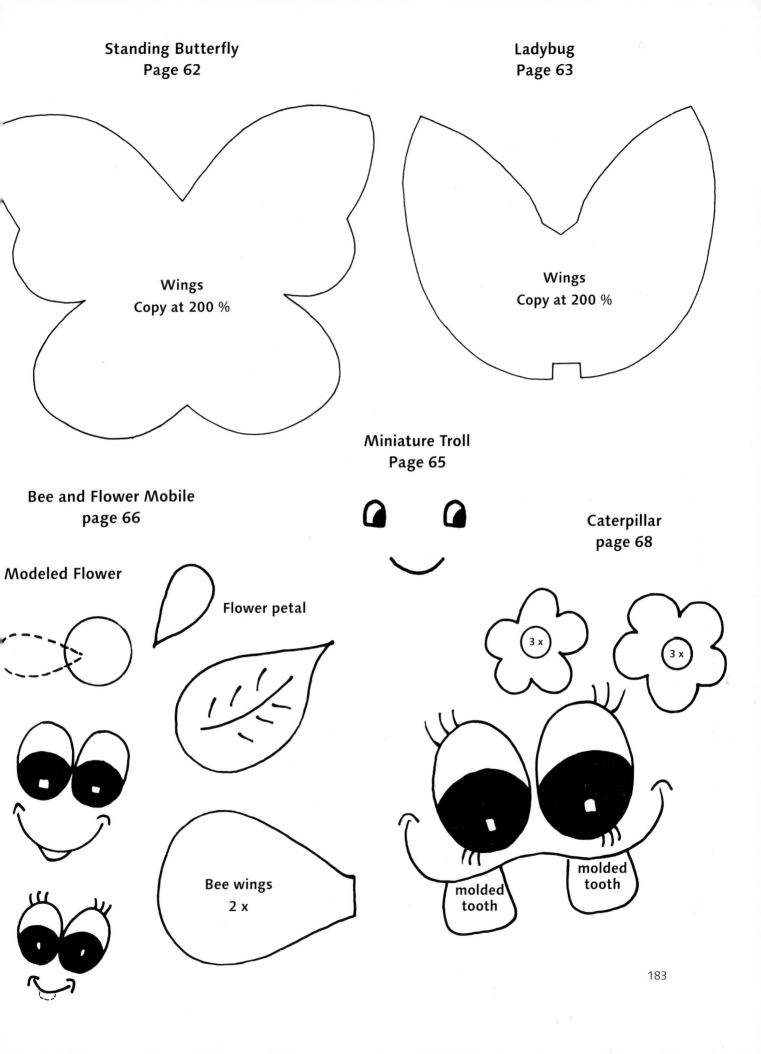

**Standing Butterfly**
**Page 62**

Wings
Copy at 200 %

**Ladybug**
**Page 63**

Wings
Copy at 200 %

**Miniature Troll**
**Page 65**

**Bee and Flower Mobile**
**page 66**

**Caterpillar**
**page 68**

**Modeled Flower**

Flower petal

3 x

3 x

Bee wings
2 x

molded
tooth

molded
tooth

183

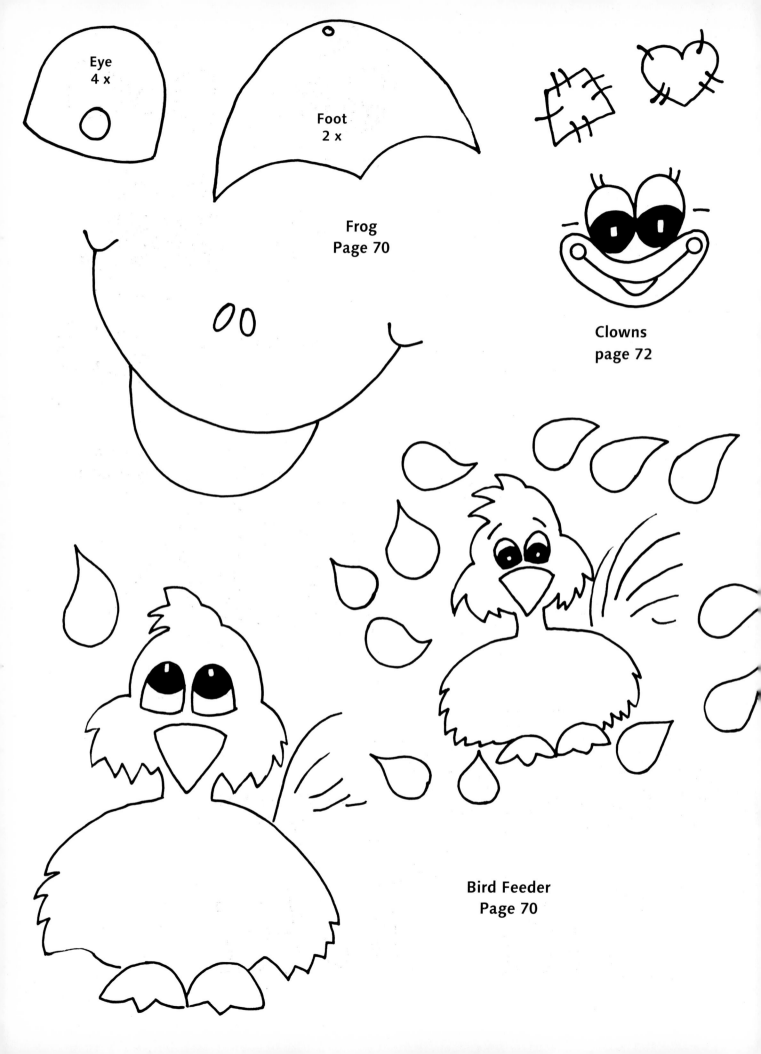

Eye
4 x

Foot
2 x

Frog
Page 70

Clowns
page 72

Bird Feeder
Page 70

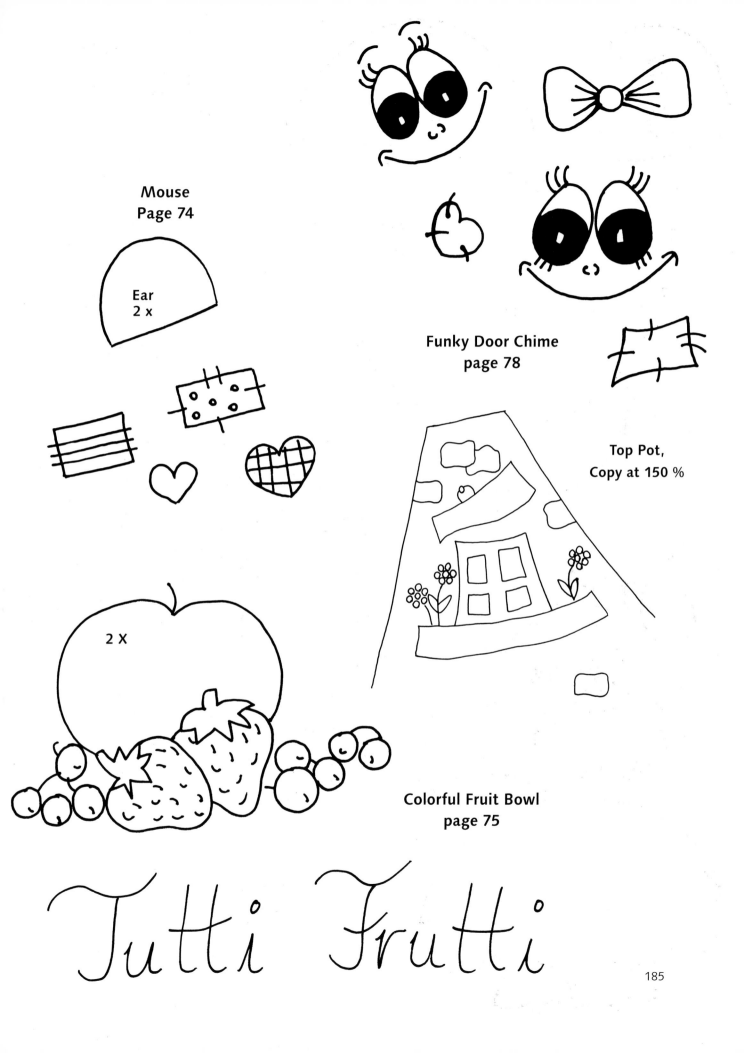

Mouse
Page 74

Ear
2 x

Funky Door Chime
page 78

Top Pot,
Copy at 150 %

2 X

Colorful Fruit Bowl
page 75

Tutti Frutti

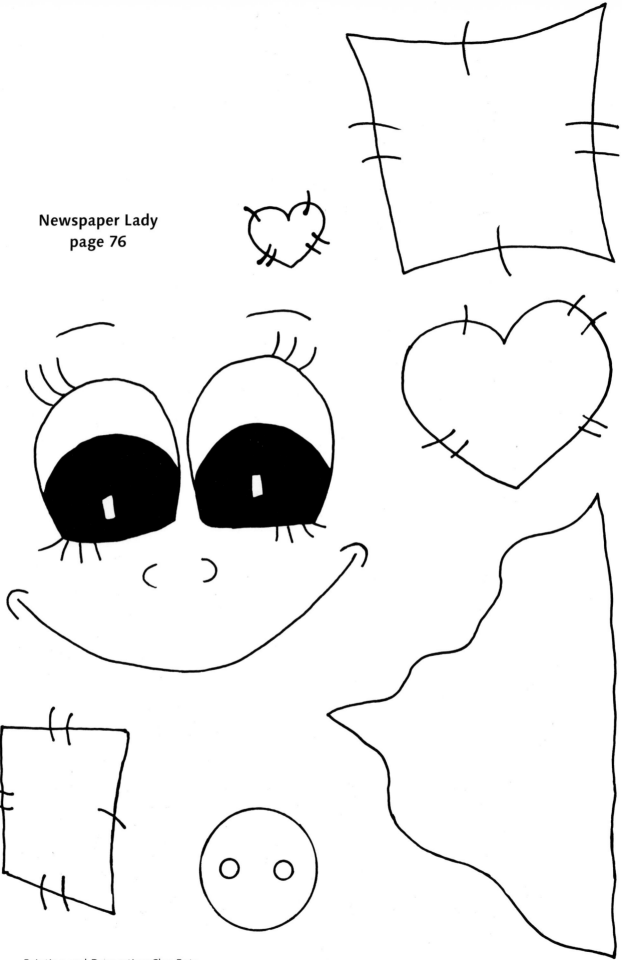

**Newspaper Lady**
**page 76**

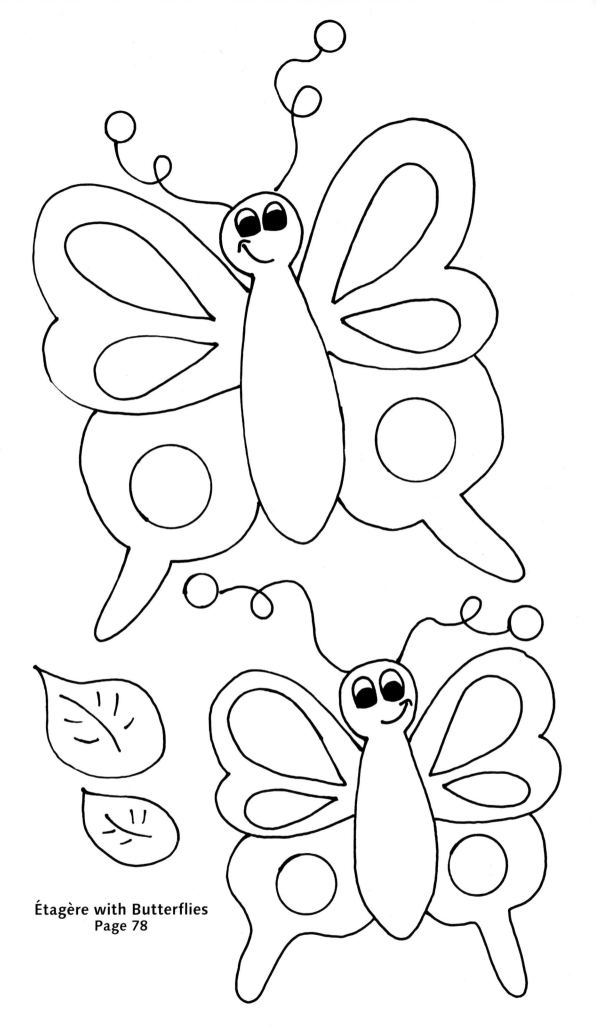

**Étagère with Butterflies**
**Page 78**

187

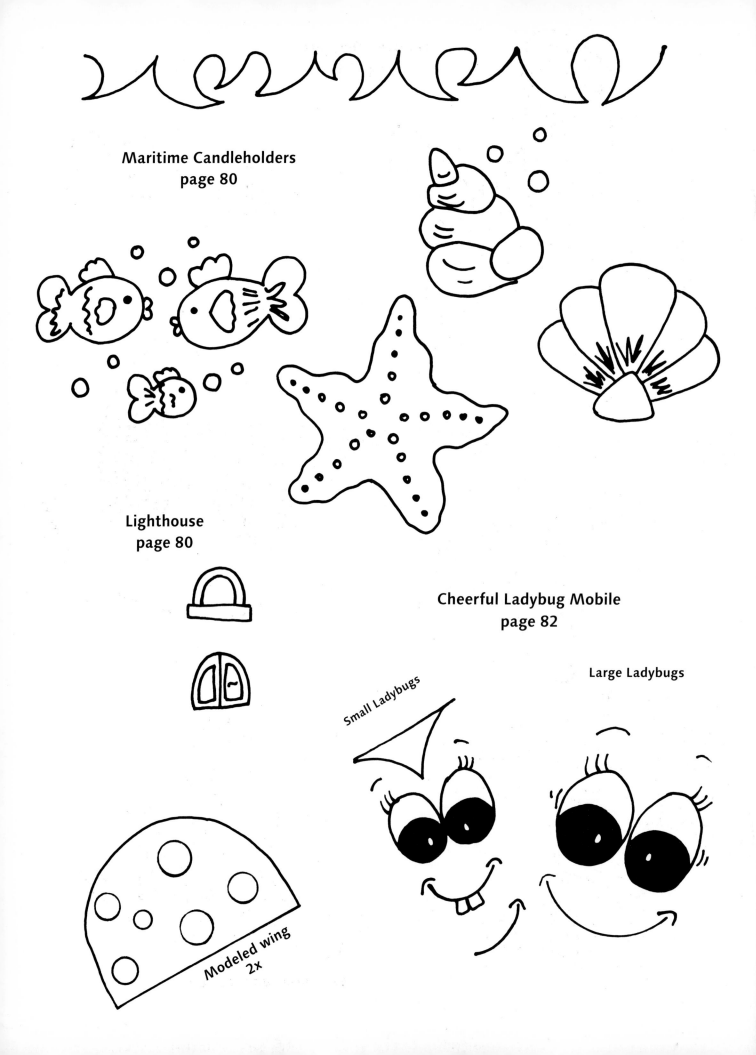

Maritime Candleholders
page 80

Lighthouse
page 80

Cheerful Ladybug Mobile
page 82

Small Ladybugs

Large Ladybugs

Modeled wing
2x

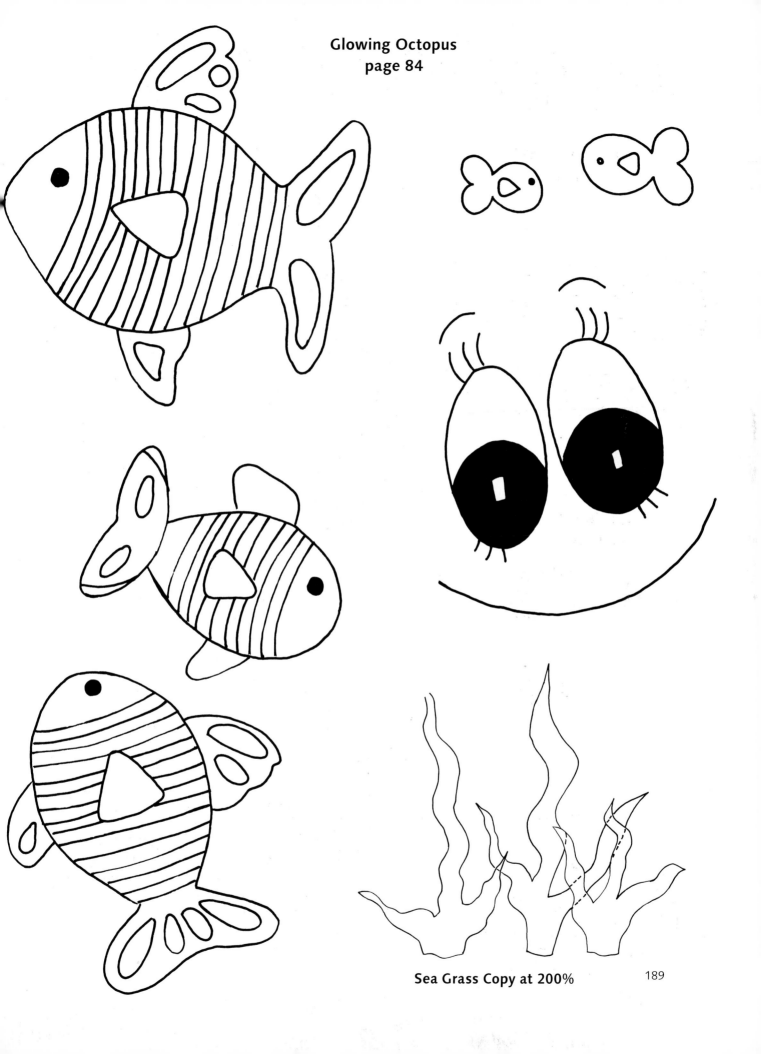

Sea Grass Copy at 200%

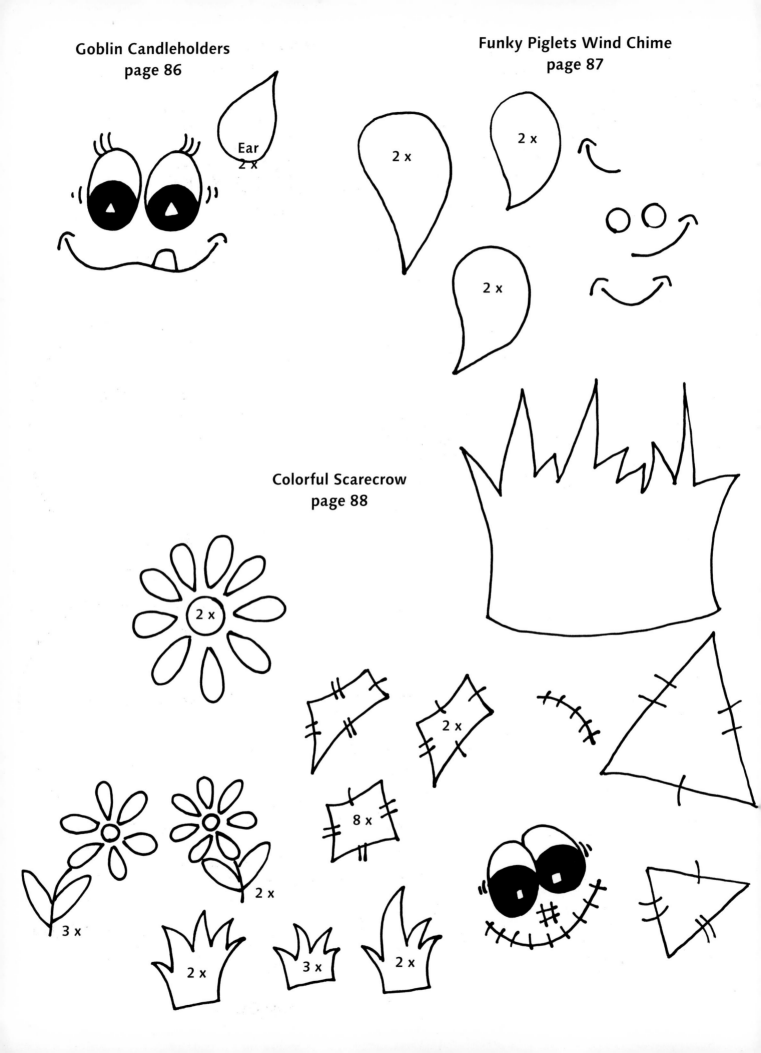

**Goblin Candleholders**
**page 86**

Ear
2 x

**Funky Piglets Wind Chime**
**page 87**

2 x

2 x

2 x

**Colorful Scarecrow**
**page 88**

2 x

2 x

2 x

8 x

3 x

2 x

2 x

3 x

2 x

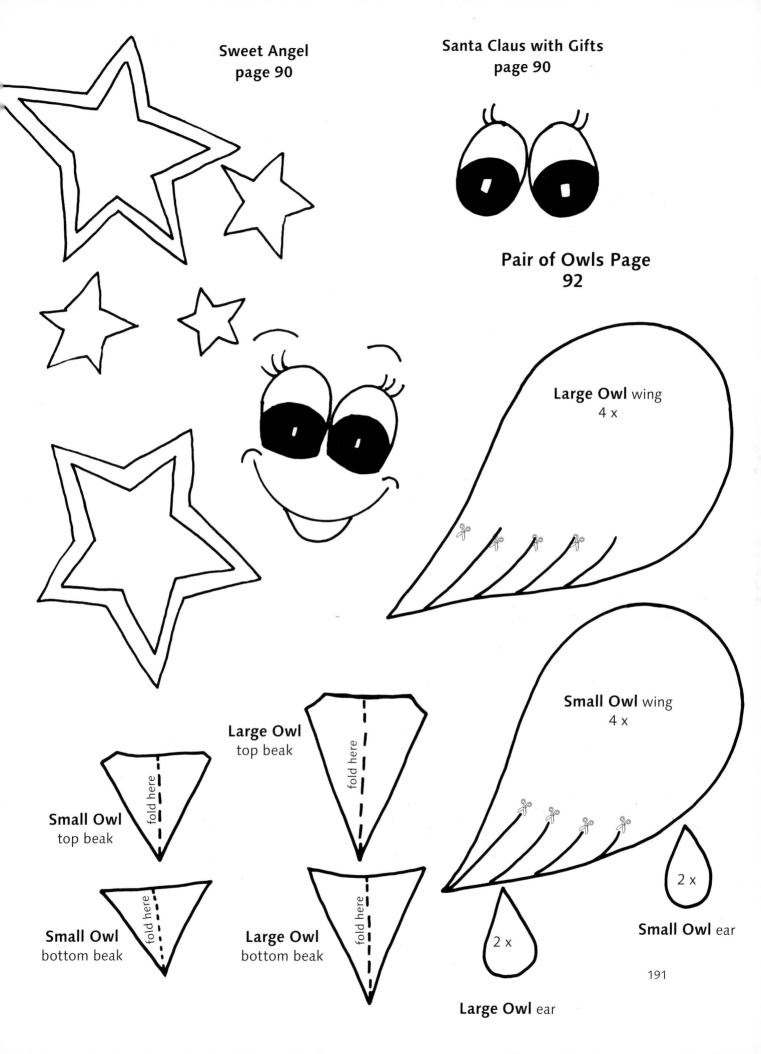

**Sweet Angel**
page 90

**Santa Claus with Gifts**
page 90

**Pair of Owls Page 92**

**Large Owl** wing
4 x

**Small Owl** wing
4 x

**Large Owl**
top beak

**Small Owl**
top beak

**Small Owl**
bottom beak

**Large Owl**
bottom beak

fold here

2 x

2 x

**Small Owl** ear

**Large Owl** ear

191

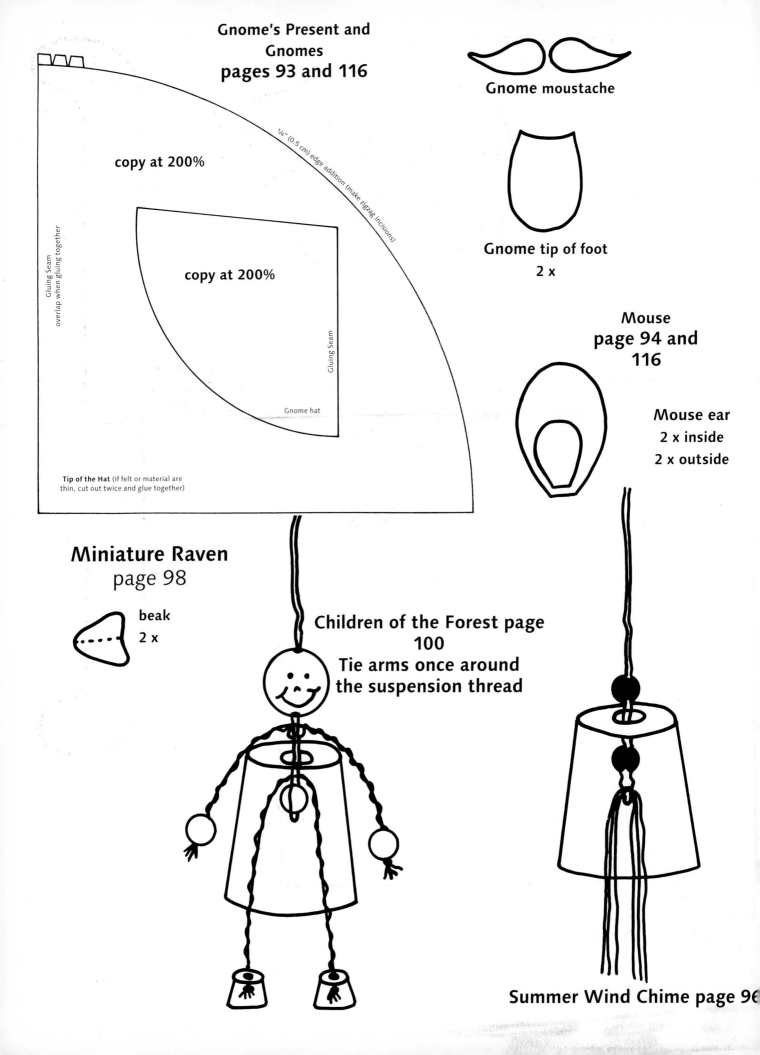

**Gnome's Present and Gnomes**
**pages 93 and 116**

Gnome moustache

copy at 200%

¼" (0.5 cm) edge addition (make zigzag incisions)

copy at 200%

Gluing Seam
overlap when gluing together

Gluing Seam

Gnome hat

**Tip of the Hat** (if felt or material are thin, cut out twice and glue together)

Gnome tip of foot
2 x

Mouse
**page 94 and 116**

Mouse ear
2 x inside
2 x outside

**Miniature Raven**
page 98

beak
2 x

**Children of the Forest page 100
Tie arms once around the suspension thread**

**Summer Wind Chime page 96**

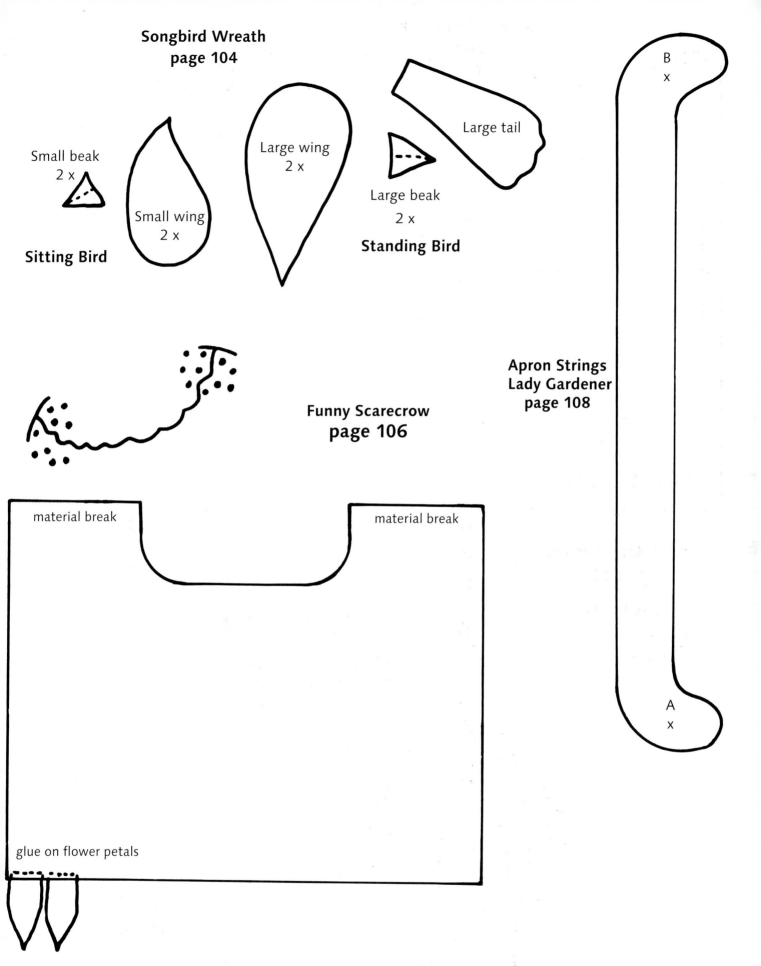

**Songbird Wreath
page 104**

Small beak
2 x

Sitting Bird

Small wing
2 x

Large wing
2 x

Large beak
2 x

Large tail

Standing Bird

**Apron Strings
Lady Gardener
page 108**

B
x

A
x

**Funny Scarecrow
page 106**

material break

material break

glue on flower petals

193

**Lady Gardener page 108**

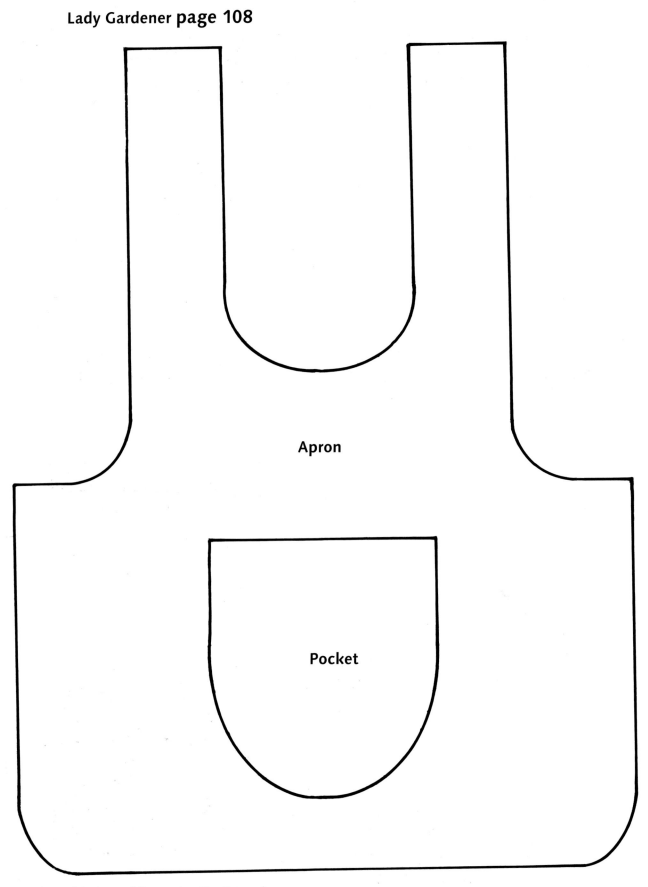

Apron

Pocket

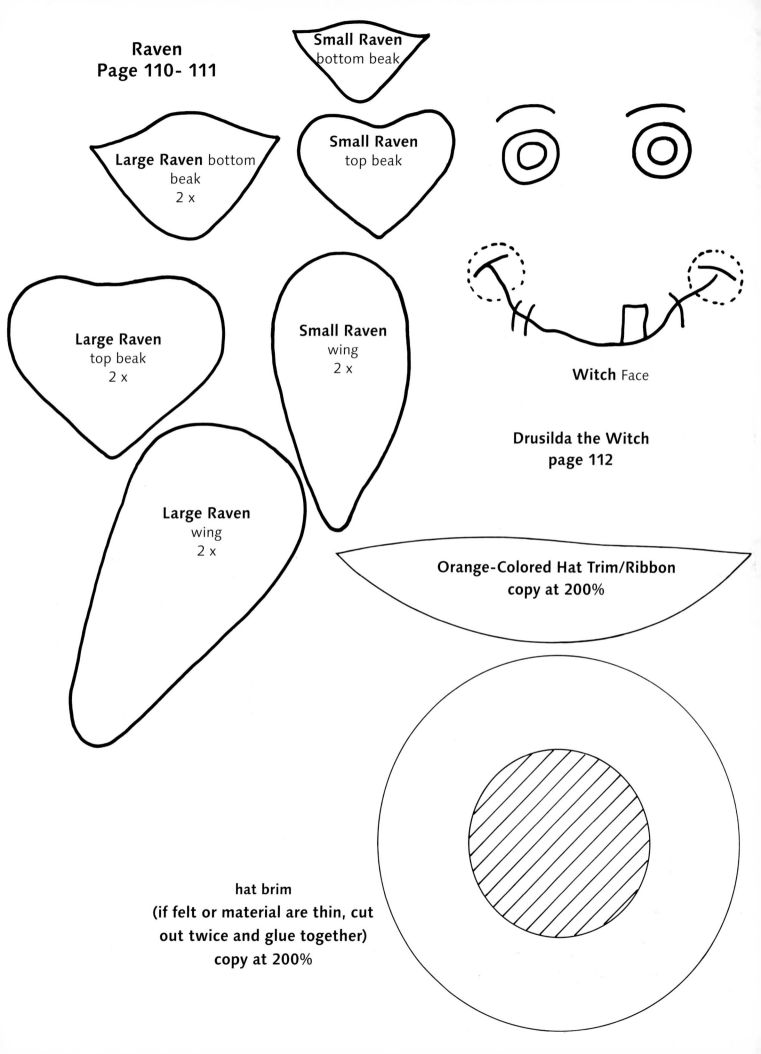

**Raven**
**Page 110- 111**

**Small Raven** bottom beak

**Large Raven** bottom beak
**2 x**

**Small Raven** top beak

**Large Raven** top beak
**2 x**

**Small Raven** wing
**2 x**

**Witch** Face

**Drusilda the Witch**
**page 112**

**Large Raven** wing
**2 x**

**Orange-Colored Hat Trim/Ribbon**
**copy at 200%**

hat brim
**(if felt or material are thin, cut out twice and glue together)**
**copy at 200%**

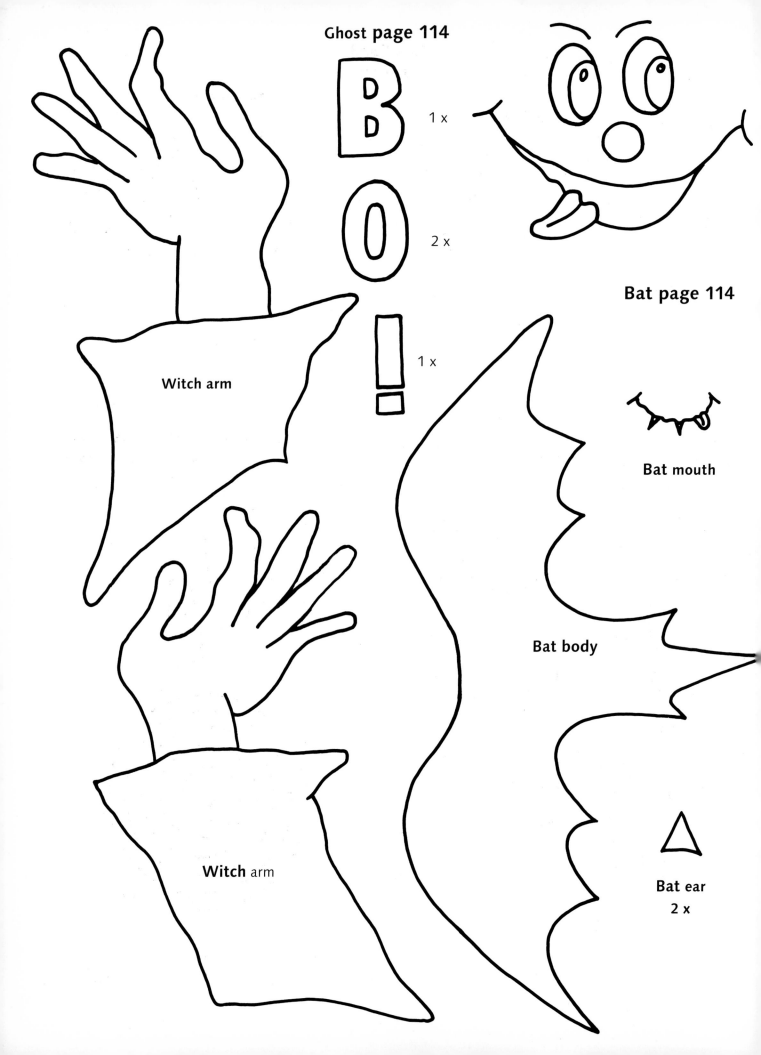

Ghost page 114

**B** 1 x

**O** 2 x

**!** 1 x

Witch arm

Witch arm

Bat page 114

Bat mouth

Bat body

Bat ear
2 x

**Big Duck**

**Duck Family
page 118**

**Small Duck**

fold here

2 x

2 x

fold here

2 x

2 x

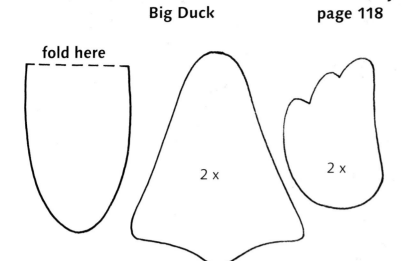

**Cow page 118**

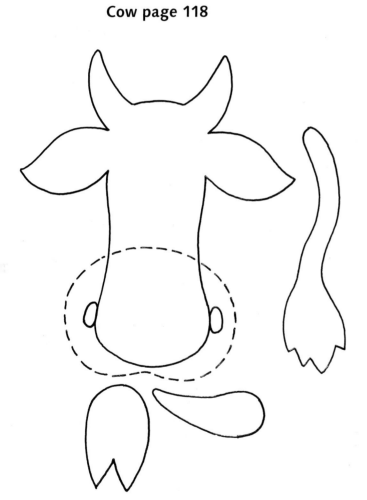

**Mouse Pot
page 121**

2 x

tail

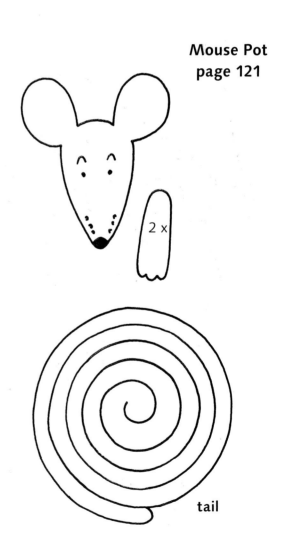

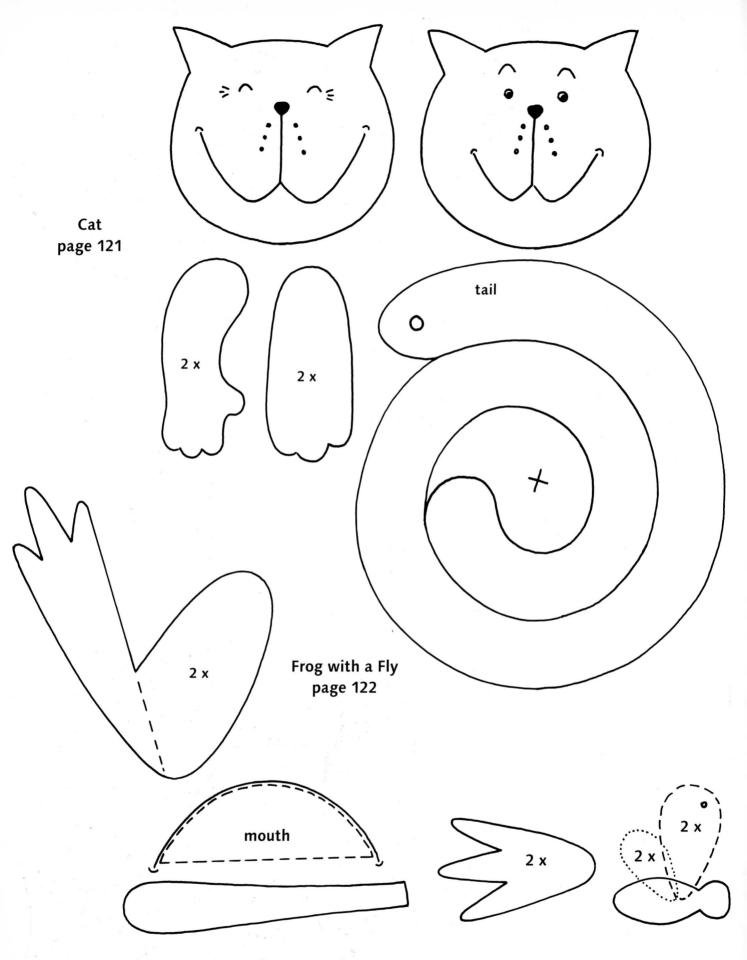

Cat
page 121

2 x

2 x

tail

2 x

Frog with a Fly
page 122

mouth

2 x

2 x

2 x

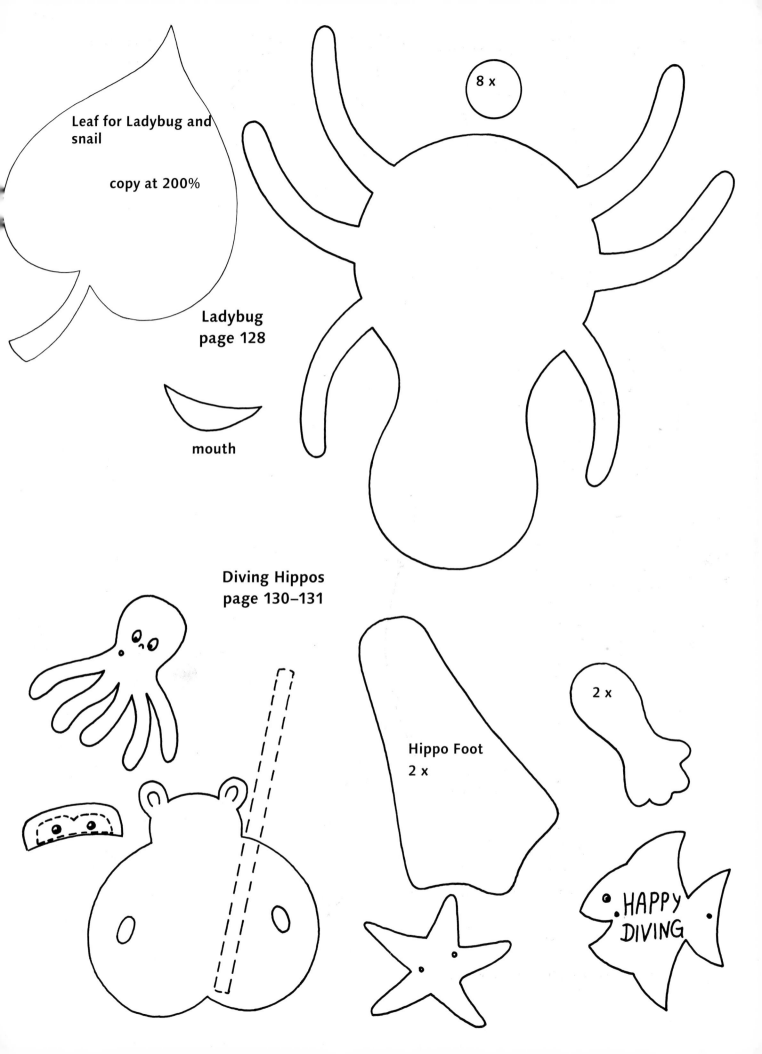

Leaf for Ladybug and snail

copy at 200%

8 x

Ladybug
page 128

mouth

Diving Hippos
page 130–131

Hippo Foot
2 x

2 x

HAPPY
DIVING

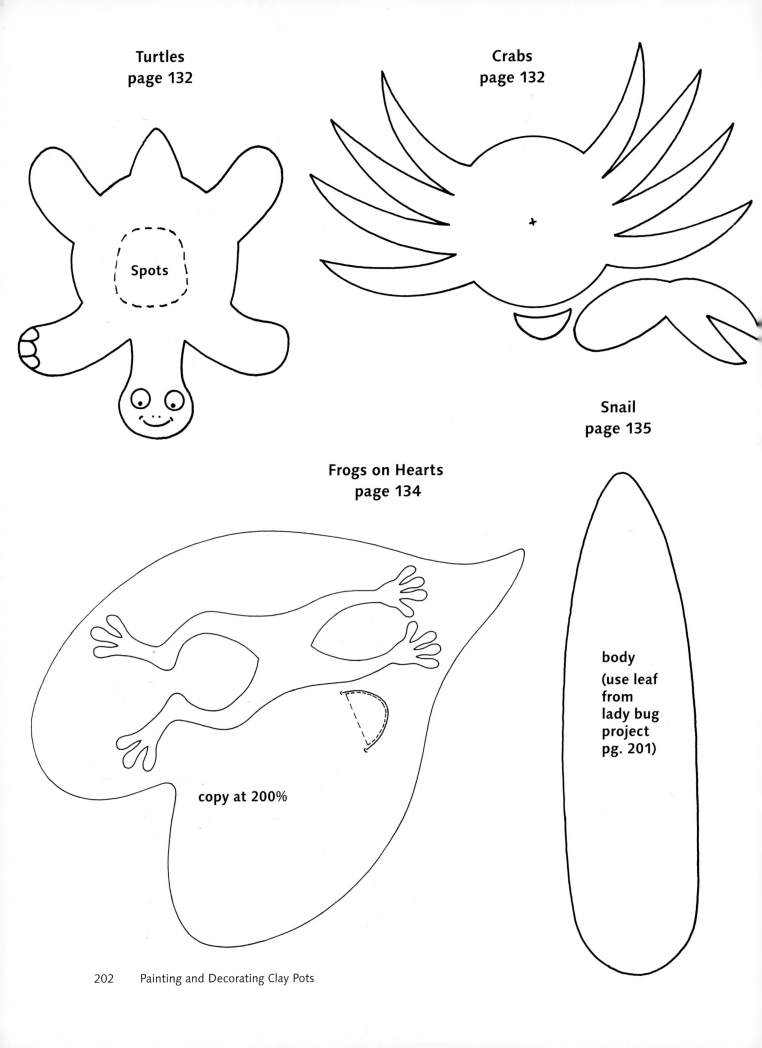

**Turtles
page 132**

Spots

**Crabs
page 132**

**Snail
page 135**

**Frogs on Hearts
page 134**

body
(use leaf
from
lady bug
project
pg. 201)

copy at 200%

# Raven Wind Chime
## page 138

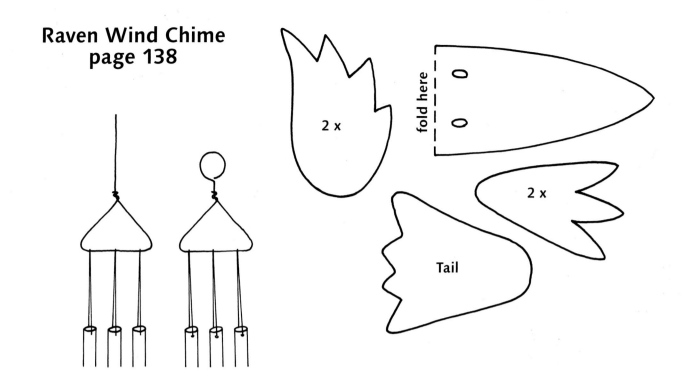

2 x

fold here

2 x

Tail

# Elephants page 138

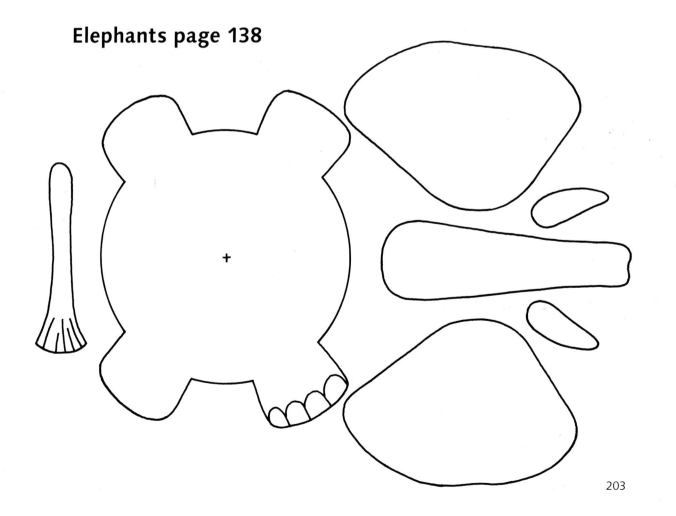

# Spider page 140

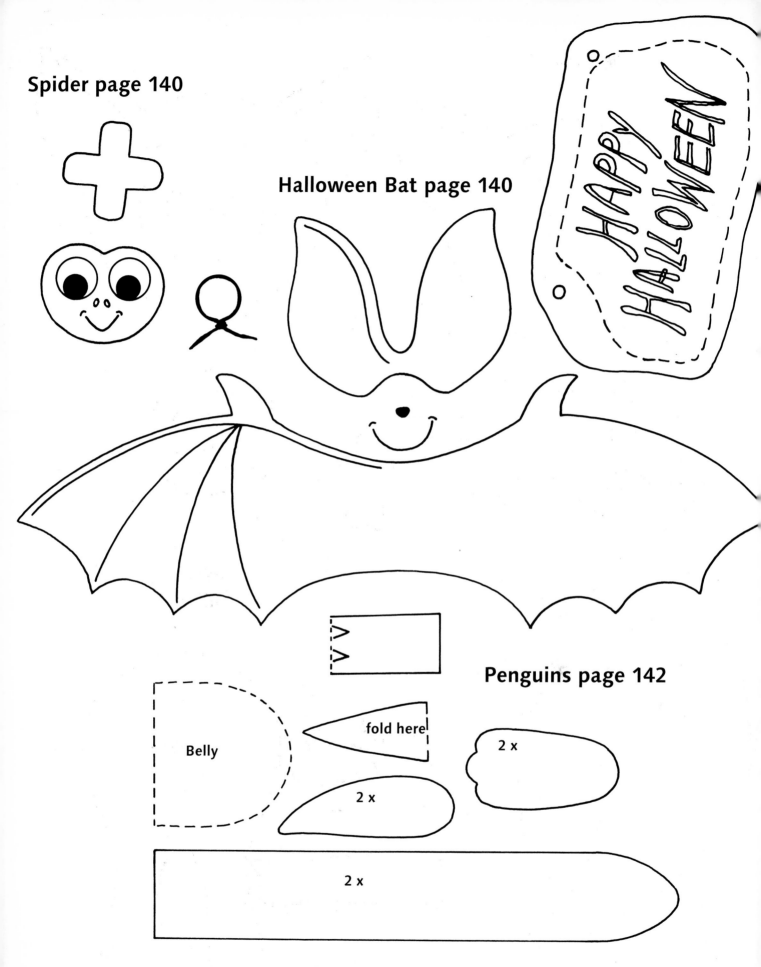

# Halloween Bat page 140

HAPPY HALLOWEEN

# Penguins page 142

Belly

fold here

2 x

2 x

2 x

2 x

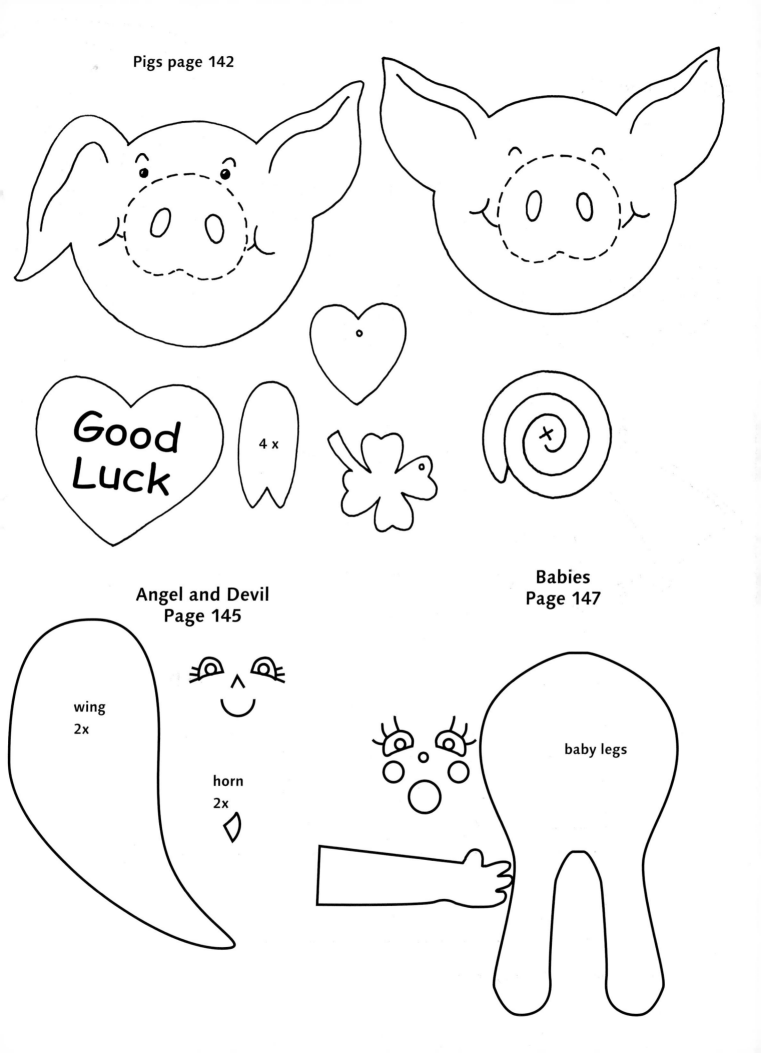

Pigs page 142

Good Luck

4 x

Angel and Devil
Page 145

wing
2x

horn
2x

Babies
Page 147

baby legs

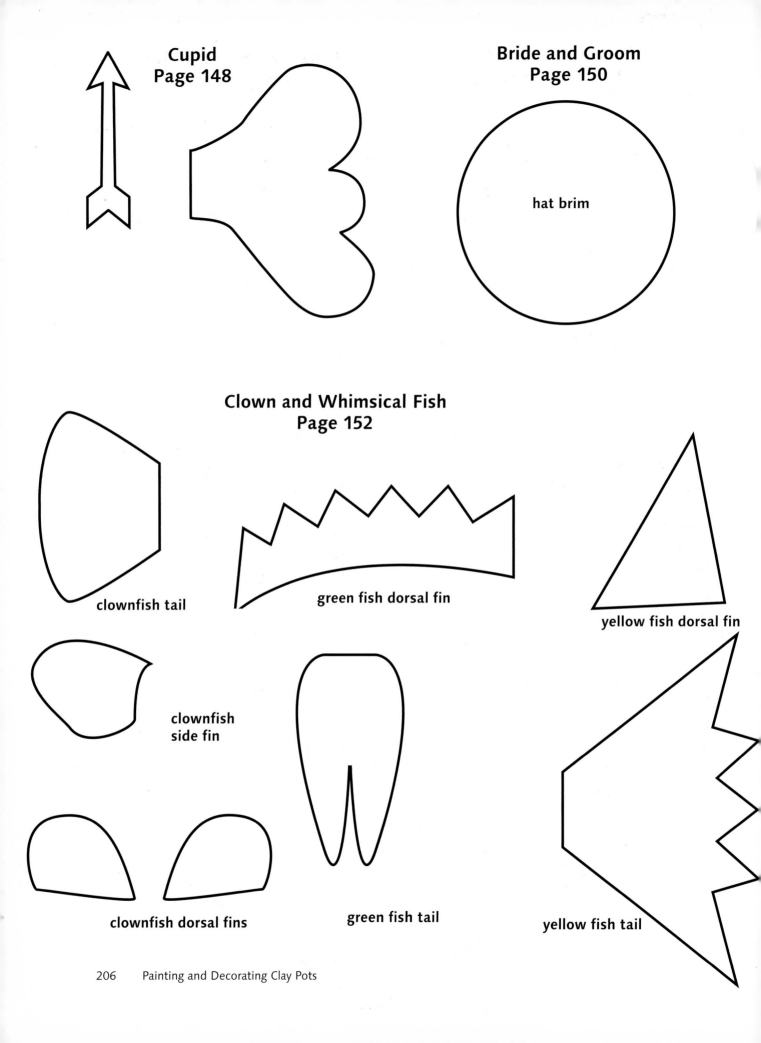

# Cupid
## Page 148

# Bride and Groom
## Page 150

hat brim

# Clown and Whimsical Fish
## Page 152

clownfish tail

green fish dorsal fin

yellow fish dorsal fin

clownfish
side fin

clownfish dorsal fins

green fish tail

yellow fish tail

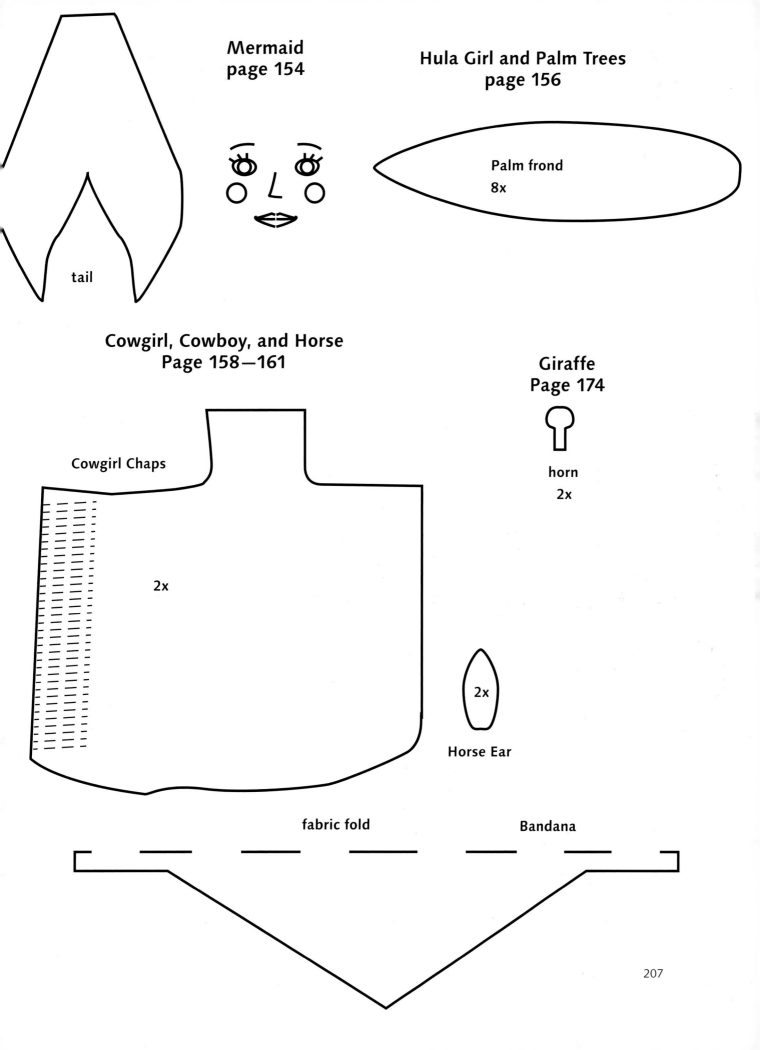

Mermaid
page 154

Hula Girl and Palm Trees
page 156

Palm frond
8x

tail

Cowgirl, Cowboy, and Horse
Page 158—161

Giraffe
Page 174

Cowgirl Chaps

horn
2x

2x

2x

Horse Ear

fabric fold          Bandana

207

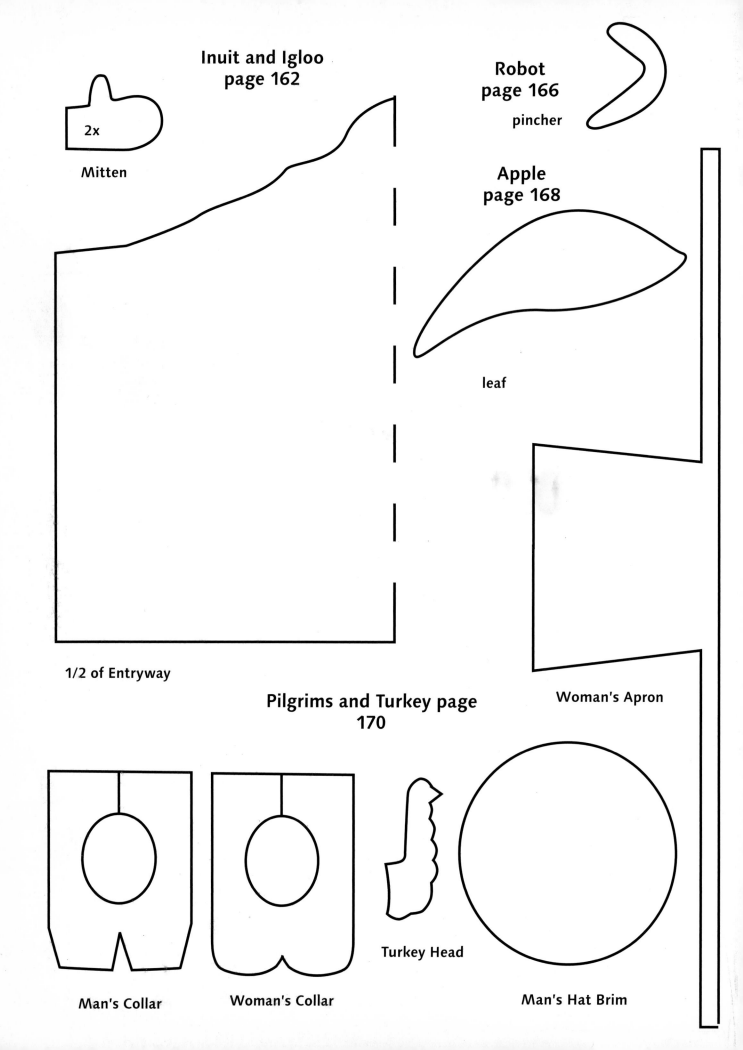

**Inuit and Igloo**
**page 162**

2x

Mitten

**Robot**
**page 166**

pincher

**Apple**
**page 168**

leaf

1/2 of Entryway

Woman's Apron

**Pilgrims and Turkey page**
**170**

Man's Collar

Woman's Collar

Turkey Head

Man's Hat Brim